MESTIZO
MODERNISM

MESTIZO MODERNISM

RACE, NATION, AND IDENTITY IN
LATIN AMERICAN CULTURE, 1900–1940

TACE HEDRICK

RUTGERS UNIVERSITY PRESS
NEW BRUNSWICK, NEW JERSEY • LONDON

LIBRARY OF CONGRESS CATALOGING-IN-PUBLICATION DATA

Hedrick, Tace, 1954–

Mestizo modernism : race, nation, and identity in Latin American

culture, 1900–1940 / Tace Hedrick.

p. cm.

Includes bibliographic references and index.

ISBN 0-8135-3216-7 (cloth : alk. paper)—ISBN 0-8135-3217-5 (pbk. : alk. paper)

1. Arts, Latin American—20th century. 2. Ethnicity in art.

3. Mestizaje—Latin America—History—20th century. I. Title.

NX501.5 .H43 2003

700' .92'368—dc21 2002012412

British Cataloging-in-Publication data for this book is available from the British Library.

Manufactured in the United States of America

For my parents, Bill and Lisa Hedrick,
whose love has made everything possible

CONTENTS

ACKNOWLEDGMENTS

O VER THE COURSE of the nine years and two institutions it has taken to see this book to publication, many people have given me intellectual and emotional aid and comfort. I must first thank Oscar Hahn, who, while he was teaching at the University of Iowa, introduced me to the poetry of César Vallejo and set me on my way, and Herman Rapaport, who gave me a solid intellectual foundation from which to write such a book as this.

Material support in the research and completion of this book was provided by a Capital College Research Council Grant from Penn State Harrisburg, a 1996 Summer Research Fellowship in Latin American Studies from the University of Pittsburgh, and two Fine Arts and Humanities Scholarship Enhancement Funds generously awarded from the University of Florida. I thank John Leavey for providing me with a junior leave, time which was spent polishing this manuscript for publication.

I must especially thank my good friends and colleagues at the University of Florida: Kenneth Kidd, Pamela Gilbert, and Brandon Kershner. They cheered me through the difficult bits, provided sound writing advice, and took me out for coffee, dinners, movies, and days at the beach. I thank Patricia Craddock for her mentoring; Marsha Bryant originated the idea for my title and gave me valuable advice and support. The ideas and conversations of the participants in both sessions of my graduate class Race and Gender in Comparative American Modernisms at the University of Florida helped to polish and refine my own thoughts about this book. Much friendship and general support has come from Debra King, Malini Scheuller, Maureen Turim, Amitava Kumar, Michael Hoffman, Kim Emory, Roger Beebe, Leah Rosenberg, Terry Harpold, Sid Dobrin, Stephanie Smith, and Phil Wegner. Angel Kwollek-Foland, director of the Center for

Women's Studies and Gender Research, has been the salvation of my joint appointment here at the University of Florida.

Although many colleagues, students, and friends have influenced my thinking, my conversations with Susan Hegeman were particularly instrumental in shaping the ultimate form of this book; José Cerna-Bazan helped me understand Vallejo's social and cultural contexts; and Erik Camayd-Freixas gave me insights into the translation of Vallejo's poetry. Vera Kutzinski provided me with intellectual models in the form of her published books, heartened me in the writing of this book, and listened with a kind ear to my long monologues on inter-American modernisms. Susan Stanford Freidman, too, gave me much-needed encouragement during the last year of my writing.

This book would not have been possible without Leslie Mitchner's zeal for my project, or Melanie Halkias's generous help with my many publication questions, or Lizabeth Paravisini-Gebert's enthusiastic reading of my manuscript. I also thank the anonymous readers of my project at various moments along its evolution.

My parents, Bill and Lisa Hedrick, believed in me throughout the long path of my academic career, providing material support when they could but, more importantly, giving me a firm foundation of unconditional love. My cousin Heather Haupt and her family gave me kinship and time at the ocean. Finally, my most heartfelt thanks go to Michael Coyle, my lover, friend, intellectual support, and bridge to that place where it is safe to love and safe to dream of finishing projects like this.

MESTIZO
MODERNISM

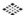

MESTIZO MODERNISM

*We need . . . to present ourselves as a strong people, hard-working, intelli-
gent, and intrepid, to that other people who abound in these conditions, and
who only respect those who possess them. They take us for a kind of female
of the American race, and it continues to be urgent that they see us in virile
labors: especially when it's certain that, without the same condition of activ-
ity, labor, and ingenuity, the men of the North will take advantage of us.*

—JOSÉ MARTÍ, *OBRAS COMPLETAS*

THIS IS A BOOK ABOUT a sense of modernity as it was both negoti-
ated and imagined, between the years of 1910 and 1940, by four very
different artists: Peruvian poet César Vallejo, Mexican artists Frida Kahlo
and Diego Rivera, and Chilean poet Gabriela Mistral. To say that, at the
beginnings of the twentieth century, these artists understood themselves
to be modern will not, certainly, startle Latin American scholars reading
this book; but to say that these individuals were modern*ists*, in what I am
proposing as the English-language sense of the term, might surprise Latin
Americanists as well as scholars of European and United States esthetic
modernism. In part, of course, this surprise owes to the difficulty of cross-
ing the disciplinary, not to say linguistic, boundaries separating scholars of
Latin American literature and culture from scholars of European and
United States modernism.[1]

That crossing disciplinary boundaries is difficult is obvious; but it is the
difficulty of moving between the sometimes very different perspectives of
Latin American and Euro-American scholars that I wish to emphasize here.
European and United States scholars have been engaged in what some

have termed a "new modernist studies" conversation of the last fifteen years or so; this discussion has greatly expanded the idea of what it means to be modern or a modernist, either in Europe or in the United States, largely by insisting that race, gender, and sexuality—and not merely esthetic or formal considerations—be the foci of modernist studies. Such a discussion has been built on groundbreaking studies like Houston Baker Jr.'s *Modernism and the Harlem Renaissance*, Rita Felski's *The Gender of Modernity*, and Michael North's *The Dialect of Modernism*. On the other hand, as we will see, theorists such as George Yúdice, Néstor García Canclini, and Neil Larsen have framed, often via a rereading of postmodernism and globalization, a somewhat different take on the problems of modernity that nations to the south of the United States have encountered and on the relation of such problems to the esthetic movements of the first part of Latin America's twentieth century.

The differences between these two perspectives are not inconsequential, and it is important to delineate them—but such differences are not, I am convinced, insuperable. My study takes critical insights from both groups—from the new modernist readings by United States and European critics engaged in opening up the conceptual framework of esthetic modernism and from Latin American critics occupied in reframing older ways of reading Latin America as peripheral to modernity and hence only belatedly modern. This is not, hopefully, to bring to Latin American texts a reading legitimated on the basis of the North's interest in the South's ability to "revitalize and revalorize the aesthetic culture of [Western] modernism and the avant-garde" (Larsen 6). The challenges that a reading of Latin American artists of the early part of the twentieth century will bring to the scholarship of European and U.S. modernist critics will perhaps open spaces for new thought about the dominance of assumptions, for instance, that modernity has already, and everywhere, happened—even if for some it always comes a little bit late.

This introduction lays out a generalized context for the claims about the connections between race, gender, and modernity, claims which I will be making in the rest of the book. Again, much of this contextual situating will be familiar ground to Latin Americanists; it is intended to bring to the forefront ways the nations to the south of the United States negotiated and represented to themselves the profound social, cultural, and economic shifts in self-perception brought about by modernizing influences,

and to confront possibly unconscious Euro-American notions about who and what was (or is) modern—and why. Such a confrontation begins with the knowledge that as Latin Americans grappled with the rapidity of changes brought by successive waves of industrialization and modernization, there was an increasing backlash against the growing economic and political imperialism of the United States as well as against a Europe which was still, in the 1920s and 1930s, perceived as the cultural capital of the world.

It is also part of my argument, however, that the very backlash against Europe and the United States was itself caught up within, even while it tried to transform, the confines of widely shared Western assumptions about the meaning of being modern and future-oriented. In insisting, against outside perceptions of the so-called primitive or timeless character of Latin American nations, that, in fact, they were progressive, many Latin Americans—the majority of them from elite sectors of society, it must be noted—began to examine their own societies by means of vocabularies of modernization. Paradoxically, these vocabularies themselves often came directly from both European and United States centers of social, cultural, and economic hegemony. However, I suggest, one of the results of adapting new ways of talking, thinking about, and representing the intertwined categories of race, gender, and nationhood was that, beginning around the 1880s, there began in Latin America a decided shift in historical feeling—one that included a new and increasingly technological and scientific sense (and lexicon) of progress; a feeling of, as Peruvian intellectual José Carlos Mariátegui would put it in the 1920s, "belonging to the century" (256). This shift also meant that men and women were experiencing the significance of gender and racial roles in a changing, politicized, and necessarily embodied way.

Beginning in the late nineteenth century and continuing, especially in places like Mexico, into the 1940s, the fact of a long heritage of race-mixing was of increasing concern to discussions of national character and harmony. How were indigenous or black populations supposed to feel national unity with white (European-derived) groups? How were European-identified whites of the middle and upper classes to feel an indigenous sense of pride in their nations? Fueling a growing attention paid not only to the then-ubiquitous Indian question but to women (as producers of

racialized bodies) was a larger series of questions centering on the reception of scientific eugenicism in South America.[2] In the face of the fact of Latin American racial mixture, called *mestizaje* when it referred to Indo-Hispanic crossings, policy makers and scientists alike set about to rework the ideas of scientific eugenics, which for the most part had deemed mixed-race individuals weak and degenerate. Instead, the mixed-race individual would come to serve for many as a symbol of racial and therefore national unity. Thus, eugenics rhetoric in Latin America often used the genetic theories of both Lamarck and, later, Mendel to propose an analogy between the vigor of hybrid plants and animals and the similar vitality of mixed races: as José Vasconcelos, the widely influential Mexican minister of education (1920–1926) maintained in 1926, "If we observe human nature closely we find that hybridism in man, as well as in plants, tends to produce better types" (Gamio and Vasconcelos, *Aspects* 85).

In much of what follows in this book, I will refer often to Mexican discourses of mestizaje as exemplary of general ideas about race in Latin America. Although I do not mean to imply that all ideas about race were the same everywhere, Mexico stands as a good illustration because nowhere else was the state itself, and by extension its various cultural and scientific ministries, quite so concerned with the promotion of certain aspects of both mestizaje and indigenism. Mexico itself then stands as an extreme case of the various degrees to which mestizaje and indigenism affected state and scientific policies of modernization in countries such as Chile and Peru. Part of what undergirded the political use to which mestizaje was put was the sometimes explicit, sometimes implicit idea that through race and cultural mixing the Indians, *qua* Indians, would eventually die out, and there would be left a modern nation of mixed Indo-Hispanic mestizos who, as Vasconcelos suggested, since they could not return to the ways of their (Indian) ancestors, would have no choice but to make of themselves a bridge into the future (Gamio and Vasconcelos, *Aspects* 83). This gives us an idea of how closely linked, by the 1920s, thinking about modernity and about race really was. In Mexico and elsewhere, Vasconcelos served as a kind of interpreter and popularizer of those ideas which not only he but many other people saw as keys to a unified and modern Mexican state. It was from such people as Mexican anthropologist Manuel Gamio (first director of the Bureau of Anthropology in 1917 and

subsecretary of the Department of Education, 1920–1924) that Vasconcelos took (and to some degree transformed) the idea that the physical and cultural act of race-mixing would be beneficial to Mexico—to produce, as Gamio put it in 1916, "the new nation of blended bronze and iron" (98).[3] This insistence on the primacy of a mestizo state permeated not only the Mexican government's cultural and educational programs, but also its underwriting of anthropological and archeological endeavors. Given this cultural and scientific focus on racial and social benefits of race-mixing, then, one might wonder how anthropologists such as Gamio justified their insistence that the government help to fund the study of ancient Mesoamerican cultures and the folkways and languages of contemporary, presumably racially pure Indians—studies that would be essentially Indian-oriented, or indigenist, in their thrust.[4] This question, in fact, lies at the heart of a modern sense of mestizaje; whatever permutations the Latin American emphasis on the mestizo would take (and there were many), the concern with a sense of the ancient in combination with the modern—a mestizaje that called for race mixing but was simultaneously indigenist—would provide both motivation and paradox in public policy and artistic endeavor alike.

We can begin to look for an answer to this question with Gamio himself. He would, of course, admit that both cultural and race mixing had already taken place for thousands of years, but unlike Vasconcelos, for instance, Gamio maintained that it was an unhealthy and unmodern fusion, based on conquest, rapine, and ongoing inequalities. In order for the fusion of race and culture to come about appropriately, he suggested, in a talk given in 1926, that "social contacts" between Indians and others must be "normalized and orientated authoritatively, a thing by all means desirable since it requires convergent racial, cultural, and spiritual fusion to secure [the] unification of tongue and equilibrium of economic interests" (Gamio and Vasconcelos, *Aspects* 127). Thus, the death of Indian languages, for example, is not only natural but is "beneficial to national unification" (127). But—and here is an important crux of the belief that the ancient needed to be brought into contact with the modern—"because these languages and dialects are the only path to the Indian's soul, we need some understanding of them" (126). Because, in countries such as Mexico and Peru, the "Indian problem" was acknowledged by liberals and conservatives alike to be one of the central problems of national, economic, and

social unity, the soul of the Indian must be studied and understood through the social sciences; only then could the Indian be reached for whatever project best fit with the future of the nation:

> The Ford, the sewing machine, the phonograph come heralding the modern civilization and penetrate to the most remote Indian villages. It is not enough, however, to provide the Indians with modern machinery; an understanding of their mental attitudes . . . is essential to an effective substitution of the instruments and institutions of modern civilization, or to a fusion of the modern and the primitive. Unless a . . . fusion takes place, industrial instruments will have no cultural dynamic influence. (Gamio and Vasconcelos, *Aspects* 122)

Gamio was right, of course, that simply plunking a piece of machinery into the midst of a people who had no cultural or social space for dealing with it was a futile undertaking. What he wanted, however, was some way to make an organic connection between what he saw as the premodern and what he knew was modern—a connection which would allow for the fusion he so earnestly reiterated as important in his writings. In part, then, it was this kind of thinking about the Indian problem in all its varied permutations (others, as we will see, thought of fusion a bit differently): Indians and Indian culture could constitute a racialized basis for a modern civilization and, as Vasconcelos put it, a "bridge" to the future (Gamio and Vasconcelos, *Aspects* 25), a thinking which impelled the mestizo (and indigenist) visualizing of artists as different as César Vallejo and Diego Rivera.

Influenced by public policy and public debate, many mixed-race artists incorporated both indigenist and mestizo discourses into their outlooks. On the part of elites who considered themselves modern, but who were nevertheless willing to admit their mixed-race status, the growing emphasis through the 1920s and 1930s on mestizaje as an articulation of a national and American sense of self meant that a modern sense of race was born of the simultaneous feeling of a familial intimacy with indigenous people and a social (and temporal) distance from them. I suggest that the work of disparate artists such as Kahlo, Rivera, Vallejo, and Mistral is modernist precisely by reason of the fact that they all believed deeply—and reflected this belief in their work—that to be modern was to be not only socially and culturally different but, importantly, temporally different from

the cultures inhabited by peasants and Indians, who in fact lived side by side with them. But two factors complicated their sense of temporal and social difference from indigenous populations: First, these artists were also quite aware of their own blood relationship with Indians; often a grandmother or even a mother would be much more "india" than mestiza. Second, because of the strong intellectual, national, and/or state emphasis in so many countries—most especially in Mexico—on a social policy which emphasized indigenism as the heritage of the nation and mestizaje as its future, artists of the 1920s and 1930s who considered themselves socially or politically engaged also felt the need to make such a fusion between what they thought of as the very old or primitive (Indians) and the new and modern (themselves).

I argue that one of the ways all four artists made such connections was to present themselves, through their art and through their artistic personas, specifically as embodied mixtures of the indigenous and the modern, figured forth in the very mixture of white European with indigenous blood in their veins. This idea appears to accord with what Fredric Jameson calls the "condition of possibility" for modernism: the "peculiar overlap" of concerns with what is often imagined to be very old, even originary—the maternal body, the indigenous body, the land—and what is imagined to be very new—science, industry, technologies, modernization, nationhood (*Postmodernism* 309). Thus, Kahlo, Vallejo, Rivera, and Mistral (especially through her Mexican influences) saw themselves in modern contrast to as well as in a complex relation with the "archaic structures" of the lives of indigenous peoples (Jameson, *Postmodernism* 309). (As we will see, Mistral and Kahlo's status as women artists made this an even more complicated maneuver.) The intimate and even familial connection on the part of these moderns with the seemingly simple and culturally ancient lives of indigenous peoples was itself, paradoxical as it might have seemed, read by these very artists as a sign of their own modernity. Thus, the racial nature of these artists' bodies (ameliorated to some degree by their social class) and, even more importantly, their representation of their own bodies as raced and gendered determined what their stakes were in proposing images of the new or the modern. The incongruities of these overlapping and interlocking categories—the new, the ancient, race, class, and even gender—were evident in the lives and labor of Latin American modernists: the claims of an anti-capitalist, bohemian, nationalist, and often

pro-indigenous stance adopted by these artists were in constant tension with a modern, European-inflected identity signified in esthetic and philosophical values, style, and manners.

Late Nineteenth Century

For a better idea of how this time—roughly the first thirty years of the new century—was shaped, we need to step back and take a look at modernizing sensibilities of the late nineteenth century. If the word *raza* (race) was not actually on everyone's lips, it was to become an increasingly central concept for almost every Latin American intellectual, artist, politician, or other public figure by the 1920s and 1930s.[5] But as I will detail in chapters 1 and 2, it was *modernista* intellectuals and writers of the turn of the century who, early on, provided ways of imagining the connection between race and modernity. As Matei Calinescu notes, Latin American *modernismo* was a poetic movement, beginning in the 1880s, which constituted a "refreshing, 'modernizing' French influence . . . consciously and fruitfully played off against the old rhetorical clichés, . . . a synthesis of all the major innovative tendencies" of late nineteenth-century France (69–70). But in addition to their interest in the Continent, many modernistas became particularly concerned with a renewal of thought about America and about the rapid changes brought by industrialization. They shared a sense that it was particularly important to address the labor—in both the productive and reproductive senses of the word—of specifically American, racialized, and gendered bodies. Such concerns included the status of artistic labor as well as the manual labor of others, how modernization would reapportion that labor according to gender and race, and what kinds of labor would be displaced from organic bodies to the inorganic ones of machines. The twin impulses of the apparently modernizing movement of machines, such as railroads and printing presses, and an organicism linked to the manual labor and static nature of (often racialized) female and male bodies are part of a process of imagining the modernization of Latin America, a process that, as I will show, Diego Rivera in particular would inherit from turn-of-the-century thought and carry through to the late 1930s.

Vicky Unruh has pointed out that Americanist rhetoric and what we might call a cultural nationalism were by the early twentieth century "widely evident in the activities of vanguardist groups and writers who

addressed questions of aesthetic modernity" (128). But late nineteenth-century modernista poets such as Nicaraguan Rubén Darío, Argentinian Leopoldo Lugones, and Uruguayan Julio Herrera y Reissig were also attempting to image in their poetry the "massive changes that took place in the late nineteenth century" throughout the Americas (Kirkpatrick, *Dissonant Legacy* 3). These three men in particular were to be powerfully influential precursors of modernist poets such as César Vallejo and Gabriela Mistral: too, such poets helped to begin the process, continued in the work of Kahlo and Rivera, of subtly transforming European-inflected artistic strategies by combining them with American vernacular genres, language, and thought in order to imagine forth the regional and urban landscapes of a new America. Many of Latin America's most important intellectuals also passed through a modernista period in their writings, from González Prada and José Martí, writing in the 1880s and 1890s, to the Peruvian socialist José Carlos Mariátegui in the 1920s; it is not surprising, then, that the Americanist thrust of Latin American modernism often allied modernismo with nationalist impulses which were deliberately nativist or indigenist and which had inherited a solid foundation of organicist metaphors with which to imagine the singularity and richness of American life.

In the face of perceptions of dependence on Europe and incursions by the United States, Latin American politicians, intellectuals, and artists were, in fact, beginning to engage in what would become, in the early twentieth century, a "search for a sharper regional and continental understanding" (Unruh 127).[6] As Unruh's comment suggests, Latin Americans began to direct their thoughts in two different, though connected, directions: toward regionalism, and toward a continental sense of "Americanism." Americanism, or the sense that (South) America was a continent worthy of cultural study in and of itself, made its appearance in such different places and under the banner of such different causes as Martí's essays "Nuestra América" (Our America, 1891) and "Mi raza" (My race, 1893), Manuel González Prada's 1880s essays and speeches, and even in the Uruguayan José Enrique Rodó's Hispanophile *Ariel*, published in 1900. Americanism continued through the beginning of the twentieth century with the Mexican anthropologist Manuel Gamio's 1916 *Forjando patria* (Forging fatherland), Mexican minister of education (1921–1924) José Vasconcelos's 1925 (again, though differently, Hispanophile) *La raza cósmica* (The cosmic race), Peruvian intellectual José Carlos Mariátegui's

1927 *Siete ensayos de interpretación de la realidad peruana* (Seven inter-pretative essays of Peruvian reality), Argentinian writer Ricardo Rojas's 1924 *Eurindia,* and even United States author Waldo Frank's 1920 *The Dark Mother* as well as the 1929 Spanish translation of his 1919 book, *Our America.*

The 1880s and 1890s, then, were a time, continent-wide, when intel-lectuals increasingly became a "new class of professional writers" struggling to reshape and reposition themselves—often through their journalism—as agents of national and even moral renewal, a renewal which would empha-size Latin American sensibilities (Bergmann 4–5). An important emphasis in these men's work was the fact of American natural abundance; but even more important, as I have already noted, was the labor required to convert it—a labor whose often mechanical nature was nevertheless imagined as fundamentally entwined with the organic world. A romantic, anti-posi-tivist, increasingly anti–United States and Americanist celebration of the organic richness of Latin America was conflated with a (somewhat ambiguous) fascination with the modernizing effects of industry, for exam-ple, in the work of Cuban pro-independence intellectual José Martí, who employed metaphors of industrialization alongside natural images in his writing in order to rework the "organicist myth" of Latin America "in a context of rapid modernization" as well as in the context of his own coun-try's continuing colonial status (Kirkpatrick, *Dissonant Legacy* 4). Martí regarded with amazement (though also at times deplored), through specif-ically organic, Americanist metaphors, the speed with which ideas could now be transmitted: "[Journalists] have their ears tuned to everything: ideas no sooner germinate, when they are loaded with flowers and fruits, and leaping onto the paper, and entering, like subtle powder, into every-one's mind; trains mow down the forest, and newspapers the human forest" (Martí, *Obras completas* 532).[7]

Other examples of an organically imagined manual labor side by side with industrial modernization, both presented to the audience as part of a new *American* sensibility, are the speeches and writings of one of the lead-ing turn-of-the-century Peruvian intellectuals, Manuel González Prada. Especially on the subject of modernizing reforms, González Prada was a supporter of the idea that Peru should industrialize by any means available (including by the introduction of foreign capital); at the same time, as in a speech given in 1888, he called for a specifically American literature which

would address the problems of contemporary Peruvian society, including the Indian problem. He especially linked this call with that of a renovation in Peruvian Spanish, recommending a turn away from academic Spanish and toward a simplified and more importantly vernacular language. In his 1890 "Notes about Language," he himself put these recommendations into practice, using new, phonetic spellings (*i* for *y, j* for *g, s* for *x,* and so on) and calling upon specifically Latin American industrial images:

> Here, in America and in this century, we need a condensed, juicy [also substantial], and nourishing language, like a meat extract; a language as fecund as the irrigation of the worked earth . . . a language, finally, where one perceives the strike of the hammer on the anvil, the stride of the locomotive on the rails, the flashing of the electric light and even the smell of carbolic acid, the smoke of the chimney or the creak of the pulley in its axle. (181–182)[8]

As far along as the late 1920s, such sentiments were still widely used: as the Cuban Martí Casanovas put it in his 1927 essay "Arte nuevo" (New art), the sign of vanguard, or modern, art is "the enormous sadness of a fecund gestation. . . . [I]n IndoLatin America, there still exists a virgin depth" (Verani 137–139).[9] As the twentieth century progressed, the impulse to plumb the "virgin depths" inherited from their precursors, the modernistas, directed many Latin American artists toward the ancient, original, and fecund nature of the Americas as, literally, a source for the newness of Latin American thought and creativity; it also directed them toward what were perceived as simpler or even primitive labors, bodies, and voices as a source for individual as well as national renewal.[10] Even a cursory glance at the modernist work of the early twentieth century makes it clear that the questions of how a specifically American esthetic modernism might look were like as not to be played out, at least in part, through imaginative encounters which still called upon nineteenth-century representations of the organic nature and manual labor of racialized, often female, bodies.[11]

Race and Photography

In the first decades of the new century, the formation, uneven and shifting as it was, of a modern, gendered, national, and racial sense of self had

already begun to be articulated in the nineteenth-century technology of photography, popular in the Americas almost from the first moment it was invented. As Deborah Poole argues, photography—especially in countries with large indigenous populations, such as Peru—indeed altered "the concepts of vision and visuality animating the Andean image world" (13), materializing "the abstract and frequently contradictory discourses of racial, ethnic, and class identity that crisscross . . . Andean subjects" (214).[12] A brief look at several of the most reproduced images of Peruvian poet César Vallejo illustrates the importance of a materially racial sense of self to this period, a sense which was also closely linked to the importance, positive as well as negative, of a racialized maternal body; and, as we will see later in chapter 4, photographs of Frida Kahlo help to explicate the complex play of traditional and modern in her particular adoption of *mexicanidad,* the "celebration of all things Mexican," which prevailed in Mexico especially from the 1920s through the 1940s.

Photographs of Vallejo offer us visual fragments of the trajectory he traced from his small northern sierra birthplace of Santiago de Chuco, through his studies in Trujillo, to his years in Lima and his expatriate life in Paris. By 1922, Vallejo considered himself a bohemian, but ideas of what constituted a bohemian form of self-presentation had much to do with the fact that he was an intellectual and poet in Trujillo and Lima. Both cities were, relatively speaking, provincial sites where to wear European dress was a sign of an upwardly mobile social sense; but to wear such a suit in order to hang around cafés reciting poetry and discussing one's drug experiences, as Vallejo did, was deeply shocking to the elite members of Lima society—and meant to be so.[13] A picture of Vallejo taken in 1922 (fig. 1.1) nevertheless shows Vallejo as a European-identified Peruvian: it is a straightforward, almost full-face studio portrait of a good-looking young man, hair parted neatly on the side, wearing a suit complete with high collar, necktie, vest, and handkerchief peeking out of the suit pocket. Vallejo was often referred to by the term *cholo,* a sometimes derogatory term meaning mixed-race; but the careful studio lighting flattens, though it cannot entirely erase, the face's Indian planes, while it also serves to lighten his skin. This portrait is no different from many other Peruvian photos of the time in that it marks a (more or less, depending on class) formal space within which the Andean subject displays the way he, or she, negotiated as well as adhered to European bourgeois ideals of social status,

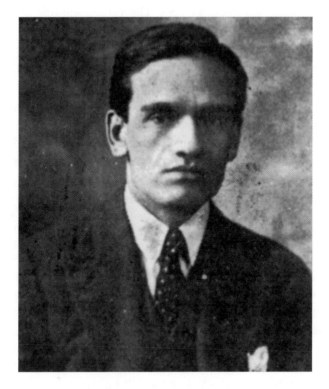

FIG. 1.1. Peru, 1922: César Vallejo at age twenty-four.
Photograph from César Vallejo, *Trilce*, trans. Clayton Eshleman
(New York: Marsilio Publishers, 1992).

family, and even gender.[14] After Vallejo's arrival in Paris in 1923, however, his self-presentation changes rather dramatically. Another oft-reproduced image shows Vallejo outdoors in Fontainbleu in 1926, leaning against a large stone, hat in his hands, looking not at the camera but pensively at the ground. A 1929 photo, a head shot of Vallejo taken in the gardens at Versailles, appears to have been taken from an angle slightly below Vallejo's seated figure, chin on fist, the other hand resting on the head of a cane (most reproductions of this photo crop out his wife, Georgette, who is sitting next to him holding his hat) (fig. 1.2). In both of these later photographs, the outdoor light emphasizes the Indian aspects of his face.[15] They also show a man who now clearly has a sense of his own dramatic and very *indio* looks: dark, longish hair swept straight back off a high forehead, a great beak of a nose, deeply incised lines running from nose to mouth,

high cheekbones, and deep-set eyes. The careful lighting of the Lima studio shot could be, and often was, used to de-emphasize skin color and round the planes of the face; or if it was to be an outdoors shoot (as it was for many of the poorer patrons of Andean portrait photography), mestizo clients sometimes whitened their faces for the camera or had their photographic likenesses whitened.[16] In Vallejo's case, any possibility of studio lighting and/or whitening has been replaced in the Paris shots with full sun, which shows up his dark skin; as Kahlo, Rivera, and even Mistral will also attempt in their self-presentations, Vallejo is turning to us a clearly mestizo face which also clearly demonstrates its indigenous heritage.

To paraphrase Judith Butler, Vallejo's mestizo heritage gave him both figuratively and literally a social "body that matters"; for Latin American readers of Vallejo, the fact that both his grandmothers were Peruvian Indians (both his grandfathers were Spanish-descent Catholic priests) highlighted (and continues to highlight) his mestizo heritage even more because of its resonance with the Latin American preoccupation with the figure of the indigenous mother. In Vallejo's case, the very indigenous nature of his physical looks, his face, seeming to show us, rising up as if from within the body itself, his grandmothers' Indian physicality, constitutes a text which is often conflated with readings of Vallejo's poetry.[17] Much literary criticism of Vallejo, for example, is shaped by a Peruvian framework which, ever since Mariátegui's own famous 1928 reading of Vallejo's poetry as indigenous, seeks to recuperate the indigenous within the Peruvian. Criticism of Kahlo's work, too, tends to read her self-presentation in Indian costume unproblematically, as evidence of her indigenous connections. In large part such readings demonstrate the leftovers of nineteenth-century Latin American sentimental abolitionist and indigenist literature, itself referencing European liberal romanticism and characterizing oppressed peoples such as the indigenous groups of Africa and South America as mournful for their lost glories and their home places. This literature began to find a happy combination late in the nineteenth century with various Latin American rereadings of scientific eugenics and evolutionary theory (I am thinking here, for example, of Peruvian writer Clorinda Matto de Turner's famous 1889 *Aves sin nido* (Torn from the nest) which I will discuss further in chapter 1). Carried through the first decades of the twentieth century, this combination rested in particular on the idea that the indigenous spirit, or character,

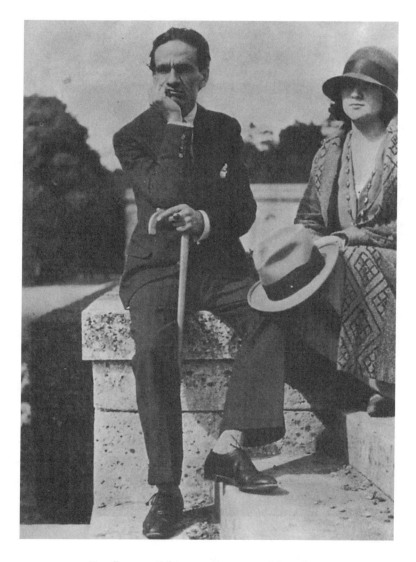

FIG. 1.2. Versailles, 1929: Vallejo, at age thirty-one, with his wife, Georgette.
Photograph from Juan Domingo Córdoba V., *César Vallejo del Peru profundo y sacrificado*
(Lima, Peru: Jaime Campodonico/Editor, 1995).

was inherently melancholy, due, it was thought, to hundreds of years of subjugation. Much as was the case with nineteenth-century United States racial thought, representations of the Latin American Indian were articulated through the sentimental genre's emphasis on character as much as

through outer, visual evidence (Boeckmann 1–10). This seemingly ingrained melancholy character, in turn, was connected to the supposed indigenous inability, or unwillingness, to enter into the mainstream of modernization, nation-building, and national history so important to Latin American countries at this period. Latin American Indians, that is, were still imagined as situated in a past which itself could be reused for nationalistic purposes, yet their undeniable presence in the present meant that the character of the contemporary Indian was hung over, immobile, and even decadent. For the Indian man, this amounted to social death. For women, on the other hand, the supposed Indian propensity for nostalgia and passivity dovetailed nicely with imaginings of the maternal as a passive, timeless, and originary source from which both nation and individual could draw strength and creativity; thus, there was continued emphasis on the importance of the maternal to the nation and, most importantly, on the image of the Indian mother as origin of racial and national energies. Because of this emphasis on the indigenous as undergirding for the modern, and on a mixed heritage, coupled with the widespread Latin American image of the sad intellectual, it is not uncommon to find that criticism still reads the fact of three of these artists—Rivera, Vallejo, and Kahlo—having indigenous blood, inscribed upon their very features, as a document of their identities as sad or melancholy indigenous artists. In fact, writing about all four artists (Mistral's physical looks presented a somewhat different text for reading) presents certain difficulties because much criticism is overlaid with the mythologies of their lives and the various cults of personality which have grown up around them. But as we will see, photographs, self-portraits, and textual self-representations of all four artists constitute important documents about both their and their critics' sense of what it meant to possess a racialized, mestizo body and what it meant to produce art from such a body.

Recent readings of United States modernism, as Carla Kaplan points out, see the modernist projects of early twentieth-century United States as deeply invested in what we might now call "identity politics" and racialism (158); I certainly see Latin American moderns in something of the same light. However, the different nature of gendered concerns with race in Latin America around these years meant that these moderns had a sense of an identity which was certainly politically informed but (as with many people, then and now) which contained blind spots—not the least of which

was class related. Again, taking the case of Vallejo gives us a sense of how complicated class could become for the mestizo subject. Although Vallejo may have been ethnically mestizo with a face that, presumably, betrayed his Indian roots, he was the son of a father who was a town functionary with some importance in the small community of Santiago de Chuco. His family owned their own house and some land, although like many people of that socioeconomic status in provincial Peru they were cash poor. Vallejo clearly began his career—first as a student of the biological sciences, then law, completing a thesis entitled "Romanticism in Spanish Poetry" as part of the requirements for his bachelor's degree—with the training and many of the aspirations of Peru's provincial petit bourgeois class, and he ultimately shared in the vanguard rebellions of many of the young men of that class. Though he was not a member of Peru's upper classes or its social elite, in the relatively small circles of the intellectual and artistic elite of Peru Vallejo gained an eventual status as a poet and thinker of some repute during his lifetime.

In fact, Vallejo's life trajectory follows a pattern which was particular to many professionals in this period in Latin America. Mistral, although her way to prominence was in many ways necessarily quite different from Vallejo's, also came from a poor background in a small, provincial town; her teaching career coincided, like Vallejo's early years, with her poetic career, and, like Vallejo, she allied herself with powerful male writers and intellectuals as she became more widely known. Rivera and Kahlo, on the other hand, were both born into fairly well-off urban Mexican families, and their artistic training as well as their oeuvres reflect the tensions between their high modernist aspirations and the socially white yet mestizo-identified stance they both ultimately adopted. Class, too, played a part in these artists' political engagements: Vallejo's socialism and Mistral's social consciousness, it can be argued, came in part from their experiences growing up in provincial, relatively poor families, while Kahlo's and Rivera's socialism could be said to be the (no less committed) politics of a class who could afford the time and education for liberalizing ideas. There was ample space for both conservative and radical interpretations of this period's public emphasis on a mestizo and/or indigenist nationalism. In fact, the left politics and art of Vallejo, Rivera, and Kahlo and the apparently more conservative politics of Mistral—all constituted a complex of progressive political beliefs mixed together with more traditionalist attitudes; but such

politics, whether radical or conservative, served socially engaged rather than autonomous ends.

Modern Systems of Thought

Industry and technology—from trains to cars, airplanes, skyscrapers, and radios—were indeed part of the experience of modernity for Latin Americans.[18] However, because of the relation of modernization to Latin American provincial and indigenous ways of living and to the powerful landholding oligarchies—which depended for their authority on feudal or semi-feudal practices—in practice most technology and mechanization was clustered in urban areas. In spite of futurist-inspired vanguard celebrations of the plane, the skyscraper, factories, and so on, the experience of technology and the machine—which a modernist critic such as Andreas Huyssen considers central to European avant-garde (9) and which Jameson considers "a crucial marker" of modernism (*Postmodernism* 305)—occupies a much more ambiguous place. Of the four artists I discuss, Rivera, fascinated as he was to become with Fordism and mass production, was the most celebratory of the machine and mass production.

Even as Latin America underwent what can only be described as a true backlash against the positivism of the nineteenth century, the modernist practices of Rivera, Vallejo, Kahlo, and even Mistral continued to reference, through their implicit acceptance, in particular, of the social sciences as well as the pseudoscience of eugenics, the philosophical assumptions of the "system builders" of the nineteenth century: the belief in rational progress and the efficacy of the scientific method (McFarlane 78). This was particularly true for evolution theories, where thinkers such as Herbert Spencer kept alive the assumption that given the right methods one could arrive at "some ultimate and overriding synthesis of all empiric knowledge" (McFarlane 78).[19] In other words, in spite of—or better, alongside of—a growing Americanist stance, scientific thought and European philosophical points of view continued to form the intellectual foundations of most educated Latin Americans through the 1910s and into the 1920s, as evidenced, for example, by the education both Vallejo and Kahlo received. In fact, Vallejo's education in the sciences gave him a job in 1913 teaching botany and anatomy in the Trujillo Central Boys' School No. 241 (Eshleman, Afterword 252–253), where he wrote pedagogical poems which explicated natural phenomena. It was also the source of his later,

anti-lyrical use of scientific vocabulary in his published and posthumous poetry. Frida Kahlo, whose first ambition was to be a doctor, received her education (cut short by her horrendous accident) at the elite, and only newly coed, National Preparatory School in Mexico City. As Hayden Herrera describes it, there Kahlo became familiar with European philosophers, including Hegel, Kant, and Spengler, as well as current Mexican writers (29).

Anthropology and Modernity

In Mexico, public policy makers and leaders, just emerging in 1920 from a bloody and protracted civil war, were very clear on the point that many of the country's peasants and indigenous groups did not necessarily think of themselves as "Mexican"; to pull Mexico's fragments back together was important for a renewed and forward-looking sense of the nation. Just as important as a new sense of raza was the increasingly popularized anthropological notion of culture. As did the United States, Latin America looked to the pseudo-science of eugenics, to folklore studies, and to the recently professionalized disciplines of archeology and anthropology in order to shape a framework which could encompass some of the contradictions that were becoming so (apparently) evident between tradition and progress. Manuel Gamio, one of the founders of modern Mexican anthropology, made clear the connection between the Mexican state, after the armed phase of the revolution, and the findings of an only recently professionalized study of anthropology:

> Fortunately a mental revolution paralleled the physical uprising of 1910, and so much attention was paid to the importance of understanding our social problems that scientific investigation was proposed; and Mexico's official project . . . was the creation of institutes or bureaus of anthropology in the different American countries so that the respective governments could by means of such institutions study and satisfy the needs of their people on the basis of applied social science. . . . In 1917, the Bureau of Anthropology was actively functioning in Mexico. (Gamio and Vasconcelos, *Aspects* 171)

Part of the program of the Bureau of Anthropology was to investigate "what really practical and adequate means should be employed by official

bodies . . . as well as private institutions . . . in order to stimulate effectively the physical, intellectual, moral, and economic development of the people" and "the racial approximation, the cultural fusion, linguistic unification, and economic equilibrium of our various groups" (172).

One of the foremost Mexican proponents of the idea of a specifically modern mestizo identity was José Vasconcelos, minister of education from 1920 to 1924, the man responsible for bringing together many of the most important architects, intellectuals, and artists (including Diego Rivera and Gabriela Mistral) of the post-armed, cultural-nationalist phase of the revolution. The year after his resignation from his post, in 1924, Vasconcelos published *La raza cósmica* (The cosmic race), a treatise wherein he proposed that the "fifth race"—the mixed race, composed of all the races (white, brown, red, yellow, as he terms them)—would become the "cosmic race": "Latin America owes what it is to the white European, and is not going to deny him. To the North Americans themselves, Latin America owes a great part of her railroads, bridges, and enterprises. By the same token, it needs of all the other races. . . . The Indian is a good bridge for racial mixing" (65–66).[20] Through a process that Vasconcelos called "esthetic eugenics," the mixed, or fifth, race would come to dominate "the world of the future": "Universopolis will rise by the great river [the Amazon], and from there the preaching, the squadrons, and the airplanes propagandizing the good news will set forth. . . . [I]f the fifth race takes ownership of the axis of the future world, then airplanes and armies will travel all over the planet educating the people for their entry into wisdom" (65).[21]

Vasconcelos's work was widely read, though not always widely applauded; in fact, he was under almost constant attack from more conservative members of the press, the church, and the public in his native Mexico for his monumental public art and education campaigns (Rivera even resorted, for a time, to carrying a pistol with him as he worked on murals commissioned by Vasconcelos; Mistral left Mexico in 1924 under something of a cloud after Vasconcelos named a women's normal school after her). And although so many of his contemporaries in other countries also felt that the Indian problem was a central one to Latin America's progress in its "economic evolution," they did not always agree on the causes or the solutions. Peru's José Carlos Mariátegui was, for all intents and purposes, an indigenist rather than a believer in mestizaje; he commented acerbically, in his 1928 essay "The Problem of the Indian," "To

expect that the Indian race will be emancipated through a steady crossing of the aboriginal race with white immigrants is an anti-sociological naiveté that could only occur to the primitive mentality of an importer of merino sheep" (25). Mariátegui instead believed strongly that the Andes, at least, needed to combine what he thought of as the socialist communitarian economy of its Aymara Indians with a capitalist economy indigenous to the Andes' special social and cultural needs. Arguing that the ongoing feudal aspects of Peru's economy, for example, had resulted in its being colonized "on behalf of foreign imperialist capitalism," Mariátegui believed that its future—and ultimately the future of Latin America—lay in a socioeconomic "indigenizing" along socialist lines: "The consanguinity of the Indian movement with world revolutionary [socialist] currents is too evident to need documentation" (29 n1). But pro-mestizaje or pro-indigenism, Vasconcelos and Mariátegui both echo some of the same sentiments expressed much earlier in Martí's 1891 "Our America":

> Those born in America [are] ashamed of the mother who reared them, because she wears an Indian apron. . . . [I]n what lands can men take more pride than in our long-suffering American republics, raised up from among the silent Indian masses by the bleeding arms of a hundred apostles. . . . That is why the imported book has been conquered in America by the natural man. Natural men have conquered learned and artificial men. The native mestizo has conquered the exotic Creole. (*Martí Reader* 112–113)

Reproaching those who would be ashamed of their mixture of Indian blood (or, in Cuba, Puerto Rico, and Brazil, black blood), Martí celebrates the "natural" or mixed-blood man over the "exotic Creole" (the man who is born in the Americas but traces his lineage through Spain); for Martí, the Americanist project, one which had not yet attained freedom from Spain's colonial rule over Cuba and Puerto Rico, already had to look askance at the United States and its dreams of empire. For Martí then, good government could only come from those who were naturally American rather than, like the Hispanicist Creoles, artificially so; and it was the naturalness of the mixing of Indian or black and Hispanic blood which would in the end conquer foreign (and, for America, artificial) ideas and people.

As we can see from the epigraph to this introduction, women take a vexed and ambiguous place in such a discourse; the language often buries, but cannot ever quite erase, its links with certain ideas about the natural place of women.[22] But it is safe to say that, whether modernity was imagined as mixed-race or indigenous, it was imagined as masculine; and its counterpart, the ancient and indigenous origins of the race, was largely imagined as feminine. This focus on the indigenous as a national concern was paralleled both by the increasing visibility of white women and mestizas working in public (for example, as teachers, telegraph operators, and factory workers) and a vigorous and public feminist movement.[23] And because by the 1910s the important scientific and anthropological languages of race were implicitly seeking not only to describe but also to shape proper heterosexual relationships, the race and class of women's bodies in particular constituted a field on which were drawn national as well as intellectual battle lines over modernity and modernization. Gamio's insistence that "the mestizo . . . born under these [inharmonious and forced] circumstances was educated by the mother, since the father abandoned the mother sooner or later" (*Aspects* 110) is a variant on the emphasis on the figure of the Indian mother as the archaic source of national as well as continental renewal. The image of the unmodern, provincial mother occupied the position of a good woman side by side with the Indian mother; because the role of women was equivocally imagined as both necessary for and dangerous to the nation-family, the provincial mother who ironed and cooked "with her own hands" was evoked over and again during these years as an explicit counter to the image of the European "new woman"—as the poet and writer Abraham Valdelomar put it in 1913, those "really ugly women, called suffragists," unmarried and selfish (22).[24] As the Latin American imagination turned more and more toward what it saw as women's primary function—motherhood—and as motherhood and the female body increasingly became objects of public scrutiny, the growing visibility of public print venues such as newspapers, journals, "penny dreadfuls," weekly and women's magazines, and hygiene manuals, in fact, performed a double function in terms of Latin American concerns about women and concerns on the part of women themselves. Journalism in particular fueled both sides of the issue: on the one hand, it provided a venue for women's and feminist writing, while on the other, it demonstrated "considerable popular and scientific concern for the monitoring of women's bodies" (Bergmann 29).

Turn-of-the-century Latin American pro-natalist concerns and, sometimes, public policies meant that women in their reproductive capacity were necessary for the nation-state. Although for women to do the most good in their reproductive capacities they needed for the most part to be kept out of the public sphere, "their public engagements as teachers or supervisors of beneficent groups generally received official support" (Bergmann 29). However, Masiello also notes, "Because of feminist activities in turn-of-the-century Latin America, women were often perceived as straying from the family unit. In a society where the family was equated with the national good, [middle-class] women who left the private sphere and moved into the public domain were often considered saboteurs of the unified household, promoting activities that undermined larger state interests" (Bergmann 29). Poor (usually indigenous and mixed-race) women who labored outside the home (either in the city or in the countryside) posed special problems for those intellectuals who were involved, in the first part of the twentieth century, in eugenicist endeavors. As Nancy Stepan points out, "all the problems connected with sexuality, gender, and motherhood which were associated with eugenics in Europe appeared in exaggerated form in Latin America, therefore providing a political space for a eugenics of puericulture, maternity, and fertility. Working-class women suffered from high maternal death rates and from hard labor in the domestic economy and agriculture, as well as from high levels of participation at very low wages in selective areas of the market economy, such as the textile industry" (110). Since the orientation toward Lamarckian ideas in Latin American eugenics meant that it was thought that learned qualities could be inherited, debate often circled around two sides of the same question. Could the effects of social reforms be inherited, or would the (social, racial) inheritance of debilitating factors be too damaging to ever ameliorate? Since women were seen as direct carriers of the next generation, concerns over social health and the problems of alcoholism, disease, and cleanliness amongst poor and indigenous people also meant that a new, "negative eugenic identity" was being created, especially for the "poor, laboring, mixed-race woman" (Stepan 110).

However, there were a few Latin American men who were at least willing to champion middle-class women's rights. Manuel González Prada, Peruvian director of the National Library, was one of those intellectuals whose isolation, as Jean Franco points out, "often stimulated them to push

their convictions to the utmost limits" (Franco, *César Vallejo* 20). The anti-clerical González Prada gave what was for the times an astounding 1904 speech entitled "Las esclavas de la Iglesia" (Slaves of the church), where he lambasted the Catholic Church for "enslaving" women, both intellectually as well as physically, with laws against divorce and restrictions on the rights and property of women, arguing against the widespread notion that women need religion (*Paginas Libres* 236). Yet even González Prada ends this speech on a note of domesticity, asserting that women must be free because they are the *mothers* of the next generation: "in the child the mother possesses a marble block in which to outline a Greek statue" (246).[25]

As the liberal-romantic concerns of nineteenth-century modernista intellectuals hardened into the more populist nationalisms of the twentieth century, Latin Americans in the 1910s and 1920s discovered that newer ethnic and national concerns could still profitably be mapped onto the image of the mother, an image that would remain for many years the mainstay of imaginings about the future of the new nations to come. It is only with the turn toward socialism—which we see manifested, for example, in Mariátegui's work—that the figure of the Indian mother is displaced (but again, never completely erased) in nationalist importance by the worker-proletariat, the "brother laborer" of the late 1920s and 1930s.

Time and Modernism

Because I am arguing for certain esthetic practices as (complex) responses to (equally complex) social senses of what modernity and modernization mean, it is difficult to use the terms "avant-garde" or "modernist" in their purely esthetic sense. Even though they share aspects in common with the avant-garde and modernist movements of Europe and the United States, in fact, the artists I am calling modernist—César Vallejo, Diego Rivera, Frida Kahlo, Gabriela Mistral—are not usually connected with each other, nor are they usually referred to by this (English-language) term.[26] In this study, modernism will be less a strictly esthetic or formal category and more a periodizing concept marked very broadly across the arts and across national boundaries by certain concerns and characteristics.[27] First, the notion of a period is useful for my purposes because it serves to (artificially) delimit across these years (around 1880 to 1940) a number of what might be called cultural themes which arise over and over again, albeit in

different forms.[28] It is to, and sometimes against, these period themes that the artists and intellectuals in whom I am interested responded. In Latin America, contemporary artistic-political movements, such as *indigenismo*, *modernismo*, *mestizaje*, workers' movements, industrialization, and feminism, or intellectual systems of thought, such as positivism and evolution theory, were, it might be argued, internally dialogic with the work of the artists I examine here. In other words, their work conducted a kind of conversation (often in the form of an argument) both with older cultural representations and with newer modernizing notions of the roles and labor of indigenous, mestizo, and white bodies.[29]

One of the most interesting, and most confusing, paradoxes of modernity is that it seems to be an idea sui generis; that is, the notion of the *modern* as we understand it today—belief in progress, instrumental rationality, technological innovation, and above all a belief in the new—seems to itself be a modern, that is new, idea, in the sense of thinking about modernity as a late nineteenth-century to early twentieth-century notion. But the vocabulary of modernity was also encumbered by figurations of history-as-linear-progress inherited from nineteenth-century evolution theories as well as from liberal romanticism's belief in the progress of human rights; at the beginning of the twentieth century, these rather general ideas would be made much more specific and local, incorporated into nationalist social policies through the up-and-coming disciplines of anthropology and archeology. What this meant was that ideas of progress and the new would be figured in vocabularies of a continuity of forward and backward, degenerate and progressive, developed and undeveloped (or, later and even more damning, underdeveloped).

In my efforts to think through what I call a mestizo modernism, I start with a revision of Fredric Jameson's general take on modernism as "uniquely corresponding to an uneven moment of social development, or to what Ernst Bloch called the 'simultaneity of the nonsimultaneous,' . . . the coexistence of realities from radically different moments of history—handicrafts alongside the great cartels, peasant fields with the Krupp factories or the Ford plant in the distance" (*Postmodernism* 307). Interestingly enough, Jameson's reading of modernism resonates with the work of one of the best-known Latin American modernists: the Mexican painter Diego Rivera, especially in his 1930s California and Detroit murals, sought to fuse the ancient and the modern by juxtaposing stoop-shouldered, stolid

Indians tilling the soil with broad-shouldered, stolid factory workers enmeshed with the machinery of their work—the ancient wellspring of race juxtaposed with the technological push forward of progress. But a problem lies in Jameson's evocation of the scene of unevenness, just as it does in Rivera's own murals: both assume, again, that there exists a kind of real, temporal gap between peasant and factory, tradition and modernity. I argue here, however, that modernist art was less a reflection of a (temporally) uneven reality than it was a modernist response to certain ways of thinking about and seeing varying social and economic conditions. So, although there were indeed socioeconomic inequalities, such inequalities were read back into modernizing discourses not as socially and economically driven, but as inherent temporal and cultural gaps between the "races." Thus, in the discursive vocabularies accrued in the effort to discuss and categorize race, citizenship, and gender, people sought a language which would help to imagine solutions to their perceptions of the seemingly all too apparent paradoxes and unevennesses of the early part of the twentieth century.

Thus, that much of what seemed uneven about modernity was at least in part articulated, if not actually created, by the framing assumptions of modern discourses themselves. Here, I do not mean the more evidently uneven introduction of a Ford automobile into a sleepy Indian village, or the presence of a factory next to a peasant field, but rather the social, temporal, and even racial unevennesses that moderns thought they saw between themselves and other seemingly premodern people. Such a notion of the spotty nature of progress in Latin America had its precursor in the long-standing idea of the belatedness or the imitative nature of Latin American thought, so that even as late as 1925 Mariátegui felt moved to write an essay titled by a question: "Does a Hispanic-American Way of Thinking Exist?"

Here, however, is also where the relation between modernism and modernity, which I have so far implicitly assumed, becomes harder to delineate. Modernist art was, in fact, being made during a time of what some would call uneven development, in the sense that both the values and the technologies of mechanical and capitalist progress did not take hold everywhere and at once.[30] This moment even seems to a late twentieth-century eye to reflect in its very esthetic content what Jameson terms the "resistance of archaic feudal structures to irresistible modernizing tendencies"

(*Postmodernism* 307). A note of caution is important, however, when we imagine that such uneven development only happened in countries other than the United States; as Susan Hegeman points out, modernization did not simultaneously appear and take root even across such a progress-oriented nation as the United States (22–23). But further, the notion of actual uneven development as a sign—and ultimately an esthetic reflection—of modernity seems strangely to echo the very assumptions of the Latin American artists I study here, whose imagining of modernity often as not depended on the imagined solace of the unmodern for its creative energies.

Because the asymmetry of capitalism and *tradition* was assumed to mark an essential difference between Latin America and the rest of the Western, developing world, it seemed even to some Latin Americans themselves as though they came belatedly to the state of being modern. Such a sense of belatedness carries with it the idea that some other, pre-modern temporality maintained its sway, in places like Mexico and Peru, at the same time as modernity was bringing with it a new era. The irony is that an artist like Rivera, for instance, thought the same thing: *he* was modern, all right; what wasn't modern were those indigenous people who kept showing up all over the place. That the unmodern seemed to trouble the formation of a truly equal while truly modern society constituted a real problem: How could a society move forward into a specifically modern future and at the same time retain elements which seemed, for lack of better words, out of (contemporary) time? Though I am putting things a bit reductively here, the thing which Rivera, Kahlo, and Vallejo (and even Mistral, who was seemingly the most determinedly antimodern of them all) wanted to do was to incorporate the unmodern neatly into a cultural narrative of (revolutionary) history so that there was formed not an unevenness, but a continuity, or a fusion, as Gamio put it—a kind of organic, narrative continuity that would have historical force and that could serve as the antidote to any sense of belated entry to modernity. At the same time, all these moderns to whom I have referred believed that modern ideas, if not modern technology, would help to fulfill the revolutionary promise of social justice.

Terminology: Modernist or Avant-Garde?

One of the problems I face in this book is that twentieth-century European and United States debates over the differences, or lack thereof,

between *modernist* and *avant-garde* movements, although useful, cannot easily be moved over onto Latin American readings of modern art movements. This has to do, in part, with the ways and the reasons why Latin American modern art movements were historically shaped, as well as with a difference in terminology, a product of the particular unfolding of Latin American literary movements of the late nineteenth and early twentieth centuries; in fact, Jameson asserts, "A comparative lexicon [of modernist terms] would be a four-or five-dimensional affair, registering the chronological appearance of the terms in the various language groups" (*Postmodernism* 304). But as I will discuss in chapter 2, the modernistas were not just slavish imitators of French style; their work was, in fact, the beginning of "a declaration of independence of South America" (Kirkpatrick, *Dissonant Legacy* 69). Thus "modernismo" in Latin American Spanish and "modernism" in the English-language sense are quite different. For this reason, Latin American critics either have had to ignore European and United States theorists of esthetic modernism altogether or must somehow get around the problem of having to distinguish between the movements grouped under the English-language headings modernism and avant-garde and the Spanish-language modernismo and *vanguardismo* or, as Saúl Yurkievich terms it, *postmodernismo.*

The solution for Latin American critics is often to locate under the umbrella term *vanguard* those works which distinguish themselves from modernismo by their representations of modernity and modernization; for example, Nelson Osorio characterizes the Latin American vanguard as a movement, historically speaking, of "artistic renovation" of the first decades of the twentieth century (227). This can be a problematic practice for several reasons. Modernismo is sometimes too rigidly defined as precious and old-fashioned over against the supposed innovative nature of the avant-garde. As we will see, modernismo came in many different forms, and a well-known writer of modernista verse—the Uruguayan Julio Herrera y Reissig, for example—was as concerned (though differently) with modern issues as were self-described vanguard artists such as the Argentine poet Vicente Huidobro. Another reason not to emphasize a vanguard break with older esthetic forms like modernismo is that many so-called *vanguardista* artists saw themselves as indebted, poetically and intellectually, to the modernistas. Denying this strong connection impoverishes our critical readings.

I take critical responses to César Vallejo's writing to be exemplary of this problem. That is, critics tend to radically separate his so-called van-guardista work from that of other contemporary artists. For my purposes, calling certain artists—who were admittedly disparate in their genres, out-looks, and social backgrounds—modernist rather than vanguard does not so much de-emphasize their differences as it brings into the picture their connections to various modernizing discourses of the time. I argue this against a critical view of esthetic modernism, one which subscribes to these artists' own self-mythologizings as persons who were in the business of rupturing, and somehow in the process revolutionizing, modern institu-tional, social, and artistic givens. Saúl Yurkievich, for instance, suggests that the Latin American "vanguard installed the rupture of tradition and the tradition of rupture"(85); this is of a piece, for example, with his sug-gestion, one still widely shared by Latin American critics, that César Vallejo's poetry constitutes such a deep break that it is hard to categorize his work as belonging to any contemporary movement (147).[31] Julio Ortega, Christiane von Buelow, Vicki Unruh, Clayton Eshleman, and, indeed, a majority of the critics of twentieth-century Latin American liter-ature wind up situating Vallejo (temporally or stylistically) outside the mar-gins of the Peruvian vanguard scene and outside of the broader scope of Latin American and international modernism. This reluctance to situate Vallejo may in part stem from the fact that his work seems to occupy, in a strictly temporal sense, the cusp between a broad flowering of vanguard movements across Latin America and, no more than a couple of years after his departure for Paris, a veritable avant-garde explosion on the local Peru-vian scene.[32] This latter vanguardist movement in Peru was prefigured by small literary journals such as *Colónida* (1916), edited by Abraham Valde-lomar (himself an influential literary and intellectual presence for Vallejo). The vanguard's actual appearance was stimulated by and channeled through small but important modernist journals such as José Carlos Mar-iátegui's Lima *Amauta* (1926–1930), to which Vallejo himself contributed from abroad, and the Orkopata *Boletín Titikaka* (1926–1930). However, because he carefully did not align himself with any camp or "ism" (he wrote several essays over the years in Paris, critiquing surrealism, futurism, and "new poetry"), Vallejo is often *mentioned* in work on Peru's own van-guard nativism but is not placed within that framework. Some critics have connected Vallejo explicity with avant-garde practices or with international

modernism, but in spite of their use of a critical move which itself belongs to vanguard theory—that is, reading Vallejo as a poet in crisis with modernity *and* as the poet who effected the single most radical break with traditional handlings of the Spanish language—none have attempted an extended reading of his work from within the framework of Latin American modernism; it is as though Vallejo is both paradigmatic of the radical nature of the early twentieth-century modernist moment and, somehow, above or beyond or outside that moment.

Such critical assessments of Latin America's vanguard movements—where a figure like Vallejo is taken to be the extreme (outside) limiting case of an accepted critical paradigm—have been reiterated so often that they are now repeated almost as articles of faith, with little attention paid to their underlying assumptions.[33] The presupposition that the most important aspect of the work of those who considered themselves avant-garde was the ability to radically fissure and even undermine bourgeois modes of artistic and social production overlooks the centrality of these artists' dependence on commonly held discourses of race, of the social sciences, or of state policy and ignores even their dependence on the marketplace in shaping their artistic perceptions and, therefore, their imaging of the modern. Accepting the idea that early twentieth-century art necessarily ruptured its ties to hegemonic cultural values and practices also undermines the possibility of understanding artists like Vallejo in a cultural context, one where, I suggest, we can clearly see connections with other artists of the time who shared some of the same cultural and even esthetic motivations.

Such motivations came from varied sources. Provincial petit bourgeois, the urban middle class, and upwardly mobile Latin Americans alike, in receiving a liberal education after the turn of the century, read popularizers of positivist and evolutionist theories. They read Max Müller's *History of Religion,* Taine's *Twentieth Century Philosophy,* and Ernst Haeckel's *The Riddle of the Universe* (Franco, *César Vallejo* 9), as well as Spengler's *Decline of the West;* these writers had a powerful effect on imagining what it might mean to be modern in the work of Kahlo, Rivera, Vallejo, and Mistral. Vallejo's 1923 short story "Los caynas," for example, tells the story of a young man who comes home to his remote Andean village only to find that the entire community believe themselves to be monkeys and behave as such; he is finally incarcerated in an asylum for, as Christiane von Beulow puts it, his "'unreasonable' belief in the fixity of the

human species ('Poor thing! He thinks he is a man!')" ("Stones" 10). Thus the "muffled protest" against scientific modernity and instrumental rationality, a protest that Jameson describes as one strand of modernism (*Postmodernism* 310), manifests a deeply rooted ambiguity on the part of these artists toward the modern. Indeed, it is my argument that modernism's representations of the ancient, or the premodern, looked so modern precisely because the unmodern—the ape, for example—had already been identified as such within the assumptions and paradigms of a modernizing world. Thus, although the conservative bourgeois viewer of Kahlo's paintings or reader of Vallejo's poetry might have felt that, indeed, there was something very odd and rather distasteful going on in their work, it is important to remember that many of these artists' underlying assumptions would be quite familiar, and possibly even comforting, to that same reader or viewer.

In *Patterns for America*, Susan Hegeman suggests that readers of United States modernism might move away from a narrative of modernism as "the experience of historical rupture" and put in its place "a more historically embedded modernism in which its creators can be seen to have held the relationship between past and present, and center and periphery, in dialectic tension" (23–24). To do this, we might rethink modernist work from the point of view of those who made it new within the context of provincial and vernacular interests, rather than from the point of view of the international or expatriate high modernism of the time. The vernacular and the regional, in fact, were of more importance in American modernism than critics have been willing to admit; Vallejo articulated his new poetic language, and the increasingly socialist vision of an indigenous Peru along with it, at least in part through the evocation of a provincial and indigenous-oriented small-town boyhood, while Gabriela Mistral conjured up images of her native Valle Elquí as the cradle and motherland of her poetic sensibility. Frida Kahlo, like many intellectuals caught up in the mexicanidad of the 1920s and 1930s, participated in identifying the regional culture (in this case, its dress) of Tehuantepec as the originary source for a modern Mexico by transforming her own image with Tehuana clothing, jewelry, and hairstyles. As well, she adapted vernacular genres in her art, such as that of the *retablo* or votive painting. And I would suggest that Diego Rivera, less and less enchanted with Mexico through the 1930s, began to represent all of Mexico as a kind of region of the United States

(especially through his participation in the United States journal *Mexican Folkways*), a place from which to tap into that unalienated source of tradition which would help to fuel the coming socialist-industrial revolution—in the United States. Derived, in countries such as Peru and Mexico especially, from the popularized ideas of indigenista anthropologists like Manuel Gamio and the Peruvian archeologists Julio Tello and Luis Valcárcel, the idea that counter-modern energies could be derived from a localized sense of tradition nevertheless contained within itself an implicit acceptance of the very tenets of modernity. That is to say, it was a modern and even bourgeois language itself which in turn gave presumably anti-bourgeois avant-garde artists ways to think about and to represent Indians, mothers, peasants, and laborers.[34] Indeed, it is true, as George Yúdice notes, that these artists attempted to rearticulate what they thought of as local traditions (Yúdice, Franco, and Flores, *On Edge* xii). But as we will see in more detail in this book, the very concepts of the local and the traditional were, by the turn of the century if not soon after, being situated by the framing and legitimating discourses of anthropology and of the sciences within a temporal and social space of indigenous and/or ancient cultures. That is, a sharper focus on the regional and local went hand in hand with the idea that a pure sense of locality necessarily drew upon a storehouse of ancient (and therefore indigenous) sites and images proper to that locale.

The question is, then, what such regional and vernacular sources meant for these artists; and I argue that one of the aspects which distinguishes Latin American from, say, United States modernism is that, through the attention paid to these sources, a strong sense of the domestic—in all its evocations of being, or thinking about being, at home—intertwined itself in Latin American visions of the modern. Such a perspective gets us, as viewers and readers of modernist art, away from the narratives of rupture and irrevocable newness suggested by the term avant-garde at the same time as it emphasizes the particularly nationalist and Americanist, as opposed to exile or expatriate, thrust of much Latin American art. The presence (and sometimes conflation) of women and Indians takes on greater importance in such a reading; we can look at them not as merely figures, but as ways of thinking differently about the supposed newness of modernist esthetic practice itself.

Chapter 1 of this book provides a framework for reading how the presumably premodern spaces and bodies occupied by peasants, women, and

Indians functioned to frame, and further to naturalize, a sense of modernity linked with nationalism. In this chapter I trace the conjunctions, around the turn of the century, between Latin American sentimental abolitionist and indigenist literature (for example, Gertrudis Gomez de Avellaneda's 1841 *Sab* and Clorinda Matto de Turner's 1898 *Aves sin nido*) with various Latin American rereadings of scientific eugenics and evolutionary theory, many of which characterized the Indian spirit as inherently melancholy and nostalgic. This strangely mixed legacy of eugenics sentiment and liberal romanticism leaves its mark in a particularly modernist form of nostalgia. By the 1920s and 1930s, earlier imaginings about the glories of pre-Conquest times would combine with a (German– and United States-- influenced) anthropological interest in the seemingly timeless artifacts of contemporary Indian cultures; the sense that the Indians inhabited, in the past and in the present, a certain atemporal (if often degraded) space was useful for nationalist histories and was echoed in modernist art like the murals of Diego Rivera or the paintings of Frida Kahlo. Like European artists from Gauguin and Van Gogh to Matisse, these moderns found that nostalgia—for folk traditions, for the maternal, for an original source of creativity presumably embodied both in female bodies and indigenous cultures—could serve as a useful glue to hold together seemingly conflicting concerns of modernity.

In chapter 2, I turn to the ways that an *Americanist* modernista imagery was appropriated for the more modernist work of Gabriela Mistral and César Vallejo (fig. 1.3). Dovetailing with concerns over women in the workforce and with scientific eugenics and evolution theories, the modernista sense of melancholy and nostalgia could be fitted quite neatly into evocations of the Indians and the maternal figure as counter-modern figures. Vallejo's and Mistral's modernist concerns both, paradoxically it might seem, depend on the figure of a provincial mother whose heritage is (sometimes implicitly, sometimes explicitly) indigenous. It is this figure which performs the domestic labor of an originary source of creativity and provides a provincial and/or regional, as the substrate of a national, voice.

Having examined the relationship between sentimental modes, social concerns, and modernism in Mistral's and Vallejo's depictions of the (indigenous) maternal figure, chapter 3 situates these readings in their broader contexts, comparing modernist work done both in Europe and in

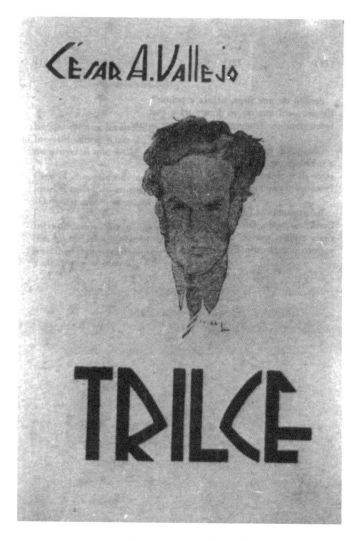

FIG. 1.3. Front cover, first edition of *Trilce*.

Latin America in the fifteen years between 1920 and 1935. Looking at Vallejo's poetry and journalism written after he moved to Paris alongside Rivera's murals painted during the same time period, I read a modernist constellation of political commitment, mestizo/indigenist nationalism, and international ties. All four artists kept a sense of the maternal body as a specifically national body at the heart of their work; but as they became

increasingly committed socialists, Rivera and Vallejo, in particular, turn more frequently toward the male worker's body, with the maternal figure signifying the foundation from which the national and fraternal sense of such workers arose. It is through an artistic investigation of masculine (working) bodies, their own included, that a modernist problematics of representation becomes clear in the increasing disjunction between Indian bodies—the foundation of the Mexican state—and mestizo worker bodies—the new masculine hybrid of machine and labor. I conclude this chapter with a discussion of the ways in which the juncture between popular culture, socialism, and modernism foregrounds these moderns' gendering of the body and orients their experimentations toward producing a socially engaged modernist position and artistic practice.

In chapter 4, I turn to a reading of how women artists Kahlo and Mistral went about imagining their own sense of modernity and its relationship to that mainstay of Latin American modern nationalism, the indigenous or mestiza maternal body. In the years between 1925 and 1935, Frida Kahlo's own donning of indigenous costume and the (more or less closeted) lesbian Gabriela Mistral's public construction of herself as the spiritual mother of all American women and children show the differences in the ways women modernists had to grapple with the gendered requirements of social and national engagement at the time, illuminating what it meant to be women, to be modern, and to be political.

In conclusion, I reiterate the main conceptual problem of the modernists whose work I examine: the very ways in which they conceived of traditional, folk, and primitive art and peoples were formulated through specifically modern ways of thinking. Using Vallejo's and Mistral's writings from around 1937 to 1938, I show that although Mistral in particular has long been characterized as completely antimodern, this is not the case. This means, then, that although their projects all included a desire to fuse or mix the Indian with the modern way of life, the perceived modernist temporal differences between the two made it impossible to successfully carry out the project of depicting them as fused or hybridized into one. I then turn briefly to two contemporary critics of Latin American modernity and postmodernity, Argentine anthropologist Néstor García Canclini and cultural critic George Yúdice, to discuss how attempts to rethink modernization in Latin America are still vexed by the inheritance of a modernist discourse on the idea of the folk and the traditional.

SENTIMENTAL MEN

*In the 1920s and 1930s patriarchy [in Mexico] may not be questioned,
but the lessons of the Revolution, the pleasurable promiscuity of soldiers
and soldaderas, the appearance of tens of thousands of unmarried moth-
ers, the explosion in the number of female factory workers, the massifica-
tion of prostitution as a labour market, the new views on poverty in the
capital city and the growing hatred of strict moral codes, all determine a
new sentimentalism that is now supported by film and song.*

—CARLOS MONSIVÁIS, *MEXICAN POSTCARDS*

*The separation of conceptualization from feeling is particularly misleading
when applied to [Vallejo's] poetry because he responds emotionally to con-
cepts and tries to give body to abstract ideas.*

—JEAN FRANCO, *CÉSAR VALLEJO*

THE USE OF ALREADY-EXISTING metaphors or images often shapes
our ideas of how a newly discovered object or newly created situation
looks or works; that is, tropes of esthetic representation play a central role
in understanding *and* in producing a (historical, political, social) reality.
Fredric Jameson proposes that in the face of rapid historical change,
esthetic representation can in fact constitute a shorthand for grasping the
material conditions of emerging cultural and historical situations (*Post-
modernism* 38). The idea, for example, that there are "mutual allegories"
which imagine a relationship between, say, romantic love, sentimental
feeling, and patriotic nationalism also suggests that the rhetorical relation-
ship between such figures helps to produce an imagined framework for

those political relations themselves (Sommer 30–32). In other words, the tropes and images—not just of poetry or novels but also of painting, song, cinema, or even photography—can function as attempts to think some social circumstance which, possibly, has not been quite yet thought.

Such was the case with many Latin American artists whose work in the early part of the twentieth century constituted an imaginative and negotiated representation of, and sometimes offered frameworks for, thinking about the exhilarations and anxieties—as well as the everyday banalities—of a modernity still in process. But as with any change which is still in the process of being thought, the rhetorical language being used to imagine such change was posited as new even as it reached back in time to more familiar, tried-and-true images, models, figures, and relationships. As Raymond Williams notes in his *Marxism and Literature*, when we think about historical processes (such as modernity), we should think not only of historical stages but in terms of "the internal dynamic relations of any actual process," relations which include overlapping "dominant," "emergent," and "residual" elements of culture (121). It is especially Williams's discussion of the residual, a cultural element which has formed in the past but is still active and an "effective element" of the present, which is useful for thinking about what I am calling mestizo modernisms. For as forward-looking as the elite were in countries like Mexico, Chile, and Peru at the turn of the century, they were also just beginning to think of themselves in modern nationalist (if not populist) terms. As theorists of nationalism have pointed out, both emerging and consolidating nation-states often required that the country's various discourse-producing institutions turn various regional, indigenous, and/or ethnic pasts into one seamless history. Thus a nationalist modernity tended to demand the stability of a beginning point, a conserved and untouched source of older, or residual, images and rhetorics from which to draw new narratives. In particular, such elements included the lives and cultures of these nations' indigenous and mixed-race populations.

Melancholy Folk

As I talk about a mestizo modernism which is at its heart sentimental, I suggest that an appeal to sentiment provided the moderns with a doubled temporal sense—looking for a present-day access to the timelessness of ancient cultures and to the passive fecundity of the female body, these

moderns could place the ancient and the maternal literally side by side with their own sense of timely and even accelerated change. A strong emotional affect, appealing not to rational thought but to feelings such as nostalgia, sympathy, or melancholy, did the work, then, of conveying a present sense of connectedness to the past.[1] The influence of German Romantic thinkers in the shaping of a masculine, romantic subjectivity was important for a Latin American temporal sense of modernity, informed by the affect of nostalgia through the works of Haeckel, Schopenhauer, Spengler, and Müller (Franco, *César Vallejo* 30–35).

With the discovery that anthropology and archeology could function as legitimating new vocabularies for public policy and nation building, the Mexican anthropologist Manuel Gamio, the Peruvian archeologists Julio C. Tello (who studied at Harvard) and Luis E. Valcárcel, the Brazilian anthropologist Gilberto Freyre, and Cuban anthropologist Fernando Ortíz were increasingly influential in their respective government's policies on native cultures. Even more importantly, men such as these popularized the idea that the indigenous past formed a continuity with the indigenous present, making this past into a national rather than merely a native history. As González Echevarría notes, writers of regionalist novels, too, picked up on anthropology, as it became "a hegemonic discourse in Latin American narrative in the twentieth century. . . . The [twentieth century] regionalist or telluric novel was concerned with myth, religion, magic, language, genealogy, the impact of modern modes of production on traditional societies." Most regionalist novelists became "experts in folklore and rural speech" (González Echevarría 144–157).

By 1916 Gamio had published *Forjando patria* (Forging fatherland), by 1917 he had moved to a position of director of anthropology for the secretary of Agriculture and Development, and in 1924 he became undersecretary of Public Education under the equally famous José Vasconcelos. In 1916, Manuel Gamio was director of the International School of Archaeology and American Ethnography, itself founded in 1911 by a group of anthropologists, among them Franz Boas. In fact, Franz Boas's culturalist, as opposed to racialist, way of looking at things exercised considerable influence on Gamio and his contemporaries. For example, it prompted Vasconcelos, ever the dabbler in new and scientific lexicons, to hesitate in calling Indians degenerate or primitive; instead, he said in 1926, "Our race, the Indian races of the tropics at least, do not constitute a primitive

stock. Call it, if you will, a decayed stock, but not a primitive stock. The new Mexic[an] Indian may be primitive, although I would rather say that instead of being primitive he is provincial; that is to say that what remains of his culture is derived from the little he could obtain" (Gamio and Vasconcelos, *Aspects* 77). Vasconcelos's prevarications on the term "primitive" show, however, that for the Latin American laypersonwho was used to thinking about Indians as in actual fact primitive, the new Boasian language could only muddy waters, not clear them. If Indians were not primitive but only decayed, nevertheless such decay seemed to have become an inherent part of the Indian character. It would be up to the sciences, and to the public policies informed by them, to rescue what remained of the Indians' culture from the problems posed by the nature of the Indian.

A popular assumption on the part of both policy makers and intellectuals was that the recuperation and production of folk culture would be a way for people to feel the sentiment of nostalgia—with a requisite sense of melancholy—necessary for a sense of historical continuity with an indigenous past; the spread of folk culture through reproductions of artifacts, songs, and dances could elicit a feeling of being united, not just culturally but racially (García Canclini, *Transforming* 44). All four artists I look at in this book were in fact profoundly influenced by folkloric and anthropological ways of thinking about race and culture, and folklore and anthropology were often conflated in popular thought. Frida Kahlo collected folk jewelry, papier-mâché figures, decorated clay pots, and Indian women's clothing, while referring, in her art, to folk genres such as the *retablo,* or votive painting. Rivera spend enormous amounts of money on pre-Columbian figures and carvings and was artistic director of the United States magazine *Mexican Folkways.* Mistral lectured throughout the Americas on the importance of folk tales and folk songs. Although Vallejo did not collect material examples of the folk genre—after 1923, his life for the most part was too marginal to afford such a habit even if he had wanted to—ultimately, for him, the Inca narratives recorded by early Conquest mestizo figures such as Garcilaso el Inca, stories which he transformed in the 1930s into a series of short stories, such as "An Incan Chronicle" (Una crónica incaica) and "*Situa* Dance" (La danza del situa), would stand as evidence both of a past anthropological Peruvian tradition and of an indigenous folk future for that nation (*Desde europa* 429–430).

As I have noted, by this time Franz Boas's work in debunking much of

scientific eugenics' conflations of culture and biological race had filtered into the thinking of most of the important anthropologists in Latin America. But racialist logic was still deeply ingrained, especially in reflection about the present-day Indian: while in the early years of the twentieth century Boas argued that "such factors as nutrition—or, later, 'culture'—might influence otherwise self-evidently 'racial' differences" (Hegeman 47), many Latin American anthropologists would subscribe to the reverse. That is, a popular Lamarckian position held that the Indians had suffered for so long under the consequences of the Conquest that their behavior and the state of their culture were effectively innate, and therefore as akin to a racial quality as one might get without actually saying so. Again from a Lamarckian point of view, then, education might be the only thing which would awaken the Indians to their plight and uplift them from their racial and cultural decay. As Alan Knight notes, for these thinkers "Indian inertia may . . . be historically and psychologically—not strictly biologically—determined, but [this inertia] is nonetheless deterministically inescapable" (93–94). If the Indian were not to be overtly labeled as racially different (and by implication lower on the scale), again, laypeople like Vasconcelos continued to hold racialized ideas: "The racial theory to which we ought to subscribe then is the theory that the differences among peoples depend more upon ability to do certain things to the exclusion of other things rather than to differences of degree in their total development. Some races develop artistic ability; other people develop commercial aptitude; and so on" (Gamio and Vasconcelos, *Aspects* 97). The concerns of earlier turn-of-the-century sentimental indigenists such as Clorinda Matto de Turner for the uplift of the Indian were transformed into something similar for nationalist rhetoric: to culturally and racially elevate or awaken the Indian, in part, as we will see, through a renewed sense of indigenous craftsmanship, to a sense of national unity along with the rest of the country's population.

García Canclini notes that Latin American folklore studies of the late 1890s through the early decades of the twentieth century "were born through the same impulses that gave rise to them in Europe: on the one hand, the need to root the formation of new nations in the identity of their past; on the other hand, the Romantic inclination to rescue popular sentiments in the face of the Enlightenment" (150). Folklore, like anthropology, could raise a national sense of a shared past, nostalgically remembered just as one might remember the stories, songs, and lullabies of one's

mother, grandmother, or nanny; one of the most salient aspects of the folk-
loric was "the popular as praised residue; deposit of peasant creativity, of
the supposed transparency of face-to-face communication, of the profun-
dity that would be lost by the 'external' changes of modernity" (García
Canclini 148).

At the same time as the governments of Latin American nation-states
such as Mexico, Peru, and Chile were consolidating their hold on cultural
and historical narratives of populist unity, public and private funds were
being funneled into the creation of museums of archeology and anthro-
pology as well as into ongoing archeological investigations. Such energies
did not come only from Latin Americans; United States and European
universities and wealthy individuals were hurrying to contribute to the
seeming explosion of archeological and anthropological discoveries in pre-
Columbian cultures. By the beginning of the twentieth century, the open-
ing of crafts or popular art exhibitions and of museums of anthropology,
archeology, popular, and folk art helped to institutionalize the sentiments
of melancholy and nostalgia as well as to bolster a sense of national and
continental pride in arts once lost but now recovered. In the shift from
more private means of addressing racial problems—through the novel, for
instance—to the participation of the state (and its competing political
groups), however, the sentimental and emotional emphasis shifted from
national unity imaged as romance between individuals to an insistence on
the state as represented by the romance of a new kind of family: Indian
mother and mestizo son, often *sans* father figure (a figure who, for mod-
ernists like Rivera, surely smacked too much of the Spanish conquistador
or the paternalist governments of the postcolonial period). From the 1930s
through to the 1940s, these images often gave way, in socialist and populist
narratives, to a nationalism which was predicated on a sentimental broth-
erhood of labor.

Modern Sentiment

Sentimental forms begin in an appeal to pathos and emotion (such as virtue
and suffering) as organizers and even conservators of instructional, moral,
and social values. That is, as Suzanne Clark points out, the sentimental "is
a turning point for narratives of sociability" (21). This is what links the sen-
timental (reform) genre, often through the mediation of scientific dis-
courses such as that of archeology, so clearly to the artists in whom I am

interested: despite these artists' political differences, their commitment to mestizaje in its various forms and projects meant that the work of Kahlo, Vallejo, Mistral, and Rivera was not merely to negotiate, condemn, or celebrate modernity; they saw their work as in fact committed, whether in a conservative or radical sense, to modern social reform.

Sentimental work which proposed social reform needed, of course, to be built on a legitimating temporal and social framework which would accommodate change while not dissolving the order of things completely. For this reason, the sentimental mode's turning point of sociability was as much a point of social stability as one of social change, one which needed a legitimating language with which to make its claims. Scientific language and imagery often constituted such a legitimating vocabulary for turn-of-the-century sentimental novels and poetry; it provided a temporal and a philosophical schema within which to encompass the possible dangers of thinking the new, for example, in the progressivist model inherited from early Victorian evolution debates. As Peter J. Bowler writes in his *The Invention of Progress,* the notion of continuous progress was given form in specific images which stayed remarkably similar across popular explanations of various scientific theories. The conflation of the growth of the embryo together with the image of the ascent from ape to modern man as well as the figure of a timeline which ran from primitive to civilized societies made for a powerful, if muddled, appeal to a way of imagining a continuous foundation from which progress could ensue:

As the idea of continuous progress was gradually taken up . . . the use of the analogy with the growth of the embryo towards maturity was frequently exploited as a means of implying that evolution has a central, purposeful trend. A progressionist version of biological evolutionism thus became available in time to be synthesized with the cultural anthropologists' linear interpretation of human progress. . . . In popular versions of evolutionism it was subordinated to the widespread assumption that there must be a main line of progress leading towards humankind and, ultimately, to European civilization. (Bowler 134–135)

Such images gave substance, at least in part, to the "time consciousness" which Matei Calinescu identifies as a sense of modernity: "the doctrine

of progress, the confidence in the beneficial possibilities of science and technology, the concern with time (a *measurable* time, a time that can be bought and sold and therefore has, like any other commodity, a calculable equivalent in money)" (41, 51). If anything, this modern time consciousness intensified in the 1920s and 1930s in the wake of such upheavals as the Mexican Revolution, World War I, the Bolshevik Revolution, and technological as well as philosophical and scientific changes, but the older nineteenth-century progressivist analogies and images were not necessarily thereby discarded. Instead, these images—and their concomitant modes of thinking about time, history, and progress—were found to be useful in their elasticity and ability to encompass all manner of social and biological concerns. The legacy of biological, eugenic, and evolutionary theories—for example, the recapitulation theory of embryonic/social development—lent scientific legitimation to the idea that the indigenous body (and, somewhat differently, the maternal body) occupied a nostalgically evoked time past. Such an apt conjunction of sentiment and temporality, legitimated by scientific language, was nothing short of necessary in the context of reconstructing a new, national sense of time (and of history) in the face of, as well as to accommodate, the changes brought by modernization.

For these moderns, the assumptions learned from evolutionist and positivist ways of thinking meant that what they thought they saw when they looked at Indians, for example, were both social and political gaps; and their ways of thinking about nation meant that what was wanted instead was continuity. If it seems strange that Vallejo, for example, responds to positivist, Darwinist, and eugenicist ideas—all of which had been in circulation from the midpoint of the previous century—as if they constituted both a new and a radical shock to his writing in the second decade of the twentieth century (at least seventy years later in some cases), this has much to do with the historical circumstances of how modernity was thought of and negotiated among the various groups in power in places such as Peru, Chile, and Mexico. In such countries, the hold on power by landowning oligarchies often ensured the continuation of essentially feudal relationships well into the first part of the twentieth century; moderns like Vallejo, Kahlo, Mistral, and Rivera not only were aware of the seemingly anomalous social and economic temporalities which characterized Latin American modernity, but were engaged in reproducing ways

of thinking about such unevennesses. To attain a sense of historical conti-
nuity, they looked to the conceptual models and metaphors with which
they were familiar: ways of imaging the ascent of the races from primitive
(dark, low) to modern (light, high); ways of imagining the progression of
the species from a passive origin (embryos, mothers, Indians) to a dynamic
growth (evolution, mestizaje, fraternal industry).

If many of the models for thinking about modernity were based on
images of progression, of forward or upward movement, as we have
already begun to see, the anxieties of such a push toward the unknowable
future demanded the rejuvenating energies of a stable and national past.[2]
In contrast to the European who had to go away to discover such rejuvena-
tion, Latin American modernism's appeal to the premodern was, literally, a
domestic issue. Like Europeans, Latin Americans too were looking—and
more often than not it was a look backward—for sources of personal cre-
ative energy, a refuge from urban life, for the origins of a national history,
or all these combined. But growing nationalist sentiment demanded that
such sources be indigenous, and even regional, rather than far away. Latin
American intellectuals and artists had already been enacting the going
away—to Europe, in fact—for too long, it was beginning to be felt; the
"going away" which Europeans were finding so attractive was exactly the
opposite from the desire of Latin Americans such as Rivera, who was con-
vinced to come home to Mexico from a career in Paris, or even Vallejo,
whose forced leave-taking of Peru rendered his mother country all the
more important to him, or Gabriela Mistral, who, though she spent much
of her life away from her homeland of Chile, nevertheless appealed to her
birthplace as a source for creative energy. European sources of the pre-
modern, for example, in African and Oceanic images, were not useful.
Instead, Latin Americans found they had a veritable storehouse of pre-
modern images already at their disposal in nineteenth- and early twentieth-
century sentimental indigenous narratives and in early twentieth-century
archeological and anthropological writings about past indigenous civiliza-
tions such as the Inca and the Aztec empires.

The modernist look backward in time was also a sentimental glance
sideways, so to speak—to the mestiza or *india* mother for Vallejo, Rivera,
and Mistral, or to the indigenous nanny or wet nurse for Frida Kahlo.
Because even these women, although they lived contemporaneously
alongside such artists, were already assumed to occupy a different and

45

older temporal space, the affect of such a gaze could still be one of melancholy and nostalgia—to the simplicity, originality, and creativity of what seemed to be another time (one's youth, a lost civilization) and/or race. In places like Mexico and Peru, moderns had easy access to such familiar images. The image of the mother could often function as a place holder for much of what moderns thought they longed for, at the same time as she was literally embodied in the provincial mother seated at the dinner table or the Indian maid at work in the kitchen.

Latin American romances were sentimental precisely because domestic drama was so often central to them. Like European and United States sentimental modes, Latin American sentimental—or what Latin American scholars call romantic—novels evoked matters of the heart within a framework which sought to instruct and humanize the reader toward social injustices and national disunities. As Doris Sommer has made abundantly clear in her *Foundational Fictions,* following the Wars of Independence of the early 1800s and the slow but steady modernization of many Latin American economies, the Latin American sentimental novel (and I would include other forms such as poetry and song) also proposed new ways of thinking about gender roles and nationalization. As such, the sentimental form was often necessarily concerned with race issues, since it was understood that the racial makeup of countries such as Cuba, Guatemala, Puerto Rico, Chile, Peru, and Mexico constituted a possible barrier to racial and cultural feelings of national unity. In the sentimental mode, then, the fate of national racial and cultural unity was found to hang on resolving the blocks to sexual, romantic, and (most importantly for early twentieth-century texts), ultimately, familial unity. In the United States, Cathy Boeckmann traces the connections between sentimental novels and racial concerns through a writer like Harriet Beecher Stowe, who saw her own mode of fiction as a "developmental step in the evolution of fiction toward Christian goodness and perfection" (56). The link that writers like Stowe saw between ideas of evolution and literature was underscored by Hippolyte-Adolph Taine. His influential *History of English Literature,* published in 1871 in translation in the United States, was also read, in a Spanish translation, in Latin America (Vallejo would read Taine in the 1910s in his native Peru). In that book, Taine makes an explicit connection between race and literature: different literatures manifest the racial character of the people from which they emerge. Through Taine's theories, race and racial

character became connected to fiction and to evolutionary thought: "As a result of these confluences between theories of race and theories of fiction, it becomes possible to argue that the genres of fiction popular in the late nineteenth century were implicitly racialized" (Boeckmann 59–61). Sentimental fiction followed the logic of *kalokagathy*, the belief that beauty is good and ugliness is evil, setting up a body of writerly conventions for characterization. Such conventions could and were employed to support liberal ideologies (Boeckmann 54–55). By the same token, in the Latin American sentimental imagination Indian and mixed-race characters could be beautiful, and so by the logic of characterization, their racial characters could also be beautiful. The notion of racial character, translated into readily recognizable physical types, would remain an important point of concern for the increasing modernization of art and writing. In fact, in his pioneering 1901 "social psychology" of the Mexican character, *The Genesis of Crime in Mexico: A Social Psychiatry Study*,[3] Julio Guerrero echoed countless observers of the Indian before him, including the famous and influential naturalist Alexander von Humboldt: "The indigenous Mexican is grave, melancholy, silent."[4] Guerrero himself maintained,

> The Mexican . . . suffers lengthy attacks of melancholy, as can be seen in the elegaic, spontaneous tone of their poets, starting with Nezahualcóyotl . . . the unending series of modern romantics; popular Mexican music, written in a minor key; those dances, full of melancholy . . . and those popular songs which, to the sound of the guitar on moonlit nights, are intoned in the houses of the neighborhood. . . . The medium in which we live is wont to transform the gravity of the Indian and the solemnity of the Castilian into melancholy tendencies. (23–24)

The Indian, Cement of Nationality

It will prove useful at this point to provide a quick sketch of how, since the middle of the nineteenth century, the Latin American discourses of mestizaje and of indigenism have been linked together. Especially in countries such as Peru and Mexico, various *indigenista* stances were often part of the discussion on mestizaje, for although indigenismo was in a very general sense a genre which sought to point out the injustices which pure indigenous populations suffered, mainstream indigenismo almost always advocated the

"progressive, persuasive integration of the Indian" into the dominant society, through cultural and/or physical race mixing and, it was thought, eventual erasure of inferior traits (Knight 81).

More than just material for sentimental novels, modernist poetry, or intellectual theorizing, the various scientific, medico-moral, and literary discourses of mestizaje and indigenismo met, intertwined, and found their way into policy debates: in discussions over immigration, over whether or not to encourage race mixing, and in debates over the place of indigenous peoples in national progress and modernity (Graham 4). In particular, in their thinking about race, Latin Americans picked and chose what they thought would serve them best from the ideas of scientific eugenics, evolution theories, genetics, and social Darwinism. Clorinda Matto de Turner's 1889 *Torn from the Nest* (Aves sin nido), for example, was praised by Luis Cácares, then president of Peru, who publicly endorsed its ideas as part of the laws protecting Indians, laws he had worked to legislate. But in a published reply, Matto de Turner urged the president not to forget to legislate white European immigration, which would provide the kind of crossbreeding with native Peruvians that would renovate Peru: "we clamor for foreign immigration which, with the crossing of [Indian] blood . . . will give us robust men, useful men" (qtd. in Kristal 154–155).[5] Thirty-five years after the publication of *Torn from the Nest*, José Carlos Mariátegui consciously rejected the more overtly racist aspects of scientific eugenics such as whitening and regeneration theories. But like many other people of the time, Mariátegui still maintained a racialized notion of cultural contamination, particularly in terms of the black descendents of freed slaves: "[The Negro] has never been able to acclimatize himself physically or spiritually to the sierra. . . . When he has mixed with the Indian, he has corrupted him with his false servility and exhibitionist and morbid psychology" (273). At almost precisely the same time, José Vasconcelos was actively promoting a nationalist-indigenist celebration of authentic Indian and African cultures while advancing the whitening, or at least lightening, virtues of miscegenation. A state-endorsed strand of 1920s race politics also makes its appearance in the Chilean poet Gabriela Mistral's essay "Chile," written from Mexico during Vasconcelos's tenure: "The race exists in a state of potent differentiation. . . . The Indian will come to be regarded as somewhat more exotic because of his scarcity. Mestizos blanket the territory and do not exhibit the weakness some note in races which are not pure. We do

not hate or even feel jealous of Europeans: the white race will always be the civilizer" (174–175).

It should be coming clear that the philosophies, beliefs, and policies put forward by exponents of mestizaje and indigenism came in many different flavors. Against the backdrop of several Indian uprisings in the 1920s in Cuzco's high pastoral provinces and President Leguía's "New Fatherland" (Patria Nueva), which championed modernization and North American capital, indigenist thinkers in Peru (where indigenism has enjoyed a long and tenacious life) took either regionalist or, in the case of Mariátegui, socialist views of Peru's relation to its indigenous populations. In Cuzco in particular, the 1911 rediscovery of important Incan sites such as Machu Picchu (by a Yale University expedition headed by archeologist Hiram Bingham) contributed to a neo-Inca vogue centered at Cuzco's Universidad San Antonio Abad (Moseley 19–20). The Peruvian school of archeology, in fact, was founded by an indigenous Peruvian named Julio C. Tello (born 1890), who won a fellowship to Harvard, came back to Peru, and eventually directed the national archeological museum in Lima (Moseley 19).

The vogue for things Incan, which followed archeological discoveries in the 1910s and 1920s in the highlands of the Andes, occupied only the periphery of a much more serious debate, indeed, something like a culture war, conducted amongst Andean anthropologists and intellectuals. Luis E. Valcárcel, a young anthropologist from Cuzco, excavated Cuzco's megalithic citadel of Sacsahuaman, an important temple in the Incan capital. Valcárcel, who in 1930 took over the post of director of the National Museum, came to understand these and other ruins whose exploration he supervised as reflecting "deep-seated native traditions" still constituting part of the Peruvian highland population's received indigenous wisdom (Moseley 19). In 1927, his widely read book *Storm in the Andes* (Tempestad en los Andes) put forward the belief that "this past or residual cultural difference . . . could then be consciously resurrected" (Poole 186). José Uriel García, on the other hand, saw "colonial history as a process of cultural and racial improvement" and published *The New Indian* (El nuevo indio) in 1930 as a rebuttal to Valcárcel's text. Mariátegui, like Valcárcel, was uninterested in celebrating the whitening or mestizaje of Peru; but unlike Valcárcel, he theorized that indigenous social structures (which he read as naturally communist) could revitalize and indigenize Peru.

By 1928, Vallejo would connect himself, while in Paris, to Mariátegui's brand of leftist Peruvian politics. On the other hand, it could be said that Mistral, Kahlo, and Rivera all connected themselves with a particularly Mexican flavor of indigenism and mestizaje. In Mexico, home, like Peru, to an equally tenacious and important tradition of indigenista thinking, the end of the armed phase of the Mexican Revolution in the 1910s saw the reworking of indigenista ideas into the more overt, and ultimately state-sponsored, philosophy of mestizaje I have described above—in brief, the "cosmic race" of men like Gamio and Vasconcelos, though not always with the emphasis on the cosmic.

Mariátegui's ideas on race, labor, and socialism were important to Vallejo in his later years in Paris; but, as I will discuss in chapter 2, in his younger years in Peru Vallejo was influenced by the vogue amongst young Andean men for a certain bohemian stance, one which Deborah Poole connects with Cuzco indigenist artists and intellectuals like García and the photographer (and painter) Figueroa Aznar (196). This was a local highlands tradition, impelled no doubt at first by European models of the bohemian, but transformed in its meaning into a man "who replaces the bonds of social tradition . . . with an . . . aesthetic of nostalgia, sentiment, and music grounded in his close ties to the land." As Poole continues, bohemianism itself was considered to be a form of "spontaneous sentimental expression enabled by the 'telluric' forces" of the Andean landscape (196). Left to the "new Indians" that García promoted—men who were not necessarily indigenous but who embodied the spirit of the Andes—was the task of expressing *el sentimento andino,* or "the Andean sentiment" (194).

Sentimental Modes

Sentimental indigenist novels presented the anxieties of one's heart and of one's race as inextricably intertwined. As with writings on the early abolitionist movement of the United States, these novels and their ways of thinking about race and gender relations became popular, not to say important, texts in Latin America. In fact, many of these national romances were canonized as official national literature, becoming required reading by the beginning of the twentieth century (Sommer 51). As the concerns for political and racial unity of the nineteenth century hardened into a more populist nationalism and *mundonovismo,* or "new-worldism," of the

twentieth century, these novels nevertheless continued to provide models for how to think about race and gender relations—albeit with some transformations to meet the new exigencies of a changing political and social landscape.

It was not only writers of poetry and novels who used the sentimental, or romantic, mode. Within the framework of what Aníbal González calls "romantic populism" (62), turn-of-the-century intellectuals such as José Martí and the Peruvian intellectual Manuel Gonzáles Prada combined the Latin American effort to find a new and also modern continental identity with a nineteenth-century liberal romantic stance and style, not only because it allowed them greater self-expression but because it served their interest in persuading their readers to social change. From the turn of the century through the 1930s, then, it was increasingly through sentimental poetry and novels, journalism and popular song, as well as the language of a popularized anthropology that a sense of a specifically modern national life was legitimated and disseminated in countries like Chile, Peru, and Mexico (Monsiváis 173–175). Connecting links between mass popular forms of expression and modernizing discourses were being forged, and the tropes borrowed from nineteenth-century European-derived romantic and liberal forms of expression, which favored the free play of emotion at the same time as it elevated sentiments of individual freedom and social justice, gradually became available (in part as a legitimating vocabulary of republican idealism) to a wider, less elite public through the technologies of mass communication (radio, cinema, and print culture). As this dissemination continued, the affect of such images diffused into the more formulaic domains of sentimentalism and kitsch. Through journalism, fiction, and photography, and later radio and film, there gradually formed a sentimental poetic language which was ideal for mapping private emotion onto national concerns: patriotism and romantic love became mirror images of each other; sentiment dissolved knotty national issues of race; love of the land became intimately connected to family love, and both were elevated to the status of the sacred.[6]

Founding Fictions: Sab *and* Aves sin nido

Authors from Latin American countries with large slave or Indian populations began to produce abolitionist and indigenist novels and poetry before the middle of the nineteenth century. More often than not, such

51

novels borrowed the language of liberal romanticism from French, English, German, and United States texts to argue for the humanity of the oppressed slaves and/or Indians and against the laws and social systems that oppressed them. Two novels, both (uncharacteristically, as it happens) written by women (unlike in the United States, Latin American sentimental novels were largely written by men), served as important models for the male writers who came after them. *Sab*, one of the best-known Cuban abolitionist novels, was written in 1841 by Gertrudis Gómez de Avellaneda, an upper-class Cuban feminist and abolitionist with ties to the small but influential abolitionist movement in her country (the novel was banned in Cuba until after slavery was declared illegal by Spain in 1872). Sab is a *mulato* slave, educated and articulate, in love with his white mistress, Carlota, who in turn is pledged to Enrique, son of a white English businessman, who wants to marry her primarily for the money he believes she will inherit; Carlota's penniless cousin, Teresa, is in turn helplessly in love with Enrique. What ensues is a highly complicated series of romantic relations and tragic misunderstandings made tangled specifically by what stands at their heart: the constraints of blackness on Sab, the constraints of being a (white) woman on Carlota and Teresa, and the thinly veiled mystery of Sab's familial relationship to his white mistress. *Torn from the Nest*, written some fifty years later (1889) by the upper-class Peruvian feminist and indigenist Clorinda Matto de Turner, also employs a sentimental mode and a "family romance" in its attempts to negotiate the social place of the Andean Indians in Peru (who, it was felt by liberals of the time, were little better than slaves). But rather than having an Indian as its main protagonist, as Sab is the mulato protagonist in *Sab,* this novel frames its narrative within the domestic space of a white, upper-class, young liberal Peruvian couple (Fernando and Lucía) who take in an orphaned Indian girl, Margarita. It is only when Margarita falls in love with a young white man, Manuel, that it is discovered in the last pages of the novel that he and Margarita are in fact half-brother and sister, children of the same corrupt parish priest. Just as Sab is a mulato, the Indian girl Margarita is revealed to be mixed-race—actually mestiza. But the clear indictment in both these novels is not against mestizaje or mulattoes. The discovery of the familial relationship between Margarita and her fiancé, or the gestures toward the relationship between Sab and his mistress's family, serve not to indict race-mixing but to foreground the

abuses of the provincial white power structure—in the Andes, the priest, the landowner, and the mayor, and fifty years earlier in Cuba, the entwined institutions of the slave system and British business on the island—against those it would oppress: the Indians or the slaves. As *Torn from the Nest* begins to reveal Manuel's true parentage—that he is the illegitimate son of the parish priest—Don Fernando embraces him and says, "Let us not lay the blame on God but on the inhumane laws of men that deprive the child of its father, the bird of its nest, the flower of its stem" (173). As in many United States sentimental race novels, it is the *secrecy* which surrounds the mixing of the races, rather than miscegenation itself, which is the tragic outcome of abuses stemming from the current state of unequal social and race relations. Finally, the important thing is that the tragedy in each of these novels is not merely individual and romantic; they are sentimental in the sense that domestic happiness (or sorrow) parallels national happiness (or sorrow). For the (progressive) protagonists of these novels, the fact that romances are thwarted and families torn apart by the secrecy and abuses endemic to a race-divided society is one which literally threatens national aspirations toward the unity of a modern nation-state: when Manuel comes to Lima to report on his successes in freeing an Indian who had been unjustly imprisoned, Don Fernando exclaims, "And so you've freed Isidro Champi. Ah, but who will free that whole hapless race?" to which Manuel replies, "That's a question for every man in Peru, my dear friend!" (Matto de Turner 170). This sentiment is even more explicitly stated early on, in an authoritative aside to the reader:

> We believe that what happens in . . . every small town of the Peruvian hinterland, is only another form of . . . savagery. The lack of schools, the lack of good faith on the part of the clergy, and the obvious depravity of those few who exploit the ignorance and consequent docility of the many, drive these towns ever farther away from true civilization, which, were it ever solidly established, would enrich our country with large areas capable of making it great. (29)

Although in Latin America it was the exception rather than the rule that women wrote sentimental novels, nevertheless Gómez de Avellaneda's work was the vanguard to the male canon of abolitionist writers, and Matto

de Turner's writing constituted a body of work around which, and even against which, turn-of-the-century male writers of the family romance envisioned their own responses.[7]

Sentimental Men

The importance of the sentimental as a mode across many genres made its expression a gendered as well as increasingly a class matter. Latin American men—freer, I will argue, than their United States counterparts to express certain kinds of emotions—nevertheless had a very good idea what the differences were between sentiment and sentimentality, melancholy and kitsch, intellectual feeling and vulgar or instinctual emotion. The Argentine poet Alfonsina Storni's work, for example, was characterized in 1923 by one male critic as just a bit too masculinely melancholic: it had that "air of intense intellectual melancholy, or better put, of intellectual loneliness, a little feverish and aggressive, which makes her poetry so heartfelt . . . intellectual pain, the pain of intelligence, [a] pain more that of men than of women" (qtd. in Kirkpatrick, "Journalism" 108).[8] To men, then, belonged intense emotions of love, passion, and loneliness, but also to men belonged an intellectual sense of melancholy and nostalgia. To women, on the other hand, belonged sentimentalized and kitschy, melodramatic, and popularized emotions.

What undoubtedly made it easier for male artists as well as intellectuals to claim the public realm of sentiment for their own was the self-characterization on the part of many early Latin American feminist and pro-woman organizations as being first and foremost dedicated to the domestic sphere, in order at least in part to counter the image in the Latin American press of the North American feminist as masculine, undomestic, and unmaternal. Following the deeply rooted idealization of women as essentially maternal, an idealization now widespread and newly reinscribed with the coming of radio and film, Latin American feminists often distinguished themselves especially from representations of the European and North American "New Woman." They did this by reassuring their audiences that they too were wives and mothers, that they cared for a home that was for them, "like for other women, the center and altar of the most generous and elevated sentiments" (qtd. in Newman 84).[9] Thus, although the United States nineteenth-century domestic novel "represents a monumental effort to reorganize culture from the woman's

point of view," (Tompkins 83), Latin American feminists certainly worked for change but did not necessarily see themselves as reorganizing the public sphere.

Feminist groups were strong and often effective in legislating for the domestic sphere in countries like Chile and Argentina. However, as the twentieth century progressed, women increasingly were faced with the public feminization of certain kinds of cultural behaviors. Women were presumably known to possess an overly sentimentalized romanticism, good as far as it went for mothering, but not useful for engagements in the public and intellectual areas more properly belonging to men. But women such as Alfonsina Storni and Mistral, important female voices of their generation, highlighted in their own 1920s journalism the ways in which they had to negotiate their place as women in the public eye. Like Gabriela Mistral, who became friends with her, Storni engaged in the very public life that was considered extraordinary for women at the time. But both women knew their position depended, paradoxically, on their characterization of themselves as ordinarily feminine; as Storni would write in her journalism, "an extraordinary life destroys in woman the very thing that makes her most prized: her femininity" (qtd. in Kirkpatrick, "Journalism" 125).

Indeed, women like Storni and Mistral may have felt themselves real exceptions to other more ordinary women (Kirkpatrick, "The Creation" 99). In her columns in the women's pages of the Buenos Aires *La Nación* and *La Nota,* Storni adopted a double discourse of sentimentalism and irony to encompass both the demands of the press and her own concerns with serious women's issues; as a result she mixes stereotypical images of feminine behavior with serious commentary on women's economic and social matters. In her essay "Marriageable Women," of 8 August 1920, Storni is scornful of women's romantic imagination: "[women's] imagination interposes itself between reality and dream like a powerfully elastic resistance which softens and extinguishes all shocks."[10] At the same time she defends against an idea, which she labels as coming from "evil pens," that women are solely instinctual, unthinking creatures: "[evil pens] even claim that the lofty maternal sentiment is pure instinct" (qtd. in Kirkpatrick, "Journalism" 127). Again, in her 1920 "The Perfect Stenographer," Storni ironically castigates her society for the use of young women as a low-paid labor force (Storni herself had worked as a stenographer):

Select a young woman from eighteen to twenty-one years old who lives in an apartment building. . . . Discreetly paint her eyes. Bleach her hair. File her nails. . . . Send her to a commercial academy for two or three months. Then keep her waiting on commercial ads for one, two or three years. Hire her for very little. (qtd. in Kirkpatrick, "Journalism" 115)

As was the case in Europe and the United States, public sentiment often figured women as ideally concerning themselves with an inherent talent for reproducing the species, while increasingly in the 1910s and 1920s young unmarried women were being encouraged to enter into service sectors of the labor force, such as typing and teaching. Although Storni undoubtedly saw the contradictions inherent in her own position as an unwed mother and journalist writing (primarily) for a female audience, much like Mistral she presented, at least in her journalism, an idealized image of women as mothers and wives.

Gabriela Mistral, for her part, is commonly presented (and represented herself) as rejecting a masculine modernity altogether. Because she endeavored to present herself according to public perceptions of the ideal woman-poet, even up through the present day Gabriela Mistral's poetry has by and large been assumed to indulge itself in the too-easy sentimentalism and even melodrama which Storni associated with female romanticism, and as such was (and still is) rejected by the Latin American canon of high poetry. And, indeed, Mistral labored actively to promote a sense of her work as imbued with a certain kind of female sentiment. Precisely because of her insistence on a specifically feminine position and because of her seemingly obsessive attention to mothers and children, Mistral's work has been identified as antimodern, antiurban, and antitechnological; Mistral has never been designated a modern, nor a modernist, much less a good poet (Pizarro 46; Franco, "Loca" 27).

But unlike her critics, who saw her work as embodying the kitschy sentimentality that male poets so vigorously eschewed, Mistral, like Storni, saw her writing as drawing a distinct line between the popular, massified forms of sentiment and her own more lofty and noble sentiment for feminine culture. In 1921, for example, in a letter from Mistral to José Vasconcelos published in the Mexican journal *El Maestro*, Mistral praises the magazine and implores Vasconcelos to send this magazine out to all the

"popular schools of America" to teach "unscrupulous journalists" "how *to make* a newspaper for the people, *without damaging or tacky literature,* without the worldliness which they give so many banal and useless photographs that they publish under pretext of current news; without that unpleasant character of the illustrated melodrama, exploiter of the most repugnant police stories" (qtd. in Schneider 149).[11] The terms she uses—tacky, banal, melodrama—make it clear that, like Storni, she makes a clear distinction between what is low sentimentalized or sensationalized culture and what is properly sentimental women's culture.

This sense of what is proper feminine sentiment is particularly important in Mistral's ideas about the nation. In 1922, Vasconcelos hired Mistral to come to Mexico to help him design a school for women teachers. He also asked her to compile a selection of readings as a text for schoolgirls, entitled *Readings for Women* (Lecturas para mujeres). In the introduction to this collection, Mistral discusses the kind of *amor patrio,* or "country love," that a proper education should form in women. Elizabeth Horan points out that "the dialectic of personal with national and continental identity is . . . a very complex problem" (137). Depending on whether Mistral thought she was writing for public relations (her job as Chilean consul) or for a more intimate poetic audience, her nationalism gestured both outward toward the nation and inward toward a more familial, regional, and ultimately feminine space: "For me, the form of feminine patriotism is perfect maternity. . . . Feminine patriotism is more sentimental than intellectual, and is emotionally formed by the native countryside" (*Lecturas* 16).[12] In accordance with her increasing emphasis on her own native Valle de Elquí as the source of her poetry, patriotism for women is both maternal and regional, connected to one's own familiar (in both senses of the word) land, one's *patria chica,* or "little country" (Horan 137). As we have seen, a supposedly antimodern attitude like Mistral's, delimited as it was by her notion of a *mujerío* or specifically "women's culture," was defined by modern, nationalist ideas. That is, her sentimental (women's) regionalism and her valorization of the folk undergird the construction of her poetic persona as the national mother of a Chile grappling with the changes of modernization and as the spiritual teacher of all Latin American peoples. These elements of Mistral's persona, which closely informed her work, would come together most successfully in her own deep and abiding investment in José Vasconcelos's notion of mestizaje.

But although the work of artists such as Kahlo, Mistral, and Storni complicated what it meant to be a woman and to be sentimental, men's expression of sentiment was nevertheless assumed to be quite different from women's. To begin with, male sentiment, as we will see in the case of Vallejo, was imagined to rightfully describe a public and political stance. The fact that the women artists I have just mentioned also made a public matter of their sentimental expressions did not keep their work from being interpreted as referring to a private, domestic, and feminine space. Although, to early twenty-first-century readers, the markers of an ideal, early twentieth-century Latin American masculinity—the pain of betrayal and/or of death, the passion for family, the home, and love— might seem to be much the same as those for an ideal feminity, one of the most important differences was the fact that the framework for these emotions was thought to be, for men, an intellectual one, and their proper place was in the coloring of public expression. That is, poetry, for example, was often thought of as the civic job of the male writer, and its writing was a civic virtue; politicians and intellectuals were poets and artists, and vice versa. At the risk of doing such men an injustice (which I do not mean to do), the deeply feeling and even sentimental male artist was, and remains, something of a standard type throughout Latin America. This has informed both Latin American artistic work and critical reception of it.

Critical readings often connected the undoubted sense of sadness, melancholy, and nostalgia that one often finds in Vallejo's poetry with the indigenous aspects of his mestizo background, just as Frida Kahlo's paintings were read by the French surrealist André Breton as supposed evidence of the melancholy and blood-obsessed racial character of the Mexican's mixed-race heritage (Herrera 228). Readings of Vallejo as the sad indigenous poet go back to the work of José Carlos Mariátegui, whose influence on Latin American socialist thought and on approaches to the Indian problem and whose support for the Latin American vanguard and for Vallejo himself can hardly be overestimated. But although Mariátegui's famous 1928 reading of Vallejo's poetry in his "Literature on Trial" does not hesitate to call upon what are by now well-established characterizations of Indians as melancholic and nostalgic, the temporal sense of newness, which is a hallmark of modernist thought, appears in a striking manner in his comments on Vallejo's poems:

Vallejo is a poet of race. . . . One of the clearest and most precise indications of Vallejo's indigenous bent is his frequent attitude of nostalgia. Valcárcel, who probably has most fully interpreted the autochthonous soul, says that the melancholy of the Indian is nothing but nostalgia. Very well. . . . He evokes the past with tenderness, but always subjectively. . . . Vallejo's nostalgia is not merely retrospective. He does not yearn for the Inca empire. . . . His nostalgia is a sentimental or a metaphysical protest; a nostalgia of exile, of absence. (Mariátegui 250, 252)

Mariátegui's readings are often notable for their combination of perceptive comments with racialist ideas about the autochthonous soul. But more important in this 1928 essay is Mariátegui's sense that this kind of *race* poetry is specifically new and modern while it is simultaneously romantic: "The revolutionary epic . . . heralds a new romanticism untouched by the individualism of that preceding it. . . . The romanticism of the 1900s is . . . spontaneous and logically socialist, unanimist. Vallejo, from this point of view, belongs not only to his race but also to his century, to his era" (250, 256). In 1928, having just been publicly accused by the socialist Nationalist Liberation Party of having fallen into "tropical illusions and absurd sentimentalism," Mariátegui is clearly vexed, in this essay, by his own use of the term "romantic" (256).[13] He understands, however, that he cannot protest completely against romanticism if he is to praise Vallejo: "Vallejo certainly conserves a great deal of the old romanticism . . . but the merit of his poetry is the way in which he transcends these residual influences. Moreover, it would be useful to come to an understanding about the meaning of the term 'romanticism'" (256 n35). Although by this time modernists would often identify romanticism and sentiment with an older, outmoded, and feminized value system, Mariátegui is too perspicacious, and too honest, to completely gloss over the sentimental aspects present both in his own work and that of others whom he admires.

Mariátegui confronts in his own writing one of the central dogmas of modernist criticism as well as of many modernists themselves: there is an unbridgeable schism between the intellectual qualities of new, modern work and the romantic, decadent, and sentimental qualities of older forms. Such a perception is echoed in Latin American modernism's own assertions of the differences between folk and kitschy, vulgar melodrama and

high sentiment. Mariátegui is conscious of the problem inherent in this distinction. Invoking such a divide, in fact, works to conceal what Mariátegui wants to reveal: the centrality of an older, indigenist-oriented sentimental affect to the newness of Latin American modernist artists. As we will see in the next chapter, such a sentimental affect, inherited in part from Americanist modernista poets, would express itself especially in Vallejo's early work (as well as in the work of Kahlo, Mistral, and Rivera) through his poetic evocation of domestic spaces and women's work.

WOMEN'S WORK

What will she be doing now my Andean and sweet Rita
Of rushes and berries. . . .
Where will her hand be which in contrite attitude
Ironed future whitenesses in the afternoons.

—CÉSAR VALLEJO, *OBRA POÉTICA*

Oh . . . that
soul-laundress of mine. What morning she'll come in
satisfied, dark berry-worker, proud
to prove that sure she knows, sure she can
HOW COULD SHE NOT!
bleach and iron every chaos.

—CÉSAR VALLEJO, *OBRA POÉTICA*

I T HAS BECOME COMMONPLACE to cite 1922 as a banner year for
international modernist and vanguard movements. As Hugo Verani
notes, 1922 was also a "key year for the blossoming of the Latin Ameri-
can vanguard" (11). In 1922 the Chilean poet Gabriela Mistral published
Desolación, her first collection of poems; César Vallejo's *Trilce* appeared;
the Semana de Arte Moderno (Modern art week) was celebrated in São
Paulo, Brazil; and in early 1923, the same year as Pablo Neruda's *Cre-*
pusculario was published, Jorge Luis Borges began publishing his *Ultra-*
ista poetry in *Fervor de Buenos Aires;* the Mexican modernist mural
painters, such as Rivera, José Orozco, and David Aífaro Siquieros, were
in full swing.

Latin American modernism, as we've begun to see, was often impelled by, and deeply invested in, nationalist projects "in the face of mounting pressures from what Martí had dubbed the 'colossus of the North'" (Kutzinski 150). Many Latin American artists also saw their work as opposed to European artistic and intellectual domination. Thus, modernism was often connected with cultural nationalist projects and influenced by anthropological explorations in folk and pre-Columbian cultures. These projects included, in Mexico, the establishment of a school art program under Adolfo Best Maugard, a former Cubist painter and friend of Rivera's who had returned to Mexico to be part of the post-revolutionary fervor; even before this, Best Maugard had produced line drawings for Franz Boas while Boas was conducting field investigations in 1910 (Folgarait 20). In 1922, Rivera, who was to become the director of the Taller de Gráfica Popular (itself established in 1922), was persuaded by the Mexican minister of Public Education, José Vasconcelos, to come back to Mexico (with a brief stop in Italy to study frescos and fresco making) after a twelve-year stay in Paris. Again in 1922, Vasconcelos invited Gabriela Mistral to come to Mexico to establish a normal school for Mexican women. Manuel Gamio, an important figure in Mexican anthropology, had already published his influential *Forjando patria* (Forging fatherland) in 1916; in Peru, the Instituto de Bellas Artes was founded in 1919 with José Sabogal as its best-known indigenist painter and illustrator (fig. 2.1). The famous Cuban ethnographer and anthropologist Fernando Ortíz's 1906 *Hampa afrocubana* (AfroCuban underworld) and 1916 *Los esclavos negros* (The black slaves), along with his 1924 *Glosario de afrocubanismos* (Glossary of AfroCubanisms) and his journal *Archivos del Folklore Cubano* (Archives of Cuban folklore, also begun in 1924), were to become enormously important a few years later for Cuba's nationalistic *poesía negra/mulata*, or "black-mulatto poetry" (Kutzinski 145).

In their very different ways, César Vallejo (1892–1938) and Gabriela Mistral (1890–1957) have emerged as two of the most important Latin American poets of the twentieth century. Vallejo's brilliant experimentations in the Spanish language have inspired intellectuals and poets from the time of his death; the prose and poetry of Gabriela Mistral, more famous perhaps for her status as the "schoolteacher of the Americas" and her 1954 Nobel Prize for poetry, have recently been the subject of renewed scrutiny and refurbished reputation for their deceptively simple

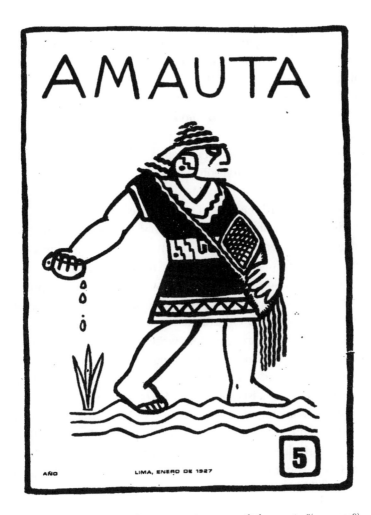

FIG. 2.1. José Sabogal illustrated Maria Teguis's important "little magazine"(1924–1928).

but, in truth, sophisticated and complex, gendered use of language. Even today, one can scarcely find a Latin American who does not at least know a few lines, and sometimes even an entire poem, of either Vallejo's or Mistral's work. Mention either poet, and one is likely to hear quoted back those lines, that poem. The works of Vallejo and Mistral have in fact become part of the cultural unconscious of Latin America; their work helped to shape a twentieth-century sense of modernity for Chile, Mexico, and Peru, as well as for the continent as a whole.

Different as they were, Mistral and Vallejo, in their writing and careers, each trace a trajectory which is central to the rise of modernism in Latin America. Vallejo's work shows clearly his indebtedness to the sentimental indigenist discourses of the late nineteenth century and also shows how residual elements of these discourses found their way into, and were transformed by, the pressures of modernity. In fact, Jean Franco's landmark literary biography of Vallejo was the first work to make it clear that Vallejo's writing, as with so much esthetic modernism, stands as emblematic of a central dialectical tension: a tension between a celebration of the new—in particular, of scientific language and evolution theory—and an anxious turning toward tradition. This dialectic was, for Vallejo as for Mistral and likewise for Kahlo and Rivera, embodied in a sentimental vision of the indigenous, the provincial, and the maternal. Mistral's enduring connection with José Vasconcelos, begun relatively early in her career, ensured that the philosophy of mestizaje would be a constant presence in her work. Vallejo's connections, through intellectuals like José Carlos Mariátegui, to an increasingly cultural nationalist brand of socialism in Latin America, and his focus throughout his writing career on questions of labor and indigenism, place him squarely among the ranks of modernists whose concerns were first and foremost with a vision of a specifically American, mestizo, and often socialist modernity. Mistral and Vallejo were, of course, not the first to bring together these aspects of Latin American modernity, but they have come to be two of the most important figures of that modernist period, rivaling, at least in the Spanish-speaking world, the importance of those who might be better known in Anglophone United States, such as Frida Kahlo and Diego Rivera.

Those who know anything about Mistral's and even Vallejo's conservative stances on the merits of the scientific and mechanical aspects of modernization might feel surprised at my characterization of both poets as modernist. But as we have begun to see, artists and intellectuals who addressed modernity, whether explicitly or implicitly, occupied a peculiar stance toward the various ideas, projects, and material manifestations of the modern. During the first decades of the twentieth century, perhaps even more important than industrialization and modernization themselves to a cultural sense of the modern were the ubiquitous representations of the unmodern: the Indian, the mestizo, and women. These representations were almost always paradoxical: conservative's rejections of moder-

nity were often couched in the same language as proponents of modernization used. Each looked to the Indian mother and/or to the mestizo to evoke their vision, whether positive or negative, of modernity and its future. In fact, the modernity of both Vallejo's and Mistral's poetic practices is tightly bound up with an antiurban and sometimes antimodernizing sensibility which critiqued, although it could never reject outright, modern values such as progress and scientific rationality, feminism, and urban concerns such as student unrest and factory labor strikes. Thus, both Mistral and Vallejo looked to the assumption of provincial voices as well as to the depiction of certain kinds of labor—maternal, rural, indigenous—as ways not so much to reflect as to negotiate the seeming social and economic paradoxes faced by nations determined to develop.[1]

It is often cited as something of a truism that modernization in Latin America was, for various reasons, uneven in its development. For example, Vallejo's own family, in the northern sierra town of Santiago de Chuco, was not immune to such supposedly opposing forces—modernity and tradition—and indeed acted within both. On the one hand, such a family was deeply conservative: as Franco has pointed out, "the structure and stability of social and private life were positive aspects of provincialism and gave a strong sense of identity. Lines were clearly drawn, duties clearly defined. . . . Because the family was a micro-model of the holy family, these structures did not appear arbitrary but constant and universal" (*César Vallejo* 3). On the other hand, Vallejo's father was a local dignitary and one of the governors of the town (and directly responsible to the subprefect); as such, his family, his sons, that is, were thus involved in the politics and the debates over progress of this provincial area. In spite of the inherent social conservatism of such a family, when push came to shove Vallejo and his brother came down solidly on the side of (at least political and industrial) progress; in 1920, the politically conservative acting subprefect jailed Vallejo's brother, Nestor, who had signed a telegram as a Leguía supporter (thus marking him and his family as being on the side of the "dangerous liberalism" of the Leguía government). This split in local politics eventually led to riots in August 1920 and to the arrest and imprisonment (from November 1920 to February 1921) of César himself as an "intellectual instigator" of the riots (in 1923, Vallejo felt forced by the fallout from these circumstances to set sail for Paris, never to return home) (*César Vallejo* 4).

65

This combination of a provincial, religious, and familial conservatism and the glimmerings of a political progressiveness in a family such as Vallejo's begins to clarify what I see as a central modernist dialectic, one which would eventually manifest itself in Vallejo's work. On the one hand, those who thought of themselves as modern and urban also more or less tended to accept the notion of a scientifically determined, secular evolutionary time; on the other hand, the newnesses and uncertainties of modernity itself seemed to call for an antimodern notion of a time and space of an idealized childhood and a provincial, domestic space. It should come as no surprise, then, that it was the increasingly modern urban spaces—Mexico City, Lima, San Francisco, Santiago de Chile—which were the sites where many of the most nostalgic and provincial images were called upon in modernist work.[2]

But, even in small and provincial cities such as Trujillo (where Vallejo studied part of the time), the innovations of the industrial revolution—the newspaper, the steamboat, the railroad—could and often did bring, without much delay, the latest in European vanguard art and thought and kept the intellectuals of these places in touch with others across the American continent. In a small city such as Orkopata in the south of Peru, for example, the indigenist vanguard writer Gamaliel Churata (the pen name of Arturo Peralta) published the modernist little magazine *Bolitín Titikaka* between 1926 and 1930. The success of this journal was in part due to the fact that steamers and trains had made travel from Orkopata to larger cities such as La Paz, and from there to even larger urban centers like Buenos Aires, possible. Indeed, for this area the 1870 construction of the railway Ferrocarril del Sur had already motivated the growth of that petit bourgeois class of small merchants and professionals from which the new artists and intellectuals often came. Another important factor was (sometimes private) educational reform: for example, the Seventh-Day Adventists had established themselves in this area and from there administered throughout the 1920s a system of primary schools whose reputation was superior to the public schools. From this system, according to David Wise, "surged an indigenous elite, Adventist, abstemious, and literate" (96).

Such factors, which contributed even in fairly remote areas to what Wise calls the "reciprocal contamination" between experimental modernist literature and the regionalism and indigenism of local artistic and social discourses, meant that provincial artists such as Gamaliel Churata

could establish ties not only with local artists and intellectuals but with others across Latin America and in Europe, so that a modernist little magazine from provincial Peru could be, and was, read in Mexico City and Buenos Aires, in Bolivia, Chile, and even in Paris (Wise 90, 97).

So it was that the long arc of what most would call development, from the mid-1800s through the first couple of decades of the twentieth century, provided both modern and seemingly antimodern sources for a poetic vocabulary and practice in which to frame a particularly American voice. First, as Nancy Stepan has made abundantly clear, the importance of medico-scientific disciplines to late nineteenth- and early twentieth-century Latin American nations provided many Latin American writers with a legitimated lexicon which in its turn codified the national discourses of race and gender, so crucial during this period. Second, Latin American artists took what they felt was useful from the formal artistic practices of European vanguard artists, practices such as Mallarméan, Dada, and Futurist typographical experimentations, as well as from the techniques of collage and Cubism. But as the 1920s progressed, American artists, in the Andes in particular, turned toward indigenist language(s) of poetic renewal and national reconciliation. It had become clear to intellectuals such as the Peruvian José Carlos Mariátegui that the push toward renewal in the European vanguard movements (especially Surrealism)—with which many, again like Mariátegui, had become acquainted while in exile in Europe—lent itself well to the project of national-indigenous renewal for which they hoped. We also see this realization in poets such as Alejandro Peralta, brother of the founder of *Boletín Titikaka*, who incorporated vanguard techniques (Palau de Nemes 205) such as using Quechua and Aymara vocabulary, Spanish-Quechua or Spanish-Aymara code-switching, and inventing (like González Prada before him) a new orthography to make Spanish look more like a phonetic transcription of Quechua, as, for example, in *nuestra ortografía bangwardista* (*nuestra orthografía vanguardista*, or "our vanguard orthography") and *indoameriqana* (Unruh 226).

Women's Work

Contributing to the sense that the temporal and social nature of eternal verities—such as motherhood—had somehow been fundamentally upset were Latin Americans' widespread concerns about the increasing visibility of women in the public sphere as well as concerns about organized labor,

across the continent. In Lima during the late 1910s, for example, women textile workers in factories were (although numerically a minority amongst Lima workers) responsible for organizing and holding several strikes (Sanborn 200). The social ferment and labor troubles culminated, in fact, in a general workers' strike in 1919. At this same time, the University Reform Movement, begun in Argentina, was reaching Peru; and General Leguía, soon to be dictator, had returned from abroad and, campaigning on a reform ticket, appealed to a *Patria Nueva* which would "encourage hopes for the end of oligarchic government" (Franco, *César Vallejo* 20). Such a move, away from the power of the large landowning oligarchies whose semifeudal practices were resistant to modernization, would in effect mean a turn to (industrial) modernization. As I have already noted, by 1920, Vallejo would find himself in political trouble, and ultimately arrested, for "instigating" a riot in his hometown—a riot which had its roots in the tensions between conservative landowning interests and the "dangerous liberalism [read modernizing tendencies] of the Leguía government," exacerbated by labor troubles in the neighboring Chicama valley (Vallejo himself spoke at a local meeting in favor of a new railway line) (Franco, *César Vallejo* 22).[3]

Increasing industrialization and modernization had a social as well as economic impact on Latin American class roles. Latin American intellectuals, who were often also poets, artists, and authors, found that they would have to enter the new, middle-class, more materialistic world they traditionally despised if they were to survive.[4] From the 1880s through the early 1900s upheavals in economies, the growing presence of workers' as well as women's movements, and the rise of a middle class—all facilitated to some extent or another by increasing industrialization—constituted a danger to the small toehold that male artists, writers, and intellectuals had in the elite landholding, urban, and export classes of a place like Peru. At the same time, those technologies which accompanied modernization, such as photography and the newspaper, were in the process of opening up new public spaces for these artists to make themselves over into a class of professional writers whose intellectual aristocracy would provide the culture necessary to lift the new bourgeoisie out of their provincial and money-grubbing materialism.

This public space could also be, and was, taken advantage of by socialist advocates of workers' rights as well as by (often feminist and, especially

in Peru, pro-indigenist) women writers. The Peruvian sentimental indigenist writer and feminist Clorinda Matto de Turner founded a publishing house and collaborated with the Bolivian writer Carolina Freyre de Jaimes through the early 1900s; Freyre de Jaimes, who was a leader among women activists and feminists, had established herself early on as a journalist in Peru, and among other things she directed the women's magazine *El Album,* published in Peru and Bolivia in the 1860s to the 1870s (Bergmann et al. 174–175). Other important women of the region included Dora Meyer de Zulen, cofounder of the Peruvian Pro-Indigenist Association (Asociación Pro-Indígena); an early public lobbyer for indigenous rights, she chronicled the end of this association in the first 1924 issue of Mariátegui's own modernist little magazine, *Amauta* (Pratt 63).[5]

The appearance on the public scene of women's journals and magazines, no matter how small and often embattled, as well as the growing fame of women writers like Chilean poet Gabriela Mistral and Argentinian Alfonsina Storni may easily have made male artists anxious about their own paternal rights to artistic creation.[6] And, in fact, Vallejo could not but be aware of the increasing presence of women on the public journalistic and artistic scene. But at the same time as Vallejo's resounding artistic silence about such matters signals his implicit (and later, in his journalism, explicit) rejection of movements such as the early feminist and labor movements as avenues for his own work, the same social and cultural changes which facilitated women's, socialist, and labor movements also furnished younger artists such as Vallejo with the break needed from the stultifying hold that elite patronage had had on the arts and letters and from the equally smothering moral and economic hold of the bourgeois classes.

These artists—modernista poets from the 1880s through the early 1900s—searching for their new role in a changing economy, turned toward an Americanism which would continue to strengthen throughout the last years of the 1920s, aided in large part by the continental university reform movement beginning in 1918.[7] This was an Americanism which expressed itself by praising the provincial small town, the countryside, and the peasant or indigenous peoples who inhabited such sites in a combination of exotic language and a provincial catalogue of sights, sounds, and smells. The *madre indígena,* or "indigenous mother," often made an appearance in these writings. As Mary Louise Pratt points out, the figure of the indigenous mother was virtually ubiquitous: "Endless repetitions and variants have mythified

this figure [of the sexually appropriated indigenous woman], simultaneously victim and traitor, as the mother of the American mestizo peoples. At the same time, she has stood for all the indigenous peoples conquered (feminized) and co-opted (seduced) by the Spanish. Nowhere have such symbols been more active than in the Andean region" (Pratt 59). In this sense Americanist writing had something of a counterpart in European ideas that the peasant or folk woman embodied an original source of life and death, of the natural, and of a sense of authenticity (Harrison, Frascina, and Perry 22).

Imperial Nostalgias

In his first two collections, Vallejo would make a seemingly unmodern gesture toward an anachronistic poetics of women's work and domesticity which, while pointing toward the provincial, the indigenous, and the colloquial and apparently away from the more urban esthetic of Vallejo's European vanguard contemporaries, in fact worked to motivate and give form to a specifically modernist poetic labor, one which is deeply inflected by the images of indigenism as well as by the implicit assumptions of mestizaje. To illustrate what I mean, we can look briefly at the two poem fragments with which I introduce this chapter.[8] These come, respectively, from the first two collections of poetry published by Vallejo while he still lived in Peru: his 1918 *The Black Heralds* (Los heraldos negros, not actually published until 1919) and his 1922 *Trilce*, both published in Peru. At first glance, these poems seem essentially unalike, although they do share a few aspects: references to women's domestic tasks such as ironing, a repetition of the word *capulí* (a dark yellow berry), and a use of the future tense and subjunctive mood which in both poems seems to suggest a (nostalgic) sense of a memory projected into a hopeful but not very likely future. In both, the references to women's domestic labor at first appear merely a natural part of a description of Peruvian provincial life. However, Vallejo's propensity to rewrite and rework previous images, sections, and even whole poems from *The Black Heralds* for inclusion in *Trilce* demonstrates important links between the overt indigenism and modernismo of many of the *Black Heralds* poems and the much more modernist concerns of *Trilce*.[9]

The section called "Imperial Nostalgias" (Nostalgias imperiales) in *Black Heralds* is one of Vallejo's early experiments in a poetic style still accepted at the time, indigenist modernismo.[10] In fact this entire collection is in a sense Vallejo's way of trying on various poetic styles and movements.

Temporally, these movements—indigenism, modernismo, and what is now, in Latin America, called vanguardismo—did not, of course, begin and end neatly; in the years when Vallejo was writing the poems and assembling them for *The Black Heralds*, these movements overlapped each other. Vallejo's (re)use of the peasant and/or indigenous laboring figures from indigenism and from an Americanist modernismo served as a more original source for the modernist experimentations with language, content, and form in *Trilce*. The title "Imperial Nostalgias" refers to that sense of nostalgia that contemporary Indians were widely assumed to have for their pre-Conquest empire—in this case, that of the Incas. This was, of course, more of a sense of nostalgia on the part of whites and mestizos than it was for indigenous peoples, and it was projected onto the Indian as part and parcel of the idea of the melancholy racial character of the Indian. This indigenista sentimentality, then, carries over strongly into *Trilce*'s particular modernist concerns and practices, where the concerns of modernity are deployed, at least in part, through the use of a folk discourse inherited from an indigenism whose rhetoric and sentiments were quite strong among many elite in Peru.[11] As I have noted before, the move from an older artistic practice (such as modernismo) to this new, presumably more radical modernism has often been presented, and even presented itself, as a decisive break, as constituting a real and unbridgeable gap between the old and the new. However, I argue that the deployments of the indigenism of *Black Heralds*, its modernista tendencies, and the folk or provincial aspects of *Trilce* can be connected by reading the appearance, specifically, of laboring and maternal women across these two collections.

However much concerns over women's work were part and parcel of the larger picture of Western modernity, Vallejo's use of women's domestic labor as a more originary and imaginary source for his own poetic energies also derived from his own very specific American cultural and communicative setting, one where women's labor was of primary importance in Andean indigenous (and mestizo) cultures (Arnold 33). Paying attention to Vallejo's imaginings and his representations of and assumptions about women, the indigenous, and women's work will allow us to avoid a too-facile reading of the differences between what has often been considered Vallejo's derivative, indigenist-inflected modernismo in *Black Heralds* and what has again been read as a highly sophisticated vanguard expression in *Trilce*. Instead, we can begin to mark the juxtapositions and superimpositions of at

least three artistic movements, showing the often overlapping, sometimes contradictory, always gendered impulses imbedded in their various practices and concerns.[12]

The Indigenous, the Modern, and the American

The general critical sense about the section "Imperial Nostalgias" in *Black Heralds* has usually been one of faint embarrassment; the style of these poems tends to be read as inferior, as a young poet's experiments with a modernismo, which is already passing out of favor amongst younger artists, and a literary indigenism which itself is generally read as lacking true literary merit. In addition, certain modernista sensibilities such as "rarefaction, the flaunting of excess . . . as well as a heavily loaded surface of verbal texture" (Kirkpatrick, *Dissonant Legacy* 15) would seem to run counter to the presumed realist esthetics of an indigenist writing which purports to faithfully represent the injustices done against indigenous populations and which often uses indigenous imagery and lexicons.[13] However, the call to renovate and to make Latin American writing and intellectual thought more American meant ultimately that modernismo would have to respond to Americanist concerns. In fact, although it has been argued that indigenist literature was actually silenced during the height of modernismo, this discourse does not disappear but is manifested within the modernismo of the time (Kristal 22). In the indigenist-inflected modernista poems of "Imperial Nostalgias," Vallejo clearly was following the advice of Manuel González Prada (himself at one time a modernista poet), who in the 1880s "had been the first to recommend that Peruvian art break with Spain and the linguistically conservative Lima spirit, explore Peru's indigenous traditions, seek renewal through popular sources, and search for new forms in other literatures" (Unruh 226). The Peruvian modernista José Santos Chocano, the important socialist intellectual José Carlos Mariátegui, and the poet Alejandro Peralta, for example, each wrote Indianist-inflected modernista poetry at various times during their careers. As Gwen Kirkpatrick notes, even the modernismo of the more urban Julio Herrera y Reissig (also an influential poet for Vallejo) became concerned with Americanist topics: "Many of the poems from the section 'Nostalgias imperiales' are reminiscent of the sonnets of *Los éxtasis de la montaña*, where Herrera y Reissig creates [Americanist] pastoral scenes and adds symbolist and decadent images. . . . The idealized and distant past is now not a classical golden age

but a lost indigenous heritage. . . . [These] show a new fusion of *modernismo's* exotic strains with the more local tone of *mundonovismo* (new-worldism)" (*Dissonant Legacy* 207–211).

Vallejo's writing in *Black Heralds* clearly takes some of its impulses from works as varied as the Uruguayan poet Herrera y Reissig's collection *Mountain Ecstasies* (Los extasis de la montaña), written between 1901 and 1910, and the Peruvian poet José Santos Chocano's 1906 *American Soul* (Alma América), or his 1908 *Fiat Lux;* at the same time, the tone, relationship (or lack of one) with modernity, and sense of intimacy with an Andean familial scene mark Vallejo's published work (that is, his first two collections) in some radically different ways.

The Uruguayan Herrera y Reissig was one of the most urbane of the grand figures of modernismo, marking his verbal facility with an irony and a sense of dissonance rarely found to such an extent in other modernista poets. In *Mountain Ecstasies,* however, Herrera y Reissig modifies his verbal pyrotechnics and the exoticism of his poetry by appealing to pastoral and small-town American scenes which, for all their lack of excitement, are nevertheless pictured with a seemingly disjunctive combination of sentimental and ironic tones. These poems stage a sentimental turn toward a pastoral Americanism in the face of the modernizing incursions of foreign and bourgeois figures, at the same time as the presence of trains, automobiles, scientific equipment, and tourists mark poems such as "Dominus Vobiscum" as themselves part of modern poetry. "Dominus Vobiscum," in fact, begins with a simple and even mind-numbingly boring Sunday village scene: "The good Sunday yawns, drone of the week" (*Poesía completa* 64), where the place is so quiet one can hear the *castañuelas,* or "clicking of the frogs," in the plaza fountain. The turn of the sonnet at the beginning of the last two tercets, however, introduces a new element:

> *Two tourists, blond dolls with unmoving faces,*
> *maneuver the visit of a spirited automobile . . .*
> *with his glasses and his flasks and traveling bags,*
>
> *the zootechnician, professor of earthworms, investigates*
> *and off to the side, in a savage gesture, two boys*
> *spy, moist fingers up noses.*
>
> (*Poesía completa* 64)[14]

As in his poem "Inspiration" (Numen), where a phrase like "your tea-electrolysis" (*tu electrolosis de té*) juxtaposes the violence of the modern image of electrolysis with the implicitly unmodern and domestic simplicity of tea, Herrera y Reissig again uses the violence of the cultural and ambient unevenness of these images—the village, seemingly timeless and traditional, and the appearance in its midst of signs of the modern age. The irony especially of his *aldea*, or "small-town," poems is exquisite, even savage itself, as it manages to satirize both the boring little towns (the "yawn" of that "good Sunday") and, as in the poem cited above, satirizes the intrusion into this scene of a probing, mechanical (even the two tourists are blond, presumably North American, "dolls" with immobile faces), scientific modernity—the figure of the "professor of earth-worms"—while the two boys unwittingly make the ultimate "savage gesture," a finger up the nose. Because irony is the dominant tone in so many of these poems, this savage gesture can be read also as a comment on the crudeness, even the primitiveness, of the boys and the town together; the gesture nevertheless implies that the simplicity and unconscious directness of such peasant crudity in fact works to contain or at least resist the intrusion of the new.

In turn, then, this primitive gesture points the way to Vallejo's own modernist move toward the simplicity of provincial life, often conflated with its very unmodernity, although he will take up this turn in more covert ways than Herrera y Reissig. Vallejo rarely invokes what we would normally think of as modern imagery either in *Black Heralds* or in *Trilce*, but his own orientation toward the sentimental simplicity of his familial and village scenes, beginning in his first collection and continuing in his second, can be read within the framework of modernizing cultural changes and concerns.

Peasant Women

The peasants and indigenous figures in Herrera y Reissig's or Santos Chocano's poems are less actors than they are parts of the landscape, itself feminized and childlike, where, for example, the "house of the mountains . . . laughs as though it were a little girl" (Herrera y Reissig, *Poesía completa* 62).[15] It is only in one poem, "The Mothers" (Las madres), that Herrera y Reissig represents the indigenous woman in a sunset scene which is clearly meant to evoke the dying of an ancient way of life. Accompanying this scene are those who "remember the old exiles," including

Matronly mothers with dim profiles,
whose flesh leaks the scent of clover and thyme,
showing the plethorous breast from which hang
sunburned infants, like ripe fruit.

(*Poesía completa* 18)[16]

Although the animal or even plantlike appearance of these indigenous mothers, whose flesh itself gives off a particular smell, with babies hanging from their breasts like "ripe fruit," is in keeping with the widespread idea that indigenous peoples were less than human in their silence and (im)passivity, the other side of this coin can be seen in Vallejo's "Imperial Nostalgias," where he connects his indigenous figures with a wild or uncultivated, primitive sensibility. The original wildness, purity, and innocence of Herrera y Reissig's country scenes is displaced in Vallejo's work onto the indigenous woman as well as onto her work. In fact, these three things—(indigenous) women, a primitive sensibility, and women's manual labor—are oftentimes conflated in this section. For example, the indigenous "shepherdess" of "Mayo" sings a "wild hallelujah" like a "sacred Ruth, pure, / who offers us a wheat stalk of tenderness"; in "Autochthonous Tercet" this same figure's "untamed white heart" is also a "spindle" and she is adorned "with pleats of candor" (*Obra poética* 68). While it is not unusual to see this combination of Judeo-Christian, neoclassical, and Indianist references in modernista poetry, this *Venus pobre,* or "poor Venus," is in remarkable contrast to other (non-indigenous) female figures in *Black Heralds:* Vallejo's exclamation in the poem "Nude in Clay" (Desnudo en barro) that "The tomb is still / a woman's sex that attracts man!" captures this collection's recurring anxiety about women's sexuality (*Obra poética* 81).

Vallejo's attribution of a candor and purity to the more simple indigenous woman echoes a widely shared idea (on both sides of the Atlantic) of (certain kinds of) women as located outside of urban spatial and temporal concerns. If one looks closely at this section, one finds that the male indigenous figures, for the most part pictured as angry, drunken, resigned, or weeping, are less convenient for a sense of innocence, purity, and nostalgia than are the female figures, who bear implicit connections with the passivity of the animal world and with the earth.

Combined with actual references (including a sprinkling of Quechua words) to a more primitive culture, the use of modernismo's twinned feeling-

tones of melancholy and a distant exoticism are important in thinking about the ways Vallejo reworked and modified an indigenist-inflected sensibility in *Trilce*. In "Imperial Nostalgias" the sense of melancholy is "blued," echoing the emphasis on this color (and on its appearance in smoke, in the dusk, in the fadings of the sky and clouds) in Latin American modernismo.[17] The predominant mood of these poems is a kind of exhausted sadness, of a meditative contemplation on a distant and possibly lost time and space which corresponds metaphorically with the evanescent blueness of dusk and smoke, as in "May." The poems "Ebony Leaves" and "May" provide some of Vallejo's most important *Trilce* poems with an entire constellation of vocabulary and images of a provincial home, connected by association with indigenous life, as here in "May":

> *Domestic smoke pours into the dawn*
> *its savor of stubble;*
> *And gathering wood, the shepherdess*
> *sings a savage Hallelujah!*
> *Sepia and red.*
> *Kitchen-smoke. . . .*
> *There's a certain desire to eat lunch*
> *and to drink from the arroyo, and kid around!*
> *To fly with the smoke away, in the heights. . . .*
> *In front of the hut*
> *the Indian grandfather smokes;*
> *the primitive altar is perfumed*
> *in the smoke of the tobacco. . . .*
> *mythic aroma of bronzed lotus,*
> *blue thread of broken breaths!*
>
> (*Obra poética* 68–69)[18]

In a similar vein, "Ebony Leaves" recalls the doors of the family house which, once *lozanas,* or "youthfully vigorous," are, now that the poetic persona has returned, "coagulated with shadows smelling of forgetfulness"; nevertheless, the "arms" of the doors welcome him back, prompting him to ask after a now-dead "Señora"; "I still see her wrapped in her shawl." (*Obra poética* 58). In "May" the too-picturesque scene of the simultaneously degraded and exoticized figures of the Indians is dis-

tanced, made unreal by the artificial language and style of the poem. Here are traces of a modernista exoticism, itself evoking a sense of distance, in references to "bronzed lotuses," (the preferred poetic term for indigenous skin color being either "copper" or "bronze"), or to the "Asiatic emotion" of the Indians.

This modernista concern with the distancing effect of exoticism and with poetic melancholy and evanescence, rather than jarring with realistic indigenous scenes and language, dovetails nicely, in fact, with a widespread imagining of indigenous populations as sad, full of melancholy, and, most importantly, nostalgic for the lost and distant time of the glories of the Incan empire. This largely imaginary indigenism owed much of its existence to nineteenth-century Andean anthropological discourse in which, as Mark Thurner notes, "contemporary Indians had no history, no contemporaneity. They were simply, and irremediably, hung over. . . . [Concomitantly, twentieth-century Andean anthropology] has nurtured, and been nurtured by, twentieth-century popular and nationalist images of 'the Andean' as essentially continuous with the precolonial Inka" (12, 15). In such lines as "The pensive old woman, that relief / from a pre-inca block" (*Obra poética* 54), or, in "Autochthonous Tercet," "In indigenous veins runs / a *yaravi* of blood filtered / by the eye in nostalgias of the sun" (*Obra poética* 62), Vallejo's word-pictures of lost glories share a vocabulary and an attitude with this doubled history of imaginings about Peru's indigenous peoples.[19]

The presumed nostalgia (sometimes attributed to the indigenous figure, sometimes felt by the indigenist writer) for an exoticized imperial past of the Incas, combined with a contemporary melancholy for a degraded indigenous present, creates a temporal feeling which is important in an Americanist reading of the conjunctions of modernist and sentimental-primitivist sensibilities. The primitive and exoticist discourses underlying modernismo and indigenismo, seemingly so different in motivation, are actually marked by a similar sensibility. They share in an exoticized distance, sometimes identified as a distance in geographical space but, for Latin American Creoles and mestizos who lived intimately (though not necessarily always lovingly) with indigenous populations, more often as a doubled distance in cultural time: a degraded yet still culturally more simple present alongside a savagely glorious past. This doubled sensibility of degradation and exoticism fits quite neatly with the similarly fascinated

sense of women's simultaneous innocence and degradation, a sense which runs throughout the rest of this collection.[20]

Ruth the Moabite: Mistral and Mestizaje

During her two-year stay in Mexico (1922–1924), working, at the behest of Vasconcelos, on establishing a normal school for girls and on gathering pieces for her text *Readings for Women* (Lecturas para mujeres), Mistral had time to write impressionistic prose pieces about Mexican Indians. In her 1923 "A Profile of the Mexican Indian Woman," Mistral turns to some of the same strategies as Vallejo had used a few years earlier: the Indian woman is *trigueña*, or "wheat colored," and "her skin . . . holds the brand of grain lavishly licked by the sun." In keeping with standard ways of evoking the presumed exotic nature of the Indian, she is both biblical and "Asiatic": "The shawl gives her simple biblical lines. . . . And this woman . . . with her Asiatic likeness, has to be kin to Ruth the Moabite: she toiled, and her face was blackened by a thousand siestas over heaps of unthreshed grain" (*Mistral Reader* 176–178). Here, as with Vallejo, the Indian woman is conflated with wheat (in reality, she probably would have cultivated corn) in skin color as well as in her agrarian life, and her purity is invoked by allying her with women of the Bible—in this case, Ruth. Again, it is "four hundred years of slavery" which have "faded the equivalent glory of their sun and fruits," just as, twenty-four years later, Mistral would still characterize the remains of the Quechua people, in her 1947 "Something about the Quechuan People," as "melancholic," holding "the bruised markings of a race that was to be defeated in body and soul" (*Mistral Reader* 183). But unlike Vallejo, who was to orient himself, specifically as a mixed-race poet, consistently with an indigenist socialism rather than an overt philosophy of mestizaje, Mistral, a self-proclaimed *vasconcelista*, saw the mestizo both as the inevitable inheritor of the Americas and as a source for a new American poetry. However, unlike Vasconcelos, she thought of "blood mixing" as encompassing "various aspects of pure tragedy; perhaps only in the arts does it present an advantage" (220). This is an advantage which, despite her admiration for the modernista poet Rubén Darío, would replace the "sticky-sweet linguistic warehouse of 'nightingales,' 'gauziness,' and 'roses' that left us mired in second-rate modernismo" (218). In her 1936 "Message about Pablo Neruda," in fact, it is specifically Neruda's mestizo nature which impels his poetry: "Although his body does

not sufficiently reveal mestizo blood, his eyes and face, and langour of his gestures, and especially his speech, his poetry, so full of occidental vestiges, reveal the conflict in bloodlines—a blessing, this time. . . . When a mestizo opens a dam, a torrent of originality is set free" (*Mistral Reader* 219–220). As we will see in chapter 4, Mistral will go on to connect her own sense of poetic womanhood with the idea of the wounded, but ultimately fruitful, consequences of race-mixing.

For Vallejo, on the other hand, the combination of turn-of-the-century *modernista* strategies with the twentieth-century acceptance of evolutionist theory seemed to offer no more than an animalized human past, a degraded female body, and a loss of the "anthropostic ideals of God, freedom, and immortality" (Haeckel 381). Both Mistral's and Vallejo's ideas of women, however, fit neatly with "antimodernist ideas about women and their roles," which were, as Nancy Stepan points out, "widely shared by men on the left and right, even as the actual behavior and experiences of women shattered the familiar myths of gender and family" (110). In this way modern, secular discourses which were reshaping closely held, traditional religious ideas about the sexual and reproductive nature of men and (especially) women were combining with equally antimodern notions about the role of woman as the center of the familial and domestic sphere to produce the (relatively new) idea of her duty as the mother of the race.

Like male poets of her generation, Mistral first began her career by constructing the requisite suffering poetic persona, in part through love poems. As was the case in the indigenist *modernismo* of Vallejo's 1918 collection *The Black Heralds,* in Mistral's 1924 collection titled *Tenderness* (Ternura), the sadness of lovers, mothers, poets, sons and daughters and the sadness of Indians often come together quite neatly, so that frequently for both poets when the (sad) mother figure is evoked, she is implicitly connected with (sad) Indian women. In these years, too, both Vallejo and Mistral borrow sentimental indigenist images and vocabulary and mix these images with Biblical and neo-Classical references to Judith, Ruth, Venus, and the Queen of Sheba. They call on a smattering of indigenous vocabulary, mostly associated with music, and in both, references to *quenas* and *yaravís* abound.[21] Most importantly for their emerging modernism, both poets find their most effective poetic strategy is to turn to the popular tones of nostalgia and homely intimacy pervasive in so much of the national expression of each poet's country at the time. "*Quechua*

Song," for example, from the section "Canciones de cuna" (Cradle songs) in *Tenderness*, is, according to Mistral's note for this poem, "an oral text of the *Quechua* woman":

> *You descended blinded by suns,*
> *flying asleep,*
> *to discover the airs*
> *of llama and indian*
> *widowed. . . .*
>
> *Return to your Pachacamac—*
> *In-Vain-Come,*
> *Crazy Indian, Indian who's born,*
> *lost bird!*
>
> *(Ternura* 34)[22]

In that these lines privilege the melancholy of the Indians, such verses resonate, again, with indigenist modernista poetry; but their evocation and use of the oral folk quality of pre-Columbian cultures imbues them with a modernity which allies them not only with the work of artists like Kahlo and Rivera, but also with the work of indigenist artists of the 1920s and 1930s such as the Peruvian Peralta brothers or the Guatemalan author Miguel Asturrias; this is not surprising considering Mistral's familiarity not only with Rubén Darío's work (he is "our Rubén" in the notes to her 1938 collection *Tala*) but with other, more contemporary poets in Latin America. But even more importantly, as we began to see in chapter 1, it is in the writing most connected to familial and provincial images that artists like Vallejo and Mistral can negotiate the links they were seeking to make between what they saw as the disconnected realms of the traditional and the modern. Because the strategies and vocabulary of earlier sentimental modes of expression could still be used to evoke—although with a good dose of nostalgia—a colloquial and provincial way of life, both poets discovered along the way that a colloquial language and a conversational tone were in fact better able to express genuine—and for both, an essentially political—feeling. Thus Mistral's turn toward poems and prose about mothers and children (writings which called on long-established sentimental tropes of the suffering mother) also made use of the same evoca-

tions of the domestic as did Vallejo, though for different career ends. This is the kind of writing which Mistral found would serve her well in her career as a professional woman: in part, these cradle poems got Mistral her first ambassadorial post, in Mexico under Vasconcelos (Schneider 148); once in Mexico, the tropes and images of Mexico's official indigenist mestizaje dovetailed neatly with her own work, and from there, her increasing fame would allow her to travel and to publish even more.

As critics are now beginning to point out, however, Mistral's poetry's homely expressions and nostalgic, simple rhymes were, as she herself would say, something of a transparent mask. One of the main differences, of course, between the formal aspects of Mistral's and Vallejo's poetry is that Mistral's was locked into seemingly simple poetic forms by her public teacher-mother persona. This meant that she could not experiment openly with the avant-garde languages or strategies available to male vanguard poets. But Mistral paid close attention to other modernist poets of the time, as the many homages and commentaries which she wrote, on everyone from Alfonsina Storni to Pablo Neruda, make clear; of necessity, then, her thinking about her own poetry was quite sophisticated.

From the beginning of her poetic career Mistral insisted on the ultimate failure of what she thought of as modern language to convey what she really wanted to say. What she really wanted to say was, of course, never free of her obligations to her state-sponsored work, first as Vasconcelos's protégée, then as ambassador for Chile. This meant, then, that her problems in finding an appropriate poetic language were in fact similar to the problems had by Vallejo, Rivera, and Kahlo—the modernist struggle with imagining a temporal, national (or even continental) lineage or history which would include marginalized groups usually imagined as occupying an atemporal space. Her writing constantly reflected the same kinds of modernist apprehensions about tradition and modernity, although for her the term "modernity" would be a buried and implicit, rather than explicit, one. That is, as Elizabeth Marchant and Licia Fiol-Matta both note, Mistral created in her prose and poetry a private, woman-centered world which she then proceeded to offer publicly in the service of the masculine-centered nation: "Her moralistic tone and the discourse of 'values' concealed the fact that she united what the discourse of the nation separated (namely, the public and the private, the prepolitical and the political) and separated what the discourse of the nation united (namely,

women and men)" (Fiol-Matta, "The Schoolteacher" 209). I would add, however, that she also appropriated the state's separation of Indianness from public, masculine connotations, often affixing the Indian part of mestizaje to the private, premodern, and feminine world of her work; again, this Indian-ized and mestiza-ized world, if you will, was offered up as the apotheosis of that at which the very nationalist projects of indigenism and mestizaje were driving: modernity. But like Kahlo's later adoption of indigenous Tehuana dress, Mistral seized a course offered to her—to make herself an icon of Americanness, mestizaje, and spiritual motherhood—and to the extent she could, she made this course her own. She lacked the protection to lead the relatively free artistic life that Kahlo was afforded by her husband, a liberal education, and the space of an elite international modernist community. Unlike Kahlo, Mistral was deeply woman-identified and unmarried; like Kahlo, she was childless; these important factors meant that Mistral, despite the fact that she solicited and received the endorsements of powerful men, could not have attained the post of Chilean consul-at-large without assigning to herself—through the mediation of children, mothers, and Indians—that atemporal space which was supposed to serve as the motivating heart of a progressive and future-oriented nation.[23]

As with other moderns, Mistral's discourse connecting women and nation was saturated with an ethnographic and anthropological emphasis on folk culture. As Jean Franco notes, "Mistral's interest in folklore has its roots in the Americanism of the beginning of the century—in the preoccupation with the originality of Hispanic America threatened by a homogenizing modernity" ("Loca" 31).[24] Mistral promoted the study of folklore from her place in the Institute of Intellectual Cooperation of the Society of Nations,[25] and she gave conferences on folklore as well as on the maritime traditions of southern Chile in her travels to Brazil, Uruguay, Argentina, Peru, Ecuador, and Cuba ("Loca" 31). Folklore, though, was not only a way to bring the world of children, Indians, and women back into a nationalist and masculine-oriented public sphere. What was then considered the universal nature of folklore also reminded the Latin American continent of its racial roots, while it gave each nation a specific set of traditions on which to base nationalist feeling: in 1932, for example, in an article in *Puerto Rico Ilustrado*, Mistral wrote that American folklore seemed "steeped in raciality, saturated with the juices of [racial] caste, a

veritable Veronica which bears the stamp of our emotional features" (qtd. in Franco, "Loca" 32).[26] If a sense of race—in both the more general sense of the term and its more specific biological sense of a genetic difference—"saturated" folklore, this would make it especially useful for teaching a nation its heritage as well as its essential mestizo nature. And those best fitted for the job of pedagogy—which would do the work of "conserving and modernizing"—were women, especially the poor mestiza who otherwise might not be able to support herself: "Through pedagogy, the spirit of the race will be saved, through pedagogy it will be possible to modernize without losing the original features of the country. As a mestiza, single schoolteacher, women would be able to share in this project" (qtd. in Franco, "Loca" 33).[27]

In part, it was true that the interest in the folk and the indigenous was motivated by the idea that such cultures—or the artifacts of those cultures—were threatened with extinction by modernization; but far more important to official, state, and anthropological discourse was the redirection and modernization of cultural artifacts which had fallen into what was thought of as a degenerate state because of the lack of education and resources suffered by the groups producing them. Although Mistral mourns the rise in popularity of music such as jazz (Franco, "Loca" 32), the real question for her as for other moderns was not so much how to rescue folk culture, but how to make it useful.

In all her work, Mistral's personal enabling myth was that as a woman she came to poetry through lullabies, simple folk songs and oral tales, and children's rhymes (the presumed opposite of what she calls the "rational and anti-rhythmic" language of modernity). However, in the 1945 afterword to a reedition of her 1924 *Tenderness*, she makes it clear that what most people see as simple, superficial, and childish in her poetry is in fact an alibi, or better yet a red herring, meant to direct attention away from profundity and mystery in her work: "I continue scrutinizing the deep and crystalline mystery of childish expression, which seems like the depths of a block of quartz . . . because it deceives the eye and the hand with its false superficiality."[28]

If one pays attention to her writing, this "childish expression" is very specifically delineated. Although even this late ("Colophón" was added to the reedited *Ternura* in 1945), Mistral still calls herself a vasconcelista, on at least one point she departs from Vasconcelos's celebration, in his

Cosmic Race, of the Spanish Conquest as the perfect pattern for race mixing. Rather, she maintains that the childish expression in her poetry is, literally, a specifically New World "verbal mestizaje" and as such is, disturbingly enough, the product of the first rapacious encounters of the Conquest: "I am one of those who carry the troubled and irregular feelings, [the] face, and [the] expression because of the graft; I count myself among the sons and daughters of that twisted thing they call a racial experience, or better said, a racial violence"; in opposition to Vasconcelos's Hispanicism, this is a language "far from the Spanish ancestral mansion, a thousand leagues away from it."[29] Performing, in her own self-representation, the modernizing project of mestizaje, Mistral refuses to celebrate the manner in which actual, physical race-mixing has taken place: she may claim, in her poetry and in her photographs, to see the Indian in her own face, but it is a face whose lines are, because of the violence implied, "troubled and irregular."

Mistral presented herself as constantly searching for a poetic language which she felt was lost in her childhood. It is not surprising, given the Christian, Theosophical, and neo-Classical influences she shared with many artists and thinkers of her generation, that she fixed on the notion of a primal experience (of the world, of language), lost along with the innocence of childhood.[30] But it is at this point that Mistral is confronted with a central problematic in her work: acknowledging and even celebrating indigenist mestizaje, she cannot but be aware that that particular discourse depends on a rhetoric of modernization as much as on one of tradition. For her to acknowledge mestizaje is to acknowledge both a racial violence and the (for her, undesirable) move toward a rationalizing modernity. The language she has to use for this project, then, is necessarily flawed. In her 1938 *Felling* (Tala), the persona of the poem "Things" (Cosas) searches for those things that "I never had / with the others I don't have anymore"; one of those "things" is "a verse I lost, / that they told me when I was seven. / It was a woman making bread / and I saw her sacred mouth"; she senses such a lost language in a river's flow, which "always runs close. / It's been 40 years I've known it. / It's the singing of my blood / or better a rhythm they gave me" (*Desolación-Ternura* 154). "They" refers to the collective "woman making bread" earlier in the poem, they who spoke to Mistral's child-persona in a language she can no longer remember. In "How I Write," Mistral connects what comes to be for her the

clearly racialized sadness and melancholy of women with the poetic language she longs for but cannot find:

> Poetry comforts my senses. . . . [It defends] the childlike quality of my character. . . . Poetry simply exists within me, and on my lap; it is the thirst of a submerged childhood. . . . Perhaps original sin is nothing more than our fall into the rational and anti-rhythmic expression which has lowered the human race. It hurts us women more because of the joy we lost, the grace of a musical and intuitive language that was going to be the language of the human race. (*Mistral Reader* 223–224)

For Mistral, folklore was also useful as a way of proposing answers to some of the most modern problems of race, gender, and language located right at the heart of national progress and modernization. A staple of Latin American folktales, the folk figure of the *mujer loca* (crazy woman) gave Mistral a convenient motif on which to map some of her struggles with the construction of an effective poetic language (Franco, "Loca" 29). It is in the evocation of nostalgia that Mistral celebrates a woman-centered and woman-identified space, even though this is an affect which is often edged about with images of female madness and loss, couched in a "delirious" language.[31] By the time *Lagar* was published in 1954, Mistral felt freer to be open about her struggles with poetry and modernity and less anxious (one would assume) that her "crazy woman" poetic persona might be mistaken for the real Mistral herself:

> Give me now the words
> that my suckling nurse didn't.
> I'll stutter them demented
> from syllable to syllable:
> the word "despoil," the word "nothing"
> and the word "final stage,"
> even though they twist in my mouth
> like bitten snakes!
> (*Desolación-Ternura* 183–184)[32]

This poem, "The Abandoned Woman" (La abandonada), from the section "Crazy Women" (Locas mujeres) in *Wine Press* (Lagar), takes as its

theme an abandoned lover who turns in fury on herself and the home they shared. But the poem's persona cannot express herself in real, true, poetic and intuitive women's language—such words literally were not imparted with her mother's milk. Instead, *la abandonada* has to use words which make her stutter, which turn in her mouth "like bitten snakes," using the same term—*balbucear*, or "stutter"—as does Vallejo when the need to express the premodern in (contemporary) language fails him. Paradoxically enough, although the terms in which the lost space of childhood and/or maternal speech is described are sentimental, using such terms does not gain these poets unproblematic access to a sentimental space; Mistral and Vallejo can only attempt to describe such a place, but the temporal and spatial assumptions of their poetry prevent them from actually speaking its language—their poetic personas can only stutter.

Female Voice and Bodily Evolution

Mistral's poetry follows a fairly clear progression from the relative (though often misleading) simplicity of her early work to her more complex later work. For Vallejo, though, the diffusion of an indigenist modernismo into a less obviously sentimental modernism in his 1922 *Trilce* is by no means a clearly delineated process. In a move undoubtedly learnt from Herrera y Reissig, Vallejo displaces the modernista emphasis on exotic sounds and smells onto the much more mundane and local smells and sounds of manure, cooking fires, barking dogs, cow- and sheep-bells tinkling, and he places an emphasis on the timelessness and unchanging nature of the small town, which for Herrera y Reissig "sleeps in the narcotic buzz of the flies."[33] Thus, in turning away from the overtly Indianist themes, images, and language of Vallejo's first collection, in *Trilce* these themes are mutated into another, closely related, vernacular—that of the provincial and the familial, which for both Vallejo and Mistral was unavoidably intertwined with women and their domestic work as well as with indigenous people, life, and culture.

It is no great news to any attentive reader either of *Trilce* or of the earlier *Black Heralds* that women figure prominently in Vallejo's work at this time. Américo Ferrari points out that while in *Trilce* "eroticism and the presence of the female reach their culminating point in Vallejo's work," at the same time *Trilce* grounds its own poetic presence on the absence or death of certain women, in particular Vallejo's mother as well as his lovers

(xii—iii). In this collection, then, Vallejo's site of poetic work is predicated at least in part on a play of feminine presences and absences. Vallejo shared in the obsessive, and often highly anxious, focus on women as mothers and on the female body as always potentially fecund (until age makes them unfit) in scientific and popular writing and thought of the time. Variations of Darwin's theory of evolution played a large role in these anxieties about woman's reproductive role; the "stone of Darwinian risk" evoked in Vallejo's 1927 *Against the Professional Secret* (Contra el secreto profesional) (19) is the same stone which is repeated several times in *Trilce* as the stumbling-stone of pregnancy and reproduction, the seeming randomness, animal nature, and capriciousness of evolution as it appears in his 1923 short story "Los caynas."

Jean Franco was one of the first to explore the fact that the poetics of Vallejo's *Trilce* was influenced by positivism and, even more strongly, by evolution theory and social Darwinism. From *Trilce* on, Vallejo would concentrate on the primacy of the earth-bound, evolutionary body (read also: poem) rather than the (God-) created body (or spiritually inspired poem):

> Vallejo sets the silent document of the body as a living text in which (after Haeckel), he saw the history of the species inscribed. For him, arms signal the fact that they have refused to become wings, the feet are columns on which *homo erectus* has raised himself over the rest of nature, his eyes are "fatal pilots," nails are vestigial claws. . . . These are the scriptures on which each life is a gloss. (*César Vallejo* vii)

In accordance with Vallejo's own scientific training and with his emphasis on the scientific discourses of the day, the vocabulary used through much of *Trilce* is mockingly pseudo-scientific, even medical. Roberto González Echevarría has discussed the authoritative nature of scientific discourse in Latin America in the early twentieth century, noting that this "language of knowledge, self-knowledge, and legitimation . . . is the hegemonic model in Latin American narrative until the 1920s" (103).[34] Medical education and law degrees served Latin Americans throughout the nineteenth century as the equivalent of a liberal arts degree, and those possessing such degrees often used them for social and/or political advancement rather than for medical or legal practice (Stepan 42). Vallejo's student career follows this path, and in 1913 while still enrolled in

school in Trujillo he taught botany and anatomy, writing pedagogical verses which explained natural phenomena for his students. In 1913 and 1914 Vallejo received as university prizes Taine's *Twentieth Century Philosophy,* Max Müller's *History of Religion,* and Ernst Haeckel's *The Riddle of the Universe* (Franco, *César Vallejo* 9).[35]

Although, because of his emphasis on evolution theory, the female bodies in Vallejo's poetry are problematized because of their very ability to reproduce, his work separates them from the true maternal body, typified as it often was in Mistral's work by the figure of his own mother. In this case, the maternal is not fleshly, sexualized, and death bound. She is, instead, especially in *Trilce,* absent, but in particularly physical terms: the loss of a real (and by implication spiritual) maternal body is reinscripted in the physical nature of food that cannot be swallowed, whose very incorporation is a *golpe,* or "blow":

> *The food of tables like these, in which a foreign love*
> *is tasted in place of my own love,*
> *the bite of food turns to earth which doesn't offer the*
> MOTHER
> *the hard gulp hits; the sweet,*
> *bile; funeral oil, the coffee.*
>
> (*Obra poética* 150)[36]

Again in T23, the maternal *bizcochos,* or "biscuits," made from the flour of the mother's ground bones ("today until / your pure bones will be flour") become stuck in the throat of the poet:

> *Mother, and now! Now, in what tooth socket*
> *is left behind, in what capillary shoot,*
> *a certain crumb gets stuck in my throat*
> *and doesn't want to pass.*
>
> (*Obra poética* 129)[37]

Earth, ashes, ground bones, funeral oil—the spiritually living nourishment of the maternal is transformed by her death into corpse food, and its presence in the mouth of the poetic persona again blocks and muffles his poetic voice. It is clear in *Trilce* that the loss of the true maternal body is directly related to the modern world's discovery of the inability of the

female body to be anything other than "the silent mouth of the species" (Franco, *César Vallejo* 20). However, this loss is figured and recuperated in this collection's references to the domestic gestures of women and the childhood sense of a provincial plenitude that accompanies them. This sense is presented to us through a stuttering vernacular of laboring women's and peasant's bodies, as in T52:

> *and at the musical lunch,*
> *popped roasted corn, flour with lard,*
> *with lard,*
> *you tease the decubital worker*
> *who today again forgets to say buenos días,*
> *those días of his, buenos with backward b,*
> *which insist on coming out of the poor guy*
> *by the butt of the dentilabial*
> *v which keeps vigil in him.*
>
> (*Obra poética* 247)[38]

As I have been arguing, both Vallejo's and Mistral's Americanist approach is dependent on particular sentimental—in the nineteenth-century sense of the word—strategies, intended to elicit the proper affective responses, such as a certain kind of mestizo and domestic patriotism, bound up with familial love. Both Vallejo's and Mistral's work tends to literalize the common sentimental metaphors of home and mother love: words get stuck in your throat; you choke up; this kind of love is, as Mistral writes, "stuttering, that which stammers" (*balbuciente, el que tartamudea*) (*Ternura* 190). At times, the breakdown in the possibility of language either to evoke the domestic, indigenously connected figure or to bring her into the present renders the poet silent. In her "Gabriela Thinks about Her Absent Mother," Mistral expands lyrically on her growth and education in the natural world of her mother's arms, yet ends with these lines: "In order to believe that you hear me, I have lowered my eyelids and I hurl this morning away from me, thinking that at this hour you have the afternoon over you. To tell you the rest, which breaks apart in words, I am going to remain silent" (*Gabriela piensa* 20).[39]

Vallejo shared with Mistral a modern anxiety about any possible wholeness of poetic language. As we have already seen, *Trilce's* T52, "And

we'll get up when we feel like it," is connected with the impulses back toward a supposedly unmodern, presumably whole childhood space that run throughout this collection and is also connected through its "dentil-abial / v" to the image of the slobbering (sexual) female lips and stuttering speech of T9, as well as the toothless mouth of T56, which has lost its speech. Each time, in fact, that the play on a slip between v and b is intro-duced in Vallejo's poetry it serves to evoke a fragile materiality of language and the maternal, a fragility constantly compromised by a crude, sexual-ized fleshiness itself often coded as female (Ortega suggests that the orthography of the letter v has female sexual connotations for Vallejo [*Trilce*, ed. Ortega 73]). Although Eshleman translates the lines "buenos con b de baldío, / salirle al pobre / por la culata de la v" as "buenos with the b of barrens, / that keep backfiring for the poor guy," his use of the term "backfire" with its mechanical overtones goes against this poem's earlier references to *bohíos,* or "huts," *fragante de boñiga,* or "dung-fragrant," and *b de baldío,* or "backward b," all of which place it firmly in a provincial or even rural setting where work is mainly done by hand. The deliberate crudeness of the original Spanish poem's final image, as the *peón*'s *b* stut-ters out like a kind of verbal fart, instead connects the stuttering language of this collection unmistakably with provincial and primitive bodies as well as with those material, animal aspects of the body coded as female in other *Trilce* poems.[40] In keeping with the vanguard desire to create a new poetic language, it is because the above poem professes to evoke a "baby air which doesn't even know its letters" that its primitive linguistic concerns are the marks of, and form the unmistakable setting for, this entire collec-tion's connections both to European experimentations in typographical and syntactic fragmentation and to Americanist concerns with a new modern poetry.

The Domestication of the Modern

Even if it is recognizably connected with European vanguardism, all mod-ernist work is, as Peter Bürger points out, "not semantically reducible to invariant meanings. . . . The effects of a technique or procedure can vary in historically different contexts" (78). In other words, as a Latin American poet Vallejo's writing, including his representations of women's work, will be structured along differing cultural lines. Although Latin American van-guard movements were often interested in the urban and the machine-

made, these artists' relationship to such modernization was mediated quite differently than that of, say, the Parisian vanguard.

Peruvian intellectuals—such as José Carlos Mariátegui, who was, as Unruh points out, "an active promoter of Peruvian vanguardist activity and a knowledgeable analyst of the international literary vanguards" (5)— were aware of the connections between cultural or creative labor and the socioeconomic conditions under which Latin American artists and intellectuals worked. Many Andean intellectuals working between 1910 and 1930 were what Mariátegui termed "situated intellectuals": alive to the newnesses and contradictions of Latin American modernization and modernity, at the same time they were often born in the provinces and still linked to country life. This link with provincial life and work meant in turn that such men had a tendency to look toward the "coherence of quotidian and domestic life, and to recuperate the practice of daily chores" (Cerna-Bazán 52).

The "coherence of domestic life" was of course, for the most part, women's domain.[41] Although middle-class women were moving out into the workforce and the public eye, still the time's dominant notion of a respectable woman's place was in the private sphere of the home. In the August 1913 dedication to his book of short stories, *The Enchanted Village* (La aldea encantada), Abraham Valdelomar (with whom, by 1918, Vallejo was very close; Valdelomar had promised to write the introduction to *The Black Heralds*) contrasts the figure of his mother, back in the Peruvian *aldea* (small provincial town) and the modern, urban women he has seen on his travels in Europe: at home in Peru at the family table, "Mama always remembered her absent son," and on Saturday nights "on the dining room table our mother ironed, with her own hands, the napkins which we would use during the week"; but meanwhile in Europe, Valdelomar exclaims, "I've seen—oh paradox!—strange things—Really ugly women, called suffragists, who don't ask their men about the vote for marriage, or the political vote" (16, 22).[42] The contrast between the good mother at home and the ugly (and often presumably sterile) woman who refuses to follow the lead of men resonates with equally anxious contemporary concerns in the United States and Europe about the changing status of women.

The way in which Vallejo, coming from a town of about fourteen thousand (Santiago de Chuco) to a small colonial city (Trujillo) and then

to a larger but still comparatively provincial city (Lima), would have imagined women poetically is inflected by a strict patriarchal and largely provincial attitude toward women as well as by the gendered naturalness of various kinds of women's manual labor. This economy, still for the most part more dependent on manual labor both within and without domestic spaces than on machine-driven technologies, gave Vallejo the opportunity to couch concerns about the modern in terms of the female and the indigenous; therefore, as Franco puts it, "there would be no Futurist celebration of the machine" in Vallejo's modernist poetry (*César Vallejo* 1). Instead, poetic creativity in *Trilce* is bound up with continuous references to women's work—cooking, cleaning, sewing, washing. This gives us female presences which form a (sometimes almost invisible) backdrop, an absent presence, to the labors of the poet, as in the ending of T35:

> Woman who without thinking about anything more,
> magpie-chattering gets to talking with us
> her tender words
> like piercing lettuces recently cut.
> Another glass, and I'm off. And we go,
> right now, to work.
> Meanwhile, she retires
> behind the curtains and oh! needle of my
> ragged days! she seats herself at the
> side of a seam, to sew my side
> to her side,
> to put back the button of that shirt
> that keeps falling off.
>
> (*Obra poética* 175)[43]

Here, the woman's "magpie-chattering" (the second line refers to the phrase *soltar el mirlo,* which means literally to "let the blackbird loose" or to "jabber") and domestic sewing task frame the (poetic) *trabajo,* or "work," of the male speaker; simultaneously, the chatter of women's speech and domestic air of women's labor points to the essentially domestic and unintellectual character of women's activities, activities which then serve as both comforting background and frame for men's work.[44]

Poetry and Women's Work

The way in which Vallejo moves from the highly stylized language and imagery of his indigenist modernismo to the punning, "stuttering and disarticulations" of *Trilce's* more modernist language has much to do with what Ortega calls Vallejo's "poetics of strikeouts," much like the strikeouts of a typed manuscript: "On the one side, we have the fracturing of referents, whose traces oftentimes we can't follow. . . . The other strikeout, the one we don't see, is the same process of revision" (*Trilce*, ed. Ortega 13–14).[45] The strikeouts to which Ortega refers, then, function as superimpositions. That is, many of the poems from *Trilce* are written over earlier work, so that *Trilce* at certain points resembles a palimpsest where language, images, and tone seep up or bleed through from past work into the present text.

More interesting, however, than the seeping-through of fragments of images and language from one collection to the other are the more deeply embedded assumptions borne along by means of those images; in turn, those assumptions have been produced by and in the service of particular discourses. The discourse of indigenism has an object—the Indian—which is largely an imagined one; however, the imagined Indian of indigenism is made up from (filtered) observations of indigenous peoples, often firsthand and intimate observations. It is the intimacy of Vallejo's (poetic) looking and, given his own cultural and familial background, his personally and domestically entangled looking at indigenous women and mestizas which serve as (always anxious) attempts at trying to work through an argument with modernity. This literal embodiment of women's work, so important in Vallejo's writing, refers us back to "The suit I wore tomorrow":

> *The suit I wore tomorrow*
> *my laundress hasn't washed it:*
> *she used to wash it in her Otilian veins,*
> *in the stream of her heart . . .*
> *Now that there's no one to go to the waters,*
> *in my guide-sheet she quills*
> *the (writing-) cloth for feathering. . . .*
> *And if I knew that she'd come back;*
> *And if I knew what morning she'll come in*

to hand me my clean clothes, that
soul-laundress of mine. What morning she'll come in
satisfied, dark berry-worker, proud
to prove that sure she knows, that sure she can
HOW COULD SHE NOT!
bleach and iron every chaos.

(*Obra poética* 63)[46]

At first glance, this poem seems to have little to do with the more indigenist concerns with weaving, knotting, and women in T26 and T66. However, "Imperial Nostalgias" begins Vallejo's tendency to make the female body one with its work; this continues in the conflation of Vallejo's real-life lover, Otilia, with her presumed duties as a laundress. The poetic persona's "dirty suit of injustice" used to be washed clean "in her otilian veins, / in the stream of her heart"; she is imagined as his "dark berry-worker," suggesting, as Clayton Eshleman has put it, that "Otilia is the fruit of her own labor" (Afterword 215). This phrase accomplishes *Trilce's* emphasis on women's manual labor further by collapsing into one female body the work of different classes of women: Otilia, in real life a middle-class woman of urban Lima, would not go "to the waters" to wash her clothes; this image conjures up instead the figure of the poor mestiza or the indigenous woman who goes to the site of public or small-town washing—a river or a public water and/or washing area—with the quite different figure, site, and work than the middle-class woman. In fact, census figures for Lima in 1908 show that for the *lavandera*, or "laundress," whose work was considered a profession outside the home, by far the majority of women working as laundresses were mestizas and *indias* combined (35 percent); by contrast, *blancas* (whites) were at 1.1 percent. If the overwhelming majority of women doing laundry work were indigenous or mixed, the ways in which Vallejo imagines an "otilian" laundress as herself a *trigueña* (wheat-colored woman) makes cultural, if not racial or social, sense (Miller, Roberts, et al. 36).[47]

The references to race, under cover of such terms as *capulí* (a yellowish berry), by implication connect the lover of T6 with those other more simple or primitive female laboring figures of "Imperial Nostalgias" by playing both on labor and on skin color. The implication of mixed race in poetic references to trigueña (swarthy, dark, wheat-colored) and capulí (the

color capulí can have a meaning similar to *moreno,* or "dark or brunette") places Otilia closer on the racial scale to the indigenous woman than to the blanca of the Creole woman while it bundles her together with references in *Black Heralds* both to *trigo* (wheat), which is metaphorically connected to women's flesh in at least three poems, and to the *rudo* (simple) agricultural life embodied in such images as the indigenous "Ruth" who offers us a "spike of wheat / beneath the Hebraic unction of the wheatfields."[48]

The general associative connections of women's weaving with the domestic nature of women's work also make connections between a poem such as "Dead Idyll," where the "andean Rita" irons in "contrite attitude," the "humility of heroic and sad wool," and T6's lover, who is fantasized as a laundress. Added to these humble, gendered, textile domestic attempts to put things right is the act or gesture of sewing and suturing, which attempts to hold together a ragged fabric/text/body. The poem T60, "My patience is of wood," further glosses the paradoxes inherent in the poetic use of such gestures. As does T26, the poem beginning "My patience" posits a female body which, though it brings the speaker into the world, also ultimately exiles the speaker from a childhood (originary, simple, and in this way primitive) imagination of maternal wholeness; at the same time, the female body and its domestic gestures engender but also suture and exile the poetic body to, or into, the merely material world of physical flesh and muffled poetic speech. The loss of wholeness already presaged by the maternal body's unknotting in T26 is here similarly denoted by the lines "you part and leave me . . . without your knot of dreams, Sunday." This departure of the whole and solid body-knot (of the "sacred" day, Sunday) leaves, poetically speaking, nothing but a "Saturday / of rags" behind, with nothing to hold it together but "this horrible suture / of pleasure which engenders us without love, / and the pleasure which exiles us."[49] The feminine suturing together of an always-ripped bodily experience, itself paralleled by and manifested through the constant comings-apart of the work's language, appears as a motif of sewing in *Trilce.*

In keeping with the constant associative connections and tensions between women's productive and reproductive properties, in Vallejo's work anxiety about and desire for the lover's body is not far separated from that for/about the maternal body. Scenes of picturesque and provincial melancholy are transformed in particular and important ways, in poems of provincial, familial life scattered through *Trilce:* in T28, for example, "I've eaten

alone now, and I haven't had / MOTHER," where because of the death of
the mother the kitchen is "darkened"; in T65, where the speaker desires to
return to the family home, "Mother, tomorrow I'm going to Santiago / to
soak myself in your benediction and in your crying"; and again in T61,

> Tonight I descend from my horse,
> in front of the doors of the house, where
> I bade goodbye at the rooster's crow.
> It's closed and nobody responds.
>
> (Obra poética 285–286)[50]

There are, however, a few poems in *Black Heralds* in which it is clear
that Vallejo's attempts to work through the problematic nature of the
middle classes' changing, modernizing, scientific, and more secular atti-
tude toward the two sacred kinds of communication—religious and
poetic—have begun to find the outlet he will pursue in *Trilce's* poems. The
distance, both in temporal as well as cultural terms of the stilted language
and forced imagery of "Imperial Nostalgias" is closed considerably by pro-
jecting onto such pastoral and small-town scenes—with which he was
familiar in poets like Herrera y Reissig and Santos Chocano—a closer and
literally more familiar (for Vallejo) poetic stance of the persona himself as
provincial boy, T61's "small-town kid."

Black Heralds' last section, entitled "Songs of Home," approaches the
intimacy of subject matter and the ease of a more vernacular language in
Trilce and is mostly couched in free verse. Although the first poem in this
section, "Fever Lace," keeps the modernista emphasis on the sonnet
form, the subject matter explicitly names and then eschews certain stock
images of modernista exoticism: it is a decidedly nonexotic *mosca*, or "fly,"
which tells "some kind of fatal legend" (*no sé qué leyenda fatal*) while "an
Orient illusion" flees the scene and a blue nest of larks die as they're born
(*Obra poética* 108). Vallejo is deliberately signaling his rejection of the
Orientalisms, bluenesses, and drama of those second-rate modernista
poets whom Mistral would also reject. The background of the poem con-
sists of nothing more exotic than the saints' pictures on the wall and the
tired, old furniture of the persona's parents' house. Watching his parents,
the persona senses "a something which doesn't want to share," the "pill
which is Host made of Science," and the "Host, pill made of Providence."

Although, in the poem, the son of these parents—the persona—attempts to convince himself that "Providence" comes before "Ciencia," in the temporal now of the poem itself they already exist together in a modernist unevenness, one signaled by the fact that the modern pill of science and the traditional host of providence linguistically overlap in the one word *oblea* (*Obra poética* 108).

The anxiety produced by this faint but troubling *algo,* or certain "something," of the final poems in *Black Heralds* is allayed for the "small-town kid" of T61, as in other poems, by the gestures of women's domestic labor, carried forward into *Trilce* by the associative connections found in "Imperial Nostalgias" between the shepherdess, Indian grandfather, *la señora,* and the provincial life of the family home, as in T52, "And we'll get up when we feel like it":

> *The smoke from the huts—oh! raw*
> *young ragamuffins!*
> *would get up early to play*
> *at bluish kites, bluing,*
> *and, crowding crossbeams and stones,*
> *would give us*
> *the dung-fragrant stimulus,*
> *to get us out*
> *into the baby-air which doesn't even know its letters yet,*
> *to kite-fight with the strings.*
>
> (*Obra poética* 246)[51]

Traces of Indianist modernista language still persist, for example, in the poem's references to *humo,* or "smoke," to (here, rural) fragrances, to the soaring blueness both of the smoke itself and by association of the kites against the sky. However, the poetic function (to evoke a set piece or scene of rural nostalgia) of the references to the manual work of women in "Imperial Nostalgias"—spinning, sheepherding, gathering wood, shearing wool, working and/or gleaning in the fields—is displaced in a poem such as T52 onto domestic but still manual and provincial labor: *la anciana,* or "old woman," cleaning out the chamber pots, the maternal figure waking the children and making the country lunch, a musical lunch evoking the kitchen clatter of labor-intensive country food. The primitive or simple

mood of the penultimate stanza further conflates the laboring maternal figure with that of the laboring indigenous figures:

Another day you'll want to pasture
in your omphaloid hollows
avid caverns,
ninth months,
my stage curtains.
Or you'll want to accompany old woman-age
to uncover the top of a twilight,
so that by day surges
all the water passed at night.

(*Obra poética* 246)[52]

Echoes from "Imperial Nostalgias" recall both the "shepherdess" and "the pensive old woman," spinning her own old age. All of these images are implicitly contained, or pastured, in the maternal space of "your omphaloid hollows," where "omphaloid" recalls the navel, archetypal sign of the maternal connection. In keeping with Vallejo's propensity in *Trilce* to make one word work in several different though related directions, this word also performs more than one associative function: it serves to call attention to the knot, repeated elsewhere, which is literally at the center of every human body, while it also recalls a neoclassical reference to Omphale, queen of Lydia, in whose service Hercules, dressed as a woman, spun wool and performed other supposedly womanly tasks for three years to appease the gods. This poetic cross-dressing in (pseudo) indigenous garb resonates with Huyssen's observation that in Europe the second half of the nineteenth century saw the "obsessively argued inferiority of woman as artist" (50); Latin American artistic notions of the essential masculinity of creativity share the same assumptions about women's artistic inferiority and the supposed naturalness of their labor. While "lover and mother" might be the absent but still primitive and original source of creativity, the poetic product is in fact the (male) poet's own.

It is clear that Vallejo sees his work in *Trilce* as sharing qualities with its (linguistic) cousin, the textile. Again, this is by no means a new idea; what interests me is a reading in which the textile nature of Vallejo's modernist writing is connected back up with its specifically Andean, indigenist,

subtext of communication by weaving and knotting. Assuming the associations I have been making among a modern sense of mestizaje, indigenist thought, and women's domestic and reproductive labor, the poetry of both Vallejo and Mistral is a specifically modern exploration of the limits of communicative gestures to solve the apparent contradictions and inequalities of the modernizing state. Couched in a practice which uses women's bodies, gestures, and ethnicity as original creative sources, the always-failing gesture toward a coherence of poetic language uses the simplicity or primitiveness of specific kinds of women's work to do three things simultaneously: to drive, to hold together, and, at the same time, to hinder or hold back the possible success of such a gesture. That is, these poets' speakers often depend on the absence and/or futility of domestic labor and maternal bodies as, paradoxically, something around which the poem can build. Their poetic concerns about coherency mean that despite the differences between Vallejo's *Trilce* and Mistral's *Tenderness, Felling,* and *Winepress,* the language of all these collections attempts to work as a kind of sewing machine whose modernist strategies derive from what Vallejo terms women's "pancreatic," domestic, physical labor, a labor that seems to arise naturally out of a woman's own internal, bodily workings.

Despite the sometimes enormous differences in tone between Vallejo's poetry and that of Mistral's (particularly where it comes to women who are not mothers), it is one of the central aspects of their work that Vallejo's and Mistral's seemingly anachronistic gestures, ever-present as they are, toward a provincial, peasant, and domestic poetics of labor and the female body generate a modernist poetry. Although Jean Franco identifies "the" theme of *Trilce* as "the dislodging of the 'I' from the home," and it is true that poems such as these are clearly nostalgic for a (vanished) childhood time enclosed by the maternal walls of the house, the speaking subject is never totally dislodged from this space ("La temática" 582). The breakdown in Vallejo's and Mistral's poetic languages is on one level a literalization of grief-stricken speech. But the weight of the modern Latin American emphasis on raza, and the inevitable connections of that concept with the figure of the mother in founding legends of indigenous mothers and Spanish fathers, cannot be set aside in these readings. Even outside the maternal domicile, the poetic voices of both these poets consistently position themselves, of necessity, as coming out of a setting of women's manual labor. In these poems, the primitive and originary nature

of women's laboring bodies is at once opposed to and implicated in anxieties over the increased rationalization and urbanization of modern life. Such a mother—connected to the land, to the region, to the premodern, and to the timelessness of provincial towns and indigenous peoples—as had been produced by that specific moment in time is, as both poets must acknowledge, the source for the new modernist language of, as Mistral put it, "racial violence"; but as both poets also know, the source, given who she is, is the temporal opposite of such a new language—and as such can never hear or even speak it. Whether this is literally true or not, it is the tension between these apparently distant poles of effort which effects, and is in turn affected by, the failings of an older sentimental discourse and the beginnings of a modernist poetry.

BROTHER MEN

Pain grasps at us, brother men,
from behind, from the side,
and drives us crazy in the cinemas
nails us in the gramophones.

—CÉSAR VALLEJO, *CÉSAR VALLEJO: THE COMPLETE*
POSTHUMOUS POETRY

You suffer, you endure and you suffer again horribly,
unfortunate monkey,
Darwin's little man,
bailiff spying on me, most atrocious microbe . . .
Poor monkey! . . . Give me your paw! . . . No. The hand, I meant.
To your health! Keep suffering!

—CÉSAR VALLEJO, *CÉSAR VALLEJO: THE COMPLETE*
POSTHUMOUS POETRY

I N THE LAST CHAPTER we saw how, as many twentieth-century Latin American nations moved into the 1910s and 1920s, older sentimental discourses still informed the newly developing lexicons of archeology, anthropology, folklore studies, eugenics, and even evolutionary theories. What is specific to my study is that all these lexicons shared at one time or another a constellation of ideas about the advantages and disadvantages of mestizje, or race mixing. By the 1920s, it had become evident to many of the intellectuals and artists of these countries that the times called for a refashioning of racial and cultural identities. This chapter will examine

how, in response to this call, both Diego Rivera and César Vallejo fash-
ioned themselves and their art in particular classed and raced ways. Alan
Knight points out that because Mexican mainstream indigenism after the
Revolution was not the result of direct Indian pressure—as opposed to
agrarian reform, which often was—Mexican indigenism "came more easily
to Mexican elites than, say, to Andean elites, for whom the threat of caste
war and reversion to barbarism seemed truly present" (77). Nevertheless,
despite the obvious and numerous differences in their personal and polit-
ical histories, both Rivera and Vallejo held indigenism, in its broadest out-
lines, as a founding concept in their respective artistic careers, and a sense
of mestizaje was also important to both. Too, Vallejo's and Rivera's careers
followed some similar artistic and political trajectories: an artistic educa-
tion (a formal one in the case of Rivera) in European models and avant-
garde movements; an increasing dedication to communism, including for
both a 1927–1928 visit to the Soviet Union. To further underscore the
rather broad similarities between the two, both men's expatriate experi-
ences and their increasing involvement in Latin American leftist move-
ments would lead them to reflect, in their art, on the contradictions and
paradoxes embodied in a modernizing and progressivist indigenist and
mestizo nationalism.

For both men, a central problem would be how to figure the historical
process—a problem which became increasingly more urgent as both Rivera
and Vallejo became more committed to the communist cause. Vallejo's
poetry and prose struggle between a materialist, human-constructed history
and a progressivist, evolutionary timeline which insists that humans cannot
escape their evolutionary and hence racial fates. In his notebooks, Vallejo
summed up his own dilemma: "Before the stones of Darwinian risk of
which the palaces of Tuileries, Potsdam, Quirinal, the White House and
Buckingham are constructed, I suffer the pain of a megatherium that med-
itates motionless, hind legs on Hegel's head and front legs on Marx's head"
(qtd. in von Buelow, "Stones" 18). The megatherium, dug up by Darwin
himself at Punta Alta on the *Beagle* voyage, is already a casualty of natural
history and evolution, caught between Hegel's philosophy of necessity
and Marx's philosophy of social change. Inevitably, then, the human being
is an "unfortunate monkey, Darwin's little man . . . most atrocious
microbe," the person whose soul "suffers from being its body," in the 1937
poem of the same name (*Posthumous Poetry* 186); but also, inevitably, such

"unfortunate little monkeys" would participate, willy-nilly, in the coming social revolutions.

Precisely because modernity equated a contemporary social distance from the Indian with a sense of a temporal distance, the Mexican nationalist urge toward imagining a progressivist temporal sequence for a modern and unified future nation, whether state- or communist-inspired, came up against two problems: First, the traditional or folk cultural (and racial) space was conceived as being literally outside the modern social space and therefore out of time. Second, the more actual problem, indigenous peoples (in Peru, as well) in fact represented a potentially real and physical resistance to various state or socialist projects of modernization or assimilation. Nineteenth-century sentimental language and its appeal to emotion provided a much safer storehouse of images and connotations because it was the language of reform rather than revolution; the post-armed phase of the Mexican Revolution, for example, was not so much revolutionary as reformist in its desire to gather in (and render useful to the state) the fighting masses of Indians, mestizos, and peasants left adrift by the cessation of hostilities.

For both men, then, the process of imagining national or socialist unification would have to start with imagining a modern, masculine self. On his return to Mexico from Paris, Rivera, who was rotund and dark skinned, reconstructed himself quite successfully as a "man of the people," if not actually a peasant. In a literal sense, this was a refashioning; although he had begun to espouse revolutionary politics before leaving Paris, once in Mexico, he began dressing (at least for public consumption) in worker's clothes and peasant hat, a look quite different than his appearance in earlier European photographs. His self-portraits, especially those in his murals, also began to play up the fact of his "workingman" status. By the decade of the 1930s, when he began to spend more time in the United States, this persona was firmly in place—as in his 1931 San Francisco *The Making of a Fresco, Showing the Building of a City*. A representation of the artist's scaffolding forms a *trompe l'oeil* framework, superimposed on the presumed subject of the fresco itself, which shows a cityscape being molded literally out of the body and tools of a giant factory worker. Again superimposed over this growing cityscape are portraits of Rivera's helpers, and of architects and designers who worked on the project, sitting and standing on the scaffold, working and painting the fresco. The piece itself

shows, as its title indicates, the various forms of labor involved in building a city, with the squares of the trompe l'oeil "scaffolding" providing frames for different kinds of labor, from the painters to the patrons of the mural itself. Such a self-referential piece almost calls for its own creator to make an appearance, and sure enough Rivera painted himself sitting on the scaffolding, center fresco, his back to the viewer, his ample behind sagging slightly over the boards. The representation of fresco-painting as itself a labor, and the representation of the actual making of the fresco as an extension of the city construction work site—itself an extension of the central body of the worker—situates Rivera as one more worker, or better still, laborer, on the scene.

Looking at these murals, and at the way Rivera presented himself to his public, we can see that in a very real sense Rivera was in the process, as would be Vallejo, of reimagining what a public, male body should look like and what emotions it should evoke. Rivera and Vallejo increasingly represented in their own personas and in their work a mestizo, male worker-body. For Mexican audiences, this laborer was if not explicitly then implicitly mestizo, a racial and cultural mixture of Hispanic and Indian; but as Rivera began to be embraced on the northern side of the Mexico–United States border, he increasingly stated a desire to find a way to connect what he saw as southern agricultural energies (from Mexico) onto the northern industrial machine (in the United States). This meant that Rivera was searching for a way to artistically represent a hybridity not just of races within Mexico, but of his (and other's) conception of North and South, of traditional manual labor and modern machine energy. Artists in this period—particularly social realist artists—were struggling with ways to show, in formal terms, what seemed to them to be the necessary coupling of man and machine. If, within this relatively new industrial sensibility, laborer's bodies needed to be conceptualized as connecting with the technologies of industry, the organic metaphor of the graft, and of the hybrid, might do something of the same work for which Rivera had employed such visual metaphors in other Mexican murals. In other words, especially in the context of his United States murals, Rivera would take the conceptual framework of mestizaje—whose underlying concept included the idea of the graft and the hybrid—and use it, with more or less successful results, to represent a mixture of male, laboring body and industrial technology.

Vallejo's career as a poet and as a journalist was in no way as public as

was Rivera's. In his murals, Rivera had to answer to the requirements of the Mexican government, the Mexican Communist Party, and, later, United States capitalists like Henry Ford and Nelson Rockefeller, not to mention conservative attacks from the press and the public. However, like Rivera, by the late 1920s Vallejo certainly thought of his work as public. He sought to have his poetry published (albeit unsuccessfully) and articulated a socialist sense of the artist's political responsibility in the plays, novels, criticism, and journalism which he did publish. In Paris, Vallejo's self-fashioning as an increasingly socially committed writer came not so much via his own style and looks (although, as I have pointed out in my introduction, he was clearly aware of the indigenous drama of his own looks). Rather, it was effected through the construction of a poet-persona which was explicitly conceived as connected not only to socialist intellectuals both in Europe and in Latin America, but, at least in spirit, to the laborers of Paris as well as the laborers—both miners and peasants—of the Andean highlands. Vallejo's was a *cholo*, or "mixed-race," persona whose Indian heritage—much like that of Rivera's and Kahlo's—was increasingly foregrounded and on whose body, like that of Rivera's persona, the marks of industrial labor would also be foregrounded.

As with Rivera, the male, urban laborer was important to Vallejo. And again like Rivera, Vallejo presented his own persona as a (Peruvian) worker who identified with the common laborer; but for him this identification would come via their shared poverty and their "anthropoidal affiliation," their all too material and fallible human—or perhaps we should say *primate*—body. For all his poetic connection with the masculine body of the worker, however, Vallejo, unlike Rivera, foregrounded his Indian side mainly through an appeal to the maternal, indigenous origins of his Peruvianness. Living in Paris, Vallejo was careful not to seem merely a tourist of the indigenous—as, in reality, so many indigenista artists were at that time—but rather an organic, native inhabitant of Peru, in spite of (or perhaps because of) his material and social distance from the Peruvian soil.

Finally, an important difference in these two men's sense of self as both mestizo and modern was the fact of Vallejo's more suspicious and more conservative stance toward the actual technologies, machines, and industries of modernity. That is, although both men heralded and celebrated the laborer as the vanguard of the coming socialist utopia, their take on the celebration of technology—especially of aspects of the second

industrial revolution, such as mass production and automobiles—was quite different and had to do at least in part with their differing perceptions of the coming dangers of Fascism. In the view of many, the dangers of Fascism were already being announced by the Futurist obsession with the technologies and machineries of war. But Rivera could afford to celebrate, conceivably too uncritically, the possibilities of mechanization and industry for a mestizo future, supported as he was in these ideals first by the Mexican government and the Mexican Communist Party, then later by his increasing popularity in the United States as a socialist goad to the powerful capitalist interests of the time. For Vallejo, there was no such support, and what we will see as his customary conservatism comes through very clearly on the subject of mechanization. In his 1925 editorial "The Modern Man" (El hombre moderno), for example, Vallejo wrote of the modern zest for fast machines: "They say that our time is characterized by horse power. . . . Velocity is the sign of the modern man. Nobody can call himself modern without showing himself to be fast" (*Desde europa* 77).[1] Characteristically, however, Vallejo first puts the general viewpoint and then his own, which is to turn the idea on its head. In the same essay, *his* idea of what makes a man modern is the "maximum perspicacity" for the "perception . . . of the phenomena of nature and the unconscious, in the least amount of time possible." Vallejo finishes the piece by summoning up the image of two people contemplating a great canvas: "the person who thrills to it first, he is the most modern" (77–78).[2]

If, rather than possessing a machine with lots of horsepower, being modern meant, for Vallejo, thrilling to an artwork with the "maximum perspicacity," then Rivera's take on being modern seems quite the opposite. In 1927, two years after Vallejo's critical analysis of the idea that the modern age was "characterized by horsepower," Rivera was commissioned to design the sets and costumes for a ballet called *H.P.*, or *Horse Power* (Helms 66). In a drawing from the designs for costumes, Rivera pictures the front and back of a figure simply designated *el hombre* (the man); it clearly evokes the figures of ballplayers depicted in pre-Columbian Aztec carvings and drawings, a game which, for the Aztecs, was "reserved for men and gods" (fig. 3.1; Miller and Taube 43). Rivera takes this figure— bare chested and dressed only in the brief shorts and knee- and arm-padding used by Aztec players—and adds goggles affixed to a helmet; one hand is upraised, and the other is holding a device which resembles a small

FIG. 3.1. Diego Rivera's drawing of a costume for the 1927 ballet
H.P. (*Horsepower*), titled *The Man* (El hombre). Museum of Modern Art, New York.
Gift of Abby Aldrich Rockefeller (00505.41.4). Digital image © The Museum of Modern Art.
Licensed by SCALA/Art Resource, New York.

Tesla coil, or possibly an electric generator. On the back of the figure are stenciled the letters "H.P." (Helms 68). The colors are simple—red, black, yellow, and blue—and Rivera has drawn the figure in much the same formal, frontal, two-dimensional way it might have been drawn by an Aztec artist. The theme of *H.P.* was "the interdependence of the industrial North and the agrarian South" (Helms 66), and Rivera's design nicely illustrates his increasing (though uneven) commitment to the Mexican Communist Party's idea that the industrialization of Mexico—its commitment to horse power, so to speak—would herald a specifically American socialist future, an idea which would shortly lead to the seemingly paradoxical connections between the openly socialist Rivera and some of the most powerful capitalists of the United States.

For Vallejo, on the other hand, modernity seemed to bring with it as many problems as it promised to solve. Such problems included what

appeared to be issues as diverse as technology's dominion over modern man or modern women's desire to cut their hair short. All these apparently unconnected problems, according to Vallejo, came from one deeply misguided impulse: to celebrate all that seemed modern and progressive as good *in itself*—"these miserable Futurists these days also praise progress unconditionally, whatever its employment in each case" (*Desde europa* 79).[3] We can surmise that Vallejo's more conservative stance resulted in, or was perhaps even prompted by, the differences in his socialist connections compared with those of Rivera—Vallejo's was a socialism connected to José Mariátegui, one which was more concerned with bringing the contemporary economy of Peru into line with indigenous economic and cultural elements than, in the case of Rivera, with "mestizo-izing" the Indians to bring them into line with economic progression toward the socialist future. In Mexico, Futurist practices might have seemed more artistic than political; *estridentismo* (Stridentists, the name for Mexican Futurist-inspired artists), for example, would be overshadowed by the publication between 1928 and 1931 of the vanguard journal *Contemporáneos,* to which Rivera himself would contribute (Schwartz 15–18). In Europe, the more directly looming threat of Fascism (the Fascist Party was first organized in 1919; Mussolini came to power in 1924) might have been more clearly connected, by socialists such as Vallejo, to uncritical celebrations of the machine.

In 1926, Vallejo described for his readers back in Peru a case in which a driverless automobile went out of control ("proclaiming itself independent of man," he said), killing a French World War I hero (the irony was not lost on Vallejo); he maintained that it was the tendency to give themselves over entirely to progress in the form of modern technology that threatened modern people with such runaway monsters:

> What will man be able to do to reassert his dominion over these monsters [of technology] he's pulled out of nothing? What will he be able to do in this regard, this humble creature, whose anthropoidal affiliation keeps demonstrating itself, day by day, if not the descendent of the monkey at least its ancestor? Winay Darwin has said the other day: "Man is not descended from the monkey, like my father said, but on the contrary the most probable thing is that he will tend to become a monkey in a more or less near future. . . ." M.

Kutzigg Wearn, well-known scientist of Vienna . . . is experimenting
now with the crossing of the human species with the anthropoidal
species. (*Desde europa* 80)[4]

This remarkable segue, from automobiles to anthropoids, ends with
the idea that crossbreeding between humans and primates proves that the
"organic equation" of the monkey will, in fact, dominate (80). It is an idea
which recapitulates Vallejo's short story "Los caynas," published in Peru in
1924, wherein a young man goes back to his remote sierran village after a
long trip only to find that all the people of the village, including his family,
have become monkeys; in turn, they believe him mad because he thinks he
is a man. Vallejo clearly, though ironically, accepted the precepts of evolu-
tionary thinking—it is the young man, not the villagers, who is mocked at
the end of the story for thinking himself human. Putting aside the autobi-
ographical aspects of the story for a moment, the fact that such an event is
set in a small sierran (and almost by definition Indian) town is telling, given
the Latin American eugenicist discourses of the day, which often charac-
terized Indians as closer, both racially and mentally, to animals.

Vallejo could not have but noticed the anomaly of his position: he
accepted an evolutionist stance, which for many equated presumably less
advanced cultures—such as Indian cultures—with less biologically
advanced humans, although he himself was clearly of Indian heritage, born
and raised in the Indian sierras of Peru. There were ways around this prob-
lem: Peruvian intellectuals—indeed, just about any Latin American who,
with the proper education and/or social status, could name themselves
gente decente, or "decent people"—could in fact "dissolve, or at least limit,
the fact of their skin color"; to this extent, many Latin American intellectu-
als who were in fact mestizo were not necessarily forced to "self-identify as
mestizos nor were they seen as such by their class peers" (de la Cadena 25).
In fact, for some, such as the regionalist *cuzqueño* Valcárcel and the social-
ist Mariátegui, the term "mestizo" meant cultural rather than racial hybrid-
ity, meant not a mixed-race and Westernized individual but the racially pure
Indian who had abandoned his or her proper cultural-geographical place to
migrate to the cities (de la Cadena 24).[5] Had Vallejo stayed in Lima, he
might eventually have been able to displace an older, more biological idea
of mestizaje inherited from sentimental indigenism onto this newer, more
anthropological, cultural one, dissolving his own cholo (with an emphasis on

the indigenous) status. But in Paris, his racialized perception of his own foreignness, his deepening sense of the irony of his own "being human" in the face of evolution and eugenics theories, and his attention to the masculine body indicate that for someone who *was* so obviously (biologically) mestizo, with a face which seemed to advertise the indigenous side of the equation, facing modern thinking about race and culture signaled the inevitability of a confrontation with his own provincial and mixed-race origins.

These origins, as I have been discussing, were first given imaginative form through the evocation of Vallejo's maternal connections to small-town, Indianized life. But as he became more and more responsive to the socialist and socialist-inspired movements in Europe and in Latin America, Vallejo began to displace the oftentimes racialized trope of female labor that he had earlier found so useful onto masculine labor, especially the urban worker. Rivera, coming back from Paris to Mexico at almost the same time as Vallejo left Peru for Paris, had already rejected abstraction in a gradual move toward a politically committed realist art; this art, too, also privileged the labor of the male urban worker. Thus, both men responded to their own growing sense of a specifically racialized national identity by de-emphasizing their actual class status and projecting instead an adopted class status of worker, a status which would be conflated, both explicitly and implicitly, with their own mestizo heritage.

The Usable Past

Whether conservative or radical, state-sponsored or individual, the organizing assumptions of much nationalist rhetoric—its insistence on a progressivist temporal sense which privileged the future while constructing a usable past—would come up time and again against what can only be called a perceptual, and hence representational, problem. If mestizaje or its related set of discourses, indigenism, constituted ways "of imagining the nation through a future history," this "future history" would have to derive its "irresistible power from *feeling* natural" (Sommer 39). Such a future history, as Renato Rosaldo notes, "employ[ed] the distinction between the modern and the traditional more as an organizing assumption than as a topic for investigation" (Foreword xv). What is naturalized, then, in the use of this dichotomy as an organizing assumption, is the feeling that "the present contains distinct historical epochs called traditional and modern . . . [a feeling which] tacitly equates social with temporal distance" (Rosaldo xvi).

Such a sensibility was already being shaped in part from the ubiqui-
tous images of popular science, especially biology, evolution theory, eugen-
ics, and anthropology. The metaphors and images used in particular by
popularizers of scientific discoveries helped both to shape the scientific
discourse itself and to configure the ways in which laypeople thought not
only about biology or evolution, but about societies and history. For exam-
ple, Ernst Haeckel introduced the analogy of the family tree into discus-
sions of phylogenesis and evolutionary discourse, probably borrowing
(possibly unconsciously) the image of the tree from two sources: from Bib-
lical genealogical family trees and from anthropology's own ethnographical
illustrations of kinship pedigrees (Bouquet 47). If one already views natu-
ral history as laboring progressively toward a higher or at least more
refined goal, the use of the tree to map out such a schema seems to make
sense. The radically changed notion of time that the biological sciences
brought with them was transferred to a seemingly natural schema of above
and below; this in turn would inevitably be transferred over (at least in the
public mind, if not the scientific one) to the idea that a historical timescale
follows an evolutionary logic which itself begins at the bottom, or in the
earth, and rises up toward the heavens, growing toward diversity and
enlightenment. Thus, the accompanying scientific discourse on race
accepted wholesale such assumptions; darker-skinned races such as Indi-
ans obviously belonged at the bottom of the evolutionary ladder, as evi-
denced by their seemingly natural relationship to the earth.

These assumptions could take one of two or three different paths, two
of which led almost inevitably to a call for physical and/or cultural assimila-
tion of darker races. As we have seen, in the case of sentimental indigenist
writing, the moral depredations and physical deprivations that Indians suf-
fered under the remnants of Spanish colonial rule could be scientifically
analyzed to explain the Indians' inability to move forward into modern
times. As early as the 1890s, scientific language had served as one of the
legitimizing vocabularies for the sentimental race novel. In Matto de
Turner's *Torn from the Nest,* for example, Doña Lucia and her husband,
Don Fernando, speak of the ways the "gentry" of Peru "have reduced the
Indian to the level of farm animal":

"There's more to it than that, dear," said Don Fernando. "It's been
proved that the diet of the Indians has enfeebled the functioning of

their brains. . . . These impoverished people hardly ever eat meat, and the discoveries of modern science prove to us that the activity of the brain is related to the nutrition it receives. The Indian has been condemned to the most absurd kind of vegetarian diet. . . . Deprived of albuminoids and organic salts, his brain has no ready source of phosphates and lecithin. It only grow fat and thus plunges him into mental darkness, making him live on the same level as his mules and oxen." (57–58)

Thus, for intellectuals as well as for state-sponsored indigenist projects and programs of mestizaje, Indians were culturally as well as socially incapable of forward motion on their own; and the prevalence of Lamarckian thought meant that the Indian was also, in a sense, not just culturally but racially stuck, with only one way to go: as Vasconcelos succinctly put it in *The Cosmic Race*, "the Indian has no other door to the future but the door of modern culture, nor any other road but the road already cleared by Latin civilization" (16).

As I have been arguing, the vocabulary with which to evoke the premodern, whether derived from low, mass-culture, or high-culture sources, was ineluctably sentimentalized and—even when people like Mistral specifically inveighed against sensation or melodrama—often melodramatic. However, when artists like Vallejo or Mistral turned, as they must, to these earlier vocabularies of indigenist, nationalist, and abolitionist sentimental genres, they found that under the pressures of modernization, the emotional and temporal certainties that such a lexicon called forth had been dangerously destabilized. The modernist negotiation between the premodern past and the modern present could not be easily carried through, and yet such a negotiation had to be effected with the help of inherited images and lexicons. The problems this created centered on the real impossibility of representing the presumably different (a)temporal universe of the maternal, spiritual, provincial, domestic—and by extension, indigenous/mestizo—within the space of the modern, urban, and scientific present. For these artists, the place where these two could come together always showed, at the same time, the seams and tensions which threatened to pull the two apart.

As we have seen, through the 1920s and 1930s national unity was increasingly conceived as depending on the incorporation and/or assimila-

tion of indigenous peoples; in Mexico, mestizaje was ultimately presented as the national answer to the "deeply horizontal, fraternal dream of a national identity" (Sommer 123).[6] In Peru, from before the turn of the century, national dialogue often centered on the status of its indigenous majority; Peru's disastrous 1880s military defeat by Chile in the War of the Pacific was blamed, for example, on the fact that indigenous Andeans could not be mobilized to fight as "Peruvians" (Pratt 61). The indigenous foregrounding practiced by many Mexican promoters of mestizaje, however, had less of an appeal for elite Peruvians; and instead, especially for those connected with industry, an influx of white European immigrants was thought to provide a desired whitening effect on race-mixing. As we have begun to understand, how to represent the problem of a forward-looking nation's relationship to its disparate populations was a central question also for artists. In literature, the allegory of a romantic, egalitarian alliance—between political parties, across race lines—as proposed by what Sommer calls the "foundational fictions" of the nineteenth century, came to seem inadequate, even suspiciously feminized, as a model for the second and third decades of the twentieth century. In fact, Sommer argues that those representations of existing gender and racial divisions made by Latin American socialists and populists alike—particularly representations of the differing kinds of labor properly belonging to public and private spaces and to differently raced bodies—actually became more, rather than less, rigid (Sommer 123).[7] This was in part a response to the increasing threat from a United States bound to modernize both itself and its neighbors on its own terms and the corresponding rise of the popular fronts of newly founded communist parties and right-wing populisms. In particular, we see the nationalist need to separate the indigenous off into its own class—that of the agricultural peasant. This was in part to identify an Indian culture which could be drawn on as the cultural storehouse for the indigenous tradition of the nation, while simultaneously suggesting mestizaje as a way to assimilate the Indians themselves.[8] That is, in Mexico, for example, public policy proposed that the Indians' culture and history was to be preserved as the nation's patrimony, while the actual physical Indians themselves were to be culturally (and physically) assimilated into the mestizo fabric of the state. In Peru at the turn of the century, political liberals and progressivist Peruvian intellectuals, such as Gonzáles Prada and Matto de Turner, advocated mestizaje as a way of assimilation and population

whitening. Although as time went on there were also Andean regionalist and socialist intellectuals who frowned on the idea of assimilating the Indian, even these intellectuals, like the Mexican thinkers, saw Indian culture as a source-point for a true and modern Peruvianness, rather than the other way around.

By the late 1920s, as Rowe and Schelling note, there were three main avenues for socialist thought in Peru in the late 1920s: the APRA (Revolutionary American Popular Alliance) organized from Mexico by the Peruvian Haya de la Torre; Mariátegui's Peruvian Socialist Party; and the Comintern, which "by the late 1920s [was] seeking to establish Stalinist parties throughout Latin America" (152). APRA "was elaborated against the conceptions of the Communist Third International," which saw the struggle against imperialism in Latin America as part of a broader global struggle; under de la Torre, APRA instead put forward a theory of the "independent historical needs of Latin America." On the other hand, Mariátegui felt that the problem for Peru "was not how to develop capitalism but how to follow an autonomous path" (155), one which would lead to the adoption of what he considered to be the organically socialist collectivism of the Indian community; for him as well as for some regional intellectuals, the Indians could form a proletariat in the Marxian sense—a peasant revolutionary force rather than a (peasant) reactionary force (Rowe and Schelling 154). In general then, for Latin American socialists, given the widespread interest amongst many thinkers in identifying the Indian qua a folk or anthropological Indian who was associated with tradition and with the land, peasants and Indians were more likely to be figured as a kind of agricultural Indian proletariat, with the emphasis on the peasant as a class, while (urban) workers were more likely to be figured as a mestizo laboring class (Knight 81); so, while class took precedence, it was also intimately bound up with race.

The perception of a class split, and the secondary but no less important imagining of an essential racial and cultural split, between the rural agrarian Indian and the urban industrial mestizo was, as I have noted, exacerbated by Latin American socialist privilegings of the urban worker; this meant conceptual problems for modernist artists like Vallejo and Rivera, concerned as they were with a specifically Latin American, increasingly socialist identity. Ultimately, both Rivera and Vallejo attempted to work through such problems by trying to fit these differently raced, classed,

and gendered bodies into one rather generalized representational space—the male worker-body. This was a body, as we have already seen, with which they themselves could identify despite class (or phenotype) differences, a body which would become, as Vallejo wrote in 1937, "interhuman and parochial," both universal and local. Both Rivera and Vallejo assumed that the "political love" needed to accompany such a body would arise naturally; as Vallejo put it, this politicized love would rise from its own necessarily masculine "public groin":

> For several days, I have felt an exuberant, political need
> to love, to kiss affection on its two cheeks. . . .
> Ah to love, this one, my own, this one, the world's,
> interhuman and parochial, ancient!
>
> It comes, perfectly timed,
> from the foundation, from the public groin.
>
> (*Posthumous Poetry* 178)[9]

If, by the 1930s, Vallejo could envisage a masculine, political sentiment of love arising homosocially from its own generative organs and Rivera could turn to the image of the male laborer to evoke much the same politicized sentiment, such an emotion was legitimized, as we have begun to see, by an American ethos of masculine sentiment underwritten not only by high culture but by popular social means as well. Some of the most popular song forms—the tango and the bolero, for example, written and interpreted almost exclusively by men—were widely disseminated first, around the turn of the century, through dance bands and inexpensive sheet music and later through the rapid spread of radio in the 1920s (as Luis A. Pérez notes, radio was formally inaugurated in Cuba in 1922, and by the early 1930s, Cuba was fourth in the world in number of radio stations in operation [331]). By the 1930s, the careers of favorite and influential singers, such as the Mexican bolero interpreter Agustín Lara, emerged "from the fits and starts with which a modern sensitivity transforms traditional sensibility. . . . The electronic media (radio, records and film) complement[ed], rather than contradict[ed], the typically premodern extolling of love as fiery rapture and unfulfilled possession" (Monsiváis 180). The bolero—which arrived in Mexico at the turn of the

century, via Havana—was an immensely popular form, one which "pres-
ent[ed] the male as vulnerable, suffering from his undying passion, and as
someone who does not hesitate to express this feeling. . . . Within its con-
ventions the man can reveal himself as sensitive and emotional in a sanc-
tioned form" (Campos 638). Intellectuals concerned with public policy
realized that an important means by which popular sentiment could be
directed was through popular song. Thus came efforts early on during the
Mexican Revolution, for example, to adopt not only a national song, but a
national song form. From one point of view, it would seem logical that,
during the armed phase of the Mexican Revolution, the *corrido*—a peas-
ant song form used to disseminate current and past political as well as
romantic events—would be the obvious choice; as Carlos Monsiváis
points out, it was, in fact, romantic song which became "central to the lan-
guage of the community." He continues, "For decades romantic song
[was] one of the main channels of a language that unite[d] composer with
trade-union leader, housewife with President of the Republic" (171–173).
In 1913, in fact, in an effort to unify the country by means of music which
would be familiar to many, the Mexican musician Manuel Ponce began to
gather old romantic songs and rearrange them for the piano, repopulariz-
ing them at the same time for the specific purpose of evoking emotion in
the people, saying, "We feel emotion without the actual provenance of
the work of art, or the details of its structure, really mattering" (qtd. in
Monsiváis 170). Ramón López Velarde's poem "Gentle Motherland"
expresses the sentiments that Ponce hoped would surface through popu-
lar song: "Motherland, I give you the key to your fortune / stay always the
same, faithful to your daily mirror" (qtd. in Monsiváis 173). As late as
1938, this sentiment would still remain a valid one for moderns like Frida
Kahlo, who quoted these very lines (though not without a sense of irony)
in a letter to her friend, Lucienne Bloch: "Besides illnesses, political
messes, visits from gringa tourists, . . . Riveraesque arguments, preoccu-
pations of the sentimental sort, . . . my life is, like the poem of López
Velarde, 'the same as its daily mirror'" (Herrera 217).

In Mexico, the bolero was unofficially nationalized by the beginning
of the 1920s with Armando Villareal's "My Brown Girl" (Monsiváis 181).
With the rise of important urban centers on the continent, the elevation
of the provincial brown-skinned maiden/mother as a pure figure of rural
innocence often came to figure the abundance and timelessness of a

rural, traditional landscape. The evocation of the pure woman—who could be represented either by the virginal love or the maternal figure—could also be depended on to provide a source of melancholy desire for the safety of an unmodern and therefore unvexed domesticity; Ponce's romantic song "Little Star" (Estrellita), for example, gave Mexicans, as he put it, a sense of a "living nostalgia," for Estrellita "embodie[d] the cobblestoned streets of Aguascalientes," a place of premodern innocence (qtd. in Monsiváis 170).

Thus, two nostalgic vocabularies—that of indigenism and mestizaje in the service of the nation and that of motherhood and pure womanly love in the service of the nation's home—became at once the raison d'être for public campaigns to educate women to their proper places and a source for a more commodified, national sense of melancholia and nostalgic sentiment. But the sentiments expressed by such popular forms, notwithstanding that a staple of the bolero and the tango was an idealized nationalism and passionate love for the land/mother, were also the sentiments of an increasingly urban mass population; they were middle- or even lower-class forms rather than traditional oral forms like the corrido, which could be traced to the folk proper; to be popular with the masses was to be kitschy, to be spread by modern technologies like radio and film rather than by oral tradition and cultural ritual.

Instead, the mestizo nationalism these artists professed (to one degree or another) in their art and their public lives was virtually always tied to a concept of the people as the rural, peasant folk. This was a function of the convergences of class, anthropological, and sociological influences and, at least for Kahlo, Rivera, and Vallejo, of leftist politics. The very modernity of these artists and what they publicly presented as their avant-garde intellectual status almost inevitably led them to reject, at least consciously, in their art (not necessarily, as we will see, in other aspects of their lives) the consumption or representation of what they saw as the *cursi*, or "kitsch" sentimentalism of the bourgeois and lower classes. Rather, for Kahlo and Rivera the formal appeal of contemporary folk art or of pre-Columbian art, often conflated with the very physiognomy of the Indians themselves, seemed to open up a way to an artistic language which would avoid kitsch at the same time that it tapped into the folk foundations of the masses. Such a view of the folk was underscored, if not actually prompted, by the ideas of important anthropologists like Manuel Gamio. In his 1922

Introduction, Synthesis, and Conclusions of the Work: The Population of the Valley of Teotihuacan, Gamio, then the Mexican government's director of anthropology, assured his readers that indigenous peoples were as smart as anyone else—just abused and degraded—at the same time as he made it clear that what was important for Indians was "the stimulation of the racial approximation, the cultural fusion, linguistic unification . . . of our various groups, which only in this manner will ever form part of a coherent and definite nationality as well as a true fatherland" (x). As Gamio makes an overview of the peoples of the region of Teotihuacan, he notes of contemporary indigenous pottery of Teotihuacan that it is "as a rule only the degenerated copy of that art in pre-Spanish times"; but "it might again come into its own if manufacturers were taught how to commercialize their product and slightly remodel it to suit modern taste, a task which the Department of Anthropology has already undertaken" (lxxii). The Indian's clothing, continues the report, shows "in a positive and convincing manner the state of decadence of the local population," since it is "un-aesthetic . . . because it shows nothing typical or even original, being nothing but a standard product turned out by factories by the thousands and tens of thousands, even millions" (lxxiv). For Gamio, the question of culture is very much a pragmatic, if vexed, one. First, commercialization is a good thing if it can bring the folk and their products into the mainstream of national culture; but it is also dangerous for its role in commodifying and, presumably, degenerating through mass production that selfsame folk culture. Second, those aspects of Indian culture which were not esthetically degraded would be kept as evidence of the folk nature of their makers; but the Indians not only would have to be shown how to recover their own lost arts, but also, in order to enter into modern economy, would have to learn how to "slightly remodel" their products for modern tastes.

Gamio had already laid out his vision of the mixture of cultures and races by 1916, in his *Forging Fatherland* (Forjando patria); in 1921, Rivera returned to Mexico from Paris, where he had established himself for more than twelve years as a Cubist painter, precisely to see such a project realized in a public manner. At Vasconcelos's behest, on his way back to Mexico Rivera traveled through Italy to study Renaissance fresco painting, so as to prepare for Vasconcelos's vision of large public murals. From his Italian trip, Rivera would combine the necessary flatness of fresco paintings with the solutions to such flatness from Cubism; from fresco cartoons,

the preliminary drawings done before the actual painting began, he also adopted the heavy outlining he would favor for representing the supposed formal simplicity of pre-Columbian and primitive artwork. Finally, Rivera adopted the Italian fresco's allegorical narrative mode, which would be ideally suited both to representing the story of the Mexican nation and to satirizing the nation's enemies in a manner accessible to people untrained in viewing and interpreting high art (it would also give Rivera a chance to include himself, his compatriots, and his patrons in the murals as well as a chance to publicly satirize his own enemies, just as Renaissance painters had done).[10]

By 1926, while urban Mexicans were listening to boleros on the radio, going to see Tin Tan and Cantinflas at the movies, and perhaps buying Indian pottery remodeled along pre-Columbian lines, Rivera (alongside other artists) was using his training to promote an anthropologically influenced vision of a unified, national folk culture, moving slowly but steadily away from Vasconcelos's Hispanophile and Theosophist notions but retaining the Mexican government's emphasis on cultural and racial mestizaje. Nowhere was the contrast between official high modernist emphasis on the folk, on the one hand, and commodified forms of popular culture, on the other, more evident than in the murals Rivera painted for the state in the late 1920s. Rivera, contracted by the Mexican government to paint a series of murals for the newly constructed Secretary of Public Education building (these murals were actually painted between 1924 and 1928), decided to use the folk song form of the corrido as an organizing tool for the murals on the third floor; these murals, comprising two series, were named *Corrido of the Agrarian Revolution* (completed about 1926) and *Corrido of the Proletarian Revolution* (completed in 1928, after his return from the Soviet Union) (Helms 246–251). The corrido was (and is) essentially an agrarian peasant ballad form, celebrating national and local events and heroes and providing a means for the transmission of important news events in a countryside where neither literacy nor technology had much of a grip. As such, it would seem ideal as a framing device: it was familiar even to urban Mexicans, and as an authentic folk mode of communication it would evoke in the mural's viewers a sense of the land, metonymically related to the nation. In a practice Rivera adopted from traditional *retablo*, or "votive paintings," the murals are literally framed with painted banners draped over the individual scenes themselves; as retablo or commemorative

paintings often identified, on a banner painted into the scene itself, the event in honor of which the painting was made, the banners in Rivera's mural have the words to a revolutionary corrido painted along their length, indicating the action and intention of the murals. But Rivera's use of the corrido form as a vehicle for the narrative of his murals itself presented pictorial as well as more strictly ideological problems. The sentiments of the *Corrido of the Agrarian Revolution*—the message that the *campesinos, or* "peasants," "lead healthier lives because of their proximity to the land" (Helms 246)—dovetails the people, the land, and the people's traditional esthetic forms neatly: the mural begins with the figure of a woman, modeled on the well-known singer Concha Michel, who "sings the corrido surrounded by a group of dark-skinned workers of the soil. In the panels that follow, a group of peasants plans a revolution while women and children eat supper; the rich are shown greedily increasing their wealth through the stock market (this scene includes caricatures of John D. Rockefeller and J. P. Morgan) and dining on gold. Other panels depict the simple existence of the *campesinos*" (Helms 246).

But the corrido must frame an entirely different message in the later series, depicting the *Corrido of the Proletarian Revolution.* Because he completed the *Proletarian Revolution* after he came back from a visit to the Soviet Union, Rivera depended in the arrangement of this mural on a more complex representation of the relationships between peasants (Indians), urban (mestizo) laborers, and the presumably socialist revolution of Mexico than he did in his earlier *Agrarian Revolution* mural (Helms 244–246). In this later mural, these three different images—peasant, urban laborer, and revolutionary fighter—compete with and even fight each other in a crowded and confusing pictorial space made even less clear by the traditional form of the corrido, supposed to be enframing them; in a panel for this mural called *Passing out Arms*, for example, urban workers stand inside a dimly lit archway, receiving arms passed out by female figures (including that of Frida Kahlo), while peasants wearing the traditional white shirts and broad-brimmed hats, with bandoliers strung across their chests, stand just outside, and to the rear of, the archway, waving a flag proclaiming "Tierra y Libertad" (Land and liberty). The viewer of this mural is forced to look closely to distinguish these groups, and the peasant fighters are not only physically standing behind the urban workers/fighters but also standing, both literally and it would seem

metaphorically, outside the central space of the room wherein the arms to fight the revolution are being handed out.

What is arresting, too, is the strangely dissonant social note struck by an appeal to peasant or agrarian images and cultural forms in the midst of a capital city—Mexico City—well on its way to embracing mass production, commodification, and modernity in all their aspects. The way the message of these particular murals is framed and presented reflects nothing of the other mechanisms by which a sense of mexicanidad was made increasingly popular by this time: mechanisms such as mass production, cinema, radio, sentimental songs, melodramatic film, calendar art, and remodeled Indian art. What the term "popular"—as in what appealed to the masses—actually meant indeed became something of a loaded question for these artists. There would seem to be something of a disconnect between the valorization on the part of artists like Rivera of folk forms such as the corrido, implemented on behalf of the state's vision of interclass and interracial unity, and the much more commodified forms by which mexicanidad was distributed among the urban masses, such as the patriotic bolero or the Aztec calendar girl. The contemporary success of Rivera's, and a bit later Kahlo's, work speaks volumes about the way a nationalist program could smooth over such gaps. In fact, of the four artists I look at here, only Rivera and Vallejo ever referred directly in their art to any kind of mass media. As we will see, popular stars such as Helen Wills Moody and Charlie Chaplin came to figure in both Vallejo's and Rivera's work; but the mass appeal of such figures would be carefully mediated by the socialist concerns of these two artists.

Indians, Workers, and Time

Latin American socialism of the time was often, and of necessity, informed by the national attention paid to the discourses of indigenism and mestizaje. Questions of the indigenous person's place in the state often revolved around the question of land rights; thus, for a socialist nationalism to mobilize itself, the male worker-figure needed to be complimented by organizing affective, popular responses around the material aspects of the nation itself—for example, the land. As we have seen, the land was often metonymically associated with the familiar images of the mother and the Indian. But these mothers and Indians (often Indian mothers) needed to be brought into allegorical and imaginative harmony with an idealized,

modern, worker-state romance. The ubiquitous image of the Latin American founding couple—in Mexico, Cortés and his Aztec Indian slave and interpreter, Malinche; in countries such as Peru, a more generalized Spanish conquistador paired with an indigenous woman—provided these artists, and others like them, with part of their solution to this problem. The more generalized figure of the dark-skinned woman could easily be factored into the family-state's vision for the future in terms of her child-bearing capacity; at the same time, she could do double duty by providing in herself an allegory of domesticity: she symbolized the very first unity of the nation-to-be, through the bringing-together within her own body of the Hispanic and the Indian to produce the mestizo subject. Fathers, on the other hand, appear almost not at all in Kahlo's, Mistral's, Vallejo's, or Rivera's work. For Latin Americans, picturing the paternal image could too easily evoke the rapacious Spanish patriarch (explicitly depicted, for example, in one of Siquieros's murals as Cortés) of the New World's Black Legend. Thus, as both state-sponsored and independent communist rhetorics legitimated themselves through the growing vogue in things and bodies indigenous, the mother and the Indian seemed to blend into each other, or even to evoke each other. This was at least in part because, as we have seen, both figures could also serve as sources from which to draw an affect of nostalgia and a timelessness, one which could literally shore up a sense of historical stability.[11] The slightly more egalitarian sensibilities of nineteenth-century liberal romantic allegories of marriage, where newlyweds would provide the unity necessary for stable government, began to give way, then, to a hardening, traced along gender lines, into the racialized family romance of a fraternal state where laboring sons—of the earth or the factory—related to each other, not to the father; and (dark) mothers provided a harmonious background sense of foundational unity.

In his National Palace mural *The History of Mexico: From the Conquest to the Future* (painted between 1929 and 1930), for example, Rivera meticulously researched the various cultures and histories of the different pre-Columbian Indians he represented. His own socialist-indigenist leanings acknowledged the desirability of bringing contemporary indigenous peoples, descended from the pre-Columbian groups he so carefully researched, into the national fold. Interestingly enough, however, his contemporary Indians lack the specificity of his pre-Columbians: they are almost invariably placed at the bottom of his murals, their body language

indicating their oppressed and (often) apolitical stolidity in blocky forms and curved-over or kneeling postures; these are irreconcilable with the upright poses of the pre-Columbian Indians or even of proletariat laborers. For a painter like Rivera, who presented himself as a committed artist even though his political relations with the Mexican Communist Party were often strained, this perceptual and imaginative contradiction frequently presented formal as well as substantive problems. From 1923 to 1930, most of Rivera's work went into murals commissioned by the Mexican government, which itself was increasingly anticommunist (although it would often use the word "socialist" in government rhetoric). As Rivera struggled to show a state-sponsored vision of an integrated future which was also in accord with his own communist sensibilities, his work increasingly privileged urban workers while it seemed to remain suspicious of *agrarista* peasants and Indians, who had in fact fought against organized labor during the Mexican Revolution. Rivera's ejection from the Mexican Communist Party in 1930 meant that for the next five years or so he would seek work in the United States rather than in Mexico; but his United States work, most often commissioned by wealthy capitalists, also strained his murals' didactic intent. I will return later to some of the solutions, both thematic and formal, he attempted during these times.

In that Vallejo did not have to answer to the state in his poetry, he was more free to experiment with his solutions to some of the same problems Rivera encountered; but from around 1927 to 1938 his increasing committedness, first to a version of Carlos Mariátegui's socialist indigenism and then (beginning in 1931) to the Spanish Communist Party, meant that he too felt the tension of integrating a unified, socialist historical vision, not all of whose parts fit neatly together. The clearest indication of Vallejo's own attempts at resolution to this problem is in his poem entitled "Telluric and Magnetic" (Telúrica y magnética), probably written in 1929 after he returned from his first visit to Russia. An ode to Peru's sierran peasants and their labor, which nevertheless self-consciously mocks its own sentimental-anthropological patriotism, the sixty-two-line poem begins its conclusion with these penultimate thoughts: "Rotation of modern afternoons / and fine archeological dawns! / Indian before man and after him!" (*Posthumous Poetry* 88).[12] The temporal tension expressed here (morning/afternoon, before/after) comes from the fact that the speaker of the poem sees before him all at once the seemingly ancient ("archeological") traditions of

the sierran Indians being enacted in the present day, the "modern afternoon." Mariátegui's utopian vision of a future where Peru would be "Indianized" according to their presumably more communal systems of local government is reflected here, but the rhetorical conflation of the times of day with different eras of history complicates the matter. If the Indians come before—in pre-Columbian history—and after—in the future—then the present-day Indians that the speaker is left with occupy a poetic space which floats in a social and temporal vacuum. Neither Rivera nor Vallejo seem to know quite what to do with those agrarian Indians who exist in the here and now; are they alienated laborers? Are they beaten down, and thus degenerate? Are they, perhaps, closer to evolution's monkeys? Are they, as Vallejo's novel *Tungsten* suggests, unalienated, at one with their work?

In this poem as well as others, Vallejo's representational problems with a confusion of temporalities are further exacerbated by his sense of humor, which, while it leavens the melancholy so often present in his work, undercuts any overly kitschy or melodramatic (possibly feminine) appeal to patriotism. In fact, this poem is full of humorous jabs at the speaker's own patriotic evocations of national symbols: "Oh patriotic asses of my life!" or his self-mocking reference to another "national" symbol, the *vicuña,* and evolution, "vicuña, gracious national descendent of my monkey!" Finally, and most sacrilegiously, Vallejo replaces the most well-known symbol of the Andes, the condor, with the image of cavies, a kind of guinea pig traditionally raised as domestic meat and eaten by indigenous Andeans: these animals are "poultry-yard angels, / birds save for a slip-up of the crest! / Cavess or cavy to be eaten fried / with the tempering of the wild bird pepper! / (Condors? Fuck the condors!)" (*Posthumous Poetry* 86).[13] Thus, the poem, populated by belated and future Indians, "poultry-yard angels," vicuñas, asses, and monkeys, itself reproduces the conceptual problems of a progressivist, eugenicist timeline colliding with a socialist desire to see history in terms of relations of human labor; and this collision itself clashes with the specifically Latin American socialist concept of the Indian peasants as (necessarily) a laboring "class."

Vallejo's writing of the 1930s continues to tackle some of the same problems of representation. After World War I and the worldwide depression of the 1930s, Kevin O'Connor notes that "Vallejo sees . . . Indians [in *Tungsten*] and the miserable unemployed masses of Depression Paris (whom he will later evoke in the Whitmanesque "Stopped on a stone") as

victims of the same monstrous force" (xix).[14] The 1931 socialist-realist
novel *Tungsten*, which first came out in Spain, was the most popular of
Vallejo's work published during his lifetime. The novel turns on the rape
and murder of an Indian girl, Graciela, by the managers of a United
States—owned Peruvian tungsten mine.[15] It is through witnessing the mis-
treatment, rape, and subsequent death of this runaway Indian girl that sev-
eral of the mines' upper echelon of workers become radicalized and decide
to join the workers' movement to overthrow the *yanqui* businessmen and
their elite Peruvian counterparts. In the final paragraph, the mine's time-
keeper, who has decided to join the revolution against the owners, can't
sleep: "Among all the words and images he retained from the blacksmith's
exhortations, words like *labor, wages, workday, bosses, exploitation, . . .*
and so on, there passed through his mind that night the memory of Gra-
ciela, the dead girl. . . . Remembering her now, the timekeeper began to
weep. Outside, the wind was rising, portending storm" (125). This storm
is, of course, the impending Marxist revolution. But the novel opens not
with an image of the miners, but with an extended scene of the unassimi-
lated Indians who live right next to the mine itself. As the novel conceived
these Indians, their inability to understand either the reason for the pres-
ence of the mine or the rationale of modern capitalism stems from an
innocence which seems, literally, outside of time:

> They came, they went, cheerful, breathing hard, their muscles tensed
> and the veins standing out with exertion, tending flocks, sowing,
> making mounds for seedlings, hunting wild vicuña and alpaca . . . in
> an incessant and, one might say, disinterested toil. They had
> absolutely no sense of utility. . . . They seemed to live life as an expan-
> sive and generous game. . . . [They] were seduced by what they saw
> in the store, rare things to their innocent and primitive minds: dyed
> flannels, picturesque bottles, multicolored boxes. (6–7)

These Indians are certainly workers, but they are not, in fact, anything
like the urban laborers Vallejo summons up as the central focus both of the
novel and of his best-known worker poem, "Stopped on a Stone" (Parado
en una piedra). Since the Indians of *Tungsten* have no "concept of utility"
and their toil is "disinterested," that is, of a piece with their lives, these
unalienated beings cannot fit into the modern scene of the mine until they

are drawn in by capitalist exploitation, going from Indians to workers in the capitalist sense. At this point in Vallejo's development as a communist, workers, it seems, must be alienated by the technologies of modernization before they can become conscious in a specifically modern sense, as in the 1928 poem "The Miners Came out of the Mine":

> *The miners came out of the mine*
> *climbing over their future ruins,*
>
> *they closed with their voices*
> *the shaft, in the shape of a profound symptom.*
>
> *(Posthumous Poetry* 82)[16]

Although the peasants-turned-miners in this poem are "shod with viz-cacha hide" and the poem praises them for their "ancient" nature and their "rustic" saliva, nevertheless, like the Paris worker in "Stopped on a Stone," these miners' thoughts are shaped or "craniated" by capitalist labor, and like the Paris workers their bodies too are conflated with their labor: the mine shaft, "profound symptom" of capitalism, is also the throat of the miner, opened and closed—literally, in the sense of a strike—by the miner's voice. The Indians of *Tungsten,* the miners of "The Miners," and the European masses of a poem like "Stopped on a Stone" may all be victims of the forces of modern capitalism, but their histories, as we are beginning to see, would be difficult to reconcile either poetically or artistically.

Mestizaje and Hybridization

If Vallejo's 1928 poem "Telluric and Magnetic" is uncomfortable with its attempt to convert the high sierran agricultural traditions of the Peruvian Indians into a workers' celebration of a "sincere and really Peruvian mechanic," complete with "theoretical soil," Vallejo worked on a solution for such a reconciliation, one which might be effected through his increasing attention to his persona's own (by implication mestizo, by profession poet-laborer) male body. By the 1930s, artists as well as intellectuals had discovered that the concept of mestizaje was not just a way to bring together races. The concept itself, being a categorizing term (rather like the word "weed"), depending on who was using it, tended to slide between the idea of a physical mixing and a (vague) philosophy of cultural mixing.

FIG. 3.2. San Angel, 1931: Guillermo Kahlo kept a photographic record of the construction of Rivera and Kahlo's house and atelier, designed by architect Juan O'Gorman.

Thus mestizaje could itself become metaphor, allegory, and answer all in one for one of the basic conceptual problems of Latin American modernity: the perception of what seemed to Latin Americans to be a socio-temporal unevenness between traditional and modern. This supposed unevenness in fact haunted American reactions to modernity at this time.

Rivera's material success may have made the seeming unevennesses of modernity—between the high modernism of his atelier, for instance, and a more ordinary, day-to-day life still connected to traditional ways of living—more stark for him than they would have been for Vallejo, who went from one kind of (comparative) poverty in Peru to another in Paris. When Rivera lived in Mexico, he had the means to engage Juan O'Gorman, the leading modernist Mexican architect, to build him an atelier in 1931 (patterned after Corbusier's Paris atelier), in San Angel, a suburb of Mexico City (fig. 3.2). It was here in this decidedly high modernist building, amidst his growing collection of primitive Mexican folk and pre-Columbian art and artifacts, where he was, in something of the same way as Vallejo, working toward a fusion, a kind of metaphorical mestizaje, of

the seeming antinomies of modern life: the North with the South, the mechanical with the organic, the agrarian with the modern, and, of course, the Indian with the Hispanic. As Stephen Hart notes, by the early 1930s Vallejo was becoming more and more a committed and (at least in his non-fiction) rather inflexible defender of Stalin's Communist Russia; and it is then that Vallejo (like Rivera) began to accept the inevitability of industry by suggesting how, "in a truly socialist society, man's body works in harmony with the machine" (123). By 1931 Vallejo would use the idea of the fusion of worker with machine in his play *Lock-Out*, where "hummings and whirrings of a factory floor . . . [are] in complete harmony with the bodily movement of the workers" (Hart 122).

Rivera's search for a way out of some of the formal impasses to which nationalist and modernist ways of conceptualizing history had brought him gave him the idea to work his way toward a similar hybridizing move, culminating in his Detroit Institute of Arts murals, collectively titled *Detroit Industry* (1932–1933). His own growing enthusiasm for the benefits of industry, fueled by the Soviet Union's revolutionary rhetoric hailing new industry, could only really be carried out in the capitalist origin of such industry, the United States.[17] As Herrera reports it, Rivera told a New York reporter, "There was only 'one thing left for me, to prove that my theory [of revolutionary art] would be accepted in an industrial nation where capitalists rule. . . . I had come [to the United States] as a spy, in disguise'" (*Frida* 116). Rivera's *Detroit Industry* murals continue his practice of incorporating pre-Columbian figures; and he seems to fully realize a gesture he has been working toward: the hybridization of the organic form with that of the mechanical, for example, in the Detroit south wall's evocation of the Aztec figure of Coatlicue, "She of the Serpent Skirt." Coatlicue, killed by her sons at the moment she gave birth to Huitzilopochtli, the god and cultural hero who was supposed to have led the Aztecs to their city-state site of Tenochtitlán, was depicted by the Aztecs as wearing a necklace of severed hands and hearts; serpents (supposed to be vehicles of rebirth and transformation) of blood gout from her face and severed hands. In Detroit and later in San Francisco (in his 1940 mural *Pan-American Unity*), Rivera painted an enormous stamping machine which bore the same squat, massive, stony yet organic outlines as that of Coatlicue (fig. 3.3; the most famous example of her figure was uncovered in 1790 alongside the cathedral of Mexico City) (Miller and Taube 64).[18] As Peter Wollen puts it,

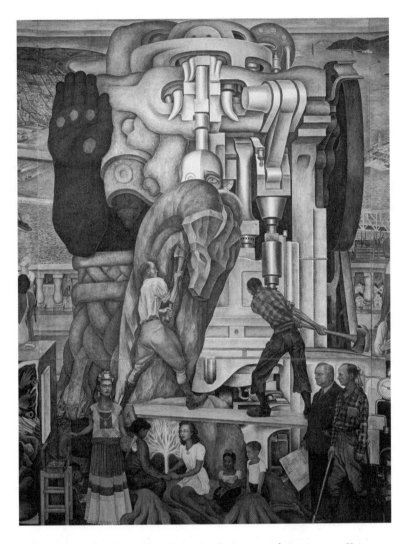

FIG. 3.3. Panel 3 of Diego Rivera's 1940 San Francisco mural, *Pan-American Unity*.
© City College of San Francisco. All rights reserved.

Rivera's strategy in Detroit was to find an artistic form that would transcend a series of antinomies and contrasts: those of modernity with authenticity (a recurrent problem for nationalist culture), of North with South, of proletariat with peasantry, and of avant-gardeism in art with local, popular traditions. In a sense, these antinomies overlapped. (193)

Because mestizaje was a mix of social projects as well as biological theories, the social aspects of mestizo mixing often rested on analogies with neo-Lamarckian theories of genetics and evolution, which maintained the inheritance of acquired or learned characteristics. The work of both Mendel and Lamarck continued to fascinate Latin Americans in biological investigations of inheritance and crossbreeding across generations; Vasconcelos, for example, calls upon a "beneficial spiritual Mendelianism, caused by a combination of contrary elements" (*Aspects* 33). As Wollen notes, Luther Burbank's experiments in grafting combined with his belief in Lamarckian genetics gave artists such as Rivera and Kahlo the legitimation for the scientific metaphors their art implicitly evoked:

> For the two to be combined into a unity, a form of art was needed that would be both advanced and traditional, both international (even universal) and local. He [Rivera] drew his conceptual model of hybridity and the graft from the agricultural experiments of Luther Burbank, whom he visited in California and painted into two of his San Francisco murals. (193)

Although Rivera already had conceptual models of hybridity closer to hand in Mexico, the North American Luther Burbank was a figure of fascination for him. An influential plant breeder and contributor to the science of genetics, Burbank grafted seedlings to fully developed plants for a quick appraisal of hybrid characteristics. What surely attracted both Rivera and Kahlo to this scientist was his assumption that the results—what he thought was his own "molding effect"—were evidence for the Lamarckian idea of inheritance of acquired characteristics (even though Gregor Mendel's principles of heredity had been published in 1901, effectively showing Lamarck's idea to be invalid). In fact, the analogy of the graft for hybridity or for mestizaje had already been put forward by Vasconcelos in 1925: "The truth is that vigor is renewed with graftings, and that the soul itself looks for diversity in order to enrich the monotony of its own contents" (*Cosmic Race* 33). Although by the 1930s Rivera had long since rejected Vasconcelos's mysticist and Theosophical leanings, he had not rejected some of the basic ideas that Vasconcelos shared with many others: a belief in mestizaje as a solution for national unity and a belief that the Anglo-Saxon race's prowess in technology and industry was necessary for

Latin America (as Vasconcelos put it, "we accept the superior ideals of the Whites but not their arrogance" [*Cosmic Race* 25]). Thus, to find Burbank's ideas would have seemed proof that the metaphor of the graft—a metaphor which would prove so useful for Latin American representations of cultural, industrial, and national unity—was in fact a scientifically as well as socially valid one.

Both Kahlo and Rivera painted Luther Burbank into their work in 1931; for Rivera, Burbank was clearly a symbol of the fecundity of California combined with the modern scientific spirit. But even more, Burbank provided presumably scientific evidence once again that a social program of genetic, and by extension cultural, mixing could be successful. For Rivera, Burbank's plant hybrids could be models not just for the Mexican state program of mestizaje but for the larger conceptual problem of how to model a national history of unification that implicitly conceived of some of its subjects as outside historical time. As Ida Rodríguez-Prampolini notes, Rivera changed his notions of how to image historical movement according to his subject matter; for example, the 1943 and 1953 murals for the Institute of Cardiology and the Institute of La Raza, respectively, represented "a concept of history as the linear, progressive accumulation of knowledge" (133). On the other hand, in his 1929 National Palace mural, *History of Mexico: From the Conquest to the Future,* Rivera attempted to "impose a dialectical chronology on a sociopolitical movement filled with contradictions, the synthesis of which provides the basis for further contradictions"; in fact, Rivera managed to depict what he thought of as class struggle in this mural by painting Aztec scenes of slavery and war, but also of the leisure of the Aztec upper classes, facing a portrait of Karl Marx on the opposite wall with a banner in his hand which reads, "The entire history of human society to the present is the history of class struggle" (Rodríguez-Prampolini 133). Thus the rescue of the timeless or premodern elements of Latin American society: once brought into historical time via a Marxist vision of class struggle, the modern science of genetics shows us by analogy the way folk traditions, peasants, and Indians can be grafted onto the modern body and assimilated via biological and/or cultural hybridization, as Rivera himself hoped:

Mexican mural painting made the masses the hero of monumental art. That is to say, the man of the fields, of the factories, of the cities,

of the towns. . . . Also for the first time in history, from the semi-mythic
past to the real, scientific, foreseeable future, an attempt was made to
portray the trajectory of the people through time in one homogeneous
and dialectic composition. (qtd. in Rodríguez-Prampolini 187)

Although by 1926, three years after he reached Paris, Vallejo was
equally as radicalized as Rivera, Vallejo's background as a cholo from the
provinces of Peru, overlaid though it was with a certain urban and intel-
lectual sophistication, must have been brought home to him in a new and
very basic way in Paris, where, in the midst of the most culturally advanced
city in the world, he himself was reduced to a kind of poverty he had never
known, even in Peru. Unlike Rivera, who was radicalized through his artis-
tic connections, it was Vallejo's poverty which helped to radicalize his writ-
ing; and because he was beholden to no one, unlike Rivera, Vallejo was
freer to choose which genre he would favor for his more overtly didactic
messages: "When Haya de la Torre [founder of APRA, the American Pop-
ular Revolutionary Alliance] underlines for me the need for artists to assist
revolutionary propaganda in America with their work, I say to him again
that in my capacity as a man I find his demand a great political undertak-
ing. . . . But in my capacity as artist I accept no order or proposition . . .
[which] subjects my esthetic freedom to this or that political propaganda"
(*Tungsten* xiv). Thus, in poems like "Stopped on a Stone," which is in fact
a political poem about the unemployment and poverty of depression Paris,
the first poetic problem Vallejo faces is that of his reluctance to write his
poetry completely according to the dictates of his politics.

A favored way to illustrate the strength and unity of labor was to
attempt to convey the very unindividualized nature of the huge numbers
of a crowd. The Italian photographer Tina Modotti, for example, used a
bird's-eye viewpoint to photograph crowds of Mexican laborers all wearing
the same type of hat. Diego Rivera literally crowded his murals with the
figures of peasants or workers all clothed in the same working "uniform."
The photographic work that Tina Modotti would do in the late 1920s and
early 1930s, for the Communist publication *Machete* in Mexico, looked not
so much for a unity between worker and machine as for the seemingly
accidental or, better, seemingly natural, formal qualities of laboring bodies
and labor's tools. But like Rivera (captivated by the formal qualities of a
primitive art), in conceiving the laborer as part of his (or her) labor, these

artists necessarily had to make formal connections between the old and the new; it was, after all, mostly mestizos who were the industrial laborers. For these artists, a sense of laboring unity depended on bringing industry and body into block-like harmony and on making immediate a feeling of (compositional) solidarity and even physical solidity.

Thus, although the political thing to do would be to address "Stopped on a Stone" to such an unindividuated mass, Vallejo refuses to make such an obvious move. The poem's first two stanzas begin instead with one worker "idle" on a stone by the side of the Seine, watching the reflections on the water. As the "tree of conscience" seems to sprout up from the river, so too does the image of the city itself, rising and falling, a city made up of "embraced wolves," undoubtedly a reference to the "bosses" who will come later in the poem. Then, by way of segue to the third stanza, where the one becomes an "idle individual among thirty million idle," the second stanza searches for a way to evoke the individual's physical, material sensation of a body experiencing enforced idleness (because of a *paro*, a "lockout"). Watching the "monumental" city bustle about, the worker-persona's body (clearly, by implication, Vallejo's body too, since he considered his writing a form of labor) is parsed out into pieces from the head to the toes, such a fragmentation conveying a sense of bodily inertia and even physical displacement. But what is all-important here is the tone. This idle worker-body is both diminished by its inability to work and still clearly the object of an affectionate and even humorous regard. The reader's gaze is directed to look at this individual with the same somatic sense that one might have for one's own body: burdensome yet vital, comically put-together, yet necessary:

> *The idle one watches the city coming and going,*
> *monumental, carrying his fasts in his concave skull,*
> *on his chest his purest lice*
> *and below*
> *his little sound, that of his pelvis,*
> *quiet between two big decisions,*
> *and below,*
> *farther down,*
> *a paperscrap, a tack, a match.*
>
> (*Posthumous Poetry* 78)[19]

The sexuality of the worker's body, often suppressed in committed art, is affectionately brought in by Vallejo as an integral part of the life of the working man: here, imaged by the "little sound" and the "two big decisions" of the male body's genitalia (these could be read alternatively as the pelvis itself and the two legs). The objects "farther down" are both diminutive and useless (in the Spanish what I, following Clayton Eshleman, have translated as "paperscrap" is the diminutive for paper, *papelito*). But paired with the body above, they take on a somatic belonging of their own, much as a toe-nail or a lock of hair still seems to belong to us even when separated from the body. Thus, when the poem expands out to encompass the "thirty million" workers idled, Vallejo has the poetic strategy he needs to make these workers both part of a mass and individualized. Further, Vallejo achieves the longed-for sense of fusion by "organicizing" the mechanical:

> . . . *and how*
> *his figure incises, edge to edge, its atrocious tool, idle,*
> *and what a painful valve-idea in his cheekbone!*
>
> *what transmission launches his hundred steps!*
> *how the motor in his ankle screeches!*
>
> (78)[20]

Here, Vallejo is not only taking the coincidence of the way a valve looks with the sharp curve of a cheekbone, but demonstrating the central-ity of labor to the worker's very physical being by conflating, through an analogical operation, both manual and mechanical work—that of the laborer with motor and transmission—with the movements of the body. But at the same time, his poetry retains the sentimental sense of humanity inherited from the indigenist tradition:

> . . . *hearing it, feeling it, in plural, humanly,*
> *how the lightning nails*
> *its headless force into his head!*
> *and what they do, below, ay!*
> *farther below, comrades,*
> *the paperstruggle, the tack, the match,*
> *the little sound, the father louse!*
>
> (80)[21]

As in the final scene of the novel *Tungsten,* certain buzzwords appear in this poem to mark it as a committed work: lockout, *patrones,* workers, comrades. However, poetic strategies—elision, allusion, analogy, conflation—give Vallejo the means to avoid the didacticism into which a straightforward narrative seems to lock him. The rhetorical strategy of finding not only analogies, but mixtures of the organic with the mechanical gives him a way to move between individual bodies and general exploitation, the bodily gestures of labor and the tools of labor, and divisions of labor according to race.

Since it is workers who are now privileged in these poems, the affect attached to the mother-country is slowly but surely displaced onto a seemingly revolutionary sentiment: fellow-feeling, combined with hope for a better (national) future. But the masculine body of the "persuadable brother, comrade, / father in greatness, mortal son, / man-friend and contender" is still the "immense document of Darwin," a figure whose hope is necessarily ironic and whose brother-love is necessarily melancholy (*Posthumous Poetry* 68).[22] In his 1929 "Today I would like to be happy willingly," the persona's desire to be happy, to "open by temperament wide open my room," serves, in fact, as a protest against "why they hurt me like this so much in my soul" (*Posthumous Poetry* 68).[23] The last stanza of this poem begins to work through how to maintain revolutionary sentiment in the face of such pain:

> At the misericordias, comrade,
> fellow man in rejection and observation, neighbor
> in whose enormous collar rises and falls,
> unseasoned, threadbare, my hope . . .
>
> (68)[24]

Misericordias, which is the relaxation of a monastery's strict rules, provides the persona with a sense of hope; nevertheless, this hope, "unseasoned, threadbare" (like the collar itself), lends the poem its air of melancholy and wistfulness. Such a tone echoes that of another one of Vallejo's best-known posthumously published poems, "Considering coldly, impartially," where the persona "coldly" considers the faults, time-boundedness, and general littleness of "man": "Considering / that man leaves softly from work / and reverberates boss, sounds subordinate; / that the

diagram of time / is a constant diorama on his medals. . . . Considering too / that man is in truth an animal," the persona concludes that "nevertheless, on turning, he hits me in the head with his sadness" (*Posthumous Poetry* 72).[25] The tone of Vallejo's poems from this time, their sentiment if you will, though it seems quite different from the reformist tone of the sentimental novel or the formulaically nostalgic or sorrowful tone of the bolero, is nevertheless informed by the same kind of melancholy affect for the condition of man. The rhetorical gestures of the poem—using affectionate diminutives whilst evoking melancholy (he is a "gloomy mammal," born "very very tiny"), pretending coldness while evoking the opposite—are specifically meant to elicit emotions of pity and fellow-feeling from the reader. What changes the register of these poems and makes them ring differently from their fellow, the sentimental indigenist work of art, is the mundane nature of their subject matter—the pitiful and slightly comic body of the urban (or rural) worker. Nevertheless, the banality of these poems' subjects is intimately connected back again with what can only be termed a sentimental melancholy:

> Considering his general documents
> and scrutinizing with eyeglasses that certificate
> which proves he was born very very tiny,
> . . . I give him a sign,
> he comes,
> and I hug him, moved.
> What more is there! Moved . . . Moved.
>
> (*Posthumous Poetry* 72)[26]

What we must translate in English as "moved" is *emocionado*, literally speaking, "emotioned," and it is this which saturates the poem, as it says, *con afecto* (with affect), with a melancholy and ultimately sentimental affection.

Dark Mothers, Modern Women

In chapter 2, I traced the subtle but effective conflation of figures of laboring women and indigenist sensibility in Vallejo's first two collections of poetry. This was a gesture, as I noted, which gave him the representational tools he needed to negotiate his own response to the changes wrought by modernization in Latin America. However, being in Paris presented both

a different landscape and an intensifying of questions of race, gender, and identity. By 1926, Vallejo had rather carefully positioned himself, via his journalism, as a poet and a commentator on Latin American national concerns with an ancient indigenous heritage and on the particularly urban, modern characteristics of European life. One of the threads which ties together his poetry with his prose at this time is his appeal to a sense of melancholy, a sense which is driven by these two apparently opposite things: modernity and ancientness. As we have seen, Vallejo's gestures toward indigenous life and culture (either ancient or contemporary) cannot step away from this sense of melancholy; and, in the face of the modernity of Paris, an appeal to the unmodern domesticity of women needs to establish itself both spatially and temporally farther and farther away from the present.

Vallejo's dependence on a poetic stance of both sentimental and intellectual melancholy and its counterpart nostalgia was, as I outlined in chapter 1, a traditionally male prerogative in Latin America and functioned to express as well as to contain masculine anxieties about the changing roles of women. In fact, clear parallels existed between the popular anxieties being expressed about women and reproduction in Europe, the United States, and Latin America. The historian Mary Louise Roberts has described the French pro-natalist campaign instituted after World War I, designed to encourage women to stop working and start reproducing; Rita Felski notes that in both Europe and the United States, "the equation of woman with nature and tradition, already a commonplace of early modern thought, received a new impetus from the popularity of Darwinian models of evolutionary development" (40). Not surprisingly then, Latin American men's renewed celebration of home, family, and motherhood were simultaneous with social Darwinist calls for women to once again take up their natural reproductive role and with state and public efforts to relocate women in the home (or at least to confine middle-class women to teaching and lower-class women to domestic work) (Bergmann et al. 29–30).

Vallejo's 1924 essay "The Women of Paris," published in the Trujillo newspaper *El Norte,* echoes—indeed, almost word for word—post–World War I anxieties about women's increased social freedom, motherhood, and depopulation in Europe and North and South America. French legislators were strongly influenced by the popular idea that the new women's fashions, such as bobbed hair, were signs of women's sterility or at least their

unwillingness to have children (Roberts 63). In response, the French adopted natalist rhetoric and agendas in the 1920s, extending the 1919 law banning propaganda for contraception and abortion: the French woman, it was thought, "was no longer interested in giving life because she wanted to 'live her own life'" (Roberts 102, 120). Echoing a contemporary French sentiment, which must have sounded to him very much like Latin American anxieties about women and motherhood, Vallejo characterizes the Parisian woman as "sterile" specifically because she is participating in active ways in the modern city: she is out in public on the boulevards, and she works

> at the side of man, in the office, in the workshop, in the factory, in the campaign, and in this way, lives the same preoccupations and fights for existence as he does, into which the angular instinct confronting the species does not enter . . . [and] if she will rise or fall back, no one knows; but she is unnatural. (*Desde europa* 26)[27]

The image of woman "denaturalized" by modernization stands in contrast to the "new poet" of Vallejo's essay "New Poetry," published in July 1926 in his own short-lived Paris journal, *Favorables París Poema*. In this essay, the poet of the "new" is chided for employing only the *lexicon* rather than the spirit of "the voices of contemporary sciences and industries"—the "cinema, motor, horsepower, airplane, radio, jazz-band, wireless telegraph" (*Desde europa* 140). This essay, along with comments made in other essays, such as in the 1927 "Against the Professional Secret," has often been read as Vallejo's rejection altogether of avant-garde or modernist poetry. However, a more careful look reveals that the objects of modernity, for example, the "wireless telegraph," are not in themselves rejected. Their appearance in a poem must instead be infused, Vallejo asserts, with an "authentically new sensibility." Beginning with *Trilce*, Vallejo was always careful to position himself away from what he thought of as the more superficial or faddish enthusiasms which appeared especially in Peruvian vanguard poetry. These took the form of the sprinkling about of a few stock images or words—airplanes and autos or Quechua and Aymara words—to make the poem modern and/or indigenous. With the more authentically new sensibility he is advocating here, though, modern things are "destined" "to awaken new nervous temples . . . pro-

found sentimental perspicacities, amplifying clairvoyances and compre-
hensions and densifying love; uneasiness thus grows and exasperates and
the breath of life, revives" (*Desde europa* 146–147).[28] That is, instead of
saying "cinema," Vallejo urges the new poet to convey a "cinematic emo-
tion" (147). These two essays imagine an internalized affect of modernity,
one which, like modern technologized spaces and objects, is a specifically
masculine one, and one which can (and should) be handled by a masculine
poetic sensibility. If women occupy and internalize such a modern sensi-
bility as they inhabit the factory, the office, the political campaign, they will
lose their real nature. Women and modernity alike must stand in their
proper relation to each other and in their proper relation to the modernist
poet, lest they both be, as "The Women of Paris" puts it, "antiesthetic"
(*Desde europa* 77).

Poetically speaking, this conservative stance serves Vallejo well, allow-
ing him in his best poetry to escape formula as well as dogma. But it is also,
at heart, what drives the use of both male and female peasant and laboring
figures in his poetry. The figure which could aid in negotiating the inher-
ently racialized overtones of what it meant to be a modern man was the
nostalgically invoked, sacred figure of the provincial mother. In something
like the same way Rivera uses the all-embracing female body to remind his
viewers of their essential Mexicanness, Vallejo, in a number of his poems
between 1923 and 1928, finds in the mother's mestiza body the more com-
modious touchstone he will need for an authentic and simultaneously
committed Peruvian identity, as in his 1927 "Spine of the Scriptures":

> *I've come now to Paris now to be a son. Listen*
> *Man, truly I tell you that you are the ETERNAL SON*
> *even though to be a brother your arms are barely equal*
> *and your malice toward being a father, is much.*
> (*Posthumous Poetry* 34)[29]

Vallejo's changing sense of the temporal nature of things is in part
predicated on a sense of homesickness which implies not merely the look
backward over the space of the trip between Lima and Paris, but a look
backward to another time altogether—the premodern time of the sierras,
the small provincial town, and the mestiza mother.[30] Again, the persona of
"Spine of the Scriptures" notices for the first time not just that he is a

Peruvian, but that the measure of his Peruvian "son-ness" is literalized in a physical (and metaphorical) evocation of his size compared to his mother: "My mother's size, moving me by the nature of movement / and making me serious, reaches me exactly at my heart."[31] Vallejo's sense of being a Peruvian, already heightened by being a foreigner, becomes intimately connected with his sense of being a son not only of his mestiza mother but of Peru itself, as the first lines of "Spine of the Scriptures" indicate:

> *Without having ever noticed it never excess through tourism*
> *and without agencies*
> *breast to breast toward the mother I unanimate.*
> *(Posthumous Poetry* 35)[32]

The literally conserving function of the maternal figure provides an authentic, rather than "touristic," place from which to begin to negotiate a sense of the nowness as well as newness of modernity.

In the years after the Mexican Revolution, one of the functions of Mexican public art was to represent the inclusion of the indigenous and peasant populations who had fought during the civil war. But further, this inclusive gesture was meant to be a transformative one as well, both racially (away from Indiannness and toward mestizaje) and in terms of the capacity for violence still implicit in the very presence of indigenous and peasant bodies. Mexican murals painted both during and after Vasconcelos's tenure often adopted the theme of indigenous, peasant figures forming a base for an upward-moving, modernizing, transformative vision.

In these reimaginings of the transformative powers of the state, representations of the animalized passivity of the dark and/or indigenous female body serve to release into the communal imagination a fecund and natural body as foundation and source for the new nationalist unity of race (the mestizo or "cosmic" race) and technology to come: "the inferior races, once educated, will become less prolific, and the better specimens will ascend on a scale of ethnic improvement" (Vasconcelos, *Cosmic Race* 32). The works of artists and intellectuals such as Rivera and Vasconcelos are ways in which a reimagining of the "New World" modernism would, like United States modernisms of the time, "stretch old categories of race and ethnicity by looking for the languages [and images]" in black, Indian, mestizo, or mulatto experience (North 160).

The theme and location for Rivera's first public mural was assigned to him by José Vasconcelos in 1922 (only three years before Vasconcelos published *The Cosmic Race*). On the same site where a mural depicting the theme of human evolution had been planned in 1910, *The Creation* shows the uplifting of the (Indian and peasant) races by the arts and sciences. This mural adorned an entrance wall to the most important secondary school in Mexico, the National Preparatory School in Mexico City (where, coincidentally, Frida Kahlo was a student). Not unsurprisingly, since Rivera's European career as a Cubist was well-known at this time, *The Creation* was termed by one contemporary viewer a "cubist decoration" and by another a "modernist" or "futurist" mural; the work, in fact, articulated the look of an Italian Renaissance fresco through a Cubist deployment of geometric forms and voids (Folgarait 40).[33] As would often be the case in Rivera's murals, it is a heavy-set, seated, nude, indigenous woman who occupies the base of this mural and, importantly, represents "Eve" (Helms 238); she is looking upward at the figures representing "Emanations of the Spirit of Woman" (Faith, Hope, Charity, Comedy, Song, Music, and Dance) with an expression of dumb wonderment on her face (239); the materiality of her thick features and curved, heavy body are made even more block-like and physical by the use of Cubist-inspired geometric volumes and shading. All the figures in this mural are female (save for Adam and the figure of "Emergent Man"), coinciding with Vasconcelos's neo-Classical idea of the Muses. Although it is sometimes difficult to determine which figures are indigenous, both Tradition and Justice clearly are. On the right side sits a lighter-skinned Hispanic or mestizo Adam with his back turned to us, and in the middle of the fresco rises "Emergent Man," the culmination of Vasconcelos's idea that the "fusion of racial strains, . . . education through art, . . . the practice of virtue taught by the Judeo-Christian religion, and the wise use of science to control nature can lead Man to absolute truth" (Billeter, *The Blue House* 14–16).

The shift from the symbolic nature of maternal or more generally female figures to that of the male worker-body is presaged in Rivera's early work, perhaps most especially in his Chapingo Chapel murals, which he painted between 1926 and 1927. This building, which had once been the Catholic chapel of a huge privately owned hacienda, was slated to serve as the assembly hall of an agricultural school; here, Rivera was given the opportunity to "emphasize two philosophical ideals of overwhelming pertinence

to the agricultural students who would gather within it"—revolution and land reform and the beauty of the "mother earth" (Helms 220). But the conceptual problem of the mural was that, for Mexico, revolution would point two ways: toward the revolution of agrarian reform and toward the communist revolution of labor. Such a tension manifests itself in the ways in which the communist agitator portrayed in the northern panel, *Birth of Class Consciousness,* rouses the peasants by pointing to a hammer and sickle and to oppressed miners laboring underground, while on the southern wall *Blood of the Revolutionary Martyrs Fertilizing the Earth* shows the bodies of the agrarian revolutionaries Zapata and Montaña feeding the roots of a cornfield beneath a great sunburst. It also manifests itself in the ways in which Rivera must integrate both women and Indians into his vision of modernity on the eastern altar wall, called *The Liberated Earth with Natural Forces Controlled by Man.* Here, the center of the wall gives the viewer a scene of electrical and mechanical power deriving from natural forces: a windmill, a turbine, and the gift of fire are presented to an upright, muscular, nude male figure with his back to the viewer. This figure is surrounded on both sides and on top by three female figures: dominating the wall, and towering over the lower half of the wall, is a huge nude mother-earth figure, modeled after Rivera's pregnant wife, Lupe Marín; she holds one hand upright in blessing, the other hand holds a seedling. On the left side is a figure of Tina Modotti, also nude, shading her eyes from the fire being given to the central male. In the lower right-hand corner a nude female with her back to us reclines on the earth; her body is limned along its back by fruits and plants. She is looking toward the male figure and is clearly Indian, identifiable both by the color of her skin and by the long braids down her back. Next to her kneels a small dark-skinned child, also with his back to us, holding two electric coils which spark over his head. Rivera also connected his *Liberated Earth* with another panel of the chapel entitled *Subterranean Forces.* Like many moderns, Rivera was attracted to ideas such as the Asian notion of yin and yang, and he translated this idea into the notion that, just as darkness was transformed into light and the unconscious into the conscious, the feminine would necessarily be transcended by, and transformed into, the masculine. Thus, in *Subterranean Forces* he depicted three dark-skinned female nudes, or "spirits," moving upward through the earth, to be transformed, as they reach the light, into a male figure. This male figure in turn

would be he who would receive the universal energies and transmute them, in turn, into modern forces for the benefit of humanity.

In *Liberated Earth*, then, the arrangement of the male figure with the child and Indian mother is clear: this is the new Mexican family, whose melding of the Indian with the modern is always a pairing of the dark mother/dark earth with the masculine forces of modern energy. Compared to the murals Rivera would be painting only three or four years later, this is a singularly clumsy one: the "forces of nature" do not seem so much liberated as jammed into the wall space helter-skelter with their "liberator"; the rounded, supine modeling of the women and the earth are at odds with the angular, upright lines of the male figure and his modern forces. Nevertheless, the very awkwardness of the mural speaks to the fact that Rivera was confronting the problem of representing more complex relationships in terms of the dualities inherent in the rhetoric of nationalism: traditional and modern, earth and machine, mapping these onto the seemingly more basic organizing binaries of Indian and non-Indian, female and male.

Brother Men

I have already begun to note that as Vallejo and Rivera became more committed to a socialism which required the privileging of the worker in an industrial setting, their representations of the maternal figure begin to slip away. As he would do in his first two collections, Vallejo takes the popular move of sacralizing the ordinary and even the profane to play around with a conflation of the Holy Family and the mundane family, as in "Spine of the Scriptures":

> *My meter is measuring two meters already,*
> *My bones agree in gender and number,*
> *and the word made flesh lives among us*
> *and the word made flesh lives, upon my sinking into the bath,*
> *a high degree of perfection.*
>
> (*Posthumous Poetry* 34)[34]

Playing on the homology between the *lomo*, or "spine," of the sacred scriptures and the spine of the human body, this poem materializes the sacred, bringing it down to the level of the physical body. The last two lines of "Spine" quoted above are both serious and ironic; in the face of

modernity's loss of faith in the transcendent, Vallejo finds that it is the "son" of Peru, the masculine body "Peruvianized" by way of its arrival in the world via the provincial mother, which is the highest degree of perfection we can attain in this world, a world which is no longer connected to the sacred space of the scriptures but sunk in the everyday, banal necessities of the body.

Similarly, in his poem "It was Sunday in the clear ears of my burro," Vallejo takes the sentiments of his mother poems—nostalgia and homesickness—and again changes their register by invoking the mundane, everyday aspects of the persona's own body, meanwhile maintaining an ironic stance toward the sadness engendered by the distance he perceives between himself and Peru/the mother:

> It was Sunday in the clear ears of my burro,
> of my Peruvian burro of Peru (Pardon my sadness)
> But today it's already eleven o'clock in my personal experience,
> experience of one single eye, nailed right in the chest,
> of one single burroed, nailed right in the chest,
>
> So do I see the painted hills of my country,
> rich in burros, sons of burros, fathers now in sight,
> that now turn painted with beliefs,
> horizontal hills of my sorrows.

(*Posthumous Poetry* 62)[35]

Here, rather than use the imperfect tense for "used to be," which would be the grammatical one for description in the past, the persona uses the preterite—*fue*, or "was"—to indicate the importance of a temporal disjunction, the over-and-done-with pastness of this particular Peruvian scene. What he sees now, in Paris, in his mind's eye—"nailed right in the chest"—is merely a representation of Peru, a formulaic painted scene of the Andean sierras replete with the requisite burros. In temporal contrast, today, where he is, it's eleven o'clock and he is standing not in front of a boring and stupid scene of the Peruvian countryside but in front of a statue of Voltaire, emblem of reason and European Enlightenment: "In his statue, with a sword, / Voltaire swirls his cape and looks at the square." But looking at Voltaire, in this public Parisian square, the Peruvian facticity of

the persona's body shows itself both faintly ridiculous and, again, melancholy. As the years spent in Europe inscribe themselves on his physical body like grooves on a record, the temporal (and social?) distance measured between the presence of Voltaire and the memory of Peru makes its impact felt: his very hair hurts, the hair he wears (possibly literally) in a patriotic, that is Peruvian, style:

> *sound of years in the murmur of my arm-needle,*
> *rain and sun in Europe, and, how I cough! how I live!*
> *how my hair hurts on glimpsing the weekly centuries!*
> *and how, with a twist, my microbial cycle,*
> *I mean to say my tremulous, patriotic hairstyle.*
> (*Posthumous Poetry* 62)[36]

If sentimental indigenist rhetoric adopted the legitimizing language of science to bolster its reformist claims, here, Vallejo's pseudo-scientific language tends to ironize the sentimental impulse of the poem to dramatize feeling—nostalgia, melancholy, love of one's mother and one's country, homesickness—as something higher or more transcendent than the material fact of the human body. Instead, being confronted by the very embodiment of the scientific Enlightenment project, the persona finds that scientific probings into the distinctly untranscendent physicality of the body and the world it inhabits make for a literalization of Vallejo's earlier attempts at desacralizing the "word made flesh," as in his "Spine of the Scriptures."

Paisano Rivera

In 1930, when Rivera came to San Francisco, his arrival was heralded in the *San Francisco Chronicle* this way: "A jovial, big jowled 'paisano,' beaming behind an ever-present cigar, . . . a broad-brimmed hat of distinct rural type on his curly locks, . . . piled domestically suitcase after suitcase . . . into the car. One looked for groceries or a canary cage to complete the 'bundle' picture" (qtd. in Lee 57). As Anthony Lee points out, this picture of the controversial (and controversially political) Rivera aims to rusticize as well as domesticate him: "The peasant Rivera is touchingly and surprisingly *of* his country, yet the rustic normality and simplicity he exudes allay concerns about his political temper" (57). But Lee also reads

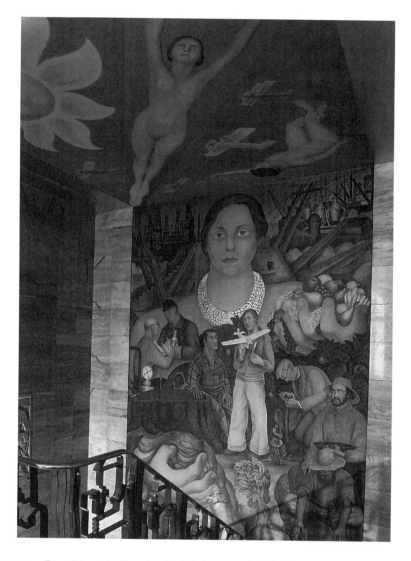

FIG. 3.4. Diego Rivera's San Francisco Stock Exchange mural titled *Allegory of California* (1930). Reproduced by permission of Stock Exchange Tower Associates.

another level encoded into such descriptions, that of journalistic editorializing about fears of racial difference and the dangers of migrant labor to the depression-hit state: such descriptions as those above "echoed common descriptions of Mexican migrant workers in their broken-down jalopies" (63). There is, in fact, yet a third level of interpretation available here: this

journalism reflects Rivera's own self-mythifying, presenting himself as a simple and rustic peasant painter of the people, who came from humble origins. This was pretty far from the truth; Rivera came from a solidly middle-class background, fulfilling the dreams of every artist of that class by moving to Paris, and coming back to Mexico only after spending thirteen years in Europe as a Cubist painter. The mythology surrounding Rivera is, of course, also part and parcel of his highly public (though actually quite vexed) communist stance. If Rivera was indisputably, with his wide girth, his peasant hat, his miner's boots, and his well-publicized affairs with women, a man of the people, his earlier use of female figures as central foci for a sense of foundational solidity in his murals would increasingly change to focus on male figures as central to the new state. The finality of this shift is apparent, for example, in some of the differences between his 1930 *Allegory of California,* painted for the new San Francisco Stock Exchange Club, and his 1931 California mural *The Making of a Fresco, Showing the Building of a City,* commissioned for the California School of Fine Arts.

One of the differences between 1929 and 1930 was, of course, the crash of the stock market and the beginning of the Great Depression. But between 1921 and 1931 Rivera's ideal audience for his murals had changed dramatically, in part because of the changing nature of Rivera's various commissions, patrons, and sites. He had been kicked out of the Mexican Communist Party for continuing to paint murals for the Mexican government, which by that time was seen as increasingly conservative; and he was being attacked by conservatives as a communist. When he was offered the *Allegory of California* commission, it seemed like a good time to leave Mexico. His new mission, as he conceived it, was to help to lead a worker's revolution in the United States; and as he began to paint for United States patrons and United States audiences, the murals become less didactically populist—less oriented toward teaching the illiterate masses both their present place and their past—and more overtly socialist—oriented (at least ideally) toward worker-viewers and patrons alike.

Perhaps following his idea for the 1930 *Allegory of California,* where the (slightly generalized and darkened) image of Helen Wills Moody, the famous tennis player, holds in the curve of her arms an array of industries, from mechanized coal mining to airplane invention to gold mining to Luther Burbank's crossbreeding experiments (fig. 3.4; Helms 279–280), Rivera's

first cartoons for his mural *The Making of a Fresco, Showing the Building of a City* (painted in 1931) show that he planned to put the figure of a large, fecund woman in the central panel, embracing, like the *Allegory* figure, the industries needed for building the city. This figure was also to play a unifying role for the entire mural, again, like *Allegory*, bringing agriculture and industry together. By the time the mural was finished, however, the central figure had been transformed into an male factory worker (with a small but still conspicuous hammer and sickle emblazoned on his shirt pocket). In this fresco, the deliberate slippages between the space of the laboring fresco painters and that of the laboring city workers make it clear that a connection between both kinds of work as labor is being aimed at (fig. 3.5). However, it is also clear that for Rivera, women's labor is so obviously different from masculine work that the previous design, featuring a large central female figure, would ultimately not be adequate to the message of the mural itself. In the first cartoon Rivera drew for the mural, the connection between the fecund and all-embracing woman and the laborers around her seems to direct attention away from the labor of the workers as well as of the mural painting itself. Inserting, in place of the mother-earth figure, the central figure of the factory worker, on the other hand, underscores a commitment to (male) labor while it makes the flowing of organic human into inorganic production that much easier.

Allegories of Tennis

Palma Guillén de Nicolau, one of Gabriela Mistral's companions, recalled the Mexico City scene of the early 1920s under the aegis of Vasconcelos in this way: "In the Capital, the Secretary of Education was editing the Greek classics, Plotinus, the Gospels and the Divine Comedy and in the Amphitheater of the Preparatory, decorated by Diego Rivera and chock-full, we listened to Beethoven's symphonies" (qtd. in Marchant 83–84). Vasconcelos, and other elites like him, dreamed that the masses would be uplifted by such programs of Beethoven, public art, and classical literature. Although Rivera began painting murals under Vasconcelos, he (Rivera) would very soon reject Vasconcelos's mysticism and Euro-Hispanicism for a more American, socialist, and indigenist vision, one which imagined the masses transformed not by Beethoven and the *Inferno,* but by their (re)adoption of folk art and culture. Neither Vasconcelos nor Rivera, nor Vallejo for his part, thought that popular culture—that is, the culture of

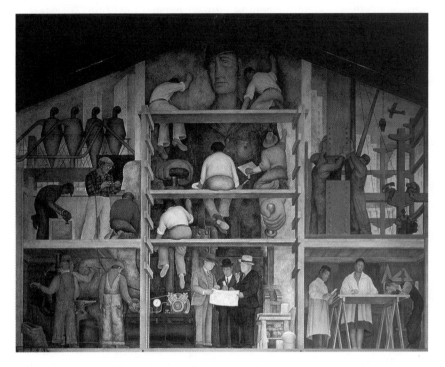

FIG. 3.5. Diego Rivera painted *The Making of a Fresco, Showing the Building of a City* in 1931 at the San Francisco School of Art. San Francisco Art Institute, gift of William Gerstle. Photo: David Wakely.

mass production and widespread technology—was the proper tool for the unification and uplift of the people. Yet in the late 1920s and early 1930s, both Vallejo and Rivera felt it necessary to respond in some way to popular culture, and one of the ways in which they both chose to do so was through the growing interest—one might even say craze—for sports. Of course, by the 1920s women were becoming prominent in sports such as tennis and swimming, and the changing circumstances of the presentation and representation of women's bodies are particularly felt in Rivera's work after 1930.

By the mid-1920s, Coco Chanel's "little black dress," loose cardigans, pants, and sporty, loose clothes for women were instantly recognizable in any newspaper or fashion magazine. She had reinvented women's fashions, sweeping away both the corsets and tight skirts of the Edwardian era and the overly extravagant colors, prints, and accessories of the Jazz Age with her

little black dress, which *Vogue* instantly designated the "Ford" of fashion: one color, practical yet modern in its simplicity, it was easily mass-produced; and Chanel was apparently delighted when U.S. manufacturers made knock-off versions of her dresses for the mass department-store market. With her sleek hats, loose yet slim clothing designs, and trousers for women, it is not exaggerating to say that Chanel transformed European, Latin American, and United States visions of women and how they should look. Her own look, which she promoted endlessly, was slim and boyish and echoed the new woman's sporting body—slim, streamlined, and fast. In the United States, such a transformation seemed to be repeated in the rise to prominence of women sports stars, such as Helen Wills Moody. From 1926 to 1932, this Californian tennis star became the epitome of the new sporty woman, the kind who would naturally wear Chanel's clothes. Wills Moody dominated the tennis scene in those years, never losing a singles play; among her other achievements, in 1924 she brought home two gold medals from the Paris summer Olympics. Pretty, but with a stoic demeanor on court, her face was everywhere by the mid-1920s; in pictures of her from that time, she wears the jaunty cloche hats and loose but slimming clothes that designers like Chanel promoted. She was truly a popular star. Rivera knew Moody, and from the 1930s to the 1940s he was quite taken with the figure of the woman sports star. In 1940, he used the lithe and streamlined figure of the national Amateur Athletic Union indoor diving champion Helen Crienkovich as an organizing element in his San Francisco *Pan American Unity* (Helms 310). Despite her connection with popular mass media, the figure of the sporting woman seemed to Rivera to embody yet again the spirit of the North: all that was modern, speedy, and new. But earlier in 1931, when Rivera was commissioned to paint a mural for the new San Francisco Stock Exchange Club, he made the decision to paint the tennis star Wills Moody as the "Allegory of California," a mother-earth figure holding the bounty of California in her arms. As Anthony Lee notes, Rivera's use of a recognizable figure in the *Allegory of California* caused some trouble: when early versions of the mural were shown to the press, the San Francisco *Chronicle* asked, "'Who posed for "California," heroic figure in the Diego Rivera mural. . . . Are the deep eyes, the classic brows of the fresco those of Helen Wills Moody in the guise of the artist's ideal of California womanhood?'" And Lee continues, "She [the Allegory] is the single figure who asks to be interpreted, not as a

historical personage, worker, or type, but as a large metaphor, her seminudity encouraging this identification. . . . But . . . Moody's identity intervened, and her bodily presence upset the balance of allegory and realism" (72). The changes Rivera made in the figure never did convince people that it was not Helen Wills he was portraying; but they did succeed in changing the compositional depth and integrity of the mural, so that although the "iconography was familiar, since it was gleaned from the promotional language of big business," the mural seemed ultimately to lack the unity, "message," and sense of containment Rivera was always striving for (Lee 73). Although Lee reads this failure as a product of Rivera's own continuing critique of capitalism, I read Rivera's use of Moody in another way. Cut loose, in the United States, from his dependence on the mother figure who images a static, premodern, temporal space, Rivera must rethink the kinds of allegorized female figures he uses, as well as their temporal place in the more overt narratives of modernity he is painting for his wealthy capitalist patrons. But although he is clearly taken with the image of the new woman, whose body he associates with the speed and clean lines of the airplane (two more "Moody" figures decorated the ceiling of the Stock Exchange Club, flying next to planes across the ceiling), the associations such women had in people's minds, with modernity and sport rather than with maternity and domesticity, make them unlikely candidates for a premodern earth goddess, much less for the conflation of folk/Indian/mother/earth he relied on so successfully in Mexico; so for Rivera as for Vallejo, men's bodies would increasingly be much the safer bet in allegories of tradition and modernity.

Vallejo, with his typical conservatism, commented acerbically in several essays on the craze for sports and in 1927 wrote an entire essay for *Variedades* called "Life as a Match" (La vida como match), where he deplores the urge for "records" of all kinds, attributing the desire to make and break records to the overpopularity of sports and, ultimately, to competitiveness and patriotism): "The 'match' is made for self love, for patriotism, to get money, for so many other stupid and egotistic motives, in which the evil of man is mixed with the good sweat of the animal" (*Desde europa* 233).[37] Although the indictment of patriotism might surprise us, given that Vallejo makes it clear that he is himself a Latin American patriot, the terms under which he is accusing the sports match (and the sports record) are political: he sees, in sports played for capitalist competition or for the glory

of the homeland, a kind of unthinking patriotism of which he would be naturally suspicious; it is a tainting of the good sweat of the innocent, animal aspect of the human being with bad political aims. Around this time, Vallejo also wrote a "tennis poem" which echoes the sense of his 1927 essay while it takes the tennis match as a metaphor for a better kind of politics; it is a poem which might serve as a parallel to the ways in which Rivera used the sporting body in some of his murals, and it is worth examining in full here:

> *The moment the tennis player masterfully serves*
> *his bullet, a totally animal innocence possesses him;*
> *the moment*
> *the philosopher surprises a new truth,*
> *he is an absolute beast.*
> *Anatole France affirmed that religious feeling*
> *is the function of a special organ in the human body,*
> *until now unrecognized and one could*
> *also say, then,*
> *that, the exact moment when such an organ*
> *fully functions*
> *the believer is so clear of evil,*
> *he could almost be said to be a vegetable.*
> *Oh soul! Oh thought! Oh Marx! Oh Feüerbach!*
> *(Posthumous Poetry* 42)[38]

Although the popularity of the sports match earns nothing but contempt from Vallejo, here he tries to capture one moment in the match, the moment when the innocence of a purely animal body engaged with the world takes over the machinations of human thought. The irony that this should be the perfect human moment—the moment of pure (animal) being when a philosopher "surprises" a new truth, for example—is not lost on the speaker of the poem, of course: the fact that thought and a pure animal nature can never be reconciled is clear in the ludicrous picture of the believer as a vegetable. Thus, the focus during a sports match on that zone when the body fully takes over from the distractions of the mind serves for Vallejo as a metaphor for the irony of a Marxist materialist, non-transcendent stance which nonetheless requires the seeming non-materiality

of intense concentration. It is important to note that here, as in almost all his poems from this time, all the poem's figures, including the tennis player, are masculine; for Vallejo, the popularity at this time of women sports stars notwithstanding, the materialist body par excellence will remain the masculine body.

Chaplin's Body

As I have been emphasizing, Latin American modernists, like many intellectuals of the time, often separated their public selves and their work from associations with urban mass culture: popular cinema, the sensational crime pages of the newspapers, romantic boleros on the radio, the illustrated *folletín,* or "pamphlet."[39] However, as I have been arguing, Latin American modernism itself, despite its disdain for mass culture, depended on much the same vocabulary of sentiment as could be found in low entertainment. Here, I find Susan Hegeman's discussion of "lowbrow" and "highbrow" culture in the United States useful in working through the distinctions that modernists thought they were making. Hegeman's argument demonstrates that in the United States the divide between low and high culture was not as rigid as it might seem; and, in Latin America as well as in the United States, the media—and audiences—for high and low forms were more varied than has been imagined. Describing the popularity in the United States of classical music programs on radio, Hegeman also observes that Charlie Chaplin's mixture of "British music-hall comedy, Hollywood sentimentality, and pointed social criticism" captured the admiration of the people and highbrow intellectuals alike in both Europe and the United States (17–18). In Latin America, too, Chaplin gained the admiration of elites and intellectuals alike. Diego Rivera visited him and his wife while in the United States and painted Chaplin into his 1940 *Unity of the Americas* mural in San Francisco. From Paris, César Vallejo wrote eloquently of Chaplin on several occasions. Chaplin's films routinely deployed the tearful and highly emotional affect of melodrama, whose social critique was most powerful when most sentimental and whose drama, when it cut too close to the bone, exchanged tears for laughter; however, modernists like Vallejo and Rivera were able to ignore—or bracket off—what might have been troubling aspects of Chaplin's lowbrow, even kitschy sentimentalism. At bottom, it was Chaplin's expression of a sentimental leftist politics, mainly through his worker persona, which

appealed to these intellectuals' nationalist-socialist sympathies, just as it appealed to them in Chaplin's contemporary, the Mexican comic and film actor Cantinflas. In fact, as Carlos Monsiváis notes, by 1940 the celebrated Cantinflas (who was sometimes identified as the Chaplin of Mexico)[40]

> becomes synonymous with the poor Mexican, representative and defender of the meek. At the same time, he is a one-man film industry and also a branch of popular craftsmanship. . . . [The press] constructs an identity: Cantinflas is the same as Chaplin—not because of his histrionics but, rather, because of the shared roots of both characters: the social defiance, the poetry, the wild romantic passion of the dispossessed. The Tramp and the *peladito*. (102–103)[41]

In 1930s Mexico, the poor identified with Cantinflas while the elite celebrated him.[42] But as Stavans notes, when lowbrow Cantinflas talked to an imagined elite socialist audience, his "verbal pyrotechnia" was at its height, as in this interview published in the *Excelsior*, 20 October 1938:

> Let's see: You want to know what's been my best performance? And I have to tell you that. . . . What do I have to tell you? Or do you tell me? OK, but what is this mess? All right, one more time: you want me to tell you what has been, is and will be, through historical-materialist-dialectic becoming, the best of my proletariat performances. And I believe that . . . the best of all my performances has been the rational and exact interpretation of the Universe, according to Article Three. What? That's not it? OK, so what are you talking about? (qtd. in Stavans 46)

Here, Cantinflas makes fun of the public rhetoric, used by the Mexican government, of "rationalism" and "socialism," satirizing the *pura palabrería* (excessive but empty words) of Mexican politicians and making clear the connections between a supposed lowbrow comic such as Cantinflas and the nationalist and modernist celebrations of mexicanidad. The filmmaker Gabriel Figueroa shot seven of Cantinflas's movies; together with Emilio "El Indio" Fernández, Figueroa also made what are arguably some of the most famous "Mexicanist" movies, including *Flor Silvestre* and *María Candelaria*, the latter starring Dolores del Río. These two filmmakers embedded the lowbrow comic antics of Cantinflas in the Mexican popular

imagination and simultaneously contributed to the modernist "black-and-white esthetic . . . of Mexican . . . peasantry" (Stavans 47), an esthetic which, as we will see in chapter 4, was continued in the interest of photographers in a modernist Mexico.

Rivera, who knew Dolores del Río well and is supposed to have encouraged her to play the title character of a poor Indian girl in the famous indigenist film *María Candelaria*, painted portraits of, or painted into many of his later murals, stars whose popularity depended on their mass-culture appeal: Dolores del Río, Cantinflas, Chaplin, Paulette Goddard, Helen Wills Moody. But modernists like Rivera still had their own lowbrow-highbrow distinctions. For example, the (often feminized) emotionalism and superstition of the Catholic faith of those selfsame masses was a matter for concern and even derision for leftists like Rivera.[43] In his controversial 1953 mural at the Mexico City Teatro de los Insurgentes, for example, Rivera painted Cantinflas as the hero of the people but included an image of the Virgin of Guadalupe on his (Cantinflas's) raincoat. Backed by the national press, the Catholic Church (which had regained much of the strength it lost under secularist attacks both during and after the Mexican Revolution) could not ignore such a blatant sign of disregard; outraged, the church accused both men of blasphemy. Rivera was forced to remove the image while Cantinflas publicly protested his own faith (Monsiváis 103–105).

In the late 1930s and early 1940s, it was not Cantinflas whose image Rivera used, but that of Chaplin: in part because Chaplin would be recognizable to United States audiences and in part because Chaplin, too, was responding to the political crises of the day in very immediate terms. Too, Rivera tended to paint people he knew or had met; just before beginning work on the San Francisco Art-in-Action mural project called *Pan American Unity* (Lee 252, n54) in 1940, Rivera met and stayed with Charlie Chaplin and Chaplin's costar, Paulette Goddard. In the mural, then, the grisaille section located below a panel titled *Trends of Creative Effort in the United States and the Rise of Woman in Various Fields of Creative Endeavor through Her Use of the Power of Manmade Machinery* included scenes from Charlie Chaplin's movie *The Great Dictator*, with Chaplin's figure surrounded by the figures of Stalin, Hitler, and Mussolini (Helms 311). By 1940, the Hitler-Stalin pact and the revelation of Stalin's purges had made Communist artists ever more anxious about what a committed art might look like or what story it might tell. Additionally, the murder of

Trotsky in August 1940 (Rivera had originally given Trotsky shelter in Mexico, but they had fallen out and Rivera had left the IV International) meant that what Rivera might paint in his next mural was a subject of some concern; so, as Lee notes, Rivera's claim in that fall of 1940 that "democracy is the only way" "was one of the few stances Rivera could occupy in the radical political climate of late 1940" (207). *Pan American Unity* moved away from the more overtly Communist celebrations of labor and industry apparent in earlier works, such as *Making a Fresco* and the 1932 *Detroit Murals,* while the design still clung to Rivera's favored notion, that of the unifying of "North and South": "In the center of my mural there is a large figure—on one side it has the neck of Quetzalcoatl, elements from the Mexican Goddess of Earth and the God of Water. On the other side the figure is made of machinery, the machine which makes fenders and parts for airplanes. . . . People are working on this figure, artists of the North and South, Mexican and North American. . . . From the South comes the plumed serpent, from the North the conveyor belt" (qtd. in Lee 209). As Lee points out, Rivera chose not to confront the questions of leftism save indirectly, through the grisaille panels of the mural, where he compares "mural painting with film and Rivera with Chaplin"; but Rivera's continued celebration of the machine sits uneasily with Chaplin's own appeal, in the movie *The Great Dictator,* that "more than machinery, we need humanity" (qtd. in Lee 212); and equally uneasily, Chaplin's open refutation of Fascism in this movie cannot be directly appropriated by Rivera.

Three years before Rivera painted Chaplin into his *Pan American Unity,* Vallejo was writing poetry which continued one of the themes of his own post-1928 embrace of communism: that of brotherly or comradely love. As we have seen, this is a sentiment tinged both with melancholy and with a sense of the ridiculous, in that it is directed toward an animalistic, evolution-bound, and—all things considered—pretty banal and non-transcendent male body. Such a sentiment, which Vallejo used again and again in his poems between the late 1920s and late 1930s, would have seemed to him to be echoed perfectly in Chaplin's enactment of the poor, hapless, but immanently lovable characters created in movies like *The Gold Rush* (1925). Indeed, Vallejo had praised Chaplin in his journalism. His 1928 "The Passion of Charles Chaplin" describes *The Gold Rush* in this way: "This film forms the best requisite for social justice of which post-war art has been capable until now. 'The Gold Rush' is a sublime blaze of political unease, a

great economic complaint of life, a brazen declaration against social injustice. . . . With the years, there will be taken from 'The Gold Rush' unsuspected political programs and economic doctrines"(*Desde europa* 266).[44] In 1947, Vallejo again evoked the figure of Chaplin, this time as a symbol for the material and therefore political nature of the masculine body in his poem "For several days, an exuberant, political need has come":

> *For several days, an exuberant, political need has come to me*
> *to love, to kiss affection on its two cheeks . . .*
>
> *Ah to love, this one, my own, this one, the world's,*
> *interhuman and parochial, mature!*
> *It comes, perfectly timed,*
> *from the foundation, from the public groin,*
> *and, coming from afar, makes me want to kiss . . .*
>
> *. . . whoever suffers, to kiss him on his frying pan,*
> *to kiss the deaf man, in his cranial noise, undaunted;*
> *to kiss whoever gives me what I forgot in my breast,*
> *on his Dante, on his Chaplin, on his shoulders.*
>
> (*Posthumous Poetry* 178)[45]

Although Vallejo never specifically says so, what clearly motivates his admiration for Chaplin's heroes is their very (tragic) absurdity, an absurdity which manifests itself in Chaplin's physical comedy. The sentimental source of Chaplin's work lies in its evocation of pity for the central character as well as the melodramatic situations in which the "Little Tramp" finds himself. But in much the same way as Vallejo treats the masculine laboring body, Chaplin leavens the sentimentality of his films and orients them away from straight melodrama by creating a body which is both ridiculous and familiar in its banality. Such a representation elicits affection as well as pity; but finally the sense of identification both Rivera and Vallejo have with Chaplin rests on the fact that political affection is inextricably tied to the specifically masculine body; love, for both artists, comes from the (mestizo) masculine site of reproduction, the public foundation of solidarity, from the persona's *cosa cosa*, his "thing thing," his "little sound."

CHILDLESS MOTHERS

I have not been very "creative" Edward as you can see—less than a print a month. That is terrible! And yet it is not lack of interest as much as lack of discipline and power of execution. I am convinced now that as far as creation is concerned (outside the creation of species) women are negative— They are too petty and lack power of concentration and the faculty to be wholly absorbed by one thing.

—TINA MODOTTI, *TINA MODOTTI: PHOTOGRAPHS*

A S WE HAVE SEEN, Vallejo's Paris writings and Rivera's Mexico and United States murals were haunted, both consciously and unconsciously, by fears and questions of race, heredity, descent, barbarism, and the degeneration of man.[1] Although the work of Frida Kahlo (1907–1954) and Gabriela Mistral (1889–1957) was also inflected by these most modern of fears and concerns, the emphasis was different: Kahlo's and Mistral's works were not so much preoccupied with race as a central concern for the creative male body as they were with the problem of productive creativity as a central concern for the racialized female body.

Whether the discourses of mestizaje, Indianism, and eugenics were privileged or reviled, Rivera, Kahlo, Mistral, and Vallejo were all aware of their mestizo heritage even if they could still (in Latin America) present themselves as socially white. Such an awareness, as we have begun to see, inserted itself in complex ways into their art. Finding a way to conceptualize and show both separateness and the idea of hybridity or mixture was key to these artists' work; and at least lip service to the ideals of mestizaje and/or indigenism was important for all four. But especially for women,

mixture—either racial or cultural—was a much more complicated matter. In this sense, Kahlo and Mistral faced more difficulties of representation than did their male counterparts. Emphasis on their own status as artists was inextricably bound with their status as women; this meant that if they portrayed women, they were of necessity portraying (at least by analogy) their own bodies and hence their complex sense of themselves as mestizas. As women artists, they were not only expected but, in a social sense, required to be interested in certain subjects: love, children, and relation-ships, most especially the maternal relationship with children—all subjects which would seem too domestic and sentimentalized for male Latin Amer-ican modernists. Kahlo and Mistral did, and, in fact, in many senses had to, occupy themselves in representing the female body; if the only means at hand to do so involved presumably sentimentalized artistic and rhetorical strategies, these were the means with which they had to work. For Kahlo and Mistral, then, these considerations would make their modernism a dif-ferent matter. If, as others have argued, these two women had to perform themselves as women artists to a much greater degree than did male artists of the time, they managed to avoid censure only by transforming their own bodies into (modernist) female icons. In part this transformation had to be effected through something of a paradox: by presenting their public and artistic personas as seamlessly one with their (presumably private, since womanly) self-identity.

Art historian Anne Higonnet has pointed out that until very recently, most women could gain access to the world of high art pretty much only by adhering to the masculine values which structured it. Subject matter, of course, was inflected by if not dictated by such values. As in Europe, "Woman" was an accepted, and even necessary, high artistic subject for Latin American poets and painters, bourgeois and avant-garde alike. As well, by the 1910s avant-garde European art and Latin American mod-ernista writing had successfully allowed for the freer representation of sexuality. But, as Higonnet argues in the case of the French Impressionist Berthe Morisot, if a woman artist wanted to be a real artist (not merely a dauber of pretty pictures or a writer of pretty verse), she had to depict Woman; and if the woman artist wished to belong to the community of artists, she had to do so by at least seeming to identify with prevailing artis-tic dictates—whether mainstream or avant-garde—of how to represent Woman. The female artist struggling to be taken seriously, in effect,

needed to occupy a double position: that of producing an image which in its "to-be-looked-at-ness" mirrored her own social and material status as a woman. As Higonnet puts it,

If she [the artist] painted a female nude she would be painting a kind of reflection of her own body. She would therefore have to transform desire into being desired and enjoy pleasure by giving pleasure. For a woman who wanted to do the looking—and no one, arguably, needs to look more actively than an artist—identifying with a masculine point of view meant being two contradictory things at once: the one who looks and the one who is looked at. (52)

What made Kahlo's and Mistral's careers as women and artists all the more striking was the very public aspect of both their lives, especially at a time of heightened anxieties about women's place in the public sphere. For, if Frida Kahlo and Gabriela Mistral were women who "wanted to do the looking," they were also women who were constantly "looked at." Added to the mix was the fact that for the most part both women unquestioningly identified with a masculinist, if intellectual, and in Kahlo's case avant-garde, point of view. Kahlo herself did not receive acknowledgment of her work from her own government until 1941, when she was selected as one of twenty-five founding members of the Seminary of Mexican Culture, Ministry of Education (Lowe 120), but her connection to Rivera and, from around 1930 onward, the growing recognition of her own talents in the service of mexicanidad made her a public figure not only in Mexico but also in the United States and Europe. Mistral's first government commission came in 1922 from Mexico's José Vasconcelos, to assist in the state's efforts at creating a pedagogy specifically to educate women; in part because of their shared theosophical and Christian beliefs, Mistral continued to identify herself as a vasconcelista for the rest of her life, which was spent as a cultural ambassador in Latin America, the United States, and Europe. Upheld as the "spiritual mother" of Latin America and the "schoolteacher to the Americas," Mistral was constantly in the public eye; and to maintain her credibility she, like Kahlo, maintained political and artistic connections with powerful men throughout her life.

Although the above argument—that these two women in particular consciously constructed themselves not only in their art but in their lives

as women artists—is not a new one, I want to use it for two purposes.[2] First, as others have noted, such a reading avoids the more essentializing discussions of women's art which tend to conflate biography with iconography. Second, and more importantly, seeing these two women's personas as deliberately self-constructed will allow me to better demonstrate the extent to which the vexations which stand at the heart of Latin American modernism were on full display in their work. That is, because in the populist climates of Chile and Mexico the distances between what it meant to be a woman, to be an artist, and to be mestiza were far greater than for men, the problems that women might have had in conceptualizing a smooth integration of all three could never be completely erased.

Because of their connections with men like Vasconcelos and Rivera, who promoted and/or engaged in nationalist projects, Kahlo and Mistral were of necessity drawn into the American dialogue over the connected discourses of indigenism and mestizaje. And in becoming public figures, they were also women whose performance as women and hence as (at least potential) mothers was subject to judgment. So because their own contribution to such a dialogue had to come from the point of view of women who were always possibly maternal, both perforce had to acknowledge in their art the fact that theirs were bodies which could, in theory anyway, reproduce the nation's mestizo body.

The fact that both Kahlo and Mistral used personal (or, in the case of Mistral, slightly fictionalized personal) circumstances as preliminary motivating factors for much of their art has led many to think of their work as feminine in a normative sense, one which expresses purely personal and domestic concerns. At the very least, though, the writing, paintings, and even the photographs taken of these two women make it clear that they knew that their own clothes, hair, bodies, and faces, as well as their writing and/or painting, had public and political signification (Lowe 61). In fact, it need hardly be argued that Kahlo's and Mistral's art is as political as that of their male contemporaries in that they fashioned both their work and their own self-presentations in complex relations and negotiations with American modernist concerns.

As was true elsewhere, in Latin America both high modernist and low mass-culture images of the ideal modern national subject—produced either by the written word or in painting, photography, music, and cinema—were heavily invested in particular ideas about the true place and

function of ideal womanhood. In the 1920s and 1930s, women's entrance into the public sphere of work and commerce was offset, and to some degree controlled, by an increased public emphasis on the essentially maternal nature of the female body.[3] As a corollary, the growth of an economic and social middle class in countries like Chile, Mexico, and Peru emphasized the importance of the woman's presence in the domestic sphere rather than the productive sphere of public space; this stress, in fact, cut across class and race lines, since even indigenous and peasant women were connected closely with the reproductive sphere of domestic space, in spite of the fact that such women were most likely to be working outside the home and/or in the fields.[4]

By now it is a truism to point out that under such ideological pressures, it was difficult for women to reconcile serious attempts at artistic production with the desire—however socially constructed—for maternal reproduction. As we see from this chapter's epigraph, written by Tina Modotti, or from Kahlo's own words—"man is the constructor, woman the creator"—the extent to which the internalization of such a paradox was a real problem for such women cannot be underestimated (Billeter, *The Blue House* 155).

Although Mistral presented herself as a humble rural schoolteacher, her looks, heritage, education, and, ultimately, international political connections made her white, while Kahlo's fair skin and solidly middle-class upbringing also gave her the social space she could have used to assume an unproblematized whiteness. However, official Mexican indigenism, as Knight notes, had at least one dominant note: the need to show the Indian integrated into the workings of state and society, *forjando patria* (forging fatherland), as the Mexican anthropologist Manuel Gamio put it (82). The ideal for this particular kind of mestizaje was ultimately to dissolve the Indian racially into an Hispano-Indian mix, but the importance of anthropological thinking in the 1920s and 1930s ensured that Indian culture and folkways would still be passed along. The conflation of race and culture that this involved meant that even though the mestizo was an "ideological symbol" of the post-armed phase of the revolution, the increasing sense was that mestizos had no culture; indeed, according to Marjorie Becker, by the 1930s the Cardenista administration thought of them as, in a sense, "Indians without a soul" (28). Thus, as the fashioning of mexicanidad among the elites of the Mexican artistic community continued, it (paradoxically)

became important to foreground the Indian racial and cultural characteristics of an ideal mestizaje. Especially in Mexico, it was at least publicly popular to maintain "the optimistic belief that acculturation could proceed in a guided, enlightened fashion, such that the positive aspects of Indian culture could be preserved, the negative expunged" (Knight 86). In spite of the culturalist spin put on mestizaje, a strictly biological sense of race remained a vital part of such a project. Influential intellectuals such as Gamio and Vasconcelos believed firmly that race was inherent to one's character, since character itself was formed by, as Gamio had put it, "the physical-biological-social environment" (qtd. in Knight 88). As Marjorie Becker ironically says of the mid-1930s Cardenista administration's (re)invention of the Indian, "the Cardenistas . . . seized these wads of clay [the Indians] and fabricated true faces. . . . [The Cardenistas believed that] habitual exploitation promoted false habits. While artistic behavior occasionally flickered through the layers of oppression, Cardenistas could not depend on it" (64, 71). As Vasconcelos had done in the 1920s during the Obregón administration, in the 1930s Cárdenas asked for "a compilation of Indian and popular Mexican music . . . [and] rural teachers were instructed to 'seek a sampling of our folklore'" (Becker 70). Ignoring the fact that during the first thirty years of the century Mexico had at least fifty distinct Indian tribes, as far as Mexican administrations from the 1920s through the 1930s were concerned, "a true, authentic Indian was a singer, a dancer. This artist could sing or dance anything, regardless of the connection to a specific Indian culture. . . . Indians were . . . living advertisements of the revolutionary concern for the downtrodden"—but because, under the heel of oppression, they had lost their innate artistic nature, Indians had to be taught the folkways which would best show both their Indianness and their Mexicanness (Becker 71–72).

Frida Kahlo's Indigenous Drag

By the time Kahlo married Rivera in 1929, she had changed her birth date to coincide with that of the beginning of the Mexican Revolution (1910; her real birth date was 1907), she was identifying herself in her painting with such revolutionary figures as the "Adelita" (an allegorical female soldier-figure in the revolutionary fight), and she had taken to wearing indigenous Tehuantepec dress. Before all this took place, however, we have evidence of a somewhat different, though related, Kahlo. In 1926, the year

after a bus accident which broke her spine in three places, shattered her pelvis, crushed her left foot, and broke her right leg in eleven places, the nineteen-year-old Frida Kahlo posed for a family picture taken by her father, who was by profession a photographer (fig. 4.1).[5] In this photograph she stands in a row with her mother, two sisters, and (half) brother in the garden of their family home. Her mother and her sisters are wearing the latest in European fashions, with jewelry, bobbed and curled hair, makeup, and heels; her younger brother is wearing a suit of plus fours. Standing between her two sisters, however, Frida is dressed in a formal three-piece European man's suit complete with tie, boutonniere, and handkerchief; one hand is thrust into a pants pocket and the other, sporting a large ring, grips a walking-stick. Her hair is parted in the middle and pulled back (a look she would affect her entire life), she wears no makeup, and she stares boldly at the camera. Along with her bold stare and straight thick brows, she does, in effect, look exactly like an urban, middle-class Mexican young man. The fact of such a masquerade in the heart of her very respectable—and very white—family is only a bit less striking if we take into account the fact that she was attending an elite school which only recently had become coed, where she belonged to a clique of mostly male students whose members deliberately presented themselves as wildly bohemian. Looked at in light of her subsequent career as an artist, which began not more than three or four years later, this photograph seems to make a sharp contrast with the later ubiquitous photos taken of Kahlo wearing indigenous women's dress (a costume which became her public and artistic trademark) and, indeed, seems not to jibe with her own self-portraits save for one. Yet, as we will see, even at nineteen years old Kahlo was already getting ready for her biggest role in life—her depiction of her own self and her art in Indian drag.

As avowedly mestiza artists associated with the masculine elite of their countries, Kahlo and Mistral both came to face an inherent conceptual difficulty: how to separate off their own stake in what they thought of as true Latin American folk culture (that is, peasant, Indian, and pre-Columbian) from kitschy, mass, sentimentalized, and sensationalist culture. However, as it was conceived by policy makers and intellectuals, the project to highlight a folk culture that could be both indigenous and national was influenced in its assumptions and in its rhetoric by an earlier nineteenth-century culture of sentimental indigenism (and more obliquely

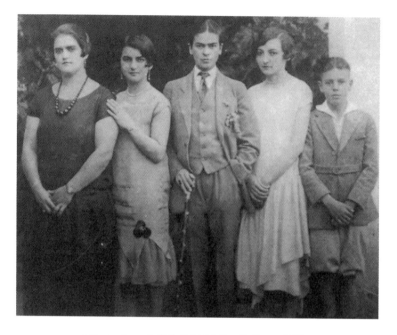

FIG. 4.1. In 1926, Frida Kahlo's father, Guillermo Kahlo,
photographed his family with nineteen-year-old Frida dressed as a man.

by sentimental abolitionism). Thus, in spite of the seeming divide between, on the one hand, an intellectual modernist and nationalist emphasis on an anthropological notion of what constituted folk culture and, on the other hand, a mass-produced and highly commodified popular culture, both sides accepted what I call a sentimentalized idea of women (as well as of Indians): they, that is, women, were not intellectually (or, interestingly enough, emotionally) fit for public or artistic life because they were (too) sentimental. Despite Kahlo's very liberal upbringing, she could not be immune to the public climate in Mexico, one which was definitively not ready, in spite of the presence of feminist groups, to allow women the freedoms which might endanger a basically conservative and Catholic order (for instance, women were not granted complete suffrage in Mexico until 1953). An example of the climate still in place when Kahlo was entering adolescence links her, albeit indirectly, with Mistral (I am here invoking Mistral's and Rivera's connections with Vasconcelos). In 1924, Calles's entrance onto the political scene—and Vasconcelos's resignation as secretary of education—encouraged more conservative teachers and

journalists to attack some of Vasconcelos's public programs, and especially to attack the normal school for women, which Vasconcelos had hired Mistral to set up and which bore Mistral's name (and a statue of her). One of the attacks came in the form of the rumor that birth control was being taught at this school. Other journalists rose to the defense of the school: "The morning papers have launched the public rumor that [Mistral's school] was giving readings from a pamphlet written by Miss Stanger[sic], that spoke—with enormous crudity of course—of the different ways to avoid the procreation of the species" (qtd. in Schneider 156).[6] Both sides were in agreement about the crudity and moral bankruptcy of teaching birth control, especially in a school dedicated to teaching women how to be teachers, and thus spiritual mothers, of children; the issue was only whether birth control actually was being taught or not, in a school named after a woman whose public role was as the spiritual mother par excellence of Latin America, Gabriela Mistral.

In such a climate, even in the international modernist community of which she soon became a part, for Kahlo to present herself as an overtly sexual woman (which she increasingly did) and as a serious artist was a difficult project. Especially when she married, Kahlo needed to present herself to the elites of the international community, which of course included Mexicans, in such a way that neither her inability to bear a child nor her desire to be taken seriously as a real artist would hinder her. Thus, as she began to take herself more and more seriously as an artist, she began to carve a public space for herself by becoming (at least for public consumption) the apotheosis of the truly new and, at the same time, truly Mexican woman—a mestiza who emphasized the indigenous side of her heritage in specifically modern ways. As Rivera's wife, Kahlo became known in the international community of intellectuals, patrons, and artists not first for her art but for her seemingly exotic dress and hairstyles, which complemented her already extraordinary beauty. In fact, it could be argued that Kahlo made herself into the embodiment of mexicanidad, that essence of Mexicanness which drew on indigenous Indian culture for its foundation while producing a mix which was neither fully Indian nor fully Hispanic.

Frida Kahlo entered completely into Mexico's modernist, indigenist-mestizaje climate when she met Rivera in 1928 and married him the subsequent year.[7] Kahlo had probably adopted indigenous dress at his urging; and his own (later) comments on the "proper" dress for Mexican women

are revealing: ignoring the fact that, as he himself well knew, there is no such thing as the "classic Mexican dress," Rivera would pontificate that "the classic Mexican dress has been created by people for people. The Mexican women who do not wear it, do not belong to the people, but are mentally and emotionally dependent on a foreign class to which they wish to belong, to the great American and French bureaucracy" (qtd. in Kismaric and Heiferman 111). When Kahlo did use indigenous dress, which was frequently for public occasions though (presumably) not so frequently when she was at home, she mostly wore the dress of the women of Tehuantepec, a region south of Mexico City in the state of Oaxaca. The Tehuantepec women, in fact, had already become the focus of anthropological and public fascination for their supposed matriarchal culture, and artists and intellectuals from Europe, the United States, and Mexico were similarly captivated by them. Identifying the people of Tehuantepec as embodiments of the authenticity of the Mexican heritage, Vasconcelos, who himself had been born in Tehuantepec, had already sent Rivera to that region at the end of 1922 so that he could steep himself in an authentic indigenous culture which was also esthetically pleasing. There, Rivera was struck in particular by the beauty of the indigenous women, producing numerous pencil sketches of them and their clothing (Ellen Sharp puts it this way: "Rivera was particularly impressed by the majestic women of Tehuantepec, who, with their long dresses falling in stiff folds and their braided coiffures, seemed like figures from antique Greek or Roman art" [209]). In the late 1920s Tina Modotti did a series of photos in Tehuantepec, focusing on Tehuana women; Rivera painted a portrait of Dolores Olmeda wearing a Tehuana dress (where her painted toenails and white-skinned, made-up face ironically belie the indigenist message of mexicanidad) (Billeter 13); and artists who published in the progressive Mexican art magazine *Forma* painted Indian as well as non-Indian women dressed as Tehuanas (Lowe 54).

In her self-presentation, then, Kahlo rejected the usual ways middle-class, urban Mexican women attempted to repress any Indian features they might have, through fashion, cosmetics, and hairstyle; she did this not only by donning indigenous garb, huge Mexican *campesina* earrings, and the enormous stones of her presumably pre-Columbian necklaces, but by playing up aspects of her own physical appearance which pointed, presumably, to her Indian heritage: she refused to pluck her straight dark single eye-

FIG. 4.2. This 1951 photo by Gisèle Freund seems to assume an inherent connection between Kahlo and the pre-Columbian artifacts with which she surrounded herself. Reproduced by kind permission of Anthony Freund.

brow or to bleach her mustache, and she allowed her thick dark hair to grow long and straight, parting it in the middle and braiding it in indigenous styles.

But above all these things, it was her direct gaze and her impassive expression (true, she was also self-conscious about her bad teeth) which brought her look together, for this very impassiveness undoubtedly seemed, to many, to reflect the nature of the Indian. Like their melancholy, the stoicism of the Indian was presumed to be inherent and was a matter of some concern for post-revolution intellectuals who felt the need for the Indian to come alive, as it were, as a full citizen of the nation. As the Mexican anthropologist Gamio put it, the Indian race will not "awaken" on its own: "it will be necessary for friendly hearts to work for your redemption" (qtd. in Knight 77); such a stance at once assumed the Lamarckian position that education would awaken the Indians to their plight and uplift them culturally while it also maintained that the impassive sleepiness of the Indians was so ingrained in them as to be effectively racial in origin— the Indians' "Egyptianism," as the anthropologist Ramos put it, referring to

the Indians' "long, collective acquaintance with conquest and oppression." As Knight notes, for these thinkers "Indian inertia may . . . be historically and psychologically—not strictly biologically—determined, but it is nonetheless deterministically inescapable" (93–94).

Such views about the fatalistically impassive nature of the Indian were widely held in both Latin America and the United States and were accorded also to the exotic but seemingly mute appeal of the massive carvings and monuments that seemed to be almost all that was left of Mayan, Incan, and Aztec cultures. Indeed, because pre-Columbian work did not seem to speak its own social meaning to contemporary Americans, such perceived muteness freed modernist artists to appreciate its stylized and repetitive formal aspects while at the same time assuming that there was an unbroken racial or cultural line between such artifacts, their ancient makers, and contemporary Indian artists and their work. Ironically enough, some photographers of Rivera and Kahlo manufactured the supposed cultural and racial links between the living modernist mestizo artists and pre-

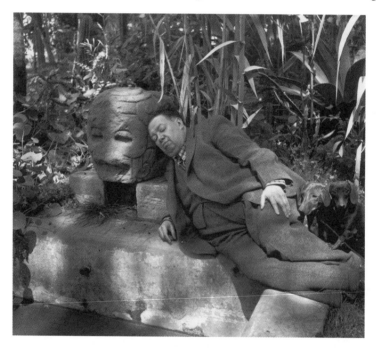

FIG. 4.3. In 1943, Fritz Henle posed Rivera resting next to a
pre-Columbian figure in his garden. © 1990 Fritz Henle.

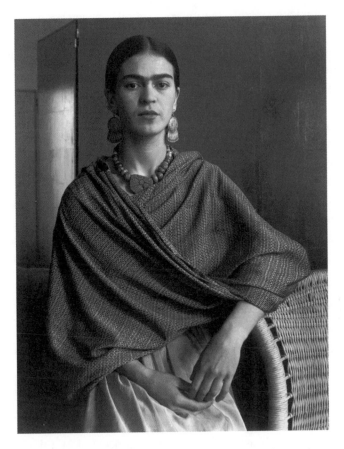

FIG. 4.4. In 1931, Imogen Cunningham was the first of many photographers
to take advantage of the formal aspects of Kahlo's "Indian" self-presentation to fashion
a modernist image of her. © 1970 The Imogen Cunningham Trust.

Columbian artwork by posing them, stony-faced, next to or even leaning
their heads against pre-Columbian carvings and statues. A 1951 photo by
Gisèle Freund, for example, situates Kahlo against a brilliantly white wall,
standing next to a primitive-looking, block-like pre-Columbian sculpture
(fig. 4.2); earlier, in 1943, Fritz Henle took several pictures of Rivera posing
(rather awkwardly, it seems) next to pre-Columbian sculptures in Kahlo's
Blue House garden (fig. 4.3; Kismaric and Heiferman 63). Other photo-
graphs of Kahlo in the garden of the Mexico City home and atelier that
Juan O'Gorman designed for her and Rivera, with its Corbusier-inspired
modernist lines, rough-hewn stone and scattered Incan, Mayan, and Aztec

carvings, implicitly sought a natural connection between her image and the formalized, stolid massiveness of the pre-Columbian images.

Whether she initially meant it to or not, it was this look Kahlo had begun to cultivate which first drew the attention of modernist photographers. As the daughter of a photographer, Kahlo was sensitive to the importance of this medium; and later, as a friend of Tina Modotti's, she could not help but understand its importance to modernist art. In fact, she began her relationship with Rivera in 1928 through her friendship with the Italian modernist photographer Tina Modotti, who had come to Mexico as a model and student of Edward Weston and stayed on after he went back to the United States. A year after her marriage to Rivera in 1929, on her first visit outside Mexico, Kahlo sat formally for Imogen Cunningham in San Francisco. The resulting work—a modernist celebration of the formal aspects of indigenous dress combined with Kahlo's own beauty—was the beginning of years of photographers seeking her (and Rivera) out (fig. 4.4). A partial list of such artists includes Cunningham; Ansel Adams; Edward Weston; Lucienne Bloch; the well-known Mexican modernist photographers Lola and Manuel Alvarez Bravo; the German photographer Fritz Henle, who worked for *Life, Bazaar,* and *Vogue;* Guillermo Dávila, who in the 1920s opened the first commercial art gallery in Mexico City; Leo Matiz, a famous Colombian photographer; and Nikolas Muray, a photographer for *Vanity Fair* (ironically, a studio portrait Muray took of Kahlo wearing Indian dress has her mustache and the central part of her eyebrows airbrushed out; despite this, Kahlo loved the picture—possibly because Muray had been her lover [fig. 4.5; Kismaric and Heiferman 57]). As Edward Weston was to record in his diary, "[Kahlo] is strong and quite beautiful, shows very little of her father's German blood. Dressed in native costume even to *huaraches* [woven leather sandals], she causes much excitement in the streets of San Francisco. People stop in their tracks to look in wonder" (qtd. in Kismaric and Heiferman 111). In Paris, when she visited for an exhibit put on for her by Breton and Duchamp, her style was taken up by high fashion, featured in the November 1938 *Vogue,* and adapted as a look by the Italian-born couture designer Elsa Schiaparelli (Mulvey and Wollen 18).

Although such imitations both amused and slightly disgusted her, they also point up Kahlo's success not just in creating but in marketing herself, so to speak, as a new, modern "Mexican." Indeed, in spite of the differences

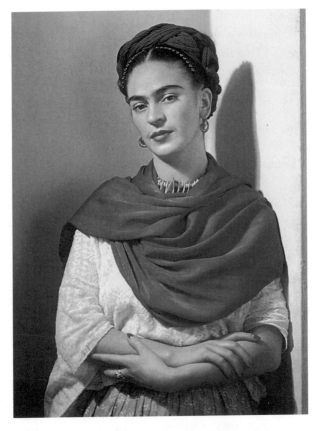

FIG. 4.5. In the 1930s, Nikolas Muray presented Kahlo with this portrait he had taken of her;
note the airbrushing out of her mustache and heavy eyebrows and the painting in
of longer eyelashes. Courtesy George Eastman House.

in media and genre, I think of these endless photographs of her as of a
piece with her own self-portraits, which themselves constituted by far the
largest part of her oeuvre—over fifty-five works, nearly one-third of her
artistic output (Lowe 34). (Kahlo could treat photographs of herself as a
kind of art—for example, she took one of the 1930 Imogen Cunningham
photographs and, signing it, "From your friend, who is very sad," penned in
teardrops on each of her own cheeks [Lowe 3].)

It was only a few times, once when Rivera began an affair with her
sister Cristina in 1934 and another time when they were briefly divorced,
1939–1940, that we see Kahlo being photographed or painting herself in
other costumes. In each of these moments, it is clear that the initial

impulse behind her transformations away from indigenous drag comes in the form of difficulties with Rivera. In 1934, when she left Rivera because of his affair with her sister, pictures by her good friend Lucienne Bloch in Bloch's New York City apartment show Kahlo abandoning the Mexicanist modernism of her self-presentation for a more ordinary, modern one: with her hair cut short, sans Mexican earrings and oversized pre-Columbian necklaces and dressed in Western clothes. In 1939, while Rivera was divorced from her, Kahlo painted *The Two Fridas*, which shows two Fridas seated and holding hands, one wearing a turn-of-the-century German dress and the other a contemporary Tehuana dress; their hearts are shown (in anatomical detail) connected by a red vein which runs from a small emblem of Rivera held by the Tehuana Frida to the hand of the other, foreign Frida, whose own hand cuts the vein with a pair of scissors, splattering her white dress with blood. Again in 1940, Kahlo returned to the theme of cross-dressing in her *Self-Portrait with Cropped Hair* (fig. 4.6). Seated, dressed in an oversized men's suit, her figure once more holds a pair of scissors which this time have cut her long hair short, the strands littering the floor about her. The inscription (words from a popular song) says, "Look, if I did love you, it was for your hair, Now that you're short-haired (*pelona*), I don't love you anymore" (Lowe 60). The term *pelona*, or "bald," was also used as a vernacular term to refer to women who bobbed their hair (Herrera 41). Even more than indigenous dress, long hair combined a contemporary symbol of real, traditional womanhood and, simultaneously for modernists, the sign of the premodern world of the indigenous woman. After her reconciliation with Rivera, a few informal pictures made by friends show Kahlo wearing pants or jeans at home, but she would almost never let herself be formally photographed again as anything other than her own modernist icon of mexicanidad, and she never again cut her hair.

Beginning in the 1930s, the production of *chromos*, or "calendar art," exploded in response to advances in printing reproduction and to the demands of advertisers, who found that printing and distributing free calendars would advertise the product as well as the printers of the calendar itself. Artists painted specific subjects according to commission, or they would paint genre scenes for the printing houses' catalogue lines (Heimann 29). Aztec subjects were popular, but were modified for a public already used to going to the movies and seeing romantic and melo-

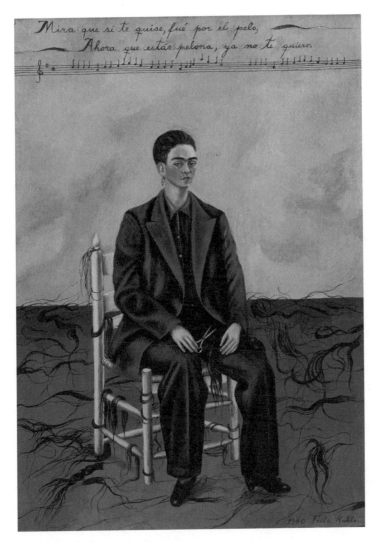

FIG. 4.6. Frida Kahlo painted *Self-Portrait with Cropped Hair* in 1940, after she and Rivera had divorced. Museum of Modern Art, New York. Gift of Edgar Kaufmann, Jr. Digital image © The Museum of Modern Art. Licensed by SCALA/Art Resource, New York.

dramatic depictions of Indians: in calendars, for example, the image of Cuauhtémoc (Moctezuma's son) was given distinctly European facial features and the bulging muscles of the contemporary weight lifter; and all women, whether Indian, pre-Columbian, or contemporary, had the Europeanized movie-star faces of women like Dolores del Río. These calendar

images, which were (and remain) ubiquitous, were printed in the most garish of colors and color combinations and depicted highly sentimental and/or melodramatic scenes, all in the most wonderfully kitschy, bad taste. Jesus Helguera was, and is, the best known of these calendar artists; his 1940 *Leyenda de los volcanes* (based on the legend of two star-crossed lovers turned into neighboring mountain ranges), an image of "mythic Aztec warrior and supine maiden," was printed by the thousands by the calendar publishing house Litoleosa and ensured the popularity of this genre—indeed, into the present day (Heimann 31). These calendar images, in other words, embodied the popularization of the nationalist insistence on the combination of the folk and the modern; and popular calendar images of the time also presented European-featured Mexican women with short bobbed and curled hair and lipstick, wearing indigenous dress. One such 1932 image called "To My Town Fair" (A la fiesta de mi pueblo) shows a calendar girl, a woman holding the reins of a horse saddled in silver and worked leather. The woman poses seductively, her *rebozo* slipping tantalizingly down her arms to reveal her Indian blouse and large breasts, one arm akimbo on her waist, and long Indian skirt revealing a side-thrust high heel. She wears a rustic *sombrero* atop dark braids and smiles winsomely; her complexion is fair with ruddy cheeks. By the 1930s, this was the popularized version of the New Woman, Mexican style; she is connected to her town's indigenous cultural heritage to the extent that she poses in (highly modified) Indian dress on local fair holidays, but her makeup, manicured fingernails, high heels and, even more importantly, cigarette prominently displayed in the fingers of one hand mark her as a modern woman.

It is interesting, and I think telling, to look briefly at the contrasts and similarities between a modernist "star" like Frida Kahlo and the film star Dolores del Río, whose Mexican career was contemporary with the height of Kahlo's public acclaim and who was also part of Kahlo and Rivera's circle in Mexico. Kahlo was not the only woman to take up the Mexicanist stance of the white, urban Mexican woman who wears native costume. Dolores del Río and María Felix wore native Mexican costume in some of their movies, glamorized versions of Mexican costume, to be sure, and with plenty of makeup; one could always tell that these were sophisticated, modern women. A comparison of a photo taken of Kahlo in a Tehuana wedding dress and one taken (by Man Ray) of del Río in the same type of costume

FIG. 4.7. While in Los Angeles in 1942, Man Ray photographed the actress
Dolores del Río dressed in a Tehuana wedding costume. The J. Paul Getty Museum,
Los Angeles. © The Man Ray Trust ARS-ADAGP.

makes obvious both the differences and the similarities in these women's
self-fashionings (figs. 4.7 and 4.8).

By 1943, Dolores del Río had moved from Hollywood back to Mexico
to start a second film career, one which built on the successes of the fash-
ioning and consolidating of the Mexican Revolution's cultural nationalism.
Del Río had gotten her start in Hollywood when she was introduced to
director Edwin Carewe by Adolfo Best Maugard, himself a close friend

and artistic colleague of Rivera's in Paris, who, coming back to Mexico in the 1920s, had authored a Mexican textbook on "socialist" art. When del Río decided to revive her career by going back to Mexico, she gained fame from the movies she made with the Mexican director Emilio Fernández, or "El Indio" Fernández, in whose *María Candelaría,* "a story of love and pain, Indians, flowers and death" Rivera reportedly convinced her to star so as not to distance herself "from the drama of the Revolution and its ideals" (Monsiváis 80). In this movie, set in 1909—the year before the revolution began—in the Náhuatl community of Xochimilco, del Río plays a sentimentalized vision of a poor Indian girl who is ultimately (and unfairly) stoned to death by her neighbors. The movie was a great hit. The Stalinist critic Georges Sadoul praised its authenticity, and Mexican nationalists praised it for discovering a "poetic Mexico" (Monsiváis 84): but as Monsiváis notes, del Río's images as a barefoot Indian girl "are definitive illustrations of a mythological undertaking then in fashion: reverence before a pure and abstract Mexicanness" (84). Del Río is the perfection of a melodramatic nationalism, one whose audience shares a double knowledge: that it is looking at the most modern of beautiful women while simultaneously knowing that she embodies the poorest, "devastated and oppressed Long-Suffering Woman" (81). Indeed, even before she left Hollywood for Mexico, del Río was photographed by none other than Man Ray, wearing a Tehuana wedding headdress and dress (see fig. 4.7). Although Man Ray (or del Río's handlers) was undoubtedly spurred to such a portrait by the success of Kahlo's 1939 "surrealist" Paris show and the subsequent popularity of the Kahlo Mexicanist look in the fashion world, in posing for such a photograph del Río, of course, had an entirely different goal in mind: despite the slight exoticism of her features compared to United States film stars, del Río's face bears no traces of an Indian heritage, as does Kahlo's, and Man Ray's image is of a glamorous and modern film star posing—not living—in one of her many roles.

Even as Kahlo collected hundreds of examples of peasant and Indian arts and crafts and dressed herself in Indian costume, government policy makers under the newly liberalized Cardenas administration sought to modernize actual Indian peasant women, weaning them away from their supposed traditional ways of religiosity, superstition, and poor hygiene. Although many of these policies aimed at Indian and peasant women never really took hold (Vaughan 203), the fact that they were put forward publicly

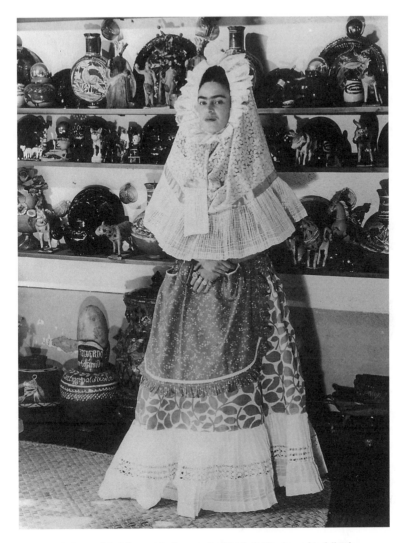

FIG. 4.8. Bernard G. Silberstein's photograph of Frida Kahlo, dressed in full Tehuana wedding dress. © Cincinnati Art Museum, gift of Bernard G. Silberstein.

as an integral part of the consolidation of the gains of the revolution sets del Río's later 1940s images of the poor but clean and virtuous young Indian woman in the movies and Kahlo's own self-Indianization through a judicious use of Indian folk culture in something of a different light. The campaigns of rural education and reform begun in Obregón's administration had been undermined by the Calles regime (1924–1928) but had been

revived and were reaching new heights by the mid-1930s when Cárdenas took office, precisely the moment when Kahlo was finding her place as an artist.[8] Under Cárdenas, development policies fashioned in response to the ongoing crises—especially that of agrarian reform—emphasized the "rationalization of domesticity," especially for poor campesino women, both mestiza and Indian.[9] As Mary Kay Vaughan points out, Latin American nations were facing a crisis of "population management," one which "lay at the intersection between an emerging mass society brimming with political demands and social ills and the state's need to control and mobilize that society for purposes of national survival" (196). Education, the cornerstone of populist governments like those in Chile, Peru, and Mexico, was to be the answer to such a crisis: as was the case in many United States rural development programs, a particular focus of Mexican development programs was on "mothers in households." Policy makers "propagated new 'scientific' discourses on human development, nutrition, hygiene, and disease. *Campesino* [peasant] homes were to be redesigned for health, comfort, and sexual propriety. . . . Teachers and health workers would fight *curanderas,* witchcraft, and homespun midwives" (Vaughan 200).

These development policies pointed up an important way of thinking about Indian culture. It was perfectly logical, within contemporary Latin American frameworks of thought about the Indian, that traditions which worked against the modernizing rhetoric of (domestic or cultural) redesign needed to be discarded while the more esthetic folk traditions could be saved and even modernized for the benefit of the entire nation—for its patrimony. Such a logic shows most clearly in the fact that while Mistral, as we shall see, chose to work on the side of domesticating folk culture, Kahlo chose to work on the side of modernizing it. It was not either of these artists' job, as they saw it, to go out and teach Indians how to live cleaner lives, or even necessarily to save the Indians from extinction. It was their job instead, as modern artists, to make sure that the historical depth represented by folk and pre-Columbian cultures was foregrounded as a foundation for the nation, providing a historically grounded yet modern vision of a racially mixed yet culturally and politically unified citizenry.

But, importantly, in presenting herself as a modern mestiza "Indian" Kahlo had to avoid the other side of the coin: the kitschy tackiness and degraded melodrama and sentimentality of urban, mass culture mexicanidad, which itself was trickling down from the saturation of the public

sphere with modernist-heroic images of the new mestizo way to be Mexican (this, of course, included the melodramatic films of stars like del Río). In part, such an avoidance had to do with the fact that Kahlo's intellectual and social upbringing was primarily amongst men. The group she belonged to in school, the Cachuchas, was predominantly male and, as Lowe notes, "their intellectual vitality was mixed with a large measure of contempt for authority" and contempt for a feminized "cuteness" or sentimentality (17): Kahlo herself would refer to her female schoolmates as *cursi*, or "kitschy" *escuinclas* (Herrera 26), *escuincle* being the name of the small, hairless Mexican dog and the *a* ending marking these girls as, essentially, dumb, hairless bitches (the term for a bobbed-hair flapper was also *pelona*, which literally means "bald," so Frida was combining references a couple of times over). As educated and modern, and especially as a male-identified woman, Kahlo personally eschewed cute, commercialized, or overly feminized ways of presenting herself or of behaving. But it is not as if, as Herrera points out, Kahlo did not also have the educated, bohemian artist's ironic love for things which were in the worst of taste: she preferred the Three Stooges to Stravinsky and would exclaim over bourgeois or pretentious ornamentation, "It's so bad it's good!"

Thus Kahlo, like many of her contemporaries, could admire (from an ironic distance) low or bad taste, while adhering in her own work and self-presentation to a distinctively high modernist style. It was middlebrow and kitsch—especially the kind of mass-produced images which came out of the mexicanidad movement—which she avoided in the construction of her own persona. This served her well; yet in her later photographs, either deliberately or through carelessness, Kahlo allowed herself to display at least a couple of the same distinctive marks as those of the mass-culture representations of the modern woman of cinema and calendar: her nails are almost invariably perfectly manicured and painted, and, more importantly, she is often photographed holding, or dragging on, a cigarette.

Smoking was something of a gesture of defiance which marked independent and sophisticated women by the 1930s, implying moreover the frisson of a dangerous sexuality. As such, it was a gesture Kahlo had to take up almost of necessity. But smoking was not something a presumably pure, rural, and innocent Indian woman would do; and, in fact, pictures of Kahlo in full Indian costume show that her smoking gestures are almost aggressive: she never bothers to hide the cigarette and drags on it in a distinctly

masculine way, holding it between thumb and first finger, squinting through the smoke. Looking at the Freund picture mentioned earlier, for example, we see Kahlo captured at the moment she is taking a hit off her cigarette, holding it man style in her manicured and painted fingernails (fig. 4.2). With her left eye narrowed a bit against the smoke and the sun, she looks every bit an insouciant, modern, urban, rebellious woman—even in full Indian drag and even with the pre-Columbian statue there next to her, helping the viewer make the necessary modernist folk (never kitsch!) associations. One can't help but wonder if her gesture was on some level purposeful, an attempt to undermine Freund's (and earlier, Henle's) too-facile reading of the official populist reverence for all that was pre-Columbian. Kahlo could be impatient with such simplistic moves: according to her, her 1939 show in Paris included a lot of "junk" that Breton had bought from a Mexican market (the same kind of Indian and peasant crafts, presumably, with which she surrounded herself in her Blue House), plus thirty-two photographs by Manuel Alvarez Bravo, the famed modernist Mexican photographer—who, incidentally, photographed Kahlo herself more than once. It was these exhibition photographs which in a fit of pique she described as "so damn intellectual and rotten that I can't stand them anymore. . . . I'd rather sit on the floor in the market of Toluca and sell tortillas, than to have anything to do with those 'artistic' bitches of Paris" (qtd. in Kismaric and Heiferman 116).

Yet Kahlo's own self-representation depended on those very same "intellectual and rotten" modernist expressions of an Indianized mestizaje. They became an integral part not just of photographs of her but of her own painterly iconography. Kahlo's 1937 self-portrait, *My Nurse and I*, seems at first glance to effect something of the same superficial gesture we see in the Henle and Freund pictures: a Frida with a little girl's body and a grown-up head is being suckled by a giant, dark-skinned nurse with a pre-Columbian face (fig. 4.9). Kahlo claimed that she had had an Indian wet-nurse, or *nana*, as a child, a woman whose breasts were washed before each suckling and whom she painted with a mask because she couldn't remember what her nana looked like (Herrera 220). The Frida-child suckles milk through a breast rendered transparent so that the flower-like milk glands and ducts are visible; droplets of rain (the "Virgin's milk") fall from the sky onto the fecund jungle scene behind them. The bottom ribbon, where the inscription would go in an ex-voto, is blank, as it was in her 1932

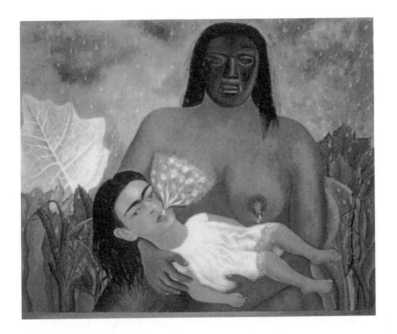

FIG. 4.9. Frida Kahlo's 1937 *My Nurse and I.*

My Birth. The nurse's body was inspired by a Jalisco figure of a nursing mother, and Kahlo modeled the nurse's face on a pre-Columbian Teoti-huacán funerary mask (Lowe 48), while the reference to the *retablo*, or Mexican ex-voto, again associates this work with that of the folk. Images of natural camouflage and metamorphosis (a praying mantis and a caterpillar turning into a butterfly) combine with the engorged vegetation and plant-like stolidity of the Indian nurse while at the same time Kahlo's loose hair and unibrow demonstrate that she is, as Hayden Herrera suggests, the inheritor of the same features on the mask; but because the features of the little-girl Kahlo are adult, we are to know that here Kahlo is establishing herself as artist: that is, as an artist naturally, by blood and by nourishment, the modern inheritor of a folk- and Indian-inspired mexicanidad.

In self-portraits, Kahlo downplays the popular ways by which women might have signaled their modernness; unlike her photographs, she por-trays herself smoking in only one (painted) self-portrait and never shows herself made up (and only once with painted fingernails), for almost all her self-portraits taking out all anachronistic details such as modern jewelry, wristwatches, and shoes. That is, in self-portraits like *My Nurse and I* Kahlo

replaces the signs of a modern woman with a more properly modern*ist*, folk reading of her connection by her own (maternal) body to that maternal Indian body which produced the mestizo nation. By such means she walked the fine line which avoided popular cinematic or *chromo* depictions, either of the sexy, rebellious city woman or the poor and innocent Indian girl, and eschewed the more naive nativist assumptions of those who would take up her self-fashioning a bit too seriously—or like Breton, for their own self-aggrandizement—at the same time as she, indeed, declared herself a modern, a modernist, and a Mexican woman.

The modernist desire to avoid kitsch was also at least partially solved by Rivera's suggestion that Kahlo emulate the genre of the traditional Mexican *retablo* (ex-voto or votive paintings and colonial portraiture). Retablos are small paintings—usually, in those days, painted on aluminum sheets—which express the gratitude of an individual to a divine figure— Christ, the Virgin Mary, one of the saints—for a miraculous cure, an averted accident, even a fulfilled prayer. The details of the event are usually written onto the painting in the form of a dedicatory inscription, including the date and the individual's name, and often displayed in the local church. Such paintings are naive in the sense that they were not made by artists, and folk in the sense that they came (and still do) out of people's everyday lives. Older, colonial folk art, which often commemorated weddings, births, and deaths as well as serving as portraiture, also contained information within its borders—usually painted in a broad ribbon-band along the bottom, or in the case of weddings, a ribbon borne by a pair of doves—who the subjects were, what the occasion was, who painted it, and when. Thus, although Mulvey and Wollen maintain that "ex-voto painting was already long in decline when rediscovered during the 1920s . . . and popular print making still existed during the 1920s, though [it was] to become extinct very soon afterwards," colonial styles of painting may have been in decline, but votive painting certainly was not, nor was popular printmaking (19). Rather than the "discovery of popular forms" being a "revival and prolongation beyond their normal historical span" of popular genres (19), the traditional folk, naive work of retablos was alive and well in Latin America and continues to be so to this day. Kahlo's job as an artist using these sources was to lift elements which would point to the traditional and the folk while at the same time making sure they were taken out of the realm of what, for her and for her contem-

poraries, was the realm of the unmodern: their religiosity, their modern colors, and tacky sentimentalism.

This brings us to an important point about the ongoing debate over the presence of the primitive, or the folk (these two were often conflated), in modernist works of art. By 1938, when Kahlo had her second solo exhibition at the Julien Levy Gallery in New York, the United States critic Walter Pach not only proclaimed her a modern painter but proclaimed in *Art News,* under the title "Frida Rivera [*sic*]: Gifted Canvases by an Unselfconscious Surrealist," that the traditional folk figures she used in her paintings were themselves "works of art . . . rightly to be called modern" (13).[10] However, Pach had it exactly wrong: the folk aspects of Kahlo's paintings, just like the folk or Indian aspects of Rivera's, Vallejo's, and Mistral's work, were not considered modern by these artists. Instead, these images could be modernized to some extent but could never represent modernity. It is important to understand that for these modernists, such folk images needed to represent not just the presence, but the contemporaneity—in a temporal sense—of the unmodern subject (the Indian, the peasant) within the modern space of the nation. Artistic appeals to the preconquest cultural or racial heritage of the Indian, that is, could be used "as a means of constructing a mythic past whose effectiveness could be felt in the present" (Mulvey and Wollen 20).

Kahlo's depictions of her own body (or other women's bodies) are a notoriously difficult area of her art about which to speak because so many of her paintings refer directly to the physical pain and limitations she suffered all her life as a result of her devastating accident. Thus, these paintings in particular have been read as merely a personal representation (or, less charitably, as an aggrandizement) of her pain, or as a psychological working-out of the torment she sustained as a result. It is in her nude paintings that I am interested, especially since Rivera's nudes often use a passive, Indianized woman as a representation of the fecundity of the earth and the indigenous race. A few things can immediately be said about Kahlo's nudes: by painting them often within the genre expectations of the retablo, she was (at the suggestion of Rivera) deliberately performing, in a fairly shocking way, the kind of anti-clericalism which marked the thinking of the revolution's intellectuals. By adopting a modern and liberal attitude toward sexuality, whereby she thought about her own and other women's bodies in specifically sexual ways, Kahlo had better success in painting the female nude than would a more socially conservative female painter.

Kahlo's performance of her own (presumed) bisexuality (if Rivera could have his flirtations and affairs, so could Kahlo, who supposedly had any number of lovers, both male and female, during her marriages to Rivera) enabled her to represent the female body if not with overt desire at least without prurient awkwardness (Rivera apparently tolerated her lesbian affairs with better grace than her affairs with men). And just as I read Kahlo's adoption of an impassive face for her pictures and self-portraits in part as an effort to avoid seeming to offer herself sexually to the viewer, the formal aspects of votive painting add to the distance between self and spectator. The smallness of the genre (many of her paintings are no more than twelve by fifteen inches or so), the naive stiffness of the figures (she could paint quite differently when she wanted to), and especially the votive's seemingly artless dependence on traditional iconography, folk symbolism, and text painted on the surface of the picture combine to make Kahlo's work appear innocent and straightforward even when it is not.

Although it would seem not to be in tune with her emphasis on the folk and the indigenous, the preeminence of scientific and positivist (what would come to be called "rationalist") ways of thinking in Latin American discourse is clear in Kahlo's life and work. Like so many Latin American men in these years (though unlike most women), Kahlo at first aspired to be a doctor. After her accident cut short this ambition, she underwent an apprenticeship for a time to a commercial engraver; her success in this prompted her to consider a career in scientific illustration (Lowe 18). However, she employed that training instead in her paintings' use of anatomically detailed depictions of internal organs, veins, glands, sperm, ovum, etc.; in fact, her frequent references to blood and bloodletting are exhibited in the ways her later paintings create a circulatory relationship between veins, nerves, glands and the veins and roots of plants.

In some of her nudes especially, without the protection of indigenous dress, Kahlo shields her self-presentation from prurience by connecting herself to the legitimating, if for her often painful, visual vocabulary of the biological and medical sciences, transforming that vocabulary into her own painterly iconography. A series of works she painted in the United States in 1931 and 1932, when Rivera was working on his Detroit murals, show her pushing toward something of the same thing with which Rivera and Vallejo were grappling: how to bring together what Rivera, writing in *Mexican Folkways* in 1926, called "the extreme modernity of the plasticity of

the North" and the "living tradition of the land of the South" (qtd. in Mulvey and Wollen 29). Unlike Rivera, Kahlo, accustomed already to presenting, in her own image, this modernist quest for a hybridity between the Indian and the Hispanic, uses her mestiza body to figure the paths through which modern, scientific, and machine energies and traditional, indigenous energies might flow and meet.

As we saw in chapter 3, while in California both Rivera and Kahlo were taken with the ideas of Luther Burbank, and both, in 1931, painted homages to him. In her depiction of Burbank, Kahlo used a device which would become customary for her: she depicted a cutaway of the earth's surface so that we can see not only plants growing above ground but their roots going into the earth. Her image of Burbank shows him, like a plant, physically connected to the soil and to living things, his body literally growing out of a tree trunk whose roots are embedded deep in a flayed human corpse. Burbank himself holds a large leafy plant whose roots also reach back down from his hands into the ground. A study for this picture shows that, along with Burbank's figure, she had originally thought of portraying disembodied hands shoveling the earth and sowing seeds. Three works from 1932 continue the themes she was concerned with in this painting: the graft, the connections between life and death, and the rootedness of her own maternal body in both the modern and the premodern worlds: *Self-Portrait on the Border between Mexico and the United States, Henry Ford Hospital,* and a pen-and-ink drawing entitled *The Miscarriage.*

Besides the emphasis on her physical problems, Kahlo's status as an artist has been almost inextricably linked with her desire to have a child. As Lowe notes, it is understandable that Kahlo, despite her unorthodox views, would want to have a child, given Mexican social codes, according to which "having a child, indeed . . . motherhood itself . . . virtually defined womanhood" (65). She became pregnant more than once, but her shattered pelvis made therapeutic abortions necessary on several occasions and caused her to have miscarriages on others. Like so many other women artists, though, Kahlo would take the circumstances of her own maternal body as an opportunity to do the work of several things at once: to labor over her own personal feelings of loss and pain but also to think through what it meant both to be modern and to have a maternal, mestiza body (a distinctly unmodern body, as we have seen). In 1932, while in the United States, she became pregnant again and at three months had a miscarriage and was

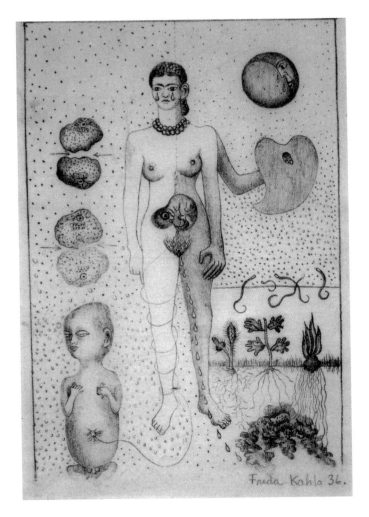

FIG. 4.10. Kahlo's depiction of her miscarriage in 1932, while in Detroit.

hospitalized for a month. The pen-and-ink drawing *The Miscarriage* (fig. 4.10) shows how Kahlo literalized the ideas she worked with in her Luther Burbank painting. This particular drawing shows her standing nude, with one of her by now trademark necklaces around her neck and two tears coming down her cheeks. Around her are arrayed drawings of cell mitosis, sperm, and plants whose roots go deep into the soil. Next to her, placed underneath the drawing of cell mitosis, is a depiction of a near-term fetus, its umbilical cord wrapped around her leg and connected to a smaller fetus

in her womb; blood drops course from her vagina down her other leg to the ground, where they pool and are taken up by the plants' roots. Her figure is half dark, half light, and has one extra arm holding a palette in the shape of a heart; above it a half-moon also weeps. *Henry Ford Hospital* (fig. 4.11) was taken in part from this drawing. Here, she uses the notion of the organic graft, taken from Burbank's ideas as well as from the discourse of mestizaje, to show her own body as effecting the (often painful) connection between the scientific and the organic worlds. *Henry Ford Hospital* shows a weeping, nude Kahlo on a hospital bed with "Henry Ford Hospital Detroit" written on the black iron side of the bed. Around her, floating in midair but connected to her by ribbons of blood, are the fetus from the earlier drawing, an anatomical model of a woman's reproductive organs, a machine (what kind is unclear), an orchid, a medical model of a pelvis, and a snail. The bed floats, seemingly in midair, while in the distance can be glimpsed the Detroit factories which so fascinated Rivera. Snail and orchid are the most hermetic and personal of the icons in this painting; Rivera brought her orchids while she was in the hospital (they could not have but reminded her of a woman's sex), and the snail, she later said, represented the way time seemed to lengthen and crawl while she was enduring this grueling miscarriage. The other four images, though, while they have to do with her personal experience, also point to the ambivalence she feels about having her body literally hooked into "the extreme modernity of the plasticity of the North." While Rivera could happily imagine the new worker-body as an amalgam of machine and organism, it was no more than an attractive political idea to him; but it actually became a personal, and not terribly liberating, experience for Kahlo.

In works such as *Henry Ford Hospital, The Miscarriage,* and her 1944 *The Broken Column,* Kahlo presented her own nude body to what eventually would become the public gaze. *Broken Column,* which again uses the cutaway device to show her spine as a column broken in numerous places, also shows one of the many plaster body-trusses she had to wear around her torso throughout her life. Again she is weeping, and she borrows from religious imagery to show her pain: numerous nails pierce her face, torso, and arms. Although the image is of a beautiful nude woman, the references to manufactured objects—the straps, the nails, the column—wrapped around and entering her body shield her from pruriency, transforming nakedness, and the sexual vulnerability associated

with it, into a nudity whose pain-studded flesh both invites and distances the sensuality of the gaze.

A similar ambivalence about the real effects of being hooked up—sometimes literally—to both sides of the modernist equation with which Rivera was so entranced (that is, the soul of the South and the machinery of the North) is achieved in *Self-Portrait on the Border,* a painting which may have been done earlier in 1932, before her miscarriage. This work shows Kahlo standing at midpoint between two landscapes which obviously represent the North and the South. The former is peopled by nothing but skyscrapers, machines, and factories, while the other side shows Aztec ruins, pre-Columbian artifacts, and living, succulent flowers and fruit. Dressed in a pink first Communion dress, Kahlo stands on a small pedestal with a cigarette in one hand and a small Mexican flag in the other. But it is the plants and the mechanical gadgets—what look like a heater, a spotlight, and an electric motor—which are the real center of the picture. Plants line the bottom of the canvas on one side of the dais on which Kahlo stands, while machines line the other side; the plants extend their roots downward and toward the other side of the picture, while the electrical cords of the machines, like the roots of the plants, do the same. In fact, the plant roots and the electrical cords are connected to each other, passing under Kahlo's small dais, on which a plant grows up one side and a motor is plugged into a socket on the other. In other words, whether she consciously understood her work to mean this or not, it is literally through her own body that the presumably different energies of Mexico and the United States flow and hybridize, just as it is literally through the female body that the Mexican state's project of mestizaje had to be effected.

The Childless Mother

As with Kahlo throughout her own career as a public figure and a painter, Mistral, as a public figure, poet, and journalist made virtues out of what would seem at the time to be fundamental drawbacks: she was a woman, she was not married, and she was not a mother (Fiol-Matta 205). At a time when truly public, international status was virtually unheard-of for women, she seized upon one of the few socially sanctioned public openings available for a woman: the figure of the mother/teacher, one who teaches not just children but other women so that they themselves can be good teachers and good mothers. She did so first by working from 1922 to 1924 for

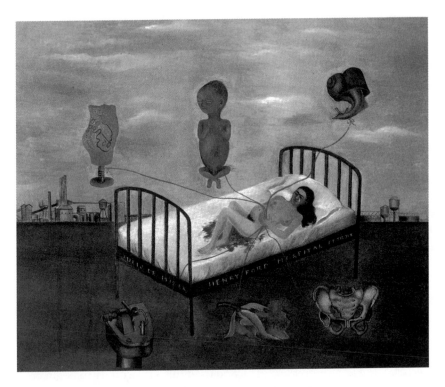

FIG. 4.11. Kahlo's 1932 *Henry Ford Hospital.*

the Mexican Ministry of Education under Vasconcelos, "helping to organ-
ize programs in rural areas, overseeing the introduction of mobile libraries,
and establishing *escuelas hogar* [home schools] for women" (Marchant
85). In 1933, she became one of Chile's ambassadors abroad, and her
increasing fame was even more enhanced when she won the Nobel prize
for poetry in 1945, the first Latin American woman to do so. Because of
her close associations with the governments of such countries, Mistral's
public and writerly personae were necessarily wrapped up in images of the
maternal; in part because of the fact that she was a public woman, in part
as a closet for her lesbianism.[11] Thus Mistral would have been unable (or
unwilling) to adopt the strategies of new twentieth-century women, nor
was she interested, at least professionally, in the new figure coming to
prominence during her career: the laborer-socialist. Instead, in something
of the same way that Vallejo rejected certain kinds of modernity or modern
thinking, Mistral would have to continue the difficult negotiations involved

in expressing the responses to and questions of modernity through the mediating figures of mother and child. This is an extremely important aspect of Mistral's political thought throughout most of her career: she believed quite passionately that it was women who had the ethical will to effect truly positive social change.

Readings of Mistral have almost always situated her as purely anti-modern, but we should not ignore the context in which she began her career—at around the same time that women modernists as diverse as Tina Modotti and Tarsila do Amaral were working in the midst of the modernist fervor of, respectively, post-revolution Mexico and Brazil's modernist art scene. But even more important than any modernist artistic milieu (which she implicitly rejected, in any case) was her involvement from the 1920s onward, both politically and artistically, in the race and gender issues which were at the heart of Latin America's modernizing discourses. As Jean Franco has noted, Mistral was deeply preoccupied with folklore and oral tradition, to the extent that she gave talks on the subject when she traveled. Mistral's participation in Mexico's revolutionary education program, for example, was effected precisely through her seemingly unmodern self-fashioning as a poet of the folklore produced by mothers, teachers, and children (Franco, "Loca" 27). She used this opportunity to begin creating what would be for her an important, if poetic, imaginary female sisterhood/audience—a *mujerío*—to whom she could speak and a sense of spiritual motherhood by which she could connect to all women, including the *madre indígena*, the "indigenous mother." The poem "The Little Box from Olinalá" (La cajita de Olinalá), from a section titled "The Delirious [or Capricious] Woman" (La desvariadora) in her 1924 collection *Tenderness*, shows her in the process of constructing an ideal female audience:

> *My little box*
> *from Olinalá*
> *rosewood,*
> *jacaranda.*
>
> *When I open it*
> *suddenly it gives*
> *its scent of Queen*
> *of Sheba.*

Like so it's
exactly made
Aztec hand,
Maya hand.

The box is my breath,
I her walk;
She knowing,
I delirium.

And we stop
like manna
where the road
already has more than enough,

Where they shout
to us halalá!
the sisterhood
of Olinalá.

(*Ternura* 101–103)[12]

All the objects in the poem and all the figures are female; but in a move which is typical of Mistral, especially at moments when she might be accused of too much arrogance as a woman, she makes sure that her poetic persona presents herself as merely the humble vehicle (the *anda*) for the queenly *saber* (knowledge) of the *cajita* (little box) and that the persona's *yo*, or "I," seems only delirious—a sort of holy but harmless fool. This is supported formally: when spoken aloud in the original Spanish, the intense and even childlike pleasure generated by the brevity and tight, condensed rhythmic and rhyming structure of this and other poems are of a piece with her well-known protestations that she was but a simple poet of what she called cradle songs.

In the many photographs which exist of her, Mistral's pale skin and broad face do not look particularly Indian. In fact, as Fiol-Matta notes, Mistral was "white and white-identified," although much of her career rested on the touchstone of her championship of indigenous peoples (*A Queer Mother* 10). But her dedication to an American project of *mestizaje* led her to fashion her poetic persona not just as teacher and spiritual

mother but as one who sees the indigenous literally mirrored in her own face, for example, in the poem "Drinking" (Beber), which was collected in her 1938 *Tala* (Felling):

> I remember the gestures of girl-children
> and they are the gestures of giving me water.
>
> *In the valley of the Río Blanco*
> *Where the Aconcagua is born,*
> *I arrived to drink, leapt to drink*
> *into the whip of a waterfall*
> *that fell long-maned and hard*
> *and broke stiff and white.*
> *I stuck my mouth in its boiling,*
> *and the holy water burned me;*
> *and three days my mouth bled*
> *Because of that gulp of Aconcagua.*
>
> *In the countryside of Mitla, one day*
> *of cicadas, of sun, of walking,*
> *I knelt at a well and an Indian came*
> *to support me over the water,*
> *and my head, like a fruit,*
> *was between his hands.*
> *I drank what he drank,*
> *so that his face was next to my face,*
> *and in a lightning flash I knew*
> *the flesh of Mitla was my race.*
>
> (*Desolación-Ternura* 152)[13]

Mistral consistently presented her female persona as a traveler, one who by roaming about connects together and unifies the immense and diverse geography of Latin America. As Fiol-Matta puts it, "the woman's abstract body functions as a compendium of the geography of Latin America. This ideal continent-body excludes all the problematic axes of difference . . . by projecting them elsewhere" outside the boundaries of the "continent-body" (214). Here, Mistral uses the act of the maternal "continent-body" drinking from different (geographical) sources to impart a

sense of unity to what might seem the too-disparate human as well as geographical landscape of Latin America and the Caribbean. Choosing the act of imbibing rather than some other activity enables Mistral to use the mirroring properties of water; like Kahlo's use of the self-portrait, Mistral uses her persona's self-regard in the mirror of the water to image the presence of the Indian not just next to her but as physically present in her own presumably mestiza flesh, visible in the contours of her own face. In fact, beginning in 1922 when she was called to Mexico, Mistral had a number of photographs taken that purported to show her in "indigenous" profile (Fiol-Matta, *A Queer Mother* 151). That such a presumably familial connection to the indigenous comes to her as a "lightning flash" places the vision on a par with a mystical experience: it is "holy water," after all, which flagellates and burns her mouth and whose reflection of the indigenous in her own face burns into her consciousness the realization of the Indian component of her mestiza heritage.

If the poem stopped here, it would merely be another interesting way in which mestizaje was represented. However, again like Kahlo, Mistral cannot invoke her own (poetic) self without the ever-present reminder that she possesses not just a mestiza but a maternal body. As others have noted, Mistral employed several different personas in her writing: spiritual mother, teacher, madwoman; but just as important to her poetry and prose is the image of the girl-child. If the first two stanzas of "Drinking" are a mystical acknowledgment of the Indian in her, the second two stanzas make it clear that this Indianness is contained in a (potentially) maternal body, one which belongs to a long line of girl-children who will become mothers, and mothers who will bear girl-children, etc. The third stanza pictures the persona in Puerto Rico, where the palms are like "a hundred mothers." The image of the palms is made all the more pertinent to the theme of this poem when we look at a short essay of Mistral's called "The Coconut Palms." Here in Puerto Rico (and in Cuba too), Mistral wrote, "we immediately recognize the coconut palms; they cannot be counted. For each dead Indian, the Spaniard planted a live palm, remaking the landscape, just as the race was remade in order to forget the former island, the home of Indians" (*Mistral Reader* 163). In "Drinking," then, when a little girl breaks open a coconut from which the persona may drink, we know that the palms are not merely exotic background, but point directly to what Mistral will call the "racial violence" not only of

mestizaje but, in this case, of *mulatez* (Afro-Hispanic mixing) and slavery.
The little girl holds

> *next to my mouth a water-coconut,*
> *and I drank, like a daughter,*
> *mother-water, palm-water.*
> *And I've never drunk sweeter*
> *with the body nor with the soul.*
> (*Desolación-Ternura* 152)[14]

Together with the realization in the first part of the poem of her own
mestizaje—itself the result of acts which, though they comprise ancient
history, are no less violent for all that—the child's offering of the coconut
water, and her drinking of it, is bitter-sweet: the palms stand in for all the
indigenous peoples the Spaniards killed, while she (and, possibly, the girl-
child) stands as living example of their rapacity toward indigenous women.
Nevertheless, the fact that it is a girl-child who makes the offering of the
palm water sweetens the bitterness of her implicit condemnation of the
Conquest and the continued inequalities stemming from those first acts.
The final stanza brings the entire poem together as the persona is reminded
of her mother and her own childhood:

> *To the house of my childhood*
> *my mother brought me water.*
> *Between one gulp and another*
> *I would see her over the cup.*
> *Her head would rise up*
> *the more the cup went down.*
> *I still have the valley,*
> *I have my thirst and her gaze.*
> *This will be eternity*
> *that even still we are what we used to be.*
> (*Desolación-Ternura* 152–153)[15]

In describing a child looking at her mother as she is drinking (the
mother's head appearing over the lip of the cup as the child lowers it for
another breath), the child's gaze at the mother is similar to the persona's

gaze at her own face in the first stanza, and similar to the child's again in the third stanza, where the persona herself drinks like a (girl) child, and the (girl) child stands in for the mother; this circular (or self-reflexive) gesture makes the persona both mother and child ("I still have her gaze") and relates this mother/child to the first stanza's valley, source of a "holy" water which burns at the same time as it enlightens her to her racial nature.

The circular nature of this poem, the way it turns back in on itself, is echoed in the last two lines. Much like race melodrama, where the threat of the dissolution of the social order through the revelation of the hitherto unknown fact of a character's miscegenation is ultimately contained by the turn to a changed but still orderly domestic and/or familial pattern, the violence of the first stanza's language and even the potential violence of the second stanza's revelation of mestizaje are caught up and contained within the domestic sentiment of the maternal water-offering: this is a gesture of change but not annihilation. Although, as in the case of Rivera and Vallejo, such gestures are sometimes presented as revolutionary, they are, in fact, inherited from the sentimental language of persuasion and reform.

Mistral is often presented as a poet of little skill, concerned only with lullabies and poorly constructed poetry.[16] But she paid extremely close attention to language, rhyme, and meter in her work (as she says in "How I Write," there were times when she "battled with language," and she revised "more than people can believe" [*Mistral Reader* 223]). Here as elsewhere, in the Spanish Mistral emphasized the oral nature of her work by using short lines and tightly controlled inner and end rhymes, which mean little unless one reads the poem aloud. Such a structure seems to underline the circularity of the above poem's content, but the author's note to "Drinking" is worth quoting in full for its awareness of a too-facile reading of a tightly closed poem such as this:

The final rhyme is missing, to some ears. In mine, inattentive and coarse, the proparoxytone word doesn't give a rhyme, precise or vague. The leap of the proparoxytone leaves its prance in mid-air like a trick which cheats those who love singsong. The fan of singsong, a collective person who used to number in the thousands, diminishes visibly; one could serve him halfway, or again not serve him at all. (*Desolación-Ternura* 177)[17]

The "proparoxytone" word to which she refers—a word which has the accent on the antepenultimate, or the syllable immediately before the penultimate syllable—is *estábamos* in the lines, "Será esto la eternidad / que aún estamos como estábamos" (This will be eternity / that even still we are what we used to be). Although she performs the rhetorical strategy of downplaying her own poetic ear ("inattentive and coarse"), she makes it clear that there is in fact nothing wrong with her poetic hearing: she is not interested in rhyme in the last line at all. Instead what interests her in constructing this poem is fooling or tricking those readers who had come to assume a singsong quality in her poetry; picturing the proparoxytone word "estábamos" like a prance or a leap, she makes it clear that this is active poetry, setting up the readers' expectations and then undermining them. At the same time, the content of this poem gives a gendered emphasis to that sense of racial (and even continental) continuity for which moderns, in their own vexed ways, so clearly longed.

The more we think about the public face of mestizaje that Kahlo and Mistral presented, the more it becomes clear how slippery the category of mestiza was. Paradoxically, it was Kahlo's privileged suburban upbringing, liberal education, and elite intellectual and artistic connections which allowed her the space to celebrate herself as a woman of the people; in Mistral's case it was her growing fame. For both, their Indian heritage had to be deliberately foregrounded—either visually or textually—in order to be noticeable. The modernist photographer Alvarez Bravo, we are told, "identified Kahlo with the peasant dignity of labor and the rural Mexican women who spend a good deal of their time washing clothes by hand" (Kismaric and Heiferman 113). Were Kahlo and Mistral elite artists whose bodies just naturally signified their connection to "peasant dignity"? The conflicts between notions of what was traditional and what was modern, the privileging of Indian culture, and the elevation by modernist elites of mestizaje to a national, or even continental, project clearly indicate the problems at hand; at the same time, such conflicts allow us to see Mistral's and Kahlo's brilliance in attempting to solve them.

HYBRID MODERN

This book starts from the assumption that there is no point in attempting
to rewrite the old polarities, especially as a substantial body of scholarship
and thinking has emerged in Latin America after the rise of the debt crisis,
the collapse of the welfare state, and the struggle for redemocratiza-
tion. . . . This "new world" order is heralded by three negations: the obso-
lescence of traditional aesthetics and its concomitant public sphere; the
superfluousness of the avant-garde or the counterculture; and the extinc-
tion of the future—socialism . . . has fallen on hard times and no longer
projects the new horizon for the Latin American masses.

—GEORGE YÚDICE, JEAN FRANCO, AND JUAN FLORES,
ON EDGE: THE CRISIS OF CONTEMPORARY LATIN
AMERICAN CULTURE

I HAVE BEEN TRACING what I argue was a basic conceptual problem of
modernity: how to illustrate the conviction that folk and indigenous tra-
ditions existed in a world which was temporally separate from, yet parallel
and contemporaneous with, the world of modernity. In their own very dif-
ferent ways, the artists I examine in this book conceived of many of the
artistic sources from which they drew—in particular, traditional cultures
and indigenous figures—as occupying a space both socially and temporally
distinct from their own, recognizably modern space. Such a view rested on
the unquestioned assumption that tradition was, in effect, static—stuck in
an ever-present moment—whereas modernity was ever-changing. Thus
the modern and the traditional were imagined to stand side by side—
Manuel Gamio's example of the Ford in the remote Indian village comes

to mind here—at the same time as they were imagined to be existing in different temporal and cultural spaces. Whether it be national, party, socialist, or (for Mistral) gender unity, the necessity for solidarity felt by so many Latin Americans at this time demanded a solution to these seemingly deep temporal and social divisions. For their own different reasons, and in their own different ways, then, all four artists were thinking about how to fuse, or hybridize, modernity and indigenous tradition: as Gamio put it in 1926, "unless a . . . fusion takes place," the Ford motor car will fail to exert a "cultural dynamic influence" on indigenous and peasant lives (Gamio and Vasconcelos 122).

By the late 1930s, it was becoming increasingly clear to Latin American moderns, whether they were (more or less, depending on the period) Leninists like Rivera, Kahlo, and Vallejo or Christian humanists like Mistral, that many of the material aspects of modernity had only exacerbated long-standing social and economic inequalities in their countries. But for all of them, even for a determinedly pro-Indian intellectual like Vallejo, these inequalities would have to be leveled from the point of view of a specifically modern, that is, twentieth-century, "spontaneous and logically socialist, unanimist" political sensibility (Mariátegui 250, 256). Mothers and Indians, belonging to a pre- or ex-modern space, had to be brought into the modern world, even if they could never really be fully modernized, so that the seeming fact of the Indian's ancient and backward-looking melancholy or the mother's deep and primitive connection with the earth could provide a feeling of firm historical ground on which a more hybrid or collective future could stand. For each artist, though, one thing was clear: "belonging to the century," as Mariátegui put it ten years earlier (in the late 1920s), meant, for better or for worse, inevitably belonging to modernity, not tradition.

Even times of grave economic or social crises did not impel these artists to retreat into exclusively antimodern positions. Beginning with the Spanish Civil War in 1936, if not before that, Latin Americans were well aware of the potential for a worldwide crisis; in late 1938 or early 1939, Mistral returned from a Europe where the signs of the world war to come were unmistakable. In early January of 1939, she was slated to give a talk in Havana, Cuba, at a conference of the Association of Writers and Artists, where the topic was to be "Culture in America." But Mistral had other things besides culture on her mind; thinking back to Europe but looking now at America, Mistral wanted to talk about what she saw as the failure of

modernity to avert war, or even to avert daily pain and suffering. Her theme for that day, then, was the deliberate exclusion of women by men from participating in—and redirecting in more beneficial ways—the course of modernity. Speaking in strong language and an extraordinarily forthright and bitter manner, Mistral must have shocked and mortified the assembled writers and artists (most of whom were undoubtedly men):

> I will say, in the first place, that we [women] look at the crumbling of European civilization as an affair whose causes have nothing to do with us Men startled women, . . . blinding them with the word "expert," and calling "old fashioned" the large part of the manners and Christian virtues which we women use precisely to conserve the spiritual body of the world. . . . Our [women's] separation from the construction of . . . the modern world . . . is tacitly assumed to be founded in our technical clumsiness in putting our hands to the beams of this new and complex organization; our exclusion is effected rather skillfully by alleging the girl-child weakness that we women have for working with the bitter materials of reality; but above all, it is given, as an excuse for our polite elimination, our natural superstitiousness, that of ignorant Eves who don't trust in science and who childishly embrace their myths, continuing to whine in front of their little idols. (*Escritos políticos* 281–282)[1]

Mistral has often been (mis)read as a thoroughly antimodern thinker; but such a view itself does, implicitly, as we see in the quote above, exactly what she accuses the modern men of Latin America of doing—it deliberately disempowers women by excluding them from participating in the processes of modernity, on the basis that women are too weak to handle such things. For Mistral, modernity without women is modernity without a collective conscience, which makes it a horrifying mixture of the good with the bad: in the same speech, she notes that nowadays "civilization" cures children with one hand while with the other it "kills entire populations with the [hand] grenade and the poison gas, its most popular fruits" (even here, she can't resist making a play on words: *grenada* is the same word for pomegranate and for hand grenade) (*Escritos políticos* 283).[2]

Beginning in 1936, impelled in part, no doubt, by the murder of his good friend Federico García Lorca, Vallejo spent a frenzied two years

working in defense of the Republican cause. He wrote feverishly and among other things managed, in 1937, to finish a fifteen-poem cycle, *Spain, Take This Cup from Me* (España, aparta de mí este cáliz).[3] The title poem of his Spanish Civil War cycle invokes "the children of the world" to come to "mother and teacher" Spain's defense:

> *Children of the world,*
> *if Spain falls—I mean, I'm just saying—*
> *if she falls*
> *from the sky downward then let her forearm be seized.* . . .
>
> *Children of the world, mother Spain*
> *is there flat on her back;*
> *there's our mother with her flat ruler,*
> *there's mother and teacher.* . . .
>
> *If I am late,*
> *if you don't see anyone, if the blunt pencils*
> *frighten you, if mother*
> *Spain falls—I mean, I'm just saying—*
> *then go out, children of the world, go and look for her!*
> <div align="right">(Posthumous Poetry 266–269)[4]</div>

Here, the deliberately homey voice and the evocation of a schoolroom where "mother Spain" rules with loving firmness are of a piece with a colloquial tone which, while looking back to childhood—complete with the anxiety of flat rulers and blunt pencils—at the same time situates itself within the worries of a modernizing world. As with Mistral, the turn to figures of domesticity and motherhood is by now a familiar one; but rather than call upon lofty rhetoric to save "mother Spain," Vallejo's persona himself takes on a maternal air and a domestic, comforting tone. It is perfectly all right, this tone suggests, to be scared about the whole situation. Simultaneously, however, Vallejo, like Mistral, employs, within the space of the domestic, the figure of a collective in order to make a call for action in the modern world.

Again, this is not a new or unusual move: calls for a collective answer to the Spanish Civil War and to the threat of Fascism were everywhere, and it is not so surprising that at a moment of what both poets see as a

crisis specifically of public modernity, both turn to domestic images of mothers and children. But even though Vallejo's mother and children are invoked on a more metaphorical register than Mistral's—for I take Mistral to really, actually mean that mothers, if allowed, could change the world—these two examples demonstrate that in the face of crisis, neither poet adopts a categorically antimodern stance. Instead, Vallejo and Mistral imagine mothers and children as those who always are, willy-nilly, drawn into the crises of the modern world. Emergency or no, for these moderns the visions of mothers, girl-children, and Indians, imagined in all their connotations—ancient, primitive, degraded, melancholy, Christian, pagan, and/or spiritual—represented keys to a specifically modern temporal logic.

Some contemporary theorists of Latin American literature and culture have been wrestling with just this modernist intellectual heritage in their attempts to think through what modernity and postmodernity (in the English-language sense of these terms) might mean for Latin America at the end of the twentieth century. For Néstor García Canclini, an Argentinian anthropologist, the older disciplinary methods and assumptions of Latin American anthropology now, at the end of the twentieth century, seem inadequate to describe Latin American cultures and societies. In their place García Canclini advocates what he calls a nomad social science which, by its movements across disciplinary borders, might render up more valuable ways of interpreting the seeming cultural and social contradictions being produced in Latin America through its participation in today's global economy.

In his 1992 essay "Cultural Reconversion," García Canclini recounts an anecdote, one which I take to be paradigmatic of the anxieties—and goals—of many contemporary Latin American critiques of modernism and postmodernism. I read this anecdote as a kind of conversion narrative, in which García Canclini is vouchsafed a way out of older, and now bankrupt, anthropological ways of thinking. Such a genre—the narrative of conversion—often plays an implicit framing role in late twentieth-century discussions of this sort; indeed, as affirmed by the title of the book in which García Canclini's essay appears (*On Edge: The Crisis of Contemporary Latin American Culture*), there is a sense of "crisis" engendered at least in part by the failure of modernist structures of thought to address—much less solve—the problems of Latin America at the end of the century.

As Vallejo and Mistral did before him, García Canclini senses himself at a moment of crisis; at the beginning of this anecdote, he confesses that he used to bemoan the influence "that the taste of urban consumers and tourists had on crafts," fearing the loss of the traditional arts. However, a field trip to a weaving community began to give him another perspective (eight years before this essay was published). While there, García Canclini entered a shop "in which a fifty-year-old man and his father were watching television and conversing in Zapotec"; when García Canclini expressed interest in the fact that he saw the influence of European high modernist painters like Picasso, Klee, and Miró in this man's weaving, the man replied that in 1968 he had begun to weave the new designs per the suggestion of a group of tourists who worked for the Museum of Modern Art in New York. The weaver (whose name we never learn) showed García Canclini a scrapbook of newspaper reviews and analyses and proceeded to "move comfortably from Zapotec to Spanish and English, from art to craft, from his ethnic culture to mass culture, and from practical knowledge of his craft to cosmopolitanism," all in the space of half an hour's chat (Yúdice 37). This paragon of an artisan, seemingly, had learned the lessons both of modernity and of tradition, but—and this is García Canclini's perhaps unconscious point—apparently he had learned them in an organic, seemingly traditional, and seamless way. One almost might suspect that García Canclini is exaggerating a bit for the sake of his stated point, which is this: "I had to admit that my worry over the loss of tradition was not shared by this man who easily negotiated three cultural systems" (Yúdice 38).[5] Here, García Canclini learns—with all the force of that lightning bolt by means of which Mistral, almost exactly sixty years earlier, personally recognized the truth of mestizaje in her poem "Drinking"—that the cultural capital of Latin America, its traditions, have not been lost but rather, under the economic pressures of the late twentieth century, "reconverted" (Yúdice 31).

Now, García Canclini sees, in the weaver to whom he spoke, that what used to be separated out as high, popular, mass, and even traditional and modern cultures is—thanks to the pressures of neoliberalism and globalism on Latin America's economies—all jumbled together. "In these new settings"—that is, in the combination of high and low cultures, or First with Third World—García Canclini says, "our cultural capital is reconverted. . . . Instead of the death of traditional cultural forms, we now discover that tradition is in transition, and articulated to modern processes"

(30–31). Conversion stories ordinarily imply salvation: García Canclini has been saved from a way of thinking which was inherited from the early twentieth century, one which saw tradition as having to be rescued from its degeneration in the face of modernity. If tradition, far from degenerating under modern pressures, is strong enough to endure and even to articulate or attach itself to modern processes, all is not lost.

But the reconversion of tradition (or, as the cultural critic George Yúdice puts it, the "rearticulation") to what García Canclini specifically calls a hybrid connection with, and firmly within, the technologies and energy flows of modernity implies the same kinds of binaries with which artists and intellectuals of the early part of the century struggled. For Gamio, it was only with the help of the state and the anthropologist that tradition could fuse with the modern; for García Canclini, it is now the weaver who reconverts tradition into modernity, and the anthropologist is but the bearer of good news. However, the weaver in García Canclini's tale is still at heart unmodern; that is, with the craftiness and practicality of the Indian and peasant underclasses, this man has, in an organic and traditional (that is, unschooled) manner, articulated both his work and himself within the structures and strictures of modernity. In other words, he has (naturally) fused or hybridized one with the other, in life as well as in art: "But cultural reconversions, in addition to being strategies for social mobility, or for following the movement from the traditional to the modern, are *hybrid* transformations generated by the horizontal coexistence of a number of symbolic systems" (Yúdice 34, my emphasis).

Implicit in contemporary Latin American uses of the notion of a hybrid identity is this notion's problematic historical connection to the idea that Latin America's difference from European or United States modernity is by way of its unevenness of development. That is, Latin America is (still) perceived to be different because it (still) is perceived to have differing temporalities coexisting side by side; such temporalities, it still seems, can only be fused or grafted together via an articulation of what appear to be traditional processes with what we take to be modern processes. Particular organic metaphors like "hybridity" also bear the unfortunate legacy of being carried forward from some of the most questionable discourses on race and eugenics in Latin America. From a feminist point of view, this reliance on an organic metaphor which implies, to this day, racial mixing—combined with the idea that different people

occupy "horizontally coexisting" temporalities—can have the effect of reinscribing the very ways in which Latin American modernists claimed newness or modernity through and over the raced and sexualized bodies of those groups they themselves deemed unmodern. To frame a contemporary Latin American actuality in terms of the hybrid nature of Latin American identity is to continue to be vexed by inherited modernist ideas about (cultural, political, economic, racial, and gendered) belatedness and temporal unevenness.

Indeed, as I have endeavored to make clear, whatever we may think of their racial or sexual politics today, Kahlo, Mistral, Vallejo, and Rivera did feel strongly about the specifically social and ethical content not only of their art, but of their other activities as well—political activism, teaching, journalism, to name but a few. And all four assumed that their own rearticulations of tradition—be it folklore, pre-Columbian art, or indigenous work—to the processes and politics of modernity were part of what gave their art, and their own lives, ethical content. But, ultimately, they held to modernist assumptions which placed certain peoples and cultures on the wrong side of development; and the strength with which such assumptions have endured into the twenty-first century and even into a much-changed and presumably postmodern world leads me to think that these assumptions possess an actual generic and categorizing force. The modern project was, and remains, as John Frow contends, "an operation; it performs a certain work, it makes certain things possible, including some of the forms of difference from the past . . . that it imagines as given in the order of things" (3). That is, the continuing force of modernist concepts literally shapes our thinking, so it seems to us that, in fact, traditional, indigenous, or underdeveloped groups are generically—or in terms of the category or genre to which they belong—different from modern nations and peoples. Instead, I would suggest that it is modernity itself which makes such differences seem so apparent; or even, as John Law puts it in his *Organizing Modernity*, that the organizing categories of modernity "more or less successfully (though partially and precariously) *generate* and perform a series of divisions" (qtd. in Frow 3). Notwithstanding their seeming usefulness in contemporary postcolonial, Chicano, Latino, and Latin American thought, ideas of grafting and hybridity, when not examined closely, carry with them certain problematic presuppositions which we stand to inherit if we are not careful.

This returns us to a work like Houston Baker Jr.'s *Modernism and the Harlem Renaissance,* in which he maintains that modernity was not opposed to categories like folk or primitive, categories which had been applied to Afro-Americans; instead, the assumptions about temporal and social spaces, assumptions which attended modernity, determined those categories in the first place: "only the success of Western 'confinement' (in the sense intended in Michel Foucault's *Madness and Civilization,* i.e., if you are in a madhouse, then you must be mad) had enabled categories such as ART, LITERATURE, CIVILIZATION and even MODERNISM to dominate. . . . Afro-Americans, who are assumed by the confining problematic to be without art, literature, civilization, *and* modernism" (xvii). Substitute Indian, peasant, weaver, or Third World nation where Baker has "Afro-American"; add to this the fact that Latin America itself is to this day not imagined, in developed countries like the United States, to be successfully modern; and one has a doubled sense of what Baker calls a "confining problematic." What is called for, then, is not a new set of terms for the same sets of binaries, but a reexamination of the very framing categories by which we identify and by which we value the temporal and social spaces to which we belong. In looking back at some of the artists and intellectuals who shaped Latin America's thinking about itself as an emerging, modern set of nations, we not only perform an esthetic exercise, but also perform an examination of some of the very powerful images by means of which we have inherited a constellation of operational concepts about time, progress, social relations, race, identity, and gender. It is in this way that I read Vallejo, Mistral, Kahlo, and Rivera as modernist, in the English-language sense of the word: that is, as caught up within the very global discourses of modernity and imperialism against which they struggled and through which they negotiated their places in a changing world.

NOTES

INTRODUCTION: MESTIZO MODERN

1. But, as Neil Larsen points out, an entire scholarly industry has sprung up (mostly in the United States) around the intertextual references and resemblances between works of the Latin American Boom, such as those by Cortázar and Gabriel García Márquez, and those of James Joyce and William Faulkner (Larsen, 6).

2. As a science of race and gender management and improvement, eugenics was widely endorsed in Europe and the United States by 1912, the year of the First International Eugenics Congress. Eugenics concepts had already been introduced to Latin American debates over "evolution, degeneration, progress and civilization" during the last decades of the nineteenth century, although it was not until after World War I that these concepts were more systematically developed within a specifically Latin American context. They often included natalist ideas of "hogaría y educación maternológica"; in Argentina, for example, scientists went so far as to propose an identity card which would give a "eugenic index of individual value in fertility," the "eugenic value" of course, among other things, having to do with the race of the woman bearing the card (Stepan 121). And although Latin Americans had themselves been situated by eugenicists from outside as backward and degenerate, by the late 1910s eugenics had been reworked by Latin American thinkers to the extent that legislation concerning "human reproduction, the control of disease, and the regulation of immigration in Latin America can be fully understood only by taking into account eugenic concepts, which at the very least gave them their rhetorical structure and their medico-moral rationale" (Stepan 8–9).

3. The early twentieth-century emphasis on the mixed-race nature of Latin American populations represented, one might say, almost a sea change in popular feelings about Indians. Although after independence from Spain the Black Legend of the Conquest was used to evoke a sense of lost Aztec, Maya, and Inca glories, contemporary Indians were for the most part universally despised. Anti-U.S. opinion, a backlash against identification with European values and styles, and a renewed sense of the need for strong, unified, and progressive nations helped to fuel attention to the progress in Latin American anthropology and archeology toward more discoveries and a better understanding of pre-Columbian peoples; at the same time, these disciplines, along with studies of folklore, meshed neatly with a sense on the part of policy makers and politicians alike that strong nations needed not just a future but an easily articulated tradition (traditions evidenced through the

folkways of those previously despised contemporary Indians) and history (preferably a glorious and ancient past).

4. *Mestizaje* refers not only to race-mixing (usually Indo-Hispanic) but to a whole discourse, deployed in everything from art and narrative to scientific documents, concerning the character, viability, and fate of the mixed-race populations of Latin America. *Mulatez* served the same functions for those South American and Caribbean countries, such as Cuba and Brazil, with large, mixed Afro-Hispanic populations. *Indigenismo,* as a Latin American set of genres—painting, photography, essay, poetry, fiction, political rhetoric—has been characterized, and indeed did serve, as an effort on the part of elite Creole and mestizo intellectuals and artists to enlighten the general population about the abuses that indigenous or black peoples suffered both culturally and economically. But in Peru, for example, indigenismo also served as a public and political rhetorical tool for various social and economic factions. These included the essentially feudalist landed oligarchy, the more "liberal" elite interested in exports and in encouraging foreign immigration, and those who favored immediate industrialization via foreign capital, all of whom struggled with each other over how to represent, integrate, and/or make best use of Peru's large (and largely unassimilated) indigenous population. In combination with artistic indigenista visions, which included indigenist photography, this discourse was variously assimilationist or preservationist; in Peru the concern was either with how to inculcate in the indigenous population a more nationalist sense of "Peruvianness" or, on the other hand, with how to create or maintain an "indigenous" and Andean sense of national self. See, for example, Efraín Kristal's introduction to his discussion of indigenismo, *The Andes Viewed from the City: Literary and Political Discourse on the Indian in Peru, 1848–1930.* The bohemian Cusco photographer Juan Manuel Figueroa Aznar was a proponent and practitioner of the Cusco indigenist movement, which flourished between 1910 and 1930; he made studio portraits of idealized Indian types, stylized indigenous theatrical tableaux, and bohemian self-portraits (Poole 187). Nils Jacobsen notes, "During the early years of the twentieth century the 'Indian problem' began to attract growing attention among intellectuals and public figures in the capital, and even conservative politicians . . . began to call for protective legislation for Indians" (338). Broadly speaking, the literary term "indigenism" refers to a Latin American genre which, while written by Creole or mestizo authors, (more or less) sympathetically narrates the plight of indigenous populations. Indigenista texts are not, by and large, written by indigenous authors themselves, as Efraín Kristal points out; rather, they are "written to present the indigenous peoples to a primarily urban reading public which, while aware of the Indian presence in the rural regions of its nation, ignored Indian culture and life" (2–3).

5. This single fact links the artists I examine here closely with other African-American and Afro-Caribbean modernist movements. See, for example, Toni Morrison, *Playing in the Dark: Whiteness and the Literary Imagination;* Walter Benn Michaels, *Our America: Nativism, Modernism, and Pluralism;* Houston A. Baker Jr., *Modernism and the Harlem Renaissance;* Paul Gilroy, *The Black Atlantic: Modernity and Double Consciousness;* and Carla Kaplan, "On Modernism and Race."

6. This growing movement was spurred on by Latin American awareness of the attitudes embodied in such U.S. publications as Josiah Strong's *Our Country,* which

became a U.S. best-seller in 1885 with its social evolutionist claims that the United States was destined "to move down upon Mexico, down upon Central and South America" and its rhetorical question "Can anyone doubt that the result of this competition of the races will be the survival of the fittest?" (qtd. in Novas 164).

7. "Se tienen el oído puesto a todo; los pensamientos no bien germinan, ya están cargados de flores y de frutos, y saltando en el papel, y entrándose, como polvo sutil, por todas las mentes; los ferrocarriles echan abajo la selva, los diarios la selva humana."

8. "Aquí, en América i en nuestro siglo, necesitamos una lengua condensada, jugosa i alimenticia, como estracto de carne; una lengua fecunda como riego en tierra de labor . . . una lengua, en fin, donde se perciba el golpe del martillo en el yunque, el estridor de la locomotora en el riel, la fulguración de la luz en el foco eléctrico i hasta el olor del ácido fénico, el humo de la chimenea o el chirrido de la polea en el eje."

9. "El dolor ingente de una gestación fecunda. . . . en la América indolatina, hay un fondo virgen todavía, que es la realidad esencial de la ascendencia aborigen."

10. In such a movement (loosely speaking) I am including such artists, intellectuals, and writers as William Carlos Williams, Waldo Frank, Diego Rivera, Frida Kahlo, Gabriela Mistral, José Martí, José Sabogal, José Carlos Mariátegui, and a host of others.

11. Saúl Yurkievich connects writers as seemingly different as the Chilean poet Gabriela Mistral and the Puerto Rican poet Luis Palés Matos through a "posmodernismo" moment "of the return to the origin, the recuperation of the birthworld, the search for authenticity, autochthony" (del regreso al origen, de la recuperación del mundo natal, de la búsqueda de la autenticidad, de la autoctonía) (73).

12. In Europe and in the United States, photography quickly became an intimate aspect of modernity, as its accessibility and reproducibility embedded its practices in people's social and even familial senses of themselves. At the same time, photography functioned as a tool with which to distance, categorize, and control certain types of people—criminals, the poor, other races, women. Thus, photography had a central location in the emerging social orders and social controls of modernity. The technologies of photography as they were developed and employed in the Andes from the late 1800s on were no less a means of manifesting, ordering, and controlling social relationships.

13. Although not treating the rest of Peru, *Mundos Interiores: Lima, 1850–1950,* by Aldo Panfichi H. and Felipe Protocarrero S., provides some very good essays on the social, cultural, and economic changes undergone in Lima; the collection *Lima Obrera: 1900–1930, Tomo II,* ed. Laura Miller, Katherine Roberts, et al., provides interesting basic information about the racial, social, and economic stratification and treatment of working women in Lima during this period; and, finally, *Mirages of Transition: The Peruvian Altiplano, 1780–1930,* by Nils Jacobsen, provides a broad overview of the ways modernization did, and did not, change life in the largely indigenous Peruvian highlands.

14. A 1921 photograph of Diego Rivera, taken in Mexico just after his return from an eleven-year residence in Paris (a fact of Rivera's artistic career that many art historians are hasty to gloss over or even elide), also shows a thoroughly Europeanized

man wearing a smart suit and necktie. The degree to which Latin Americans identified with Europeans (and, indeed, vice versa) has often been either overplayed by Hispanophiles or underplayed by Americanists; nevertheless, it is important to understand the interplay between the two in order to begin to understand Latin America's (often vexed and ambiguous) relationship to European–North American modernity.

15. Both these later pictures show a thinner and seemingly far older man. Although when Vallejo arrived in Paris he almost immediately began writing for Trujillo and Lima newspapers and for publications in Paris and Spain, he faced severe economic hardships for several years. In 1924 his father died, and he (Vallejo) spent some time in a hospital; he became ill again in 1925 and 1926. By 1927, only four years after he had left Lima, he had undergone "a profound moral and intellectual crisis" and had begun to take an interest in Marxism (Vallejo, *Trilce*, trans. Eshleman 267–268).

16. Poole notes, "Facial whitening was a commonly used tool in Andean studio photography. . . . Rather than whitening their faces with cosmetics or even flour, the photographer [sometimes] instead chose to 'improve their race' by tampering with the emulsion" (205). So in a Cusco family portrait that Poole discusses, facial whitening on the part of the two daughters contrasts with the darker skin of the mother, and her traditional peasant dress contrasts with the display of "a newspaper, gloves, a watch, a toy rifle, or an attitude compressed into the fashionable newness of their suit, sunglasses, or dress . . . [which] mark each individual's claim to modernity with respect to the family they collectively compose" (206).

17. Following this logic, Vallejo's face and body constitute a connection with the originary nature and authenticity of the very soil the "melancholy" Peruvian Indian must work: the Peruvian poet Cirio Alegría, reflecting on the first time he saw Vallejo, writes, "[Vallejo] struck me as a message from the earth" (qtd. in Eshleman, afterword 238). Nowhere has this cult of the artist been more evident than in the work of Espejo Asturrizaga and the Spanish poet Juan Larrea, both of whom were friends of Vallejo's. See, for example, Fernando R. Lafuente's "La *invención* de César Vallejo por Juan Larrea."

18. Lawrence Clayton traces some of the ways Peru modernized from the mid-nineteenth century to the late twentieth century; both the railroads and the first plane flights and regular plane service were brought to Peru by entrepreneurs from the United States. Henry Mieggs persuaded the Peruvian government to overextend itself to build railroads in the late 1860s, and large public works were initiated in Lima and Callao to modernize both port cities "with broad boulevards, modern housing, new port facilities" in anticipation of the mineral wealth brought by the railroads from the interior. Elmer Faucett pioneered the first trans-Andean flight from Lima to Iquitos in 1921 (the Leguía government had offered a prize to the first person to do this), and in 1928 he founded his own Faucett Airlines (Clayton 54–55, 131–133).

19. There was also in Latin America, as in Europe, "a palpable increase in intellectual traffic of all kinds, in ideological trade, in cultural exchange," it is no less true of Latin America's international relations than it is of those of Europe and the United States that "a chart of the movements of artists, writers and thinkers in time and

space during these years" would reveal a tangled network of artistic and intellectual encounters (McFarlane 78).

20. "La América latina debe lo que es al europeo blanco y no va a renegar de él; al mismo norteamericano le debe gran parte de sus frocarriles y puentes y empresas, y de igual suerte necesita de todas las otras razas. . . . [e]l indio es buen puente de mestizaje."

21. "Cerca del gran río se levantará Universópolis y de allí saldrán las predicaciones, las escuadras y los aviones de propaganda de buenas nuevas. . . . si la quinta raza se adueña del eje del mundo futuro, entonces aviones y ejércitos irán por todo el planeta educando a las gentes para su ingreso a la sabiduría."

22. "Se nos tiene por una especie de hembras de la raza americana, y va siendo urgente que nos vean en trabajos viriles: sobre todo cuando es cierto, que, dados medios equales, en condición ninguna de actividad, laboriosidad e ingenio nos sacan ventaja los hombres del Norte" (José Martí, *Obras Completas* 2: 531).

23. The essays in the anthology *Women, Culture, and Politics in Latin America*, ed. Emilie Bergmann et al., show the relationship of Latin American women writers, intellectuals, and feminists to Latin American culture and politics. Through her analysis of literary, journalistic, and popular texts, Francesca Miller maintains that "women played an important symbolic and active role in Latin American civil society of the 1910s and 1920s" (qtd. in Bergmann et al. 33); feminist movements of Latin America were also involved in international debates over the rights of women: "The history of Latin American women's participation in the inter-American conferences suggests that the transnational arena held a particular appeal for Latin American feminists" (Bergmann et al. 10). "Toward a History of Women's Periodicals" demonstrates the importance and visibility of feminist movements during the 1920s and 1930s: "The greatest burst of feminist magazine activity in any period excluding the 1980s was in the 1920s and 1930s. Over fifty magazines on this list appeared in these decades" (Bergmann et al. 173).

24. "Unas mujeres muy feas, llamada sufragistas."

25. "En el niño posee la madre un bloque de mármol donde bosquejar una estatua griega."

26. Male artists of the time who considered themselves avant-garde worked aggressively to exclude their female contemporaries, poets like Gabriela Mistral, Alfonsina Storni, and Juana de Ibarbourou. This exclusion still works today; Gabriela Mistral, for example, is virtually obscured under her reputation as "schoolteacher to the Americas" and her (presumably fond) nickname, "la fea"; as Mary Pratt adds, the most these women are accorded is to be "benignly classified in literary typologies as *posmodernistas* distinct from the avant-garde. The experimentalism of their writing goes largely unrecognized by the literary establishment" (Pratt 57).

27. I owe this concept to Susan Hegeman's discussions of modernism in her *Patterns for America*. Other theorists of modernism make a sharper distinction between culture, period, and process than I do: "Modernism should properly be seen as a *culture*—a constellation of related ideas, beliefs, values, and modes of perception—that came into existence during the mid to late nineteenth century. . . . Modernization, by contrast, denotes a *process* of social and economic development,

involving the rise of industry, technology, urbanization, . . . that can be traced back as far as the seventeenth century" (Singal 7).

28. For condensed but helpful overviews of Latin American political, social, and economic changes around the turn of the century, as well as for an almost encyclopedic comparative overview of Latin American vanguard movements, see Vicky Unruh's *Latin American Vanguards: The Art of Contentious Encounters*. For summaries of the complex ways in which Latin American women were represented and represented themselves during the course of early twentieth-century modernization, see *Women, Culture, and Politics in Latin America*, ed. Emilie Bergmann et al., and Francesca Miller, *Latin American Women and the Search for Social Justice*. For discussions of Latin American vanguard art and its connections with U.S. modernism (and, more recently, its connections with Chicano and Latino art and thought), see Shifra Goldman's comprehensive *Dimensions of the Americas: Art and Social Change in Latin America and the United States*.

29. In his "Digesting Modernismo: Peristalsis and Poetic Paternity in Vallejo," Gari LaGuardia extensively examines Vallejo's poetic relationship to modernismo and Symbolism, especially comparing him to Rubén Darío. See also Saúl Yurkievich's "El ser que se disocia" for another discussion of the connection between Vallejo's *The Black Heralds* and modernismo.

30. In his economic history of the southern altiplano or high sierras of Peru, Nils Jacobsen argues that it is not the "penetration" of all areas of economic activity by capitalism which necessarily creates inequalities whose more visible cultural and artistic manifestations I am emphasizing here; instead, he maintains that the forces that propelled the transition to capitalism, particularly outside of the concentration of authority in Lima, "provoked a reawakening and readjustment of an older set of social forces: . . . monopoly, clientalism, and communal solidarity . . . understood as ingrained modes of behavior tending toward institutionalization. . . . In short, there are dynamics of inequality, some surviving from the colonial era, others newly arising in the last century, that have roots independent of the capitalist economy" (7–8).

31. This sense has continued to leave its mark even on contemporary readings of modernist art. As Rita Felski has pointed out, the insistence by European modernist and avant-garde artists of the early twentieth century that their work was radically new in contrast to an old or outdated (or bourgeois) tradition has itself been taken at face value by critics and historians of modernism alike (27). As in Europe and the United States, vanguard movements in Latin America endlessly repeated in their art, manifestos, and essays the theme of a break with the traditional past and with the bourgeois present. Again, this theme is taken up by theorists of modernism and the avant-garde: modern art is fundamentally constituted as what Matei Calinescu calls an oppositional "crisis concept"; "aesthetic modernity should be understood as a crisis concept involved in a threefold dialectical opposition to tradition, to the modernity of bourgeois civilization (with its ideals of rationality, utility, progress), and, finally, to itself, insofar as it perceives itself as a new tradition or form of authority" (10).

This view of modernism also accepts the idea that there does in fact exist a "great divide" (Huyssen vii) or opposition between modernism and such aspects of bourgeois culture as mass production—and by extension, then, a divide

between (high) modernism and things "feminine": the popular, the kitschy, the sentimental. Although vanguard practices often do constitute real ruptures with traditional ideas and practices, nevertheless, many underlying assumptions to be found in modernist art in fact form tightly wound albeit elastic links between discourse *and* counterdiscourse. Rita Felski puts it this way: "a feminist reading often reveals striking lines of continuity between dominant discourse and aesthetic counterdiscourses in terms of a shared valorization of . . . models of competitive masculinity [A] text which may appear subversive and destabilizing from one political perspective becomes a bearer of dominant ideologies when read in the context of another" (27). Feminist critics in particular argue that part of what makes it possible for critics to read vanguard art as though it were radically disconnected from the ideological frameworks within which it arises is the fact that there is a certain circular logic which often attends discussions of the terms "modernity" and "modernism," as Rita Felski points out: "The modernist artwork is seen to offer exemplary insights into the modern condition, crystallizing the contradictory impulses of an epoch through its use of radical and experimental form. . . .The modernist canon, paradoxically, is seen to provide a heightened perception of a historical reality that it has itself helped to construct" (191). That is, those rhetorical and/or artistic practices of rupture, fragmentation, and linguistic experimentation are assumed to reflect the reality of the historical context which produced them. This circular logic works to institute and reify a picture of modernism as mirroring the reality of a self-enclosed, monolithic, and not coincidentally purely masculine and Anglo-European view, a picture which obscures discourses of race and gender within modernism itself.

Against this binary and ultimately circular logic, Perry Anderson has argued that the European response to the modernity of the "new machine age" was more complicated than a simple notion of rupture would indicate. Anderson maintains that "European modernism in the first years of this century . . . flowered in the space between a still usable classical past, a still indeterminate technical present, and a still unpredictable political future" (326). On the other hand, critics such as Renato Rosaldo and George Yúdice argue that in Latin America itself modernity should not be theorized in the traditional terms of avant-garde "rupture" with the past, but rather should be seen as a series of "necessarily unfinished projects" which were more about "establishing new relationships with tradition," such as indigenous and Afro-Hispanic cultures (Yúdice 20–21). Or perhaps we should better say that these movements were engaged in trying to establish new relationships with existing *representations* of traditional cultures and, I would add, traditional gender roles. Felski notes, "The 'old new' of dominant bourgeois values was thus regularly challenged by diverse groups who defined themselves as 'authentically new'" (14).

32. For an extended discussion of the various beginning and ending dates proposed for Latin American vanguardism, see the section "Periodización" in Jorge Schwartz's introduction to his anthology *Las vanguardias latinoamericana: Textos programáticos y críticos*.

33. Vicky Unruh's 1994 *Latin American Vanguards: The Art of Contentious Encounters*; Jorge Schwartz's 1991 *Las vanguardias latinoamericanas: Textos programáticos y críticos*, both volumes of Gloria Videla de Rivero's 1990 *Direcciones*

del vanguardismo hispanoamericano, all otherwise extremely helpful studies of early twentieth-century modern art, are just a few of the works that critics were writing in the 1990s, critics who begin their studies with the same assumption of vanguard rupture.

34. As Andreas Huyssen notes, European vanguard art, too, "even in its most adversary, anti-bourgeois manifestations, is deeply implicated in the processes and pressures of the same mundane modernization it so ostensibly repudiates" (56).

CHAPTER ONE: SENTIMENTAL MEN

1. The sense of nostalgia, indeed, is a clear force in European discourses of modernity and modernization; Felski notes, "If the experience of modernity brought with it an overwhelming sense of innovation, ephemerality, and chaotic change, it simultaneously engendered multiple expressions of desire for stability and continuity" (40).

2. At the end of the nineteenth century in Europe, Frances Frascini writes, "The contemporary European [was obsessed] with the myth of the rural peasant as a figure of great moral worth, uncorrupted by the sophistication and materialism of the modern world"; in the German context, "notions of the rural peasant as the 'soul' of a race . . . contribute[d] to various mystical and nationalistic discourses"; these notions were conflated with "a well-established convention within Post-Enlightenment European art and culture . . . in which the rural female was represented as close to nature, as a symbol of the 'natural' peasant life" (Harrison, Frascina, and Perry 10, 14, 22). The French painter Gauguin, writing to Strindberg at the turn of the century, nicely summed up the sense that the "primitive" was a source of renewal as well as of the "new": of his life in Tahiti he said, "[It is] a shock between your [Strindberg's] civilization and my barbarism. Civilization from which you suffer, barbarism which has been rejuvenation for me" (qtd. in Harrison, Frascina, and Perry 24).

3. Guerrero, *La génesis del crimen en México: Estudio de psiquiatría social.*

4. Alexander von Humboldt, *Ensayo político sobre el reino de la Nueva España*, vol. 2 (Mexico City: P. Robredo, 1941), 86.

5. "Clamaremos por la inmigración extranjera que, con el cruzamiento de sangre . . . nos den hombres robustos, hombres útiles."

6. For example, Monsiváis explains, during and after the Mexican Revolution, rather than use the *corrido*, which while it is a genuine popular form "possesses no cultural aura and does not 'elevate,'" the Mexican government looked to the poetic and musical vocabulary of romantic song and *modernista* poetry, already in place as a "vehicle of exaltation" (176). Doris Sommer has pointed out that, from the mid-nineteenth century through the beginnings of the twentieth century, "romantic novels go hand in hand with patriotic history in Latin America. The books fueled a desire for domestic happiness that runs over into dreams of national prosperity; and nation-building projects invested private passions with public purpose" (7). The fact, as Sommer continues, that the "national romances" of the mid- to late nineteenth century were required school reading in the first decades of the twentieth century made them, in her words, "founding fictions"

for Americans searching for ways to govern diverse populations and political groups (51).

7. See Sommer's chapter on *Sab* and *Cecilia Valdés*. Matto de Turner's work and politics eventually got her exiled from Peru.

8. "... aire de intensa melancolía intelectual, mejor dicho, de soledad intelectual un poco febril y agresiva que hace tan entrañable su poesía. . . . dolor intelectual, dolor de inteligencia, dolor más bien de hombres que dolor de mujeres."

9. A strongly pro-woman writer like the Argentinian Alfonsina Storni, who herself wrote romantic and sentimental short stories, averred that although women possessed "sensibility," this was not enough to be able to write novels: for a March 1921 edition of the Argentine newspaper *La Nación*, Storni wrote "The Woman as Novelist," maintaining that "although the feminine sensibility is rich, pure sensibility is not enough for the work of art" (si la sensibilidad femenina es rica, la sensibilidad pura no basta para la obra de arte) (qtd. in Kirkpatrick, "Journalism" 125).

10. "Vuestra imaginación se interpone así entre la realidad y el sueño como un elástico de poderosa resistencia que apaga y sauviza los choques."

11. "... a *hacer* una revista para el pueblo, *sin literatura dañada o cursi*, sin la mundanería que les da tanta fotografía banal e inútil que publican con pretexto de actualidades; sin ese carácter tan antipáticao de folletines ilustrados, explotadores de la crónica policial más repugnante."

12. "Para mí, la forma del patriotismo femenino es la maternidad perfecta. . . . El patriotismo femenino es más sentimental que intelectual, y está formado . . . de la emoción del paisaje nativo."

13. Here, Mariátegui is reading Vallejo's first two volumes of poetry about five years after they have been published, at the height of the indigenous modernism in Peru. This was a modernism which sought to make itself new by introducing Quechua and Aymara words and images, themselves often derived not from the poet's firsthand knowledge but from anthropological and archeological work on the "folk," into the work. And because by this time the folkloric is in fact associated with romanticism, Mariátegui maintains that Vallejo is not exploiting but is merely appropriating folklore in his poetry: "But the Indian is the fundamental characteristic feature of his art. In Vallejo there is a genuine Americanism, not a descriptive or local Americanism. Vallejo does not exploit folklore. Quechua words . . . are not artificially introduced into his language; they are spontaneous. . . . It might be said that Vallejo does not choose his vocabulary. He is not deliberately autochthonous. . . . His poetry and language emanate from his flesh and spirit; he embodies his message. Indigenous sentiment operates in his art perhaps without his knowledge or desire. . . .The pessimism of Vallejo, like the pessimism of the Indian . . . is tinged with an oriental fatalism. . . . [Vallejo] is a mystic of poverty" (252–257).

CHAPTER TWO: WOMEN'S WORK

1. As Susan Hegeman notes of the "anti-modernism" of artists such as William Morris, who "attempted to address the problem of worker alienation in industrial

society through a revitalization of handicraft traditions," what was "explicitly backward-looking in its fascination with pre-industrial technology" was also at times "at least proto-modernist—*ante*-modernist—in terms of . . . formal innovations" (24).

2. Although the city of Lima has been called preindustrial between the years 1900 and 1930, this is something of a mischaracterization. By 1902 the center (though not the rest) of the city was lit by electric lights, and the horse-drawn trolley of the late nineteenth century gave way in 1907 to the electric trolley; by the end of the first decade "cars, trucks, motorcycles and the bus appeared. . . . [and] grand avenues, parks, monuments and hospitals were constructed" ([a]parecen los automóviles, camiones, motocicletas, y los ómnibus . . . se construyen grandes avenidas, parques, monumentos y hospitales) (Tejada 145), and by the 1910s factories were in operation. Branches of the leading Parisian department stores were opened in Lima. Modernization included urban planning: *callejones* (alley-like streets), which were the first inner-city (slum) living spaces to appear in Lima, were destroyed to make way for avenues as well as to move the streets' inhabitants out of the middle of the city.

3. Vallejo lived in Lima for the better part of 1911; when he was writing and compiling *Trilce* (during the years 1918–1921), he lived in Lima almost continuously from 1918 to his departure for Paris in 1923.

4. As Gari LaGuardia notes, it was, ironically, the exportation of raw materials such as guano (in much demand on the international market as fertilizer) "that created the social ambience that allowed the birth of the particular tastes and sensibilities that determined the *modernista* world view" (79). This paradox put modernista poets in a difficult position of opposing the very bourgeois values which made their own sensibilities possible. At almost exactly the same time as Stéphane Mallarmé was fomenting against the rise of the newspaper and mourning the death of poetry, artists like the Nicaraguan Rubén Darío were doing the same thing in Latin America; however, these same artists did not always have the luxury of turning away from the "nueva época maquinista" (Rama 35). Christine Poggi discusses the role of the newspaper in her "Mallarmé, Picasso, and the Newspaper as Commodity": "Stéphane Mallarmé, who had experienced the growing marginalization of the poet in contemporary society and the erosion of a genuine public sphere for noncommercial writing, defined his own poetry as the 'other' of the writing in the newspapers. . . . For Mallarmé . . . the newspaper and the poster exemplified the prevailing tendency to transform language into a commodity, thereby rendering its qualitative value as symbol into mere exchange value" (173–174). And Latin American modernistas could also complain about having to write for newspapers; Darío's 1896 *Prosas profanas*, with its famous prologue, asserts in frankly crusty terms the lack of "true" artists in Latin America. Against the unoriginality of the bourgeois materialism of his culture, he proclaims the originality of his own artistic genius. In the midst of growing *mundonovismo* and interest in things indigenous, Darío has this to say: "¿Hay en mi sangre alguna gota de sangre de Africa, o de indio . . . ? Pudiera ser, a despecho de mis manos de marqués. . . . Si hay poesía en nuestra América, ella está en las cosas viejas . . . en el indio legendario y el inca sensual y fino, y en el gran Moctezuma de la silla de oro. Lo demás es tuyo, demócrata Walt Whitman" (Is there in my blood one drop of Africa, or of the

Indian . . . ? It could be, in spite of my marques' hands. . . . If there is poetry in our America, it's in the old things, . . . in the legendary Indian and the fine, sensual Inca, and in the great Moctezuma of the golden throne. The rest is yours, democrat Walt Whitman) (*Antología* 28–29). The (only possible) "drop" of black or indigenous blood in his own body, along with the poetry of the "inca sensual," is temporally situated elsewhere than in the work of his own hands ("manos de marqués") yet can be connected to his own present in terms of its ancient, exotic "nobility." He "detests" the time in which he is born, most obviously for its materialism and its emphasis on present-day America, and puts this hatred in explicitly gendered terms: "Mi esposa es de mi tierra; mi querida, de París. . . . Y la primera ley, creador: crear. Bufe el eunoco. Cuando una musa te dé un hijo, queden las otras ocho en cinta" (My wife is from my country; my love, from Paris. . . . And the first law, creator: to create. I eschew the eunuch. When a Muse gives you a child, keep the other eight pregnant) (29). Here, his native country is the (despised, indigenous?) wife, while Paris is the "love"; and the Muse rather than directly inspiring him is impregnated by him to give him "sons"—poems. "Bufe el eunoco," he advises poets: literally, "snorting at the eunuch" clearly genders the poet as male and even more clearly virile. Yet, at the same time Darío finds himself having to write for American newspapers. In 1897, in the Buenos Aires newspaper *La nación,* he characterizes newspaper writing itself (he has "heard," he says, that it is "la tumba de los poetas," [the tomb of poets]) as instead being good practice for writers, making them "ágiles y flexibles en el pensar y en el decir" (agile and flexible in thinking and in speaking) (qtd. in Kirkpatrick, *Dissonant Legacy* 28). Darío's frustrated desire to retreat from the commercial world in his poetry, while the impulse may be similar, does not take quite the same form as Mallarmé's; the year after Darío's modernista *Prosas profanas,* Mallarmé published his much more radical *Un coup de dès n'abolira pas le hasard.* Mallarmé's own connection to the newspaper is described by Poggi in this way: "Mallarmé . . . dreamed of a new poetry that would overcome the arbitrariness of the vertical column as well as that of standard typography. This new poetry would also guarantee a truthful relation of sound to meaning. The poet deplored the perverse effects of chance that had put the sounds of the word *nuit,* so bright, and of the word *jour,* so sombre, in opposition to their meaning. As Mallarmé conceived it, the task of the new poetry was to prevail over *le hasard* by giving primacy to the aural and optical, rather than the representative, function of words" (Poggi 175). For more on the connection between Symbolists, modernista poetry, and print journalism, see LaGuardia, "Digesting Modernismo"; and Kirkpatrick, *Dissonant Legacy,* 22–30.

5. In fact, there was a continuous line of women who wrote journalism and published (women's) journals and who were based in Peru at one time or another, beginning with Matto de Turner (Bergmann et al. 174–175). Argentina, though different in many important ways from Peru, was an important source of intellectual and artistic thought for places like Lima. Alfonsina Storni, for example, who worked at various times in a glove factory and as a cashier, an office worker, and a teacher in the early 1900s, was part of the "rise of a new class of activist professional women, often immigrants or first-generation citizens, whose emergence in Argentina was affected by a growing feminist movement and by labor movements

in urban areas. These women often entered the public sphere through the classroom, through journalism, or through community organizing and service fields" (Kirkpatrick, "Journalism" 110).

6. As the 1990 Seminar on Women and Culture in Latin America at the University of California, Stanford, makes clear, there were generally two kinds of women's magazines in mid-nineteenth-century Latin America: the ladies' magazine and the "liberal republican periodical" edited by women and "devoted principally to demands for female emancipation and a voice in national debate" (Bergmann et al. 175). These latter journals often came under explicit attack by men: "In Argentina, journals titled *La Matrona Comentadora* or *El Hijo de su Madre* played on misogynist images of women as libertines or unrestrained gossips" (175).

7. "The innovations of modernismo are based on the modernistas' widening awareness of the dependence . . . on traditional and European models. . . . Modernismo's emphasis on the ideal of an intellectual, and not necessarily an economic, aristocracy was part of a persistent search to create a new role for artists in a society whose hierarchies were being dissolved" (Kirkpatrick, *Dissonant Legacy* 23, 25).

8. All quoted work from Vallejo's *Los heraldos negros* (The black heralds) will be from the volume edited by Américo Ferrari, *Obra poética;* all quoted work from *Trilce* will be from *Obra poética*, edited by Américo Ferrari; and all quoted work from Vallejo's poshumously published poems will come from Eshleman's bilingual edition, *César Vallejo: The Complete Posthumous Poetry.* All translations are mine unless otherwise noted; however, I owe a great debt of gratitude to Eshleman's exhaustive research on and translations of Vallejo's poetry, without which reading and interpreting Vallejo's work would have been infinitely more difficult.

None of the poems in *Trilce* have titles; instead they are numbered with Roman numerals. For ease of reference, I will refer to them with the designation *T* and Arabic numerals; for example, "T6." Following are the two opening epigraphs in the original Spanish.

> Qué estará haciendo a esta hora mi andina y dulce Rita
> de junco y capulí. . . .
> Dónde estarán sus manos que en actitud contrita
> planchaban en als tardes blancuras por venir.
> (Vallejo, *Obra poética* 72)

> Y si supiera si ha de volver;
> y si supiera qué mañana entrará
> a entregarme las ropas lavadas, mi aquella
> lavandera del alma. Qué mañana entrará
> satisfecha, capulí de obrería, dichosa
> de probar que sí sabe, que sí puede
> ¡COMO NO VA A PODER!
> azular y planchar todos los caos.
> (Vallejo, *Obra poética* 15)

9. As Julio Ortega notes, "we know that Vallejo tried to erase explicit evidence of the [original] poem, in a process of revision equivalent to cutting out [specific] refer-

ents" (sabemos que Vallejo trataba be borrar las evidencias explícitas del poema [original], en un proceso de revisión equivalente a recortar los referentes) (Vallejo, *Trilce*, Ortega 10).

10. *Black Heralds* is divided into six sections, "Agile Ceilings," "Divers," "Of the Earth," "Imperial Nostalgias," "Thunder," and "Songs of the Home." The first section, "Agile Ceilings," is a more conventional collection of modernista-inspired poems, mostly addressed to women and relying heavily on the conceit of the poet as (crucified) Christ. "Divers" and "Of the Earth" also concentrate on the figure, sometimes reviled, sometimes praised, of women, but moves farther away from modernista metrical and formal strategies. It is largely in "Imperial Nostalgias" and in "Songs of the Home" that we can see the beginnings of *Trilce's* modernist turn.

11. I am using the term "discourse" in the Foucauldian sense. "Discourse theory" posits, as Gill Perry points out, a "set of statements and interests inscribed in . . . a whole range of texts. By 'texts' [is meant] all kinds of cultural products, including documents and publications, from books and newspapers to advertisements and letters . . . [involving] . . . a relationship of power . . . for example, that those within western society who analyse, teach, paint or reproduce a view of the 'primitive' would, by this activity, be dominating, restructuring and having authority over that which they define as 'primitive'" (Harrison, Frascina, and Perry 4).

12. In his essay "The Literary Process" (El proceso de la literatura), José Carlos Mariátegui argued that "the indigenous sentiment" (el sentimiento indígena) is the origin for the message, technique, and language of Vallejo's first two collections (qtd. in Guzmán 40). As Guzmán points out, Mariátegui was sensitive to Peruvian culture and texts; further, he wrote, "when the interest in the regional was beginning to take form . . . Mariátegui was extremely close to the beginnings of this new regional consciousness, which began not to be ashamed to put the great themes of literature in relation with the Indian" (cuando recién el interés por lo propio regional empezaba tomar forma . . . Mariátegui estuvo bastante cerca del comienzo de esa nueva conciencia regional que empezó a no avergonzarse de poner los grandes temas de la cultura en relación con el indio) (40).

13. As Efraín Kristal points out, the presumed "realism" of *indigenista* texts accords more with their critics' and readers' ideological standpoints than with verisimilitude: "As long as the [ideological] norms that define reality at a given point in time continue to be relevant in non-literary social spheres, the effect of realism of a literary work can be maintained. Once the norms change . . . then the works . . . seem inaccurate accounts of the historical moments they were supposed to represent" (7).

14. *Dos turistas, muñecos rubios de rostro inmóvil,*
maniobran la visita de un fogoso automóvil . . .
Con su lente y sus frascos y su equipo de viaje,
investiga el zootécnico, profesor de lombrices,
y a su vera, dos chicos, en un gesto salvaje,
atisban, con los húmedos dedos en las narices.

15. ". . . casa de las montañas . . . ríe de tal modo que parece una niña" (Herrera y Reissig, *Poesía* 62).

16. *Mujeres matronales de perfiles oscuros,*
 cuyas carnes a trébol y a tomillo trascienden,
 ostentando el pletórico seno de donde penden
 sonrosados infantes, como frutos maduros.

17. Saúl Yurkievich has also noted these appropriations of *modernista* sensibility: the use of *azul*, the exotic sensibility, and the mixture of classical references with Biblical allusions (75–79); but he maintains that Vallejo's Catholic background impeded any appropriations of the more decadent subject-positions of the modernistas: "He couldn't be *voyeur*, satyr, sadist, nor vampire" (No puede ser ni *voyeur*, ni sátiro, ni sádico, ni vampiro) (81).

18. *Vierte el humo doméstico en la aurora*
 su sabor a rastrojo;
 y canta, haciendo leña, la pastora
 un salvaje aleluya!
 Sepia y rojo.
 Humo de la cocina. . . .
 Hay ciertas gana linda de almorzar,
 y beber del arroyo, y chivatear!
 Aletear con el humo allá, en la altura. . . .
 Delante de la choza
 el indio abuelo fuma;
 y el serrano crepúsculo de rosa,
 el ara primitiva se sahúma
 en el gas de tabaco . . .
 mítico aroma de broncíneos lotos,
 el hilo azul de los alientos rotos!

19. "La anciana pensativa, cual relieve / de un bloque pre-incaico"; "En las venas indígenas rutila / un yaraví de sangre que se cuela / en nostalgias de sol por la pupila."
 Efraín Kristal makes clear the ways in which internal political conflicts as well as nationalistic rhetoric were connected with the different indigenist ways of imagining and constructing the Indian. However, there are (and were) various strands of indigenismo which for various reasons emphasize different (and sometimes competing) aspects of the genre; there are critics (such as Antonia Cornejo Polar) who argue that indigenista literature, especially the more contemporary works by indigenous writers, does in fact work to raise awareness about indigenous life and problems, and even works to effect change.

20. The political, economic, and cultural concerns of countries like Mexico, Guatemala, Peru, and Chile with their respective, largely non-assimilated indigenous populations were by no means a new thing; Vallejo's work between the publication of *The Black Heralds* and *Trilce* is itself poised on the cusp between a long-standing indigenista movement in literature (according to Efraín Kristal, literature which can be called indigenista has been produced in the Andean region—in Bolivia, Peru, and Ecuador—at least since the 1840s [1–2]) and the flowering in the early to mid-1920s of Peruvian vanguard experiments with linguistic indigenismo. These included experiments with Spanish orthography and indigenous pronunciation, the use of indigenous figures and language, and even Quechua-Spanish and Aymara-Spanish code-switching in vanguard publications

like *Amauta* (1926–1930) and *Boletín Titikaka* (1926–1930). The celebration of vernacular cultures in American avant-garde practices was thus effected by "claiming a cultural proximity to the discovered." Vicky Unruh goes on to note that Latin American modernist practices tended to invoke "Taulipang and Arekuna myths, Andean cosmology, Afro-Cuban ritual, Mesoamerican rites, . . . and America's untamed song as prodigious aesthetic resources." (158); importantly, for American artists, these were claims Europeans could not by and large make.

21. The *quena* is an Andean flute; the *yaraví* is a Quechuan (Andean Indian) song form.

22. *Bajaste ciego de soles,*
 volando dormido,
 para hallar viudos los aires
 de llama y de indio . . .

 ¡Regresa a tu Pachacamac,
 En-Vano-Venido,
 Indio loco, Indio que nace,
 pájaro perdido!

23. Franco maintains, "Traditional forms, especially cradle songs, rounds, and childrens' games are models for delirious language. Here the civic and pedagogical task is sometimes ceded to that which is not representable" (Formas tradicionales, especialmente las canciones de cuna, las rondas y las jugarretas son modelos para el lenguaje desvariado. Aquí la tarea cívica y pedagógica a veces cede ante lo no representable) ("Loca" 34).

24. "El interés de Gabriela Mistral por el folklore . . . tiene sus raíces en el americanismo de principios de siglo—en la preocupación por la originalidad de América hispana amenazada por una modernidad homogeneizante."

25. Instituto de Cooperación Intelectual de la Sociedad de las Naciones.

26. ". . . empapado en racialidad, saturado de los jugos de la casta, verdadera Verónica que lleva estampadas nuestras facciones emotivas."

27. "Por la pedagogía, se salvará el espíritu de la raza, por la pedagogía se podrá modernizar sin perder los rasgos orignales del país. Como maestra casta y soltera la mujer podía compartir este proyecto."

28. "Continúo escudriñando en el misterio cristalino y profundo de la expresión infantil, el cual se parece por la hondura al bloque de cuarzo . . . porque engaña vista y mano con su falsa superficialidad."

29. "Soy de los que llevan entrañas, rostro y expresión *conturbados e irregulares,* a causa del injerto; me cuento entre los hijos de esa cosa torcida que se llama una experiencea racial, mejor dicho, una *violencia racial.* . . . [Es una lengua] lejos del solar español, a mil leguas de él."

30. The large-scale literacy campaign begun by Vasconcelos in the early 1920s was built around the assumption that the right kind of culture for the masses was based on Western European neo-Classical texts: "Vasconcelos oversaw the reprinting of Roman and Greek classics as reading material for the newly literate, many of whom were indeed Amerindians" (Marchant 82).

31. See Elizabeth Marchant's *Critical Acts* for a succinct discussion of the woman-centered universe Mistral constructs.

32. *Denme ahora las palaras*
 que no me dio la nodriza.
 Las balbucearé demente
 de la sílaba a la sílaba:
 palabra "expolio," palabra "nada"
 y palabra "postrimería,"
 ¡aunque se tuerzan en mi boca
 como las víboras mordidas!

33. "... se duerme en el narcótico zumbido de las moscas."

34. "The crisis that produced *Trilce* was probably precipitated, as much as anything, by the profound contradictions Vallejo discovered between the Romantic exaltation of the self and the displacement of man from the central role in creation which had followed from evolutionist theory" (Franco, *César Vallejo* 79).

35. The deliberately scientific language Vallejo uses in *Trilce* makes its poetry unsensual and neologistic in its use of words derived from the Latin, culled from medical texts, and awkward puns. We can see this process clearly in T5:

 Grupo dicotiledón. Oberturan
 desde él petreles, propensiones de trinidad,
 finales que comienzan, ohs de ayes
 creyérase avaloriados de heterogeneidad.
 ¡Grupo de los dos cotiledones! (13)

 A poetic language which employs such scientific and medical terms as "dicotiledón," "heterogeneidad," and "cotiledones" works to flatten sensuality, robs poetry of its rounded, softer aspects, and subjects the poetic body to the dissecting tool of scientific inquiry. Paradoxically, scientific and factual language, supposed to convey positivistic information rather than emotive experience, is, here, cut loose from its function so that even the impulse toward a harmonious whole through scientific knowledge or statistical enumeration is rejected.

36. *El yantar de estas mesas así, en que se prueba*
 amor ajeno en vez del propio amor,
 torna tierra el bocado que no brinda la
 MADRE,
 hace golpe la dura deglusión; el dulce,
 hiel; aceite funéreo, el café.

37. *Madre, y ahora! Ahora, en cuál alvéolo*
 quedaría, en qué retoño capilar,
 cierta migaja que hoy se me ata al cuello
 y no quiere pasar.

38. *... y en el almuerzo musical,*
 cancha reventada, harina con manteca,
 con manteca,
 le tomas el pelo al peón decúbito
 que hoy otra vez olvida dar los buenos días,

esos sus días, buenos con b de baldío,
que insisten en salirle al pobre
por la culata de la v
dentilabial que vela en él.

39. "Para creer que me oyes he bajado los párpados y arrojo de mí la mañana, pensando que a esta hora tú tienes la tarde sobre ti. Y para decirte lo demás, que se quiebra en las palabras, voy quedándome en silencio."

40. In *Black Heralds* and *Trilce* the reader can note the use of anti-Semitic language as well as what would seem to us to be pejorative attitudes about indigenous peoples (for example, it is clear that the child speaker of T52 is laughing at the *peón* for his poorly pronounced Spanish, even mocking him). Franco is the only critic I know of who has commented on the anti-Semitic aspects of *Black Heralds;* because Vallejo is often celebrated as a committed or engaged poet, critics have hesitated to point out the ways in which Vallejo shared, ideologically speaking, in the prejudices and ideas of his culture.

41. In Lima, socioeconomic changes at the turn of the century meant that poor women who migrated from the country to the city did enter the developing factory workforce, while middle-class women were also entering the workplace by becoming, for example, teachers, a profession which was made more appropriate for women by being linked at this time in nationalist rhetorics with the teaching role of motherhood (Yeager xv). Middle-class women could work in the public arena through women's and philanthropic groups. Indeed, feminist and women's organizations were active in cities like Lima and included efforts to improve the lot of working and/or professional women (one of Peru's first women's organizations, "Evolución Femenina" [Feminine evolution] was directed by María Jesús Alvarado and made up of professional and middle-class women [Guardia 70]).

42. "Mamá se acordaba siempre del hijo ausente . . . en la mesa del comedor nuestra madre planchaba, con sus proprias manos, los pañuelos que habíamos de usar durante la semana. . . . He visto—o paradoja!—raras cosas. . . . Unas mujeres muy feas, llamadas sufragistas, que no consiguen de los hombres ni el voto de matrimonio, ni el político."

43. *Mujer que sin pensar en nada más allá,*
suelta el mirlo y se pone a conversarnos
sus palabras tiernas
como lancinantes lechugas recién cortadas.
Otro vaso, y me voy. Y nos marchamos,
ahora sí, a trabajar.
Entre tanto, ella se interna
entre los cortinajes y ¡oh aguja de mis días
desgarrados! se sienta a la orilla
de una costura, a coserme el costado
a su costado,
a pegar el botón de esa camisa
que se ha vuelto a caer.

44. Friends of Vallejo have contributed many of the anecdotes about his life and work, anecdotes which have helped to construct the cult of the artist that has grown up

around Vallejo; these anecdotes also, not coincidentally, reflect the same attitudes about women and their role in the process of male creativity. A poet/friend of Vallejo's, Juan Espejo Asturrizaga, tells, for example, about a stroll one evening in 1918 Lima with Vallejo and his friends. Pausing at the end of a bridge where a street vendor displayed her food, Espejo Asturrizaga reports that she had made, to sell, "anticuchos, Huancaina-style potatoes, cau-cau, glasses each with corn chicha, beautiful ears of corn, and other edible things" (94). According to Espejo Asturrizaga, the sight—specifically of this place and the *vivandera*, or "female street vendor," who sold food there—conjured up memories for Vallejo of a time when he had been in this same spot with his former lover, Otilia Villanueva. Vallejo was profoundly moved, and "on the parapet of the bridge on the back of a racing-form [Vallejo] wrote 'The evening cook lingers'" (94), a sonnet that would appear later in *Trilce*.

Although Espejo Asturrizaga clearly suggests that this poem was generated spontaneously on the spot, it seems likely, given its sonnet form, that Vallejo expended some time and labor in writing it; it would undergo even further reworking before being included (sans its original mention of Otilia's name) in *Trilce* as T46. Espejo Asturrizaga's own memory of this scene of artistic labor is also invested with the evidently spontaneous magic of (male) creativity, which in its turn is framed and underwritten by the absence of a woman, Otilia. This is an absence which is necessary as that toward which the work of art—the sonnet—can gesture. But working women are not, after all, totally absent from this vignette, just as they are not completely absent from the final sonnet (the vivandera reappears in T46 as a *cocinera*, or "cook"). Espejo's careful cataloging of the "edible products" made by the street vendor undoubtedly served his desire to add a touch of background verisimilitude. However, when foregrounded, this very listing calls attention to women's actual labor—here, the labor-intensive work of preparing such things from scratch, then cooking and selling them. Further, and more importantly, Espejo Asturrizaga's list and Vallejo's resulting sonnet call attention to the ways in which women's work is presented as both ephemeral (the food, no matter how beautifully prepared, will disappear shortly) and so naturally part of the background of male creativity as to be necessary and at the same time, necessarily, virtually invisible.

45. "Por un lado, tenemos la fractura de los referentes, cuya huella no podemos, muchas veces, seguir . . . la otra tachadura, la que no vemos, es la del proceso mismo de revisión."

46. *El traje que vestí mañana*
 no lo ha lavado mi lavandera:
 lo lavaba en sus venas otilinas,
 en el chorro de su corazón . . .
 A hora que no hay quien vaya a las aguas,
 en mis falsillas encañona
 el lienzo para emplumar . . .
 Y si supiera si ha de volver;
 y si supiera qué mañana entrará
 a entregarme las ropas lavadas, mi aquella
 lavandera del alma. Qué mañana entrará

satisfecha, capulí de obrería, dichosa
de probar que sí sabe, que sí puede
¡COMO NO VA A PODER!
azular y planchar todos los caos.

47. In fact, Espejo Asturrizaga connects this poem with an anecdote wherein Otilia is supposed to have solicited "a used handkerchief" of Vallejo's. In this "lover's coquette," Espejo Asturrizaga maintains that Otilia wanted to "prove to him that she knew how to wash and iron'" (qtd. in Vallejo, *Trilce*, ed. Ortega 63). If in fact this anecdote is true, the very playfulness of the gesture contributes to the idea that Otilia as a middle-class *limeña* would not be doing much (heavy) laundering.

48. ". . . espiga de ternura / bajo la hebraica unción de los trigales."

49. ". . . esta horrible sutura / del placer que nos engendra sin querer, / y el placer que nos DestieRRa."

50. *Esta noche desciendo del caballo,*
 ante la puerta de la casa, donde
 me despedí con el cantar del gallo.
 Está cerrado y nadie responde.

51. *Los humos de los bohíos ¡ah golfillos*
 en rama! madrugarían a jugar
 a las cometas azulina, azulantes,
 y, apañuscando alfarjes y piedras, nos darían
 su estímulo fragante de boñiga,
 para sacarnos
 al aire nene que no conoce aún las letras,
 a pelearles los hilos.

52. *Otro día querrás pastorear*
 entre tus huecos onfalóidos
 ávidas cavernas,
 meses nonos,
 mis telones.
 O querrás acompañar a la anciania
 a destapar la toma de un crepúsculo,
 para que de día surja
 toda el agua que pasa de noche.

CHAPTER THREE: BROTHER MEN

1. "Dicen que nuestro tiempo se caracteriza por los caballos de fuerza. . . . La velocidad es la seña del hombre moderno. Nadie puede llamarse moderno sin mostrándose rápido."

2. ". . . la percepción . . . [de] los fenómenos de la naturaleza y del reino subconciente, en el menor tiempo posible. . . . La que más pronto es emociona, esa es la más moderna."

3. "Estos desgraciados futuristas de nuestros días alaban también el progreso, incondicionalmente, sea cual sea su empleo en cada instante."

4. "¿Qué podrá hacer el hombre para volver a someter a su dominio a estos monsturos que él sacó de la nada? ¿Qué podrá hacer en tal sentido esta humilde criatura, cuya afiliación antropoidal va demostrándose día a día, si no como descendiente del mono, al menos como su ancestro? La señorita Winay Darwin ha dicho el otro día: 'El hombre no desciende del mono, como asevera mi padre, sino, al contrario, lo más probable es que tiende a ser mono en un futuro más o menos próximo. . . .' M. Kutzigg Wearn, renombrado sabio de Viena . . . ensaya en estos momentos el cruzamiento de la especie humana con la especie antropoidea."

5. Terms such as *cuzqueño* and *limeño* are regionalist terms denoting someone who was born and raised in a certain city or area: in this case, Cuzco and Lima, respectively.

6. As Sommer makes clear, the political need to make a virtue out of racial harmony had been clear since the Wars of Independence: "If nations were to survive and to prosper, they had to mitigate racial and regional antagonisms and to coordinate the most diverse national sectors through the hegemony of an enlightened elite" (123).

7. "Unlike the militant populist novels that would follow, . . . the early novels celebrated a domestic, sentimental, and almost feminized brand of heroism" (Sommer 123).

8. Although, as Alan Knight points out, especially in Mexico, figuring out what Indian meant—given the many different indigenous groups with their own dialects and cultural practices present in Mexico—and even who was Indian were essentially impossible tasks: "When later indigenistas set out to recover a pristine Indian culture, they either attempted the impossible or, more realistically, they took the syncretic culture of the colonial Indian as their yardstick. Precisely because this was a syncretic culture—a fusion of earlier cultures into one that was new and different—it became somewhat pointless to produce checklists of pristine Indian as against imported Spanish, mestizo elements" (76).

9. *Me viene, hay días, una gana ubérrima, política,*
 de querer, de besar al cariño en sus dos rostros. . . .
 ¡Ah querer, éste, el mío, éste, el mundial,
 interhumano y parroquial, provecto!
 Me viene a pelo,
 desde el cimiento, desde la ingle pública.

10. The Peruvian José Sabogal and the Mexican Diego Rivera (whom Sabogal visited in Mexico in 1922), upon returning from stays in Europe, both inflected their training in European modernist styles with particularly Latin American concerns. Sabogal instituted an interest in Peru in painting indigenous subjects; his blocky, geometric woodcuts, which took their inspiration in part from Inca manuscripts, were used in Mariátegui's important "little magazine" *Amauta*, just as Rivera's cartoon line drawings taken from Aztec codices were used for the covers of the magazine *Mexican Folkways*, a magazine "published by Frances Toor in English and Spanish to promote interest in the study of Mexican culture and art" (Sharp 210). As is pointed out in "Rivera as Draftsman," Rivera saw the Indians as "simplified, monumental" (207); Edward Weston, a friend of Rivera's, advised artists to "go to

Mexico, and there one finds an even greater drama, values more intense—black and white, cutting contrasts" (qtd. in Sharp 207).

11. Mary Louise Pratt suggests that in Peru the 1920s saw the displacement of the indigenous woman by a fraternal model where it is the masculine Indian figure (the *amauta*, for example) which stands in for the intellectual's identification with the Indian (59–62).

12. "¡Rotación de tardes modernas / y finas madrugadas arqueológicas! / ¡Indio después del hombre y antes de él!"

13. "¡Oh patrióticos asnos de mi vida! . . . ¡Vicuña, descendiente nacional y graciosa de mi mono!"; "¡Angeles de corral, / aves por un descuido de la cresta! / Cuya o cuy para comerlos fritos / con el bravo rocoto de los temples! / ¿Cóndores? Me friegan los cóndores!"

14. Though O'Connor claims that Vallejo refers at the end of this novel to the destruction of one of Rivera's murals (destroyed because of its portrait of Lenin), O'Connor has his dates mixed up; the mural was not painted until 1933 and was destroyed in 1934.

15. She is nicknamed "la rosada" in the novel because of a reddish tint to her skin, "an uncommon trait among the Indians and prized as a mark of beauty" (Vallejo, *Tungsten* 129, translator's note).

16. *Los mineros salieron de la mina*
 remontando sus ruinas venideras, . . .
 cerraron con sus voces
 el socavón, en forma de síntoma profunda.

17. As Rivera himself said, "the best known modern architects of our age are finding their aesthetic and functional inspiration in American industrial buildings, machine-design, and engineering, the greatest expressions of the plastic genius of this New World" (qtd. in Helms 287).

18. This machine-goddess would appear again, in a more obviously "hybrid" manner, in the third panel of Rivera's 1940 San Francisco mural, *Pan-American Unity*.

19. *El parado la ve yendo y vinendo,*
 monumental, llevando sus ayunos en la cabeza cóncava
 en el pecho sus piojos purísimos
 y abajo
 su pequeño sonido, el de su pelvis,
 callado entre dos grandes decisiones,
 y abajo,
 más abajo,
 un papelito, un clavo, una cerilla.

20. *. . . y cómo*
 su talle incide, canto a canto, en su herramienta atroz, parada,
 y qué idea de dolorosa válvula en su pómulo!

 ¡qué transmisión entablan sus cien pasos!
 ¡cómo chilla el motor en su tobillo!

21.	*. . . oyéndolo, sintiéndolo, en plural, humanamente,*
	¡cómo clava el relámpago
	su fuerza sin cabeza en su cabeza!
	¡más abajo, camaradas,
	el papelucho, el clavo, la cerilla,
	el pequeño sonido, el piojo padre!

22.	Or as another 1937 poem has it:

	¡Cómo, hermanos humanos,
	no decirnos que ya no puedo y
	ya no puedo con tánto cajón,
	tánto minuto, tánta
	lagartija y tánta
	inversión, tánto lejos y tánta sed de sed!
	Señor Ministro de Salud: ¿qué hacer?
	¡Ah! desgraciadamente, hombres humanos,
	hay, hermanos, muchísimo que hacer.
	(Vallejo, *Posthumous Poetry* 174)

23.	". . . abrir por temperamentio de par en par mi cuarto . . . porqué me dan así tanto el en alma."

24.	*A las miseridordias, camarada,*
	hombre mío en rechazo y observación, vecino
	en cuyo cuello enorme sube y baja,
	al natural, sin hilo, mi esperanza.

25.	*Considerando*
	que el hombre procede suavemente del trabajo
	y repercute jefe, suena subordinado;
	que el diagrama del tiempo
	es constante diorama en sus medallas

	Considerando también
	que el hombre es en verdad un animal
	y, no obstante, al voltear, me da con su tristeza en la cabeza.

26.	*Considerando sus documentos generales*
	y mirando con lentes aquel certificado
	que prueba que nació muy pequeñito . . .
	le hago una seña,
	viene,
	y le doy un abrazo, emocionado.
	¡Qué más da! Emocionado . . . Emocionado . . .

27.	". . . al lado del hombre, en el bureau, en el taller, en la fábrica, en la campaña, y, de esta manera, vive las mismas preoccupaciones y luchas por la existencia que él, en las que para nada entra el instinto angular frente a la especie. . . . Se supera o se rebaja, no se sabe; pero se desnaturaliza."

28.	". . . profundas perspicacias sentimentales, amplificando videncias y comprensiones y densificando el amor; la inquietud entonces crece y se exaspera y el soplo de la vida, se aviva."

29. *Hasta Paris ahora vengo a ser hijo. Escucha*
 Hombre, en verdad te digo que eres el HIJO ETERNO,
 pues para ser hermano tus brazos son escasamente iguales
 y tu malicia para ser padre, es mucha.

30. Even before leaving Peru, Vallejo had already expressed homesickness for his sier-
 ran roots in *Trilce* 64: "Oh valley without mother-height, where everything sleeps
 in a horrible semidarkness, without fresh rivers, without love-admission" (170).

31. "La talla de mi madre, moviéndome por índole de movimiento / y poniéndome
 serio, me llega exactamente al corazón."

32. "Sin haberlo advertido jamás exceso por turismo / y sin agencias / de pecho en
 pecho hacia la madre unánime."

33. See Leonard Folgarait's *Mural Painting and Social Revolution in Mexico,*
 1920–1940: Art of the New Order for an analysis of the ideological content of
 Mexican mural painting during these years.

34. *Mi metro está midiendo ya dos metros,*
 mis huesos concuerdan en género y en número
 y el verbo encarnado habita entre nosotros
 y el verbo encarnado habita, al hundirme en el baño,
 un alto grado de perfección.

35. *Fué domingo en las claras orejas de mi burro,*
 de mi burro peruano en el Perú (Perdonen la tristeza)
 Mas hoy ya son las once en mi experiencia personal,
 experiencia de un solo ojo, clavado en pleno pecho,
 de una sola burrada, clavada en pleno pecho . . .

 Tal de mi tierra veo los cerros retratados,
 ricos en burros, hijos de burros, padres hoy de vista,
 que tornan ya pintados de creencias,
 cerros horizontales de mis penas.

36. *En su estatua, de espada,*
 Voltaire cruza su capa y mira el zócalo . . .

 sonido de años en el rumor de aguja de mi brazo,
 lluvia y sol en Europea, y ¡cómo toso! ¡cómo vivo!
 ¡cómo me duele el pelo al columbrar los siglos semenales!
 y cómo, por recodo, mi ciclo microbiano,
 quiero decir mi trémulo, patriótico peinado.

37. "El match se hace . . . por el amor propio, por patriotismo, por ganar dinero, por
 tantos otros móviles estúpidos y egoístas, en que la malicia del hombre se mezcla
 al buen sudor del animal."

38. *En el momento en que el tenista lanza magistralmente*
 su bala, le posee una inocencia totalmente animal;
 en el momento
 en que el filósofo sorprende una nueva verdad,
 es un bestia completa.
 Anatole France afirmaba

que el sentimiento religioso
es la función de un órgano sepecial del cuerpo human,
hasta ahora ignorado y se podría
decir también, entonces,
que, en el momento exacto en que un tal órgano
funciona plenamente
tan puro de malicia está el creyente,
que se diría casi un vegetal.
¡Oh alma! ¡Oh pensamiento! ¡Oh Marx! ¡Oh Feüerbach!

39. The *folletín* was a cheaply produced, illustrated pamphlet which carried lurid, sentimental, or melodramatic stories (something like the *telenovelas* of today).

40. As Ilan Stavans points out, despite some of the similarities between these two comics, it is his use of language rather than physical comedy for which Cantinflas became famous (45).

41. According to Monsiváis, the Mexican sociologist Samuel Ramos, in his influential 1936 *El perfil del hombre y la cultura en México* (A profile of man and culture in Mexico), provides a description of the *pelado* as a *machista*—angry, primitive, and representative of the violence of the urban poor. Cantinflas tamed the negative aspects of the *pelado* and transformed the figure into a hero of the working class (Monsiváis 103–104).

42. In a satirical sketch which would be sure to win favor with left-leaning modernists and workers alike, Cantinflas plays a union leader negotiating "in flowery proletarian language" with the boss, who happily raises the price of soap. When the boss calculates, however, the amount of time the employees actually work—taking into account religious holidays, birthdays, saint's days, union meetings, etc.—he realizes that they work four days a year. "Cantinflas, visibly depressed, asks the owner of the factory how much they owe him for the privilege of working for his company" (Stavans 100).

43. The 1926–1929 Cristero rebellion—where tens of thousands of people, many of them women, reacted violently against the revolutionary government's anticlerical legislation—only made the secularism of revolutionary Mexico's elite more determined to undermine Catholicism.

44. "Esta pelicula formula la mejor requisitoria de justicia social de que ha sido capaz hasta ahora el arte d'apres-guerre. 'En pos de oro' es una sublime llamarada de inquietud politica, una gran queja economica de la vida, un alegato desgarrador contra la injusticia social. . . . Con los años, ya se sacará de 'En pos de oro' insospechados programas políticos y doctrinas economicas."

45. Me viene, hay días, una gana ubérrima, política,
de querer, de besar al cariño en sus dos rostros . . .

¡Ah querer, éste, el mío, éste, el mundial,
interhumano y parroquial, provecto!
Me viene a pelo,
desde el cimiento, desde la ingle pública,
y viniendo de lejos, da ganas de besarle . . .
. . . al que sufre, besarle en su sartén,
al sordo, en su rumor craneano, impávido;

al que me da lo que olvidé en mi seno,
en su Dante, en su Chaplin, en sus hombros.

CHAPER FOUR: CHILDLESS MOTHERS

1. As Mulvey and Wollen put it, there was much artifice in Kahlo's "rootedness" to things Mexican, "the extent to which her presentation of self *como Tehuana* was inextricably bound up with masquerade and a taste both for the archaic and the ornamental" (18).

2. "The state was not merely socially conservative because of religious and cultural reasons; it was also crucially interested in marriage and reproduction for economic reasons. Women were . . . a source of cheap or unpaid labor, for example, in the schools. Therefore, the state had a direct stake in the persona of the school-teacher-mother-icon" (Fiol-Matta, "Schoolteacher of America" 205).

3. Pratt makes the point that particularly in the Andes, and despite the fact that Indian women worked in the fields and as street vendors, laundresses, and maids in the cities, in popular presentations the Indian woman was almost always identified with her maternal role: "One of the oldest and most durable myths of self-definition in Spanish America is that of the sexual appropriation of the indigenous woman by the European invader. . . . Endless repetitions and variants have mythi-fied this figure, simultaneously victim and traitor, as the mother of the American mestizo peoples. At the same time, she has stood for all the indigenous peoples conquered (feminized) and co-opted (seduced) by the Spanish" (59).

4. Masculinity and serious artistry, on the other hand, did not just easily overlap but were considered inherently connected; hence the emphasis (as with the early Vallejo and with Rivera all his life) on the insatiable heterosexuality of the male artist.

5. The details of the accident Kahlo suffered when she was sixteen, in 1925, have been reiterated time and again in Kahlo criticism, but they bear reviewing here. Herrera catalogues her injuries, suffered in a bus accident in Mexico City: "Her spinal column was broken in three places Her collarbone was broken, and her third and fourth ribs. Her right leg had eleven fractures and her right foot was dislocated and crushed. Her left shoulder was out of joint, her pelvis broken in three places. The steel handrail [of the trolley which hit the bus] had literally skewered her body at the level of the abdomen; entering on the left side, it had come out through the vagina" (49).

6. "Los diarios de la mañana han lanzado a la publicidad la specie de que. . . . Se estaba dando lectura a un folleto escrito por la señora Stanger, que habla, con bas-tante crudeza por cierto, de las diferentes maneras de evitar la procreación del especie."

7. By 1932 Rivera had commissioned an atelier and house from the architect Juan O'Gorman in San Angel, a suburb of Mexico City. The atelier and house were both modeled specifically on an atelier built by le Corbusier in Paris. To the times' (and to our) modernist eye it seemed that there was a kind of felicitous formal match between the clean modernist lines and massive, open spaces and Rivera's growing collection of pre-Columbian artifacts and contemporary Indian

crafts. In later years the couple were to divide their time between this and Kahlo's parents' house, which she (apparently) inherited. This house, built by her father in 1904 in Coyoacán, a historic suburb of Mexico City which dates back to precolonial times, became known as the Blue House when Kahlo had it painted a deep vivid blue. It also became a showcase for her modernist interpretation of mexicanidad, and she filled it with her collection of thousands of votive paintings and examples of Mexican folk arts and crafts. Many portraits of Kahlo (and Rivera) were taken in this house.

8. Folgarait notes that the three Mexican presidents between 1928 and 1934—Emilio Portes Gil, Pascual Ortis Rubio, and Abelardo Rodríguez—were essentially puppets for a "false-front political system" managed by Calles (117).

9. The term "rationalist" was in fact often used by the government at this time, as was "socialist"; but not in the ways we would think of those terms today: "The PNR (Partido Nacional Revolucionario) convention [of 1933] had heard both terms used interchangeably, causing a confusion. . . . It was 'rationalist,' based on 'laws of scientific order,' in its opposition to education by the Church, and 'socialist' by mere service to the needs of the 'socialist' Revolution, a characterization that had never been resolved within the capitalist context of the Calles years" (Folgarait 128).

10. Pach's (or the magazine's) conflation of Kahlo's name with Rivera's—she always signed her canvases "Frida Kahlo"—and his assumption of her supposedly unself-conscious surrealism indicate the problems she was still to encounter in having her art taken seriously as her own.

11. As Fiol-Matta says, the solution to the danger of exposing Mistral's homosexuality was "to submerge her sexuality in the place where, paradoxically enough, it was the most on display: in gender. Because sexuality was naturalized through gender, . . . gender discourse became, for Mistral, the ideal closet" ("Schoolteacher of America" 206).

12. *Cajita mía*
de Olinalá
palo-rosa,
jacarandá.

Cuando la abro
de golpe da
su olor de Reina
de Sabá.

Así la hace
de cabal
mano azteca,
mano quetzal.

Ella es mi hálito
yo su anda,
ella saber,
yo desvariar.

Y paramos
como el maná

> *donde el camino*
> *se sobre ya,*
>
> *Donde nos grita*
> *un ¡halalá!*
> *el mujerío*
> *de Olinalá.*

13. *Recuerdo gestos de criaturas*
 y son gestos de darme el agua.

 En el Valle de Río Blanco,
 en donde nace el Acondagua,
 llegué a beber, salté a beber
 en el fuete de una cascada,
 que caía crinada y dura
 y se rompía yerta y blanca.
 Pegue mi boca al hervidero,
 y me quemaba el agua santa,
 y tres días sangró mi boca
 de aquel sorbo de Aconcagua.

 En el campo de Mitla, un día
 de cigarras, de sol, de marcha,
 me doblé a un pozo y vino un indio
 a sostenerme sobre el agua,
 y mi cabeza, como un fruto,
 estaba dentro de sus palmas.
 Bebía yo lo que bebía,
 que era su cara con mi cara,
 y en un relámpago yo supe
 carne de Mitla ser mi casta.

14. *Junto a mi boca un coco de agua,*
 y yo bebí, como una hija,
 agua de madre, agua de palma.
 Y más dulzura no he bebido
 con el cuerpo ni con el alma.

15. *A la casa de mis niñeces*
 mi madre me llevaba el agua.
 Entre un sorbo y el otro sorbo
 la veía sobre la jarra.
 La cabeza más se subía
 y la jarra más se abajaba.
 Todavía yo tengo el valle,
 tengo mi sed y su mirada.
 Será esto la eternidad
 que aún estamos como estábamos.

16. As Gastón Lillo notes, "la construcción canónica sólo selecciona una parcela de su producción poética, e ignora casi por completo su extensa producción en prosa" (Lillo and Renart 19).

17. "Falta la rima final, para algunos oídos. En el mío, desatento y basto, la palabra esdrújula no da rima prcisa ni vaga. El salto del esdrújulo deja en el aire su cabriola como una trampa que engaña al amador del sonsonete [singsong]. Este amador, persona colectiva que fue millón, disminuye a ojos vistas, y bien se puede servirlo a medias, y también dejar de servirlo."

CONCLUSION: HYBRID MODERN

1. Diré, en primer lugar, que nosotras miramos la quiebra de la civilización europea como asunto cuyas causales no nos tocan. . . . Los hombres asustaron a las mujeres . . . diciéndoles la cegadora palabra de 'técnica,' ellos pusieron el mote de 'vejestorios' a la mayor parte de las maneras y de las virtudes cristianas que precisamente las mujeres usábamos para la conservación del cuerpo espiritual del mund. . . . Nuestro apartamiento en la construcción . . . del mundo moderno . . . se la fundamentó tácitamente en nuestra torpeza técnica para poner las manos sobre las vigas de la nueva y compleja organización, nuestra exclusión se la hizo, un poco mañosamente, alegando la blandura niña que tenemos para trabajar con los materiales agrios de la realidad; pero, sobre todo, se dio por pretexto de la cortes eliminación nuestro natural supersticioso de Evas ignorantonas que desconfían de la ciencia y siguen puerilmente abrazadas a sus mítos gimoteando sobre sus idolillos.

2. ". . . mata a poblaciones enteras con la granada y el gas fétido, sus frutos más populares."

3. In March 1938 Vallejo himself died in Paris, of unknown causes.

4. *Niños del mundo,*
 si cae España—digo, es un decir—
 si cae
 del cielo abajo su antebrazo que asen. . . .

 ¡Niños del mundo, está
 la madre España con su vientre a cuestas:
 está nuestra madre con sus férulas,
 está madre y maestra. . . .

 si tardo,
 si no veis a nadie, si os asustan
 los lápices sin punta, si la madre
 España cae—digo, es un decir—
 salid, niños del mundo; id a buscarla!

5. Although García Canclini does not remark on this, that the weaver's direction for his change of design came at the suggestion of people whose own worldview would have been deeply imbued with modernist ideas about the formal connections between so-called primitive art and modern art is, given the history of modernism in Latin America, deeply ironic.

WORKS CITED

Adán, Martín. *The Cardboard House*. Trans. Katherine Silver. St. Paul, MN: Graywolf Press, 1990.

Anderson, Benedict. *Imagined Communities: Reflection on the Origin and Spread of Nationalism*. Rev. ed. New York: Verso, 1991.

Anderson, Perry. "Modernity and Revolution." *Marxism and the Interpretation of Culture*. Ed. Cary Nelson and Lawrence Grossberg. Urbana: University of Illinois Press, 1988.

Arnold, Denise Y. "Using Ethnography to Unravel Different Kinds of Knowledge in the Andes." *Journal of Latin American Cultural Studies* 6 (1997): 33–50.

Baker, Houston A., Jr. *Modernism and the Harlem Renaissance*. Chicago, IL: University of Chicago Press, 1987.

Ballinger, James K., organizer. *Diego Rivera: The Cubist Years*. Ramón Favela, guest curator. Phoenix, AZ: Phoenix Art Museum, 1984.

Barkan, Elazar, and Ronald Bush, eds. *Prehistories of the Future: The Primitivist Project and the Culture of Modernism*. Stanford, CA: Stanford University Press, 1995.

Becker, Marjorie. *Setting the Virgin on Fire: Lázaro Cárdenas, Michoacán Peasants, and the Redemption of the Mexican Revolution*. Berkeley: University of California Press, 1995.

Belnap, Jeffrey, and Raúl Fernández, eds. *José Martí's "Our America": From National to Hemispheric Cultural Studies*. Durham, NC: Duke University Press, 1998.

Bergmann, Emilie, et al., eds. *Women, Culture, and Politics in Latin America: Seminar on Feminism and Culture in Latin America*. Berkeley: University of California Press, 1990.

Bhabha, Homi K., ed. *Nation and Narration*. New York: Routledge, 1990.

Billeter, Erika, ed. *Images of Mexico: The Contribution of Mexico to 20th Century Art*. Dallas, TX: Dallas Museum of Art, 1987.

———, ed. *The Blue House: The World of Frida Kahlo*. Seattle: University of Washington Press, 1993.

Bochner, Jay. "New York Secession." *Modernism: Challenges and Perspectives*. Ed. Monique Chefdor, Ricardo Quiñones, and Albert Wachtel. Urbana: University of Illinois Press, 1986. 180–211.

Boeckmann, Cathy. *A Question of Character: Scientific Racism and the Genres of American Fiction, 1892–1912*. Tuscaloosa: University of Alabama Press, 2000.

Bouquet, Mary. "Exhibiting Knowledge: The Trees of DuBois, Haeckel, Jesse, and Rivers at the *Pithecanthropus* Centennial Exhibition." *Shifting Contexts: Transformations in Anthropological Knowledge*. Ed. Marilyn Strathern. New York: Routledge, 1995. 31–56.

Bowler, Peter J. *Evolution: The History of an Idea*. Berkeley: University of California Press, 1989.

————. *The Invention of Progress: The Victorians and the Past*. Cambridge, MA: B. Blackwell, 1989.

Bürger, Peter. *Theory of the Avant-Garde*. Trans. Michael Shaw. Minneapolis: University of Minnesota Press, 1984.

Calinescu, Matei. *Five Faces of Modernity: Modernism, Avant-garde, Decadence, Kitsch, Postmodernism*. Durham: Duke University Press, 1987.

Campos, Rene A. "The Poetics of the Bolero in the Novels of Manuel Puig." *World Literature Today: A Literary Quarterly of the University of Oklahoma* 65.4 (autumn 1991): 637–642.

Cardoza y Aragón, Luis. *Diego Rivera: Los frescos en la secretaría de educación pública*. México, D.F.: Secretaría de Educación Pública, 1994.

Cerna-Bazán, José. *Sujeto a cambio: De las relaciones del texto y la sociedad en la escritura de César Vallejo (1914–1930)*. Lima-Berkeley: Latinoamericana Editores, 1995.

Chadwick, Whitney. *Women, Art, and Society*. London: Thames and Hudson, 1990.

Churata, Gamaliel. *El pez de oro (Retablos del Laykhakuy)*. La Paz, Bolivia: Editorial Canata, n.d.

Clark, Suzanne. *Sentimental Modernism: Women Writers and the Revolution of the Word*. Bloomington: Indiana University Press, 1991.

Clayton, Lawrence A. *Peru and the United States: The Condor and the Eagle*. Athens: University of Georgia Press, 1999.

Collazos, Oscar. *Los vanguardismos en la América Latina*. Barcelona: Ediciones Península, 1977.

Darío, Rubén. *Antología de Rubén Darío*. México, D.F: Talleres de B. Costa-Amic, Editor, 1967.

————. *Poesias completas*. Madrid: Aguilar, S.A. de Ediciones, 1967.

de la Cadena, Marisol. *Indigenous Mestizos: The Politics of Race and Culture in Cuzco, Peru, 1919–1991*. Durham, NC: Duke University Press, 2000.

de Rivero, Gloria Videla. *Dirreciones del vanguardismo hispanoamericano*. Tomos 1 and 2. Mendoza, Argentina: Universidad Nacional de Cuyo, Facultad de Filosofía y Letras, 1990.

del Castillo, Richard Griswold. *Chicano Art: Resistance and Affirmation, 1965–1985*. Los Angeles: Wight Art Gallery, University of California Press, 1991.

Deleuze, Gilles, and Félix Guattari. *A Thousand Plateaus: Capitalism and Schizophrenia*. Trans. Brian Massumi. Minneapolis: University of Minnesota Press, 1987.

Duchamp, Marcel. *The Writings of Marcel Duchamp*. Ed. Michel Sanouillet and Elmer Peterson. New York: Oxford University Press, 1973.

Eshleman, Clayton. Afterword: "Vallejo's Succulent Snack of Unity." *Trilce*. By César Vallejo. Trans. Clayton Eshleman. New York: Marsilio Publishers, 1992. 237–260.

———. Translator's Note. *Trilce*. By César Vallejo. Trans. Clayton Eshleman. New York: Marsilio Publishers, 1992. xxi—xxvi.

Espejo Asturrizaga, Juan. *César Vallejo: Itinerario del hombre, 1892–1923*. Lima, Peru: Seglusa Editores, 1989.

Felski, Rita. *The Gender of Modernity*. Cambridge: Harvard University Press, 1995.

Ferrari, Américo. Introduction. *Trilce*. By César Vallejo. Trans. Clayton Eshleman. New York: Marsilio Publishers, 1992. ix—xx.

Fiol-Matta. "The 'Schoolteacher of America': Gender, Sexuality, and Nation in Gabriela Mistral." *¿Entiendes? Queer Readings, Hispanic Writings*. Ed. Emilie L. Bergmann and Paul Julian Smith. Durham, NC: Duke University Press, 1995.

———. *A Queer Mother for the Nation*. Minneapolis: University of Minnesota Press, 2002.

Fletcher, Valerie, ed. *Crosscurrents of Modernism: Four Pioneers, Diego Rivera, Joaquín Torres-García, Wifredo Lam, Matta*. Washington, DC: Smithsonian Institution Press, 1992.

Folgarait, Leonard. *Mural Painting and Social Revolution in Mexico, 1920–1940*. Cambridge: Cambridge University Press, 1998.

Franco, Jean. *César Vallejo: The Dialectics of Poetry and Silence*. Cambridge: Cambridge University Press, 1976.

———. "La temática: De *Los heraldos negros* a los 'Poemas póstumos.'" *César Vallejo: Obra poética*. Ed. Américo Ferrari. Paris: Collección Archivos, 1988. 575–605.

———. "Loca y no loca. La cultura popular en la obra de Gabriela Mistral." *Re-leer hoy a Gabriela Mistral*. Ed. Gastón Lillo and J. Guillermo Renart. Ottowa, Canada: University of Ottowa, 1997. 27–42.

Frank, Waldo. *Our America*. New York: Boni and Liveright, 1919.

Freyre, Gilberto. *The Mansions and the Shanties: The Making of Modern Brazil*. Ed. and trans. Harriet de Onís. Westport, CT: Greenwood Press, 1980.

Frow, John. *Time and Commodity Culture: Essays in Cultural Theory and Postmodernity*. Oxford: Clarendon Press, 1997.

Gamio, Manuel. *Forjando patria*. Mexico: Editorial Porrúa, 1960 (1916).

———. *Introduction, Synthesis, and Conclusions of the Work: The Population of the Valley of Teotihuacán*. Mexico, D.F.: Talleres Gráficos de la Nación, 1922.

Gamio, Manuel, and José Vasconcelos. *Aspects of Mexican Civilization (Lectures on the Harris Foundation, 1926)*. Chicago: University of Chicago Press, 1926.

García Calderón, Ventura. *Obra literaria selecta*. Caracas, Venezuela: Biblioteca Ayacucho, 1989.

García Canclini, Néstor. "Cultural Reconversion." *On Edge: The Crisis of Contemporary Latin American Culture*. Ed. George Yúdice, Jean Franco, and Juan Flores. Minneapolis, MN: University of Minnesota Press, 1992. 29–43.

García Canclini, Néstor. *Transforming Modernity: Popular Culture in Mexico*. Trans. Lidia Lozano. Austin: University of Texas Press, 1993.

———. *Hybrid Cultures: Strategies for Entering and Leaving Modernity*. Trans. Christopher L. Chiappari and Silivia L. López. Minneapolis: University of Minnesota Press, 1995.

Gilroy, Paul. *The Black Atlantic: Modernity and Double Consciousness*. Cambridge, MA: Harvard University Press, 1993.

Goldman, Shifra M. *Dimensions of the Americas: Art and Social Change in Latin America and the United States*. Chicago: University of Chicago Press, 1994.

González, Aníbal. *Journalism and the Development of Spanish American Narrative*. New York, NY: Cambridge University Press, 1993.

González Echevarría, Roberto. *Myth and Archive: A Theory of Latin American Narrative*. Cambridge: Cambridge University Press, 1990.

González Prada, Manuel. *Paginas Libres/Horas de Lucha*. Caracas, Venezuela: Biblioteca Ayacucho, 1976.

González Prada, Manuel, and Abraham Valdelomar, eds. *Colónida*. Lima, Peru: Ediciones Copé, 1981.

Graham, Richard, ed. *The Idea of Race in Latin America, 1870–1940*. Austin: University of Texas Press, 1990.

Greenberg, Clement. "Collage." *Collage: Critical Views*. Ed. Katherine Hoffman. Ann Arbor: University of Michigan Press, 1989. 67–77.

Guardia, Sara Beatríz. *Mujeres Peruanas: El Otro lado de la historia*. Lima, Peru: Tempus, 1986.

Guerrero, Julio. *La génesis del crimen en México: Estudio de psiquiatría social*. Paris: Charles Bouret, 1901.

Guzmán, Jorge Ch. *Contra el secreto profesional: Lectura mestiza de César Vallejo*. Santiago de Chile: Editorial Universitaria, 1991.

Haeckel, Ernst. *The Wonders of Life: A Popular Study of Biological Philosophy*. New York: Harper & Brothers, 1905.

Harrison, Charles, Francis Frascina, and Gill Perry. *Primitivism, Cubism, Abstraction: The Early 20th Century*. New Haven: Yale University Press, 1993.

Hart, Stephen M., ed. *"No Pasarán": Art, Literature, and the Spanish Civil War* London: Tamesis, 1988.

Hegeman, Susan. *Patterns for America: Modernism and the Concept of Culture*. Princeton, NJ: Princeton University Press, 1999.

Heimann, Jim. "Calendario Girls: Mexican Chromos." *Art Juxtapoz* 28 (Sept.—Oct. 2000): 28–33.

Helms, Cynthia Newman, ed. *Diego Rivera: A Retrospective*. New York: W. W. Norton, 1986.

Herrera, Hayden. *Frida: A Biography of Frida Kahlo*. New York: Harper & Row, 1983.

Herrera y Reissig, Julio. *Poesía completa y prosa selecta*. Ed. Alicia Migdal. Caracas, Venezuela: Biblioteca Ayacucho, 1978.

Hershfield, Joanne, and David R. Maciel, eds. *Mexico's Cinema: A Century of Film and Filmmakers*. Wilmington, DE: Scholarly Resources, 1999.

Higgins, James. "Vallejo, poeta de la periferia." *Caminando con César Vallejo: Actas del coloquio internacional sobre CV*. Lima, Peru: Editorial Perla, 1988. 147–161.

Higgins, John, ed. *The Raymond Williams Reader*. Malden, MA: Blackwell Publishers, 2001.

Higonnet, Anne. *Berthe Morisot's Images of Women*. Cambridge, MA: Harvard University Press, 1992.

Horan, Elizabeth. "Gabriela Mistral: Language Is the Only Homeland." *A Dream of Light and Shadow: Portraits of Latin American Women Writers*. Albuquerque: University of New Mexico Press, 1995. 119–142.

Huyssen, Andreas. *After the Great Divide: Modernism, Mass Culture, Postmodernism*. Bloomington: Indiana University Press, 1986.

Irigaray, Luce. "Ce sexe qui n'en est pas une" (This sex which is not one). *New French Feminisms*. Ed. Elaine Marks and Isabelle de Courtivron. New York: Schocken Books, 1981.

Jacobsen, Nils. *Mirages of Transition: The Peruvian Altiplano, 1780–1930*. Berkeley: University of California Press, 1993.

Jameson, Fredric. *The Political Unconscious: Narrative as a Socially Symbolic Act*. Ithaca, NY: Cornell University Press, 1981.

———. *Postmodernism: Or, the Cultural Logic of Late Capitalism*. Durham: Duke University Press, 1991.

Jardine, Alice A. *Gynesis: Configurations of Women and Modernity*. Ithaca, NY: Cornell University Press, 1985.

Jones, Robert B., and Margery Toomer Latimer, eds. *The Collected Poems of Jean Toomer*. Chapel Hill: University of North Carolina Press, 1988.

Kaplan, Carla. Review Essays: "On Modernism and Race." *Modernism/Modernity* 4 (1997): 157–174.

Kellner, Bruce. *The Harlem Renaissance: A Historical Dictionary for the Era*. New York: Methuen, 1987.

Kirkpatrick, Gwen. *The Dissonant Legacy of Modernismo: Lugones, Herrera y Reissig, and the Voices of Modern Spanish American Poetry*. Ed. Emilie Bergmann et al. Berkeley: University of California Press, 1989.

———. "The Journalism of Alfonsina Storni: A New Approach to Women's History in Argentina." *Women, Culture, and Politics in Latin America: Seminar on Feminism and Culture in Latin America*. Ed. Emilie Bergmann et al. Berkeley: University of California Press, 1990. 105–129.

———. "The Creation of Alfonsina Storni." *A Dream of Light and Shadow: Portraits of Latin American Women Writers*. Ed. Marjorie Agosín. Albuquerque: University of New Mexico Press, 1995. 95–118.

Kismaric, Carole, and Marvin Heiferman, eds. *Frida Kahlo: The Camera Seduced*. San Francisco: Chronicle Books, 1992.

Knight, Alan. "Racism, Revolution, and *Indigenismo:* Mexico, 1910–1940." *The Idea of Race in Latin America, 1870–1940.* Ed. Richard Graham. Austin: University of Texas Press, 1990. 71–114.

Kristal, Efraín. *The Andes Viewed from the City: Literary and Political Discourse on the Indian in Peru, 1848–1930.* New York: Peter Lang, 1987.

Kristeva, Julia. *Powers of Horror: An Essay on Abjection.* Trans. Leon S. Roudiez. New York: Columbia University Press, 1982.

Kutzinski, Vera M. *Sugar's Secrets: Race and the Erotics of Cuban Nationalism.* Charlottesville: University Press of Virginia, 1993.

Lafuente, Fernando R. "La *invención* de César Vallejo por Juan Larrea." *Insula* 586 (Oct. 1995): 5–6.

LaGuardia, Gari. "Digesting Modernismo: Peristalsis and Poetic Paternity in Vallejo." *Neophilologus* 77 (Jan. 1993): 75–97.

Lambie, George. *El pensamiento político de César Vallejo y la guerra civil Española.* Trans. Walter Gamarra Arana. Peru: Editorial Milla Batres, 1993.

Larsen, Neil. *Reading North by South: On Latin American Literature, Culture, and Politics.* Minneapolis: University of Minnesota Press, 1995.

Lee, Anthony W. *Painting on the Left: Diego Rivera, Radical Politics, and San Francisco's Public Murals.* Berkeley: University of California Press, 1999.

León O., Jaime. *César Vallejo: Investigación fotográfico literaria sobre la vida y obra.* Miraflores, Peru: CONCYTEC, 1988.

Lillo, Gastón, and J. Guillermo Renart, eds. *Re-leer hoy a Gabriela Mistral: Mujer, historia y sociedad en América Latina.* Ottowa, Canada: University of Ottowa, 1997.

Lowe, Sarah M. *Frida Kahlo.* New York: Universe Publishing, 1991.

Lucie-Smith, Edward. *Latin American Art of the Twentieth Century.* London: Thames and Hudson, 1993.

Lydenberg, Robin. "Engendering Collage: Collaboration and Desire in Dada and Surrealism." *Collage: Critical Views.* Ed. Katherine Hoffman. Ann Arbor: University of Michigan Press, 1989. 271–286.

Marchant, Elizabeth. *Critical Acts: Latin American Women and Cultural Criticism.* Gainesville: University of Florida Press, 1999.

Mariátegui, José Carlos. *Seven Interpretive Essays on Peruvian Reality.* Trans. Marjory Urquidi. Austin: University of Texas Press, 1971.

Martí, José. *José Martí: Obras Completas.* Vol. 2. La Habana, Cuba: Editorial Lex, 1953.

———. *Our America by José Martí: Writings on Latin America and the Struggle for Cuban Independence.* Trans. Elinor Randall. Ed. Philip S. Foner. New York: Monthly Review Press, 1977.

———. *José Martí Reader: Writings on the Americas.* Ed. Deborah Shnookal and Mirta Muñoz. New York: Ocean Press, 1999.

Masiello, Francine, ed. *La mujer y el espacio público: El periodismo femenino en la Argentina del siglo XIX.* Buenos Aires, Argentina: Feminaria, 1994.

Matto de Turner, Clorinda. *Torn from the Nest.* Trans. John H. R. Polt. Ed. Antonio Cornejo Polar. New York: Oxford University Press, 1998.

McFarlane, James. "The Mind of Modernism." *Modernism, 1890–1930.* Ed. Malcom Bradbury and James McFarlane. New York: Penguin Books, 1976.

Michaels, Walter Benn. *Our America: Nativism, Modernism, and Pluralism.* Durham, NC: Duke University Press, 1995.

Miller, Francesca. *Latin American Women and the Search for Social Justice.* Hanover: University Press of New England, 1991.

Miller, Laura, Katherine Roberts, et al., eds. *Lima Obrera, 1900–1930: Tomo II.* Lima, Peru: Ediciones el Virrey, 1986.

Miller, Mary, and Karl Taube. *An Illustrated Dictionary of the Gods and Symbols of Ancient Mexico and the Maya.* London: Thames and Hudson, 1993.

Miller, Robert, and Spencer Throckmorton. *Tina Modotti: Photographs.* New York: Robert Miller Gallery, 1997.

Mistral, Gabriela. *Ternura.* Buenos Aires, Argentina: Editora Espasa-Calpe Argentina, S.A., 1945.

———. *Desolación.* Editora Espasa-Calpe Argentina, S.A., 1951.

———. *Lagar.* Santiago de Chile, Chile: Editorial del Pacífico, S.A., 1954.

———. *Lecturas para mujeres.* San Salvador, El Salvador: Ministerio de Educación, Dirección de Publicaciones, 1977.

———. *Gabriela piensa en . . . Selección de prosas y prólogo.* Ed. Roque Esteban Scarpa. Santiago, Chile: Editorial Andres Bello, 1978.

———. *Desolación-Ternura-Tala-Lagar.* Intr. Palma Guillén de Nicolau. Mexico, D.F.: Editorial Porrúa, 1979.

———. *A Gabriela Mistral Reader.* Trans. Maria Giachetti. Ed. Marjorie Agosin. Fredonia, NY: White Pine Press, 1993.

———. *Gabriela Mistral: Escritos políticos.* Ed. Jaime Quezada. México, D.F.: Fondo de Cultura Económica, 1994.

Monsiváis, Carlos. *Mexican Postcards.* Ed. and trans. John Kraniauskas. New York: Verso, 1997.

Morrison, Toni. *Playing in the Dark: Whiteness and the Literary Imagination.* New York: Vintage, 1992.

Moseley, Michael E. *The Incas and Their Ancestors: The Archeology of Peru.* London: Thames and Hudson, 1992.

Motherwell, Robert. "Beyond the Aesthetic." *Design* 47.8 (1946): 14–15.

Mulvey, Laura, and Peter Wollen. "Frida Kahlo and Tina Modotti." *Frida Kahlo and Tina Modotti.* Dir. Nicholas Seroti. London: Whitechapel Art Gallery, 1982.

Newman, Kathleen. "The Modernization of Femininity: Argentina, 1916–1926." *Women, Culture, and Politics in Latin America: Seminar on Feminism and Culture in Latin America.* Ed. Emilie Bergmann et al. Berkeley: University of California Press, 1990. 74–89.

North, Michael. *The Dialect of Modernism: Race, Language, and Twentieth-Century Literature* New York: Oxford University Press, 1994.

Novas, Himilce. *Everything You Need to Know about Latino History.* New York: Plume, 1994.

Nugent, David. *Modernity at the Edge of Empire: State, Individual, and Nation in the Northern Peruvian Andes, 1885–1935.* Stanford: Stanford University Press, 1997.

O'Connor, Kevin. Foreword. *Tungsten: A Novel by César Vallejo.* Trans. Robert Mezey. Syracuse, NY: Syracuse University Press, 1988.

Oliart, Patricia. "Poniendo a cada quien en su lugar: Estereotipos raciales y sexuales en la Lima del siglo XIX." *Mundos Interiores: Lima, 1850–1950.* Ed. Aldo Panfichi H. and Felipe Protocarrero S. Lima, Peru: Universidad del Pacífico, Centro de Investigación, 1995.

Ortega, Julio. "La hermenéutica vallejiana y el hablar materno." *César Vallejo: Obra poética.* Ed. Américo Ferrari. Madrid: Collección Archivos, 1988. 606–620.

Osorio T., Nelson. "Para una caracterización histórica del vanguardismo literario hispanoamericano." *Revista Iboamericana* 47.114–115 (Jan.—June 1981): 227–254.

Ostria González, Mauricio. "Gabriela Mistral y César Vallejo: La americanidad como desgarramiento." *Revista Chilena de Literatura* 47 (Aug. 1993): 193–199.

Pach, Walter. "Frida Rivera: Gifted Canvases by an Unselfconscious Surrealist." *Art News* 37 (Nov. 1938): 13.

Palau de Nemes, Graciela. "La poesía indigenista de vanguardia de Alejandro Peralta." *Revista Iberoamericana* 110–111 (Jan.—June 1980): 205–216.

Parker, David S. "Los pobres de la clase media: Estilo de vida, consumo e identidad en una ciudad tradicional." *Mundos Interiores: Lima, 1850–1950.* Ed. Aldo Panfichi H. and Felipe Protocarrero S. Lima, Peru: Universidad del Pacífico, Centro de Investigación, 1995.

Peralta, Alejandro. *Poesía de entretiempo.* Lima, Peru: Ediciones Andimar, 1968.

Pérez, Louis A., Jr. *On Becoming Cuban: Identity, Nationality, and Culture.* Chapel Hill: University of North Carolina Press, 1999.

Pizarro, Ana. "Mistral, ¿Qué modernidad?" *Re-leer hoy a Gabriela Mistral: Mujer, historia y sociedad en América Latina.* Ed. Gastón Lillo and J. Guillermo Renart. Ottowa, Ontario: Legas Productions, 1997. 43–52.

Poggi, Christine. "Mallarmé, Picasso, and the Newspaper as Commodity." *Collage: Critical Views.* Ed. Katherine Hoffman. Ann Arbor: University of Michigan Press, 1989. 171–192.

Poole, Deborah. *Vision, Race, and Modernity: A Visual Economy of the Andean Image World.* Princeton, NJ: Princeton University Press, 1997.

Prada, Manuel González. *Páginas libres: Horas de lucha.* Ed. Luis Alberto Sánchez. Caracas: Biblioteca Ayacucho, 1976.

Pratt, Mary Louise. "Women, Literature, and National Brotherhood." *Women, Culture, and Politics in Latin America: Seminar on Feminism and Culture in Latin America.* Ed. Emilie Bergmann et al. Berkeley: University of California Press, 1990. 48–73.

Rama, Angel. *Rubén Darío y el modernismo: Circunstancia socioeconómica de un arte americano*. Caracas: Ediciones de la Biblioteca de la Universidad Central de Venezuela, 1970.

Roberts, Mary Louise. *Civilization without Sexes: Reconstructing Gender in Postwar France, 1917–1927*. Chicago: University of Chicago Press, 1994.

Rodríguez-Prampolini, Ida. "Diego Rivera's Murals." *Diego Rivera: A Retrospective*. Ed. Cynthia Newman Helms. New York: W. W. Norton, 1986.

Rosaldo, Renato. Foreword. *Hybrid Cultures: Strategies for Entering and Leaving Modernity*. By Néstor García Canclini. Trans. Christopher L. Chiappari and Silvia L. López. Minneapolis: University of Minnesota Press, 1995. i—xxi.

Rosenblum, Robert. "Cubism as Pop Art." *Modern Art and Popular Culture: Readings in High and Low*. New York: Abrams, 1990. 116–133.

Rowe, William, and Vivian Schelling. *Memory and Modernity: Popular Culture in Latin America*. New York: Verso, 1991.

Sanborn, Cynthia. "Los obreros textiles de Lima: Redes sociales y organización laboral, 1900–1930." *Mundos Interiores: Lima, 1850–1950*. Ed. Aldo Panfichi H. and Felipe Protocarrero S. Lima, Peru: Universidad del Pacífico, Centro de Investigación, 1995.

Santos Chocano, José. *Los cien mejores poemas de José Santos Chocano*. Ed. Antonio Castro Leal. México, D.F.: M. Aguilar, Editor, S.A., 1971.

Schneider, Luis Mario. "Gabriela Mistral en México: Una devota del misionerismo vasconcelista." *Re-leer hoy a Gabriela Mistral: Mujer, historia y sociedad en América Latina*. Ed. Gastón Lillo and J. Guillermo Renart. Ottowa, Ontario: Legas Productions, 1997. 147–158.

Schwartz, Jorge. *Las vanguardias latinoamericanas: Textos programáticos y críticos*. Madrid: Ediciones Cátedra, 1991.

Scruggs, Charles, and Lee VanDemarr. *Jean Toomer and the Terrors of American History*. Philadelphia: University of Pennsylvania Press, 1998.

Seroti, Nicholas, Dir. *Frida Kahlo and Tina Modotti*. London: Whitechapel Art Gallery, 1982.

Sharman, Adam. *The Poetry and Poetics of César Vallejo: The Fourth Angle of the Circle*. Lampeter, Dyfed, Wales: Edwin Mellen Press, 1997.

Sharp, Ellen. "Rivera as a Draftsman." *Diego Rivera: A Retrospective*. Ed. Cynthia Newman Helms. New York: W. W. Norton, 1986. 203–214.

Singal, Daniel Joseph. "Towards a Definition of American Modernism." *American Quarterly* 39 (1987): 7–25.

Skidmore, Thomas E. "Racial Ideas and Social Policy in Brazil, 1870–1940." *The Idea of Race in Latin America, 1870–1940*. Ed. Richard Graham. Austin: University of Texas Press, 1990. 7–36.

Sommer, Doris. *Foundational Fictions: The National Romances of Latin America*. Berkeley: University of California Press, 1991.

Spillers, Hortense J. *Comparative American Identities: Race, Sex, and Nationality in the Modern Text*. New York: Routledge, 1991.

Stavans, Ilan. *The Riddle of Cantinflas: Essays on Hispanic Popular Culture.* Albuquerque: University of New Mexico Press, 1998.

Stepan, Nancy Leys. *"The Hour of Eugenics": Race Gender, and Nation in Latin America.* Ithaca, NY: Cornell University Press, 1991.

Stocking, George W., Jr. *Race, Culture, and Evolution: Essays in the History of Anthropology.* Chicago: University of Chicago Press, 1968.

Strathern, Marilyn, ed. *Shifting Contexts: Transformations in Anthropological Knowledge.* New York: Routledge, 1995.

Suleiman, Susan. *Subversive Intent: Gender, Politics, and the Avant-Garde.* Cambridge, MA: Harvard University Press, 1990.

Tejada R., Luis. "Malambo." *Mundos Interiores: Lima, 1850–1950.* Ed. Aldo Panfichi H. and Felipe Protocarrero S. Lima, Peru: Universidad del Pacífico, Centro de Investigación, 1995.

Thurner, Mark. *From Two Republics to One Divided: Contradictions of Postcolonial Nationmaking in Andean Peru.* Durham, NC: Duke University Press, 1997.

Tompkins, Jane. "Sentimental Power: *Uncle Tom's Cabin* and the Politics of Literary History." *Feminist Criticism: Essays on Women, Literature, and Theory.* Ed. Elaine Showalter. New York: Pantheon Books, 1985. 81–104.

Toomer, Jean. *Cane.* New York: Boni and Liveright, 1923.

Unruh, Vicky. *Latin American Vanguards: The Art of Contentious Encounters.* Berkeley: University of California Press, 1994.

Valdelomar, Abraham. *La aldea encantada.* Lima, Peru: Ediciones Los Andes, 1973.

Vallejo, César. *Contra el secreto profesional.* Lima: Mosca Azul, 1973.

———. *César Vallejo: The Complete Posthumous Poetry.* Trans. Clayton Eshleman and José Rubia Barcia. Berkeley: University of California Press, 1980.

———. *Desde europa: Crónicas y artículos.* Ed. Jorge Puccinelli. Lima, Peru: Ediciones Fuente de Cultura Peruana, 1987.

———. *Obra poética.* Ed. Américo Ferrari. Madrid: Collección Archivos, 1988.

———. *Tungsten: A Novel.* Trans. Robert Mezey. Syracuse, NY: Syracuse University Press, 1988.

———. *The Black Heralds.* Trans. Richard Schaaf and Kathleen Ross. Pittsburgh: Latin American Literary Review Press, 1990.

———. *Trilce.* Ed. Julio Ortega. Madrid: Ediciones Cátedra, S.A., 1991.

———. *Trilce.* Trans. Clayton Eshleman. New York: Marsilio Publishers, 1992.

———. *Narrativa completa.* Ed. Antonio Merino. Madrid: Ediciones Akal, 1996.

Vasconcelos, José. *The Cosmic Race/La raza cósmica.* Trans. Didier T. Jaén. Baltimore, MD: Johns Hopkins University Press, 1979.

Vaughan, Mary Kay. "Modernizing Patriarchy: State Policies, Rural Households, and Women in Mexico, 1930–1940." *Hidden Histories of Gender and the State in Latin America.* Ed. Elizabeth Dore and Maxine Molyneux. Durham, NC: Duke University Press, 2000. 194–214.

Verani, Hugo J. *Las vanguardias literarias en hispanoamérica (manifiestos, proclamas, y otros escritos)*. México, D.F.: Fondo de Cultura Económica, 1990.

Videla de Rivero, Gloria. *Direcciones del vanguardismo hispanoamericano, Tomo 1: Estudios sobe poesía de vanguardia en la decada del veinte*. Mendoza, Argentina: Universidad Nacional de Cuyo, 1990.

———. *Direcciones del vanguardismo hispanoamericano, Tomo 2: Documentos*. Mendoza, Argentina: Universidad Nacional de Cuyo, 1990.

von Buelow, Christiane. "The Allegorical Gaze of César Vallejo." *Modern Language Notes* 100 (1985): 298–329.

———. "Vallejo's *Venus de Milo* and the Ruins of Language." *Publications of the Modern Language Association* 104.1 (1989): 41–52.

———. "César Vallejo and the Stones of Darwinian Risk." *Studies in Twentieth-Century Literature* 1 (winter 1990): 9–19.

Williams, Raymond. *Marxism and Literature*. Oxford, UK: Oxford University Press, 1977.

———. *The Politics of Modernism: Against the New Conformists*. New York: Verso, 1989.

Wise, David. "Vanguardismo a 3800 metros: El caso del *Boletín Titikaka* (Puno, 1926–1930)." *Revista de Crítica Literaria Latinoamericana* 10 (2nd semester 1984): 89–100.

Wollen, Peter. *Raiding the Icebox: Reflections on Twentieth-Century Culture*. Bloomington: Indiana University Press, 1993.

Yáñez, Mirta, ed. *La novela romántica latinoamericana*. La Habana, Cuba: Casa de las Américas, 1978.

Yeager, Gertrude M. Introduction. *Confronting Change, Challenging Tradition: Women in Latin American History*. Ed. Gertrude M. Yeager. Wilmington, DE: Scholarly Resources Inc., 1994. xi—xxi.

Yúdice, George. "Postmodernity and Transnational Capitalism in Latin America." *On Edge: The Crisis of Contemporary Latin American Culture*. Ed. George Yúdice, Jean Franco, and Juan Flores. Minneapolis: University of Minnesota Press, 1992. 1–27.

Yúdice, George, Jean Franco, and Juan Flores, eds. *On Edge: The Crisis of Contemporary Latin American Culture*. Minneapolis: University of Minnesota Press, 1992.

Yurkievich, Sául. *La movediza modernidad*. Madrid, España: Santillana, S.A. Taurus, 1996. 71–104.

Zamora, Martha, ed. *The Letters of Frida Kahlo: Cartas Apasionadas*. San Francisco: Chronicle Books, 1995.

Zea, Leopoldo. *Precursores del pensamiento Latinoamericano contemporáneo*. Mexico, D.F.: Sep Diana, 1979

INDEX

ABOUT THE AUTHOR

ASSISTANT PROFESSOR TACE HEDRICK received her B.A. in English and writing from the University of Colorado at Denver and her M.A. and Ph.D. in comparative literature (twentieth-century Latin-American and French literature and contemporary theory) from the University of Iowa. Before her current joint appointment in English and women's studies at the University of Florida, she taught at Pennsylvania State University, Harrisburg. At Florida, Professor Hedrick offers courses in Chicano and Latino literature and theory as well as in women's studies and feminist theory. Currently, her areas of interest focus primarily on the work produced during the Chicano and Latino civil rights period of the late 1960s and 1970s in the United States. She has published articles on U.S. Latino culture, bilingual Chicano poetry, César Vallejo's poetry, and Brazilian literature in journals such as the *Translator*, the *Latin American Literary Review,* and the *Luso-Brazilian Review* and in collections, including *Footnotes: On Shoes* and *The Returning Gaze: Primitivism and Identity in Latin America.*

A NOTE ON THE TYPE

This book was set in New Caledonia, a digital interpretation of
the typeface Caledonia created in 1938 by the noted American designer
and typographer William Addison Dwiggins (1880–1956). Dwiggins was
responsible for creating the typographic house style at Alfred Knopf
Publishers in the 1930s and '40s. Caledonia was one of three typefaces
created in the early twentieth century for the Linotype machine (the
others were Dwiggins' Electra, issued in 1935, and Rudolf Růžička's
Fairfield, issued in 1940) which became immediate staples of American
publishing and significant precursors of postmodern type design.

Designed and composed by Kevin Hanek

Printed and bound by Sheridan Books, Inc.,
Ann Arbor, Michigan